ARTICULATE IMAGES

The Sister Arts
from Hogarth to Tennyson

ARTICULATE IMAGES

*The Sister Arts
from Hogarth to Tennyson*

Edited by

Richard Wendorf

University of Minnesota Press ☐ *Minneapolis*

The Northwestern University
Research Grants Committee
and the Office of the Provost
have provided partial support
for the publication of this book.
The University of Minnesota Press
gratefully acknowledges
this assistance.

Published by the University of Minnesota Press,
2037 University Avenue Southeast, Minneapolis, MN 55414
Printed in the United States of America.

Library of Congress Cataloging in Publication Data
Main entry under title:

Articulate images.

Bibliography: p.
Includes index.
1. English literature—19th century—History and
criticism—Addresses, essays, lectures. 2. English literature—
18th century—History and criticism—Addresses, essays,
lectures. 3. Art, English—Addresses, essays, lectures. 4.
Art and literature—England—Addresses, essays, lectures.
5. Blake, William, 1757-1827—Criticism and interpretation—
Addresses, essays, lectures. I. Wendorf, Richard.
PR468.A76E95 1983 700'.942 83-5798
ISBN 0-8166-1143-2

The University of Minnesota
is an equal-opportunity
educator and employer.

For

Jean Howard Hagstrum

CONTENTS

PREFACE

M en who cherish more than one of the arts have often made comparisons between them": this is how Jean Hagstrum opened *The Sister Arts*, his pioneering study of the influence of the visual arts on the imagination of English poets in the seventeenth and eighteenth centuries. What must certainly strike us today is the increasing frequency with which the arts have been compared, or at least considered in relation to each other, in the twenty-five years since Hagstrum's book was published. One of the major reasons for the recent popularity of this area of comparative studies is to be found, of course, in the general explosion of academic scholarship in the past two decades; we can chart similar growth in art history and criticism, in the careful establishment and analysis of literary texts, and (most recently) in literary and linguistic theory. In the case of the sister arts, however, no single scholar has had a greater influence than Hagstrum in suggesting the intimate (and sometimes troubled) relationship between poetry and painting. Few books can truthfully be described as "seminal," but this seems to be the most accurate description of *The Sister Arts*, which more than any other work has provided a basis for development and refinement within the comparative field of art and literature. The following critical essays, published here for the first time, are meant both to pay tribute to Jean Hagstrum's work and to suggest the variety of subjects and approaches of those now working in the field he helped to create.

"The Sister Arts" is itself an amorphous and perhaps unsatisfactory description of several different kinds of critical activity. In the introduction to his book, Hagstrum was careful to point out how his method differed from those of others engaged in similar work on poetry and painting. The claims he makes for his own study are characteristically modest, and he in fact implicitly argues that his work on literary pictorialism cannot be strictly defined as *inter*disciplinary: it does not fall squarely between two separate branches of learning; its primary method is close literary analysis (of the pictorial within—or behind—the poetic). Hagstrum did not intend to compare works in two artistic forms, nor to suggest how comparable works emerge from the same cultural milieu. But it should be clear that even this restricted study of iconic poetry and the tradition of *ut pictura poesis* is closely related to work of a more ostensibly comparative nature; and Hagstrum's more recent work on composite art (in *William Blake Poet and Painter*) and on the verbal, visual, and musical treatment of love and eroticism (in *Sex and Sensibility*) also illuminates the ground shared by these different kinds of critical activity.

The following collection of essays, which focuses on major English figures from the Augustan through the early Victorian periods, necessarily reflects the diversity that characterizes current approaches to art and literature. Closest in spirit and method to *The Sister Arts* is Lawrence Lipking's reexamination of the pictorial nature of eighteenth-century English poetry. Two contributions are appropriately the work of art historians: Robert Wark offers cautionary advice to literary critics approaching visual "texts" for the first time; Larry Silver considers painting in the double guise of sister art and liberal art, with an emphasis on the fate of Renaissance theories of painting in eighteenth-century England. A similarly fresh perspective is to be found in Earl Miner's discussion of the concept of mimesis in non-Western culture (specifically in Japanese composite art of the late eighteenth century).

W. J. T. Mitchell's wide-ranging essay is also concerned with examples of composite art (in Blake and Turner), but his major interest lies in examining the evolution of a form—the vortex, often portrayed as the swirling maelstrom or whirlpool—that permeates the art and literature of the eighteenth and early nineteenth centuries. The essay by Karl Kroeber (on Wordsworth and Constable, Tennyson

and Millais) analyzes parallel developments in painting and poetry in the Romantic and early Victorian periods; my own contribution on biography and portrait painting suggests a new pairing of related arts. Even the two essays that focus on the same figure—William Blake—consider his achievements from different perspectives: Morton Paley examines Blake's interest in (and symbolic use of) architecture, while Ronald Paulson confronts the tensions between word and image in several of Blake's revolutionary poems and designs.

Considered as a whole, the nine essays in this volume are intended to provide a sense of the different ways in which the comparative criticism of art and literature is currently practiced. We have attempted to appeal to readers first entering this field as well as to specialists in the sister arts, and we have therefore illustrated our varied methodological approaches by paying careful attention to specific verbal and visual texts. We have also appended both a checklist of modern scholarship on the sister arts and a bibliography of the works of Jean Hagstrum, to whom we dedicate our contributions with great affection and admiration.

* * *

I have benefited from generous advice and assistance at every stage in the preparation of this collection of essays. The publication of this volume was greatly assisted by the Northwestern University Research Grants Committee, and by the encouragement of Raymond Mack, Northwestern's Provost. Marjorie Cullen Jones helped prepare the checklist of relevant scholarship; Marjorie Weiner once again lent her valuable aid in readying the manuscript for the press. My greatest debts are to several colleagues who cheerfully shared both various editorial tasks and their knowledge of the sister arts with me. I should like to thank Leonard Barkan, Douglas Cole, Larry Silver, Donald Torchiana, Herbert Tucker, Catherine Miles Wallace, and (in particular) Lawrence Lipking.

Richard Wendorf
Northwestern University

ARTICULATE IMAGES
The Sister Arts
from Hogarth to Tennyson

QUICK POETIC EYES
Another Look
at Literary Pictorialism

Lawrence Lipking

The sister arts have raised a family. In the more than twenty years since Jean Hagstrum published his germinal book, scholarship on the interrelations of the arts in the eighteenth century has multiplied dramatically in size as well as range. Indeed, we cannot speak of the sister arts now as a single field of study, since obviously they have branched off into many fields. This book itself bears witness. To begin with, many more arts have been added to the original twins of painting and poetry with their sister music. The family tree now includes architecture, landscape gardening, sculpture, and the graphic arts of book illustration at the very least. Nor do these exhaust the list. J. H. Plumb has shown us how much can be done with the domestic arts, for instance, and Maynard Mack with a grotto.[1] The house of eighteenth-century studies hardly has enough room to contain them all. And only someone very foolhardy would claim that additional sisters and nieces—acting, epicurism, calligraphy, etc.—do not remain to be pried out of a back closet.

Even scholars who confine themselves to one or two arts, moreover, are not necessarily working in the same field. The many literary scholars who focus on painting, to take only the most noted example, often do not share each other's interests. Some of them work essentially as art historians, scrupulously avoiding analogies between the arts and revealing their literary backgrounds only by the objects they choose to study (as in W. K. Wimsatt's catalog of the portraits of Pope). Some of them adapt the techniques of

literary criticism to the analysis of paintings (as in Ronald Paulson's studies of what and how a painting "means").[2] Some of them view the relations between the arts philosophically, as a problem in aesthetics, and some practically, as a way of matching specific texts to specific images (comparing Pope's or Thomson's poems, for instance, with paintings they refer to or paintings made to illustrate them).[3] Some of them, like W. J. T. Mitchell, are iconologists, concerned with the history of images and forms, and some, like David Erdman, are iconographers, concerned to read the individual image like a piece of writing. Some are interested in the *Zeitgeist* that poems and paintings share, and some in the irreducible differences between any poem and any painting. Some speculate, and some do not. Nor do such scholars always read each other's books.

Much of this proliferation of fields and attitudes should doubtless be considered a positive good: a tribute to the richness and fascination of the sister arts themselves. At a time when interdisciplinary studies have become fashionable, the traditional kinship among the arts seems to offer a model for scholarship—always with the proviso, of course, that two half-understood "disciplines" will never combine in a whole one. A student of the sister arts must learn to work twice as hard. But a surprising number of scholars has been willing to do so. It seems incontestable to me that the last twenty years have witnessed a vast improvement in our understanding of the sisters. Scholars are far more knowledgeable than they used to be, far more sophisticated. The booming Blake industry, much of it devoted to intense study of illuminations known largely by rumor a few decades ago, is only the most obvious sign of this change. And our resources for study also have improved, most conspicuously in that emblem of scholarly grace, the Yale Center for British Art. Here and elsewhere, the growing quantity of work on the sister arts has been accompanied by a growth in quality. This book provides some of the evidence. Not many years ago it would have been difficult to assemble a quorum of distinguished literary scholars who doubled as experts on painting; today there is an embarrassment of riches.

In one respect, however, the increase in studies of the sister arts has not yet accomplished much of a reform. I refer to the subject that Hagstrum himself thought central to his enterprise and predicated in his subtitle: "The Tradition of Literary Pictorialism" in English poetry. He chose, it seems to me, the right direction. If

The Sister Arts had decisively influenced a generation's reading of eighteenth-century poems—as critics of romantic poetry, for instance, have induced innumerable readers to sense an apocalyptic or visionary strain in poems where an earlier generation once recognized only "nature"—its effect would have been wholly for the better. The proper way to read and teach those poets from Dryden to Gray is still to *see* their poems. Hagstrum's book remains by far the best introduction to that method. But its teachings have been absorbed by connoisseurs and specialists more readily than by general readers of poetry.[4] Partly this is a matter of class. The very phrase "the sister arts," with its eighteenth-century associations, speaks of a world of leisure, money, education, and travel—long weekends spent touring country estates, unaffordable books straining the coffee table—that might well intimidate anyone not willing to make a large investment. Partly it is a matter of Hagstrum's own judicious and unpolemical style, without a grain of self-advertisement or oversimplification. *The Sister Arts* is not the sort of book that provokes arguments. Yet whatever the reasons, its implications have yet to stir the widespread discussion they deserve. Perhaps they need to be restated in a more simplified and controversial form. This essay should be considered a modest attempt to begin that restatement.

* * *

To put it bluntly: the vast majority of modern readers are blind to eighteenth-century poetry. We do not see poems well; we do not make the pictures in our minds that the poets direct and excite us to make; and we are often so complacent about our ways of reading poetry that we blame the poem for our own failure to notice its signals. This blindness affects readers on every level, from tyros to specialists in eighteenth-century literature (I do not claim that my own eyesight in these matters is 20/20). As a result, ordinary educated reading of poetry from Dryden to Gray remains at the same stage, more or less, as those early twentieth-century readings of metaphysical poetry that found it impenetrably crabbed and obscure, or those somewhat later readings of romantic poetry that found it ludicrously vague or emotional. Most of us now hear the music of the metaphysicals and the romantics with more precision. But we have yet to see the pictures of the eighteenth century with any consistent clarity.[5]

The causes of this failure are legion. In the largest sense one might ascribe it to the primacy of the spoken and written word in Western culture. The verbal culture dominates the visual. In saying that many readers today are literally blind to poetic pictures, for instance, I have to use a word that refers to letters: "literally." Our language contains no equivalent word for exact visual accuracy, no phrase like "picturally blind" ("pictorially," of course, conveys a far different meaning, much closer to "picturesque" conventions).[6] In this respect, we might say, the language defends itself from rival methods of understanding by reducing all knowledge to questions of language. Everybody *knows* that reading and writing, and probably thinking, consist of the manipulation of words. Indeed, I do not doubt that some of my readers, looking over these words, already begin to suspect me of a fallacy or a sophistical argument: the notion that reading could ever escape the primacy of the word and tend toward the immediate transmission of pictures from one mind to another. And they are right to suspect me, along with the many eighteenth-century thinkers who committed the same "fallacy"; for I am very far from regarding as sophistry Locke's assumption that words are "*Signs of internal Conceptions,*" and "stand as marks for the *Ideas* within [the] Mind."[7] By "ideas," of course, Locke means quite explicitly (though not exclusively) mental pictures. That this account represents the *whole* truth about language, I very much doubt. But that it represents a *part* of the truth, verifiable in the experience of everyone who uses language, seems to me a fact both foolish and dangerous to ignore.

The argument itself I leave to Locke (who is capable of taking care of himself). But simple experiments will confirm that language does have the powers he attributes to it. If I ask you to close your eyes and picture the Mona Lisa, for instance, only someone born blind or totally deprived of an education will be unable to conjure up some image. A moment ago the internal conception was in my mind alone; now your mind holds an equivalent picture. Moreover, that mental picture cannot be identified with any particular set of words. If my instructions had asked you not to "picture the Mona Lisa" but to "visualize La Gioconda," for instance, the substitution of one phrase for another need hardly have altered the image. The conception is independent of its sign. Some of our internal pictures will be more clear and distinct than others, of course, depending on how recently we have seen the painting as well as on

the strength of our inner eyes. "Imagination," according to Hobbes's famous formula, "is nothing but *decaying sense*"; and Locke concurs that "*The Pictures drawn in our Minds, are laid in fading Colours*; and if not sometimes refreshed, vanish and disappear."[8] Our mind's eye requires exercise to keep it healthy. Nor can we ever be certain how closely our individual mental pictures correspond with someone else's, any more than we can count on a perfectly shared understanding of words. Yet that *some* visual conceptions can be transmitted through the agency of language, only the most doctrinaire literati will want to dispute.

Now let us picture a full moon. I leave the details to your own imagination. Concentrate hard on seeing it. Are there many particular marks and shadings? Do you see some relation to clouds and stars? Is everything as clear in your vision as it would be if the actual moon were in sight? Does it shine so brightly that it hurts your eyes? Does it have a human face? And above all, could you describe it so vividly and accurately that everyone who heard you would see it too? Take care with your answers; for upon them hangs the question of whether or not you are qualified to be an eighteenth-century poet.

The test I have just suggested (*not* a test at juggling words or hearing voices) would have been acknowledged by almost every critic from Hobbes to Goethe as a fair way of estimating one's powers in writing and reading poems. "Poetry consists much more in Description, than is generally imagined," according to Joseph Trapp. We do receive some limited pleasure, to be sure, from the harmony of verse. "But still we feel a much higher, from the Images of Things beautifully painted, and strongly impressed upon the Mind."[9] And more than half a century later Hugh Blair confirms the point: "Description is the great test of a Poet's imagination; and always distinguishes an original from a second-rate Genius." An inferior poet "gives us words rather than ideas; we meet with the language indeed of poetical description, but we apprehend the object described very indistinctly. Whereas, a true Poet makes us imagine that we see it before our eyes; . . . he places it in such a light, that a Painter could copy after him."[10] Dryden had put it best: "Imaging is, in itself, the very height and life of Poetry."[11] Indeed, Blair's test of imagination was inevitable, given the primary definition of the word proposed by Hobbes and certified by Johnson's *Dictionary*: "*Imagination*. 1. Fancy; the power of forming

ideal pictures; the power of representing things absent to one's self or others"; and under *Fancy*: "Imagination; the power by which the mind forms to itself images and representations of things, persons, or scenes of being." Without that power of picturing, one could not be a poet.

These definitions will be sufficiently familiar, I hope, to any student of eighteenth-century literature. But perhaps their consequences for the practice of poetry have been somewhat less familiar. The reader who believes with Yeats that "Words alone are certain good" will not find much good in the eighteenth century. Consider, for instance, the immensely popular *Pleasures of Imagination* (1744) by Mark Akenside, a poet who held words rather cheap and spent them freely (I am afraid that words did not like him much either!). Like a great many other ambitious poems, this one begins with a myth of creation; but creation with a difference. Before the universe had come into being, according to Akenside,

> Then lived the Eternal One: then, deep-retired
> In his unfathomed essence, viewed at large
> The uncreated images of things. . . .
> From the first
> Of days, on them his love divine he fixed,
> His admiration; till in time complete,
> What he admired and loved, his vital smile
> Unfolded into being.
>
> (1744; I, 64-73)

He lived, he viewed, he admired, he smiled, he unfolded. What he did not do, you will have noticed, is speak. God's pictures in the mind require no word to bring them forth. Just how they *do* come forth, in fact, remains a puzzle for almost thirty lines, until we learn what men of imagination or "finer mould" have always known: the Sire Omnipotent is a poet-painter.

> On every part
> They trace the bright impressions of his hand:
> In earth or air, . . .
> they see portrayed
> That uncreated beauty, which delights
> The mind supreme.
>
> (1744; I, 101-7)

Hence the ultimate pleasure of imagination, on Akenside's account, is to restore God's pictures back into the mind, into their state

as "uncreated images."[12] On this earth we see God's hand as in a painting darkly; but on the day of resurrection we shall gaze directly at the images in his mind, without the corrupting intermediary of a world or word.

The pleasures of imagination are still available to us today. Even if we reject the Idealism and iconophilia of Akenside's myth, we need hardly deny ourselves the delights of intensely visualizing the poems we read. The saddest thing is not to live in a visible world. And through training and exercise — especially the exercise of reading eighteenth-century poems with our inner eyes alert and at the ready — almost all readers ought to be able to strengthen and refine their powers of picturing verse. Under such scrutiny much eighteenth-century poetry will unfurl and reveal its beauties. Nor is it too late to begin. Anyone who made the effort, a few moments ago, to visualize a full moon in all its brilliance and clarity has already anticipated the problems of reading a dozen "night-pieces" from the Countess of Winchilsea to Wordsworth. And a few similar experiments will quickly open many eighteenth-century traditions to the view. Closing your eyes or fixing them on a blank wall, climb up a hill and slowly turn around until you have taken in the varied topography, the course of rivers, the fields with their multi-colored crops, and perhaps one great house off in the distance. Now, for the sake of variety, try to see very far, where a group of antlike schoolboys race around the fields of Eton. In one mood, perhaps, you might descend into a cave where your eyes, adjusting to the light, gradually pick out a bird with black wings or a sooty, toiling miner. In another mood you walk the streets of London, observing the costumes, the architecture, the faces, or perhaps a dirty liquid arrested in the act of falling. Now that your powers are developing, try something harder. Picture the streaming glory of a scene in heaven, where a soul that has recently passed from earth is welcomed into the assembly of the blest. Then dim that scene, and imagine the descent of evening from the sky. If that does not challenge your powers, how clear a picture can your vision make out of Melancholy? Or Winter. Concentrate hard on seeing Winter until the image is fixed in your mind. Then tell me what you see. Is it a man or a woman?

The answer, of course, is a man: "See, Winter comes to rule the varied year, / Sullen and sad, with all his rising train— / Vapours, and clouds, and storms." So at least Thomson saw it in 1726. But

the question and answer alike may foment doubts about the whole enterprise of visualizing poetry. Surely matters of sex are irrelevant to the picture of a season unless we are talking about formulas and conventions of pictorialism rather than about any native keenness of sight. Did eighteenth-century poets and readers really see better than their successors, or did they merely see differently, according to a different mental stock of paintings? No reader of E. H. Gombrich's *Art and Illusion* will need to be reminded how thoroughly formulas determine both how and what we visualize. Indeed, "seeing" itself might be regarded as a series of conventions varying from culture to culture. When Thomson looked out his window in winter he saw a Poussin or a Gaspard Dughet, while my window frames an Edward Hopper or a Robert Altman; but neither of us ever viewed "the scene itself." No eye is innocent. Nor can descriptive poetry ever escape the prison-house of visual habit and protocols in which the brain has caged the sight. If eighteenth-century poets do not project clear pictures into modern minds, on this line of thought, the reason may be less that we are blind than that they wore blinkers: rigidly restricted formulas for seeing.

The force of this argument cannot be denied. We do see according to conventions, and our minds paint pictures, as our hands do, in conformity with the pictures they already know. Not one of the exercises in visualizing proposed earlier, for instance, depended on scenes really to be found in "nature." No one—with the possible exception of William Blake—has ever gazed at a soul entering heaven, or spied out the sex of winter. Not even Euclid has looked on Beauty bare. Even poems that seem to derive from accurate visual information often prove thoroughly artificial when closely inspected. Can anyone view the distant prospect of Eton College, for example, as Gray once viewed it? The spot of ground still exists at Stoke Poges, perched above Windsor and Eton. Yet whether or not Gray was writing with the scene before his eyes, he could not help superimposing a far more distant prospect upon it.[13] Literature, not observation, supplies the details. The true picture in Gray's mind, in fact, was the best-known imaginary landscape of the century, the so-called Tablet of Cebes or Picture of Human Life, based on the simple ancient allegory from which most schoolboys first learned Greek.[14] (The irony of the poem turns on the author's ability to interpret that text more wisely and grimly than they can, precisely because he can look down and see them in it.) The fictional Greek

mountain overwhelms the actual English hill. And virtually every other picture in eighteenth-century poetry is informed by a similar convention. Poets who live by the side of the Thames can scarcely write about the river they see every day without imagining a Father Thames within it. Are such conventions a genuine aid to vision, or merely a way of protecting the poet from ever having to use his eyes at all?

Perhaps a little of both. The accuracy of visual representations, as Gombrich reminds us, results less from the use of one formula or another than from the correction and refinement of any formula through attention to the particulars that escape it—in his terms, the process of "matching." We cannot see without formulas; but unless we sometimes modify those formulas to take account of anomalies and illusions, we shall never be able to develop an educated eye. Some people see better than others, not because they break out of their habits of vision but because they learn how to use them. Thus some eighteenth-century poets consider their work done when they have repeated the stock phrases of vision; but the work of other poets begins at that point. Nor were such poets unaware of how much they relied on conventions. Indeed, the very dominance of convention served to warn them against trusting in their own "innocence" (the situation is different today, when we speak without self-consciousness of a "photographic memory" and when a naive realism based on photographs and movies conditions the way that many authors report their visions). The long vogue of *ut pictura poesis* ensured that good poets would learn to refine and sophisticate their ways of seeing. Hence the eighteenth century is truly an age of *insight*—not superior to formulas of vision but supremely conscious of how they can be used.

Consider, for instance, the sylphs in *The Rape of the Lock*. You had better watch them carefully; for visually the whole point about such "lucid" creatures, of course, is that now you see them and now you don't.

> Transparent Forms, too fine for mortal Sight,
> Their fluid Bodies half dissolv'd in Light.

> (1714; II, 61-62)

The exquisite painterly touches of the passage as a whole make it only too easy to overlook how much of it hangs on the border of vision.[15] "Too fine for mortal sight"—the reader is privileged

to see what cannot be seen. No one has ever laid an eye on a sylph, and no one ever will except through the magical trickery of this poem. Pope uses all the resources of literary pictorialism to sketch a classic of misdirections and optical illusions, from the Morning-Dream that hovers o'er Belinda's head at the beginning to the disappearance of the Lock itself at the end. Even the central action of the poem, the cutting of the Lock, is accomplished through misdirection, aided by Belinda's preoccupation with "th' Ideas rising in her Mind" and especially the internal picture of "An Earthly Lover." Ariel can scarcely hope to make her *see* what is happening. Much of the *Rape* depends on a similar doubleness of vision—not only verbal allusions to the classics, which every reader notices, but the unceasing superimposition of pretty though flimsy mental pictures on the quotidian scenes of life. Pope is a master painter. And his special talent is to allow one to see the unseeable by treating the conventions of art—the celestial protectors, the cosmetic radiance of beauty, the personified Spleen—as if they occupied a precise visual field. The end of the poem is the poet's triumph in every sense, since he alone observes the flight of the Lock.

> But trust the Muse—she saw it upward rise,
> Tho' mark'd by none but quick Poetic Eyes.
>
> (1714; V, 123-24)

"Poetic Eyes" catch sights that no one else can detect, because poetry itself supplies the pictures. In this respect, one might say, the theme of *The Rape of the Lock* is how to see, and its conclusion is that no one makes finer pictures than a poet.

Pope's eyes were very quick. Finesse like his becomes possible only when visual conventions have been established not just as a repertoire for the artist but as a source of play. More than two centuries of experiments with literary pictorialism lie behind him. Indeed, one way of dealing with his quicksilver optical illusions would be to maintain that he was sending up the tradition—deliberately exceeding the limits of what the mind can see. I would not go so far. But certainly Pope's extreme pictorial refinement, like his technical achievements in many other departments of poetry, left his successors with a difficult problem: how could they possibly surpass him? "Transparent Forms, too fine for mortal Sight" can hardly be distilled much further without vanishing altogether. Poets of the mid-eighteenth century inherited, along with the

traditions and conventions of pictorialism, a growing suspicion that those conventions might be nearly played out. Their response to this situation helps account for the development of a whole new visual field—a *matching* of their own perceptions, as Gombrich might say, against the pictures *made* by Pope and the generations before him. They had to change the forms in which they saw.

Only such a background, I believe, can begin to account for the complexity of vision in mid-century poetry. If modern readers are often blind to that poetry because, first, they do not bother to visualize it and, second, they have not learned its pictorial conventions, a third source of trouble must also be added: the poems themselves often seem to emphasize not only the rewards of seeing but its problems. At times they actively work to *frustrate* our seeing (an effect identified by Burke with the Sublime).[16] The visual sophistication of such poetry is easily missed by readers who know only that they have been left in the dark. But poems that treat the pictures in our minds as problematic, not merely as given, have their own fascination. They test the idea of pictorialism and the idea of Ideas until they make us doubt our own eyes and minds; not even the laws of perception are free from their probing. And they also develop principles of their own. The poetic visions of the 1740s—that crucial decade in the revolution of literary forms—obey a different imperative from the pictures of Dryden or Addison. They look toward other sights and other ways of seeing them. The attempt to define those changes will focus my own speculations.

First of all, even a casual reader of mid-century English poetry is likely to notice at least one remarkable fashion: a positive mania for seeing in the dark. When Pope concluded his own career with the dreadful anti-fiat, "And Universal Darkness buries All," he probably assumed that the death of light would also mean the death of pictorialism; but the case proved exactly the opposite. Young's *Night Thoughts*, that infallible cure for insomnia, is only the most popular among a host of such subfusc descriptions.

> Thus, darkness aiding intellectual light, . . .
> My song the midnight raven has outwing'd,
> And shot, ambitious of unbounded scenes,
> Beyond the flaming limits of the world,
> Her gloomy flight.

(IX, 2407-13)

The paradox of seeing in darkness, or what might be called the Nicodemean mode, had of course been used in poetry often before.[17] But never before had poets concentrated so hard on exact descriptions of how things look when almost nothing can be seen. The results, one must say, were mixed. As might be expected, "the gradual dusky veil" of evening or the mingled lights and shades of twilight—"Now fades the glimmering landscape on the sight"— furnished the best effects. Utter darkness could lead only to utter confusion: what Thomson calls "one universal blot,"[18] where the image significantly collapses the bafflement of sight into a catastrophic painting. Yet the exploration of night-pictures and night-visions did inspire a good deal of subtle and delicate descriptive poetry. Here was one refinement that Pope's quick eyes had not exhausted; and poets from Thomson to Cowper took their chance.

From another point of view, however, the fashion for seeing in the dark may appear less a refinement of vision than a confession of the difficulty of seeing at all. That is a second way in which literary pictorialism was modified during the eighteenth century: poets and readers began to agree that seeing might not be easy. One kind of evidence is provided by those constant references to curtains and screens and mantles and veils—a veritable strip-tease of nature— that so inhabit the poems of Akenside, Collins, and the Wartons.[19] Poets developed a whole arsenal of devices to strain their readers' powers of sight. Consider for instance the opening of *The Vanity of Human Wishes*, with its rapid shifts in perspective, its busy scenes and clouded maze and phantoms and mist and fancies. "If there is any complaint to be made," according to Donald Greene, "it is that Johnson has been *too* extravagant with his imagery: the mind is taxed as it tries to take in all this condensed into the space of six lines."[20] But I cannot agree with him. The visionary overload or crowding of the mind with half-fledged personifications is exactly the right effect with which to begin a poem that will deal at such length with the difficulty of seeing anything clearly on this earth. Our puzzled sight reflects our puzzled minds. The effect is not to be found in Juvenal. But almost all good poems of the 1740s contain a similar straining of the vision.

Another kind of evidence consists of explicit aesthetic statements. Burke's vigorous argument against the power of "sensible images" to match the force of words in exciting emotion is only the best known of many attacks on poetic "seeing." Jean Hagstrum puts

it well: "Such a theory as this, in which obscurity, darkness, and incompleteness have great value and in which undefined but powerful kinesthetic emotions can be aroused by words with no visual image, leaves little room for *ut pictura poesis.*"[21] Eventually that theory carried the day. But in the meantime the precariousness of mental pictures did not keep poets from accepting the challenge to imagine the dark and the void. "You still *see*," as Hagstrum comments, "even when you see through a glass darkly."[22] To some extent, in fact, the acknowledged difficulty of seeing only stimulated poets to exhort their readers to try harder. At no period has the imperative "See!" been used more often. In a time of darkness the reader's eyes must not be allowed to shut. *The Seasons* begins with "See!" and Samuel Johnson uses the word so often that one may suspect him of fearing that his audience is asleep. In his last English poem, for instance, the lovely translation of "Diffugure nives," a direction for viewing is added to each of Horace's first two phrases.

> The snow dissolv'd no more is seen,
> The fields, and woods, behold, are green.

Seen and *behold* do not occur in the Latin. Yet Johnson insists that the reader must function as a viewer. Indeed, the charming futility of the opening line, in which the onlooker cannot see anything because the snow has already dissolved, would serve as an appropriate epitaph for a whole age of literary pictorialism in dissolution.

Nevertheless, the difficulty of seeing is by no means an entirely negative element in mid-century poetry. Properly understood, it can also work as a means of discovery or a principle of organization. That is a third respect in which literary pictorialism was modified during the century: its problems became mobile and functional. To put the matter simply, one of the defining characteristics of the eighteenth-century poem is its search for a point of view. And in a pictoral sense "point of view" may be understood literally (or picturally) as well as rhetorically. A typical descriptive poem of the mid century keeps shifting its vantage point in hope of finding a better perspective or a place to stand. Theoretically, this process had already received its definitive statement, and perhaps its dismissal, in *An Essay on Man.*

> See, thro' this air, this ocean, and this earth,
> All matter quick, and bursting into birth.

> Above, how high progressive life may go!
> Around, how wide! how deep extend below!
> Vast chain of being, which from God began,
> Natures æthereal, human, angel, man,
> Beast, bird, fish, insect! what no eye can see,
> No glass can reach! from Infinite to thee,
> From thee to Nothing!

> (I, 233-41)

Pope tries out every point of view, from infinite to nothing, from telescope to microscope, above, beneath, around, only to conclude that the right vantage place is exactly where we were standing all along. A similar homing device might be ascribed to Thomson, who probably shifts his point of view more often and comprehensively than any other descriptive poet in history, yet who also never doubts that One Perspective ultimately contains all the others.

> The great eternal scheme,
> Involving all, and in a perfect whole
> Uniting, as the prospect wider spreads,
> To reason's eye refined clears up apace.[23]

Reason's eye takes in all points of view at once—at least when it wears the spectacles of Religion.

To the next generation of poets, however, the search for a point of view was not merely a means to an end but often an end in itself. The multiple perspectives so characteristic of the work of Collins, the Wartons, Gray, and later Goldsmith, Smart, and Cowper seldom arrive at any undivided focus or resolution. The structure of *The Vanity of Human Wishes*, I have argued elsewhere,[24] consists of a series of "observations," beginning with a personified "Observation" in the sky and ending with the discerning eyes of Heaven or Celestial Wisdom, in which the reader restlessly looks for a place of human vantage. But most of Johnson's contemporaries were even more restless. See Collins, for instance, being led by Evening from vale to lake to fallows to mountainside in his effort to catch a glimpse, or chasing Milton's poetical character vainly up the hill of Eden, or drifting down the Thames in search of Thomson. See Goldsmith travel in visionary imagination from one countryside and mountain-top to another, in hope of finding somewhere a better "prospect."

Or pause at Christopher Smart. The emphasis in recent years on Smart's undoubted love of music and words has tended to slight

what he himself thought his special gift: "For my talent is to give an impression upon words by punching that when the reader casts his eye upon 'em, he takes up the image from the mould wch I have made."[25] Pictorially, this talent for punching means the rapid-fire creation of a great many brief but vivid icons. One picture succeeds another with dizzying speed.

> Strong is the lion—like a coal
> His eye-ball—like a bastion's mole
> His chest against the foes:
> Strong, the gier-eagle on his sail,
> Strong against tide, th'enormous whale
> Emerges as he goes.[26]

Like almost every stanza of *A Song to David*, this passage juggles three images—the lion, the eagle, the whale—which represent the three kingdoms of earth, air, and water; a trinity miraculously one through prayer. Smart follows Pope, both literally and picturally, by organizing his poem according to three points of view: above, beneath, around. Indeed, the whole conception of *David* depends on the triple-tiered ministers of praise—Christ, David, and Smart— who lead the choirs of their several spheres in a threefold typological harmony. But Smart can join the three perspectives into one only through mystery. Thus the glorious conclusion of the poem, which represents at once the creation of the universe, the incarnation, and the poet's achievement of his plan—"DETERMINED, DARED, and DONE"—may momentarily persuade us that above, beneath, and around are all the same place. But only someone with six eyes could see that vision clearly. What remains thrilling about the *Song* is not its resolution but its vertigo: the rapidity of its shifts from one point of view to another.

Each of the developments in mid-century pictorialism discussed so far—the fashion for darkness, the difficulty of seeing, the search for a point of view—receives an exquisite treatment in the poem that most readers associate supremely with the age. The attraction of Gray's "Elegy" to darkness hardly needs pointing out here. The difficulty of the poet in seeing the figures buried in the churchyard, born as they are to "blush unseen" and to lie literally beneath notice, could also furnish material for a long analysis. But nothing in the poem reveals Gray's artistry more fully than his handling of point of view.

I shall mention just one aspect of this well-worked subject. In his fine recent book *Absorption and Theatricality: Painting and Beholder in the Age of Diderot*, Michael Fried has placed French painting of the 1750s under "the primacy of absorption." Meditating, reading, or paying attention only to their own activities, the figures in the painting refuse to notice the beholder. This denial of theatricality paradoxically draws the audience in by absorbing it too—severing the distinction between what is outside and inside the picture. Fried makes no reference to poetry or England. Yet the final version of the "Elegy" could scarcely follow the prescription better.[27] The self-conscious "me" of the opening quatrain, posed in companionship with darkness, gradually becomes more engrossed in his meditations until, as Bertrand Bronson has said, his identity diffuses and he becomes one with the reader. The culmination of his subtle transference is the reference to "thee," the author of these lines, as "we join the poet in addressing himself in the second person."[28] But the process of absorption goes still further. When the "hoary-headed swain" invites the "kindred spirit" to "Approach and read (for thou can'st read) the lay, / Graved on the stone beneath yon aged thorn," he beckons the reader also into the picture. We all approach and read (for we can read) the epitaph; the line between what is inside and outside the poem fades away. Gray sees himself as if he were another and we see Gray as if he were ourselves. The effect is totally absorbing. In that moment the poet achieves the point of view he has been seeking: a vision of the churchyard so sympathetic that all of us can share it and see ourselves there.

The view from inside the ground and inside the heart, however, usually lacks clarity; too much of the bosom gets in the way. Eighteenth-century pictorialism sealed its own doom, we might say, when the pleasures of imagination became identified with indistinct seeing. Locke had been alert to the dangers. It has not been noticed often enough, I think, how much his famous distinction between Wit and Judgment relies on pictorial assumptions. "For *Wit* lying most in the assemblage of *Ideas*, and putting those together with quickness and variety, wherein can be found any resemblance or congruity, thereby to make up pleasant Pictures, and agreeable Visions in the Fancy: *Judgment*, on the contrary, lies quite on the other side, in separating carefully, one from another, Ideas, wherein can be found the least difference, thereby to avoid being misled

by Similitude, and by affinity to take one thing for another. . . . To the well distinguishing our *Ideas*, it chiefly contributes, that they be *clear and determinate.*"[29]

Yet ideas could not be kept clear. In pictorial terms, the evidence seems decisive that what Locke called *Wit* was exactly what Wordsworth was to call *Imagination*: a preference for those pictures made by assembling and combining images. Consider the famous picture of the Leech-gatherer—first a stone, then a sea-beast, finally a Man—which Wordsworth uses to *define* the Imagination. "The stone is endowed with something of the power of life to approximate it to the sea-beast; and the sea-beast stripped of some of its vital qualities to assimilate it to the stone; which intermediate image is thus treated for the purpose of bringing the original image . . . to a nearer resemblance to the figure and condition of the aged Man; who is divested of so much of the indications of life and motion as to bring him to the point where the two objects unite and coalesce in just comparison."[30] The final phrase may *sound* like judgment, but the whole object of the "just comparison" is of course a specimen of Lockean wit, "by affinity to take one thing for another." No clear and distinct picture of the image could ever be made.

Nor does Wordsworth consider that a defect. On the contrary, it is just *because* the imagination has powers unknown to the eye that he admires it. A similar preference obviously underlies Harold Bloom's election of a few eighteenth-century poets to his Visionary Company because of their "'fade-out' or fluid dissolving of the imagination." Collins and Smart, he says, "reduce the manifold of sensation to a number of objects that can actually be contemplated," and then "proceed to dissolve the objects into one another."[31] The canvas smears and blurs. Romanticism begins, according to this model, when pictures fuse and visualizing yields to vision.

Undoubtedly the change can be exaggerated. No one who has read Ian Jack's *Keats and the Mirror of Art*, for example, will overlook the healthy survival of literary pictorialism long after the theory of the sister arts had been condemned. Nor am I about to complement the Untuning of the Sky, as some readers may suspect, by lamenting the Erasing of the Eye. Yet neither can the movement from pictures to words and music, over a period of less than fifty years, be ignored. No sooner does Cowper get hold of a picture of his dead mother, in one of his most moving poems, than he tries to remember her *language*. No sooner does Coleridge envision his

Abyssinian maid, in "Kubla Khan," than he tries to remember her symphony and song and talks about building his dome in air with *music*. Something had certainly changed. One place to look for the change, in addition to those weighty movements in philosophy and consciousness that have engrossed so many scholars, ought to be in the internal dynamics of pictorialism itself—the changes induced in poems by the efforts of generations of poets to use and build on pictorial tradition.

To begin with, we should not discount eyestrain. Pictures of darkness, difficulty in seeing, the search for a point of view—such emphasis on the problems of visualizing was eventually bound for exhaustion. Nor should we disregard another curious theme of mid-century poetry: the actual *fear* of seeing. Collins expresses it most memorably in the opening lines of his "Ode to Fear."

> Thou, to whom the World unknown
> With all its shadowy Shapes is shown;
> Who see'st appall'd th' unreal Scene,
> While Fancy lifts the Veil between:
> Ah *Fear*! Ah frantic *Fear*!
> I see, I see Thee near.

Seeing is doubly fearful, in this striking apostrophe, because it characterizes the personification as well as the poet. *Fear* has a "haggard Eye"; she defines herself not through acting but looking, gazing at scenes to which most watchers are blind. And the poet does not take long to catch the infection and also become a seer. He proves himself a genuine votary, as "madly wild" as she is, precisely by conjuring up her image in his mind and responding to it so strongly that he cannot differentiate the internal picture from the external field of vision. To see is to fear, and to fear is to see.

Perhaps this equation is not so irrational. When Johnson warned of the "dangerous prevalence of imagination," we know that he was speaking from experience. Prolonged attention to visionary pictures can strain the understanding and the inner eye beyond their limits. Though the physiology of such optical stress is not well understood, its practical consequences have been noted in many cultures. In the Soviet Union, for instance, blindfold chess exhibitions are banned on the grounds that they are dangerous to health. The American grandmaster Harry Nelson Pillsbury is said to have killed himself through too much blindfold play; and if I may add my own experience, as a young man I sometimes gave such exhibitions myself,

but had to stop because of the blinding headaches that invariably followed. Pictures in the mind can be hazardous. Although I doubt that any reader has been permanently damaged by the exercises proposed here for the inner eye, perhaps a warning should be issued to the susceptible: beware of overexertion. Not all eighteenth-century poets heeded this warning. Insofar as there is any pattern to the often-noted and much-exaggerated phenomenon that many of the best mid-century poets went "mad," one common factor may be that all of them were intensely visual ("mad poets" of later generations have tended to hear voices rather than see visions). Perhaps pictorialism exhausted its own best devotees and died through a process of natural selection: survival of those poets least fit to see.

A less mechanistic explanation may also be offered. Like almost any mode of poetry continued over many generations, pictorialism eventually may have foundered on an internal contradiction: an effect associated with moments of the highest passion and inspiration became so standard that the least inspired poet could duplicate it. Even a blind man can describe a picture once he has heard it described. The obvious case is personification, whose "inherent values" were defined so well thirty years ago by Earl Wasserman.[32] In theory, and sometimes in practice, the eighteenth-century poet "saw" a personified abstraction, as Collins saw Fear, only when wrought to a pitch of excitement; he humanized his ideas through a sympathetic grasping movement of the soul. At its best, as in Collins, the theory certainly worked. But unfortunately nothing prevents a poet from naming personifications in cold blood. In excitement "The heavenly Forms start forth, appear to breathe, / And in bright shapes converse with men beneath," according to Parnell;[33] but if the shapes do not come of themselves one can always invite them: "Inoculation, heavenly maid, descend!" A blind, idealess man could write that line. Hence flat, unfeeling personifications acquired that dreadful momentum so vilified—and not without reason— by Wordsworth and Coleridge. Bored readers swiftly learned to close their eyes. The change of styles in capitalization, moreover, which reduced all nouns except the most proper to lower case, encouraged that weaker form of personification so common by the end of the century, when a reader often cannot tell whether to visualize a word or not. When Gray wrote of leaving the world "to darkness and to me," for instance, did he really intend us to see "Darkness" as a *person*? William Blake certainly thought so;

his drawing of Gray's Darkness figures it with a sharp-edged human face. But by then, of course, Blake was among the last poets in England who *saw*.

Not many readers these days learn to see. The replacement of pictures in the mind by words, or at any rate of sophisticated mental paintings by what I have already called a naive realism based on photography, may well be irreversible. Nor should we be ungrateful for some of the effects that became possible in verse when poets and readers lost the habit of using their eyes. The lovely musicality of such half-blind poets as Tennyson and Yeats, for example, could hardly have survived for a moment in a culture that required its poets to watch what they were saying. No eighteenth-century poet wrote such melodies. Yet the specific pleasures of eighteenth-century imagination, those clear and distinct ideas that retain their firmness in the mind even when subjected to darkness, continue to represent a permanent alternative in poetic taste. We still can make them new. Much of the Imagist program early in this century, for instance, repeated the eighteenth-century doctrine of the clear and distinct image without knowing it. In any case, no reader need choose between being deaf and being blind. A small amount of training in the sister arts still pays rich dividends in opening a world of older poetry to the view.

At the end of his survey of eighteenth-century pictorialism in *The Sister Arts*, Jean Hagstrum placed a memorable image: the final leap of Gray's archetypal "Bard."

> He spoke, and headlong from the mountain's height
> Deep in the roaring tide he plung'd to endless night.

The visual fabric dissolves. As Hagstrum notes, the whole poem has derived from pictorial tradition and in the last effect, of which Gray said "I felt myself the Bard," the picture suddenly vanishes. Allow me to carry the allegory a little further. The Bard is himself a maker of pictures. Unlike a poet of the next generation, who might have emphasized the harp and lyre or dulcimer, Gray shows a prophecy composed of visions: "On yonder cliffs, a grisly band, / I see them sit, they linger yet, / Avengers of their native land." The work of the Bard is to *see*. Gazing beyond the present into the future, he weaves an imaginary tapestry that figures the doom of princes and the triumph of poets. The future belongs to the bards; at least to pictorialist bards. The poem itself insists by its example

that poets can make you see. Yet the final plunge to night may suggest another moral. Like many other eighteenth-century poems, this one concludes in darkness, and its stress on the heroic difficulty of seeing and the precarious balance of a point of view—night falls so apocalyptically, of course, because the Bard has lost his perspective—implies the end of an era. Gray does not trust his eyes to see beyond his own moment. Perhaps the pictures now have all gone out, and the day of visual imagination is over.

But I do not read the poem that way. Rather, the essence of "The Bard" is Gray's ability to recapture a primitive power of seeing—a mode of verse that makes no distinction between pictures in a landscape and pictures in the mind. He not only feels himself the Bard, he imagines it; he looks through his eyes. And though the final plunge may represent a final challenge to pictorial tradition—the canvas emptied of its central figure—it also represents the courage to follow that tradition right to the bottom: the eyes kept open even in the tide of darkness. Gray sees with his Bard to the end. He completes the picture by showing that its vision survives the night of its poet. And we, unless we are blind, will also see that. The darkness is light enough.

Notes

1. J. H. Plumb, *Georgian Delights* (London: Weidenfeld and Nicolson, 1980); Maynard Mack, *The Garden and the City* (Toronto: Univ. of Toronto Press, 1969).

2. See especially *Emblem and Expression: Meaning in English Art of the Eighteenth Century* (Cambridge, Mass.: Harvard Univ. Press, 1975).

3. Robert Halsband has studied *"The Rape of the Lock" and its Illustrations, 1714-1896* (Oxford: Clarendon Press, 1980). In *The Art of Discrimination* (Berkeley and Los Angeles: Univ. of California Press, 1964), Ralph Cohen examines illustrations of Thomson's *Seasons* as a sort of "non-verbal criticism," pp. 248-314.

4. Most critics of eighteenth-century poetry continue to make elementary blunders by failing to visualize it. But even so good a book as John Dixon Hunt's *The Figure in the Landscape* (Baltimore and London: Johns Hopkins Univ. Press, 1976) is weakened by its neglect of the sister arts tradition as described both by Hagstrum and by his student Jeffry B. Spencer, *Heroic Nature* (Evanston: Northwestern Univ. Press, 1973).

5. In *The Poetry of Vision* (Cambridge, Mass.: Harvard Univ. Press, 1967), Patricia Meyer Spacks has made an admirable attempt "to suggest some of the values this poetry holds for the twentieth-century reader by investigating the function in it of visual imagery" (p. vii). The attempt is not very convincing, however, perhaps because it relies on a modern understanding of "imagery" rather than on a recreation of eighteenth-century ways of seeing; for instance, the book does not refer to a single painting.

6. The rare word "pictural," a synonym for "pictorial, like a picture," obviously fails to carry the same distinction as "literal," which suggests an unmediated or uninterpreted sense independent of "the spirit." Our words for "vision" seldom discriminate

"false" visions from "true"; for instance, there is no proper antonym for "illusion," since "perception" can always be impaired by conceptions and deceptions.

7. *An Essay Concerning Human Understanding*, III, i, 2.

8. Hobbes, *Leviathan*, I, 2; Locke, *Essay*, II, x, 5.

9. *Lectures on Poetry* (1742), pp. 17, 26. The original Latin version of the lectures was published in three volumes, 1711, 1715, 1719.

10. *Lectures on Rhetoric and Belles Lettres* (1783), II, 371.

11. "The Author's Apology for Heroic Poetry and Poetic Licence" (1677), in *Essays of John Dryden*, ed. W. P. Ker (Oxford: Clarendon Press, 1900), I, 186.

12. In later editions of *The Pleasures of Imagination*, Akenside, disturbed either logically or theologically by the status of "uncreated images of things," revised the phrase to "the forms, / The forms eternal of created things" (1757; I, 107-8); and changed "that uncreated beauty" to "those lineaments of beauty" (I, 147).

13. Roger Lonsdale, in his edition of *The Poems of Gray, Collins and Goldsmith* (London: Longmans, 1969), concludes that Gray "had a literal 'prospect' before him and he could literally feel the winds blowing from Eton" (p. 56). The prospect as described, however, seems "literal" largely in the secondary sense of "derived from letters"; not a single particular is without some literary antecedent.

14. The influence of the *Tablet* on a wide range of painters and authors is remarked by Hagstrum, *The Sister Arts*, pp. 33-34, and by Earl Wasserman, "Johnson's *Rasselas*: Implicit Contexts," *Journal of English and Germanic Philology* 74 (1975): 12-16. The Eton Ode and Joseph Spence's version of "The Picture of Human Life" were both first published by Robert Dodsley in 1747.

15. The point may be reinforced through study of the illustrations reproduced by Halsband (note 3 above), where the solidity of the sylphs tends to coarsen and broaden the poet's effects.

16. *A Philosophical Inquiry into the Origin of our Ideas of the Sublime and Beautiful* (1757); see especially IV, 13-18. The recent tendency to discuss the psychology and philosophy of the eighteenth-century Sublime without reference to its basis in vision, as in Thomas Weiskel's *The Romantic Sublime* (Baltimore and London: Johns Hopkins Univ. Press, 1976), often glosses over Burke's own emphasis on the eye.

17. Eighteenth-century authors usually associated such effects with Milton, and especially with "Il Penseroso." But most of Milton's night-pieces depend on smuggled or checkered light rather than unrelieved darkness. Hence Melancholy wears black, he points out, only because her "saintly visage is too bright / To hit the sense of human sight." Characteristically Milton attempts to "Teach light to counterfeit a gloom."

18. "Autumn" (1730), line 1143.

19. John E. Sitter, "Mother, Memory, Muse and Poetry after Pope," *ELH* 44 (1977): 312-36, analyzes such disrobing.

20. "'Pictures to the Mind': Johnson and Imagery," in *Johnson, Boswell, and their Circle* (Oxford: Clarendon Press, 1965), p. 150. Greene's emphasis on Johnson's predilection for vivid and concrete imagery is both refreshing and important, but his neglect of the conventions behind Johnson's imagery has the unfortunate effect of making all pictures in the mind seem equally original.

21. *The Sister Arts*, p. 153.

22. Ibid., p. 154.

23. *Winter* (1730), lines 1046-49. The original version of the middle two lines, in 1726, had stressed instead the limits of earthly sightlines: "That Dark Perplexity, that Mystic Maze, / Which Sight cou'd never trace, nor Heart conceive."

24. "Learning to Read Johnson: *The Vision of Theodore* and *The Vanity of Human Wishes*," *ELH* 43 (1976): 517-37.

25. *Jubilate Agno*, B$_2$. 404.

26. *A Song to David*, stanza 76.

27. One reason may be a common source, since the absorption in Poussin's paintings influenced both Diderot and Gray. See *Absorption and Theatricality* (Berkeley, Los Angeles, and London: Univ. of California Press, 1980), pp. 41-43, and *The Sister Arts*, pp. 296-301.

28. Bertrand H. Bronson, "On a Special Decorum in Gray's *Elegy*," in *From Sensibility to Romanticism*, ed. F. W. Hilles and Harold Bloom (New York: Oxford Univ. Press, 1965), p. 176.

29. *An Essay Concerning Human Understanding*, II, xi, 2-3.

30. 1815 Preface; *Prose Works*, ed. W. J. B. Owen and J. W. Smyser (Oxford: Clarendon Press, 1974), III, 33.

31. *The Visionary Company* (Garden City, N.Y.: Doubleday, 1961), p. 4. Pictorially, by the way, the effect described by Bloom seems to me to occur seldom in Collins and almost never in Smart.

32. "The Inherent Values of Eighteenth-Century Personification," *PMLA* 65 (1950): 435-63.

33. Thomas Parnell, "An Essay on the Different Styles of Poetry"; quoted by Wasserman, p. 445.

THE WEAK SISTER'S VIEW
OF THE SISTER ARTS

Robert R. Wark

I

English poetry and English painting are unequal siblings, unequal in many ways. This fact must be accepted and its implications understood in any comments on interdisciplinary studies between English literature and art.

From the fifteenth to the twentieth century, English poetry consistently ranks with the best that Europe has produced. Only for a brief period, at the close of the eighteenth century and the beginning of the nineteenth, can English painting stand comparison with the finest Continental work.

It is not surprising, accordingly, that the study of English poetry is a much longer-established and heavily populated discipline than the study of English painting. No doubt it is possible to push a computer button somewhere in the offices of the Modern Language Association and discover how many thousand teachers, publishers, editors in America list English literature as their primary professional concern. A comparable undertaking at the College Art Association would probably reveal fewer than a hundred scholars currently in colleges and museums of the United States and Canada whose principal commitment is to English art. Every liberal arts college in the country lists scores of courses in English literature. Only about two dozen colleges regularly offer any course whatsoever in the history of English art.

Further emphasizing the inequality between the sisters is the fact that the history of art in all its branches (and especially the

history of English art) is a newcomer among academic disciplines. With a few notable exceptions, before the mid-twentieth century the bibliography on English painting consisted of biographical and anecdotal books about artists. Elementary and not always trustworthy checklists of works had been compiled for a handful of the better-known painters; but in the field as a whole the ground had barely been broken. Thus for the past thirty years or so the small group of art historians working with English painting have been busy with basic spade work in their own back yard.

For these reasons the numerous interdisciplinary studies spanning English literature and art that have been appearing since the middle of the twentieth century are almost entirely the work of scholars based in English literature. Nor does it seem likely that this situation will change dramatically in the next few years.

Art historians, like all living creatures, guard their home territory. But those concerned with the study of English painting for the period 1750 to 1850 will readily admit that their garden has been much enriched by interdisciplinary studies. Fresh insights and new perspectives from outside art history have acted to fertilize our field.

The following comments are offered partly in gratitude for past favors, but primarily in the hope of assisting additional students from literature whose studies may lead them to the visual arts. The comments are directed especially toward students of English literature who may study English paintings, drawings, and prints. The intention is to alert these students to problems that, if not peculiar to the study of art, are at least of different relative importance in the study of literature and art.

II

The basic material for students of literature is some form of the written word; the basic material for students of art is (or should be) some form of artifact. Many of the problems that arise in interdisciplinary studies covering art and literature can be traced to this difference. Probably the most fundamental of these problems concerns the authenticity and attribution of the source materials.

The list of an author's works is normally established by his publications. Many difficulties exist: spurious and unauthorized publications; anonymous publications; pseudonyms; posthumous and

hence disputable publications; unpublished manuscripts. Nevertheless the core of a writer's *oeuvre* remains a known and fairly stable quantity. The principal difficulty is usually less with authenticity than in establishing a detailed text that reflects the author's intentions.

The situation is different with the study of paintings. Problems similar to those in textual criticism, most of which are created by the presence of a middleman (printer, transcriber, editor) between the author and the public, are not nearly so acute in the study of paintings and drawings, where the student ideally has immediate access to the object as it left the artist's hand. It is only when the student is obliged to work with some form of reproductive print or photograph, or with an original altered by change in physical condition or later restorations, that the problem of seeing the work as the artist made it will arise.

But the authorship and authenticity of the work itself is much more open to question than the authorship of a printed book. In a few rare instances, some kind of list of an artist's paintings carries the same authority as a bibliography of an author's published works. Claude Gellée made a visual record of his authentic compositions, the *Liber Veritatis*, as a safeguard against imitations. Portraitists like Reynolds and Romney kept sitter books or ledgers that (when they survive) give us a record of actual portraits painted. Contemporary engravings after an artist's paintings often help to establish the artist's *oeuvre*, as do records of works exhibited during an artist's lifetime. Even in these instances, however, the record is merely of a composition or sitter, and offers little help in deciding whether any given version of a painting is an original or a copy.

For the majority of painters, there is not even this kind of aid to consult; to construct an artist's *oeuvre*, the art historian must be a connoisseur. Connoisseurship is not an exact science. It rests on the sensitivity of a highly trained eye to the subtleties of style, form, brushwork, calligraphy, and all those facets of a work of art that are the product of a single personality. This sensitivity varies from one connoisseur to another, and from one generation of connoisseurs to another. Disputes and uncertainties are the rule rather than the exception. Different connoisseurs reach radically different conclusions from the same data. The *oeuvre* of even so fully studied an artist as Rembrandt expands and contracts like an accordian.

For all except the most important English painters, the establishment of an *oeuvre* catalog has hardly more than begun. We now have up-to-date *catalogues raisonnés* of the paintings of Turner and Blake. We are promised in the near future a full catalog of the works of Constable. Useful catalogs exist of the portraits of Reynolds and Gainsborough; and a catalog of Gainsborough's landscape painting is due as this essay goes to press. The coverage for lesser artists is spotty and often very much out of date.

This situation is likely to be frustrating and bewildering for a student coming to English painting from English literature. The basic bibliographical tools in literature are much more extensive and the disagreements much less fundamental. Yet anything one says about art rests ultimately on individual works. If the facts about these works are in doubt, any superstructure erected on them is shaky.

I do not mean to imply that every student of literature who wishes to work with English art must become a connoisseur of the particular artist or art form with which he is concerned. But the literary scholar should be aware of the connoisseurship problems that exist. If one is constructing an argument that depends for its validity on the authenticity of a painting or drawing that is not well-known, one should contact a well-informed specialist to check current opinion.

The uncertainties of connoisseurship lead art historians to seek additional props to support attributions. Scientific tests of one kind or another are helpful: ultra-violet light (to detect recent surface alterations); infrared and x-ray photography (to detect more deep-seated problems); occasionally the chemical analysis of pigments (to detect suspicious, anachronistic substances). Also of importance are such matters as previous ownership of a work of art, exhibitions where it has been shown, books, contemporary journals, diaries, and correspondence in which it has been discussed. Students from outside the discipline of art history may be puzzled and even annoyed by the amount of attention given to these last matters by an art historian when cataloging a work of art. But to be able to trace the provenance of an object to an owner known to have acquired the original from the artist may be of crucial importance in establishing authenticity. It may also be useful to know those occasions and places where a work of art has been exposed to public scrutiny, either in exhibitions or publications. The absence of

provenance, exhibitions, and publications certainly does not in itself cast doubt on the authenticity of an art object, but it is a danger signal.

III

The creation of works of art, verbal and visual, operates within established techniques, conventions, and traditions. Everyone participates to some extent in the use of words, and consequently has some acquaintance with literary techniques and conventions. Comparatively few people are regularly engaged in activity that has a corresponding relation to painting, sculpting, or erecting a building.

The creation of paintings, drawings, prints is surrounded by traditions that may not be immediately apparent to someone outside the field. Some of these traditions have to do with the craft and technical character of the various media involved; others result from stylistic and formal trends of a given period; still others may be conventions (often rather arbitrary) governing the way artists treat certain subjects or themes. It is difficult for students outside the field of art who wish (for some interdisciplinary investigation) to make a cross-cut survey of, say, English portraiture during the 1790s to know how much of what they find is the result of these techniques and traditions, how much is peculiar to the time and artists they are considering. The difficulty exists in all interdisciplinary studies, but is particularly acute where art is the field outside the investigator's home territory.

Consider some of the difficulties posed by medium and technique. Anyone constructing an argument that involves a painting, drawing, print or some other two-dimensional work of art must know enough about the medium and technique to understand what is normal, exceptional, possible. Many people, for instance, use the terms "drawing" and "print" interchangeably for any work of art executed on paper. There is an enormous difference. A drawing is a unique work of art executed by the artist working directly on paper. A print is one of hundreds of nearly identical impressions made by running a specially prepared plate through a press. Drawings, which are often preparatory to some other work of art, are sometimes casual jottings, fascinating indications of how the artist grapples with an artistic problem, but not documents in which every dot and scratch is

loaded with significance. Prints pulled from the same plate are nearly identical, but seldom precisely so. A smudge in a particular impression may be nothing more or less than faulty inking. A lack of clear definition in another impression may be due to physical deterioration of the plate rather than artistic intention. Color in an impression may be printed, or applied by hand (possibly much later) by someone who had nothing to do with making the plate or pulling the impression.

Technical processes and physical condition can be equally troublesome in dealing with an oil painting. For example, Gainsborough, especially late in his career, applied his paint in such a way that in the passage of time it has often become semitransparent, creating a diaphanous effect that was no part of his original intention. Reynolds's notorious use of bitumen has opened up cavernous cracks in the dark areas of many of his paintings and has made those areas much more opaque in appearance, both effects close to the opposite of what he had in mind. Romney, on the other hand, was a sound technician, many of whose paintings survive (except for dirty varnish) almost as they left his studio.

One of the most frequent errors of a student from another discipline looking at an isolated segment of art is to mistake a general and virtually meaningless pictorial convention for something of special significance. It was, for instance, a normal convention of French portraiture during the first half of the eighteenth century to represent ladies with the attributes of Venus, Diana, Juno, etc. To attach any special meaning to these attributes in a portrait of the period is foolish. Fancy dress costumes are a normal convention of mid and late eighteenth-century portraiture. Most of the costumes reveal more about the artist than about the sitter. Gestures and actions that may seem pregnant with meaning today may be mere convention and of no significance at the time a work of art was executed.

In narrative painting, pictorial traditions are often very strong. A whole branch of the history of painting is concerned primarily with the continuity of these traditions. As an example: God the Father in the act of creation is normally represented as supported and attended by miscellaneous heavenly creatures. The tradition goes back to Michelangelo and earlier. When Blake, in his sketches for an illuminated manuscript of *Genesis*, represents God the Father in this way, perhaps no significance need be attached to the

attendant figures other than Blake's awareness of this tradition. Conversely, so strongly established was the image of the Return of the Prodigal Son as a kneeling figure receiving on his forehead the kiss of his father, who bends over him, that when Blake (also in his *Genesis* manuscript) uses this image to illustrate "and the Lord put a mark on Cain," the assumption that he wishes us to make that connection is probably valid; and this interpretation is supported by independent information concerning Blake's religious beliefs.

Probably the most difficult category of these "conventions" for the non-art-historian to grasp quickly has to do with style or form, and the evolution and coherence of form. Difficult because response to form in painting (as in any type of art) requires fairly long exposure and some innate sensitivity to abstract qualities, such as color, line, shape, suggested mass and depth. Insofar as most literary scholars look at art for the image or subject matter rather than the form or style, difficulties in dealing with form crop up less often in interdisciplinary studies. But the interrelationships between literary and visual forms are at least as interesting as thematic connections. Happily the stylistic approach to the study of art has been extensively explored (some students may say exhausted) by art historians. It was the mainstream of the history of art from the late nineteenth century until nearly the middle of the twentieth. Literary historians who have the time to read, and look as they read, can learn more readily about the general evolution of style and the formal properties of various styles than about the other matters mentioned in this paper.[1]

Proper attention to the prevailing style or form is often essential in accounting for meaning. It is, for instance, naive to criticize a Gravelot illustration to one of Shakespeare's tragedies as lacking in intensity and pathos if one does not understand at the same time that rococo form (the only one Gravelot had at his command) does not lend itself to a concentrated and strongly emotional statement.

Interestingly enough it is in the mid-eighteenth century (where most interdisciplinary studies spanning English literature and art begin) that the problem of form in European, and particularly British, art becomes complicated, and the normal pattern of stylistic coherence and evolution breaks down. From that point on, artists become much more self-conscious about form and develop an ability (not noticeably apparent earlier) to manipulate form for

variety in emotional effect. Among painters Reynolds is a pioneer in this expressive manipulation of form. The tendency reaches its fullest artistic development in the early works of Turner, and then subsides around 1840. Blake, although more limited in his stylistic vocabulary than many of his contemporaries, partakes of this phenomenon. He makes clear adjustments in linear organization for expressive purposes. An analysis of these adjustments is a means to understanding his expressive intentions.

Traditions and conventions are prevalent in book illustration, a branch of art that is of special interest to students of literature. Leaving aside the fascinating but atypical situations where a text is supplied to existing illustrations (Rowlandson), or the artist supplies both text and illustrations (Blake), most illustrations are to a preexisting text. Much as one might like to think that artists creating these illustrations did so in direct response to the text, such is not always the case. At least as influential are the works of their predecessors in illustrating the same text, the requirements imposed by the publisher or bookseller, and the general pictorial conventions concerning book illustration, which happen to change very little in England from about 1740 to close to 1800.

IV

Much of the foregoing discussion is familiar to serious students of interdisciplinary studies involving English literature and art. Most such studies written by students of English literature proceed with knowledge, often empirically obtained, of these principles. But difficulties remain, and frequently interpretations of works of art that appear valid to students of literature are much less persuasive to art historians. The difficulty is usually the lack of the type of external evidence that art historians, rightly or wrongly, have come to expect in corroborating an interpretation of a work of art. Students of literature often seem genuinely surprised when the art historian asks petulantly for external proof that such and such a proposed interpretation of a painting is the one intended. They seem to regard no such proof as necessary. That they find support for their interpretation in the work itself is enough.

Literary historians are certainly at least as rigorous as art historians in demanding adequate corroboration for interpretations of works within their own field. That they appear less so when

dealing with the visual arts is puzzling. Perhaps the reason may have something to do with fundamental differences between words and the elements of visual form as means of communication. Individual words have definable meanings. Combinations of words may have great variety in meaning; but the component words mean a limited number of things to all readers. No such commonly acknowledged meaning inheres in the component particles of a painting: color, line, shape, suggested depth, or even signs, symbols, and images. In spite of the best efforts of theoreticians of perception to prove otherwise, red does not always mean the same thing to everyone, nor does a diagonal, an oval, or a deep or shallow space. It is only in a given context that these elements take on specific meaning. Signs, symbols, and images are likewise neither constant nor universal in meaning. Because of these factors, it may be that corroboration for the interpretation and meaning of a work of literature is legitimately sought within the work itself, whereas corroboration for interpretation of a work of art is sought in the context and things external to the work.

Whatever the explanation, art historians have a deep-seated distrust of interpretations of works of art that are unsupported by external evidence. This evidence may come from contemporary written documents, from other comparable but more fully documented works of art, from the life of the artist, from general circumstances surrounding the creation of the work. In the last category, patronage is often a valuable area to explore. Until the early nineteenth century, most art was created on commission. The artists adjusted their work to the expectations of the person paying the bill. The difference between art and literature in this regard is worth pondering. A painting, perhaps after a brief exhibition, usually entered the house of a private individual. Only rarely was it created for the wide public audience an author had in mind when writing a book. Prints, such as those of Hogarth, are an interesting compromise. In any event, the interpretation of a work of art must be compatible with the audience for which it was intended; or, if not, an explanation must be forthcoming.

Armed with, or battered by, these suggestions, the student of English literature peeks over the fence between his vast estate and the tiny garden of English art. To jump over the fence entirely is to confront the art historian on his own ground. To do so

successfully one must become a fully qualified art historian; otherwise the encounter is likely to be unpleasant.

Where art historians are concerned, the most useful interdisciplinary studies by literary historians looking at art are those in which the literary scholar is concerned with verbal aspects of art: theories of art, aesthetics, the identification of literary themes in narrative paintings. Art historians, who are usually visually minded, are often ill-at-ease with these matters. Thus it is that interdisciplinary studies by literary scholars that have to do with such things as the theory of the picturesque, concepts of the sublime and the beautiful, writings on gardening, and of artists about art, have often been of great value and of a kind that art historians are disinclined and ill-qualified to undertake. In other words, the most helpful interdisciplinarians are those who keep their feet firmly planted on their own side of the fence while surveying their neighbor's yard. The scholar to whom this volume is dedicated is one of the most sure-footed in this regard and his Introduction to *The Sister Arts*, written a quarter century ago, remains one of the most useful documents for a student of literature to ponder when embarking on interdisciplinary studies.

Note

1. For an excellent introduction (with bibliography) see Meyer Schapiro, "Style," in *Anthropology Today, An Encyclopedic Inventory . . .* , ed. A. L. Kroeger (Chicago: Univ. of Chicago Press, 1953), pp. 287-312.

STEP-SISTER OF THE MUSES
Painting as Liberal Art and Sister Art

Larry Silver

A visitor to Parnassus might wonder upon meeting the nine muses which of them supervised the creation of visual beauty in the realm of Apollo. There dwelt the guardians of eloquence and epic poetry (Calliope), history (Clio), music and lyric poetry (Euterpe), tragedy (Melpomene), dance (Terpsichore), comedy and pastoral (Thalia), sacred poetry (Polyhymnia), love or lyric poetry (Erato), and even astronomy (Urania).[1] But nowhere in this Greek pantheon of beauty could one find a superintendent of painting or any other visual art. This lacuna was just as prominent during the medieval tradition of the seven liberal arts, or branches of learning. Founded on the fifth-century treatise on the arts by Martianus Capella[2] and enshrined on the portals of innumerable Gothic churches of Europe were the personifications of the several paths to wisdom: Arithmetic, Astronomy, Geometry, Music; Dialectic, Grammar, Rhetoric. Even though these two systems overlap in only a few fields and encompass vastly different intellectual universes, they still are intended to present the sum of higher forms of intellectual life; in each system, significantly, both painting and sculpture were excluded, relegated to the mechanical arts (*artes mechanicae*).

If this inferior status is distressing to the modern art historian, it was a gnawing chancre to Renaissance painters. Who, after all, wants to be an ugly step-sister instead of a full-fledged sibling rival? Beginning in the fifteenth century, the defenders of painting developed an argument in support of their claims to learning and to

full status as a liberal art. Much of their pretension rested on Horace's classical dictum: *ut pictura poesis* ("as is painting, so is poetry"). Poetry was the very essence of Apollo's creation, so this ancient comparison of painting to poetry could help to justify the importance and seriousness of the visual arts. Despite a variety of individual responses to, and critical reformulations of, the *ut pictura poesis* tradition, painting—in theory and in practice—remained committed to the creation of epic themes of noble action based on shared literary and pictorial traditions. Ironically, the final establishment of painting's importance was to culminate at the end of the eighteenth century with the notion of the Fine Arts as an independent aesthetic realm, requiring neither moral nor literary justification. Until its demise around 1800, however, the humanistic theory of painting dominated European art and fostered academies and visual narratives of this newest, adopted liberal art.

Jean Hagstrum's pioneering study, *The Sister Arts*, began with Aristotle and defined pictorialism in English poetry, especially for the eighteenth century. Complementing this essentially literary perspective, Rensselaer Lee's *Ut Pictura Poesis* focused on the ways in which painters defined their kinship to the hallowed liberal arts tradition of poetry; Lee's center of gravity was seventeenth-century Italy. In this essay, written from the perspective of the art historian, I intend to survey the claims made by painting's leading apologists, beginning, like Lee, with Renaissance Italy, and then concentrating, like Hagstrum, on some major figures of eighteenth-century England, especially Hogarth and Reynolds. I place my own particular emphasis on the principles that painters realized in their works and reconciled, however inconsistently, with their theories, and on the eventual breakdown of this humanistic and traditional view of art at the turn of the nineteenth century.

I. Renaissance and Rubens

The first riposte in defense of painting came in Leone Battista Alberti's treatise *De pictura* (1435).[3] Alberti, despairing of the lack of models of great art from antiquity akin to surviving classical texts, nevertheless sets out to reconstruct a theoretical foundation for good painting in his own day: "So much the more our fame should be greater if we, without teachers or any model, find arts and sciences unheard of and never seen."[4] He makes clear from the

beginning that painting, aided by mathematics, rises up "pleasant and most noble" from its sources in nature. It is in this context of replicating perception that Alberti's famous construction of linear perspective appears alongside consideration of colors, composition, and the like.[5] But in addition to the goal of "imitation" of nature or perceptions, Alberti also introduces another ambition, the improvement on nature's model. Citing the example of Zeuxis, who amalgamated the finest features of the five most beautiful women of Crotona in order to produce a single image of female pulchritude, Alberti insists that "we should always take what we want to paint from nature, and always pick out the most beautiful things."[6] In this operation, artistic intellect, already instructed in the mathematical arts, operates in much the same learned fashion as the writers and thinkers of the traditional liberal arts. Alberti's treatise, in fact, was designed precisely to provide a training manual, a handbook of knowledge required of the new, learned painter. Alberti discusses "painting as it is derived from fundamental principles of nature."[7]

Alberti thus stands at the fountainhead of a rich, broad stream of artistic tradition that Lee calls "the humanistic theory of painting."[8] Hagstrum and Lee have both pointed to one important emphasis of Alberti's treatise that later served as a justification for the painter's importance and as a link between painters and poets: history painting.[9] By choosing to paint a "history"—that is, some significant human action, usually drawn from myth, the Bible, or ancient chroniclers—the painters found a subject as lofty as the beauty of their forms. In the process, moreover, these history painters closely associated their pictures with the exalted texts that provided their subjects. Several corollaries follow from this Renaissance axiom: painters should be well versed in great literature, and they should be worthy individuals in their own right, to appreciate fully the high moral qualities of that literature. Alberti states:

> But it would please me that the painter, to grasp all these things, should be a good man and versed in literature. . . . And for their mutual delight he will make himself one with poets and orators, for they have many graces in common with the painter and are plenteous in knowledge of many things. So they will greatly assist in the fine composing of narrative pictures, whose whole praise consists in the invention.[10]

The defense of painting's new claims to status as a liberal art was abetted by another Renaissance *topos*: the *paragone*, or contest

debate between the respective merits of painting and poetry (or, alternatively, painting and sculpture).[11] An early and famous instance of the paragone is Leonardo da Vinci's discussion, which formed the first part of his "Treatise on Painting." Leonardo's argument places the source of all knowledge in the senses and "experience." Painting, like all the other sciences, originates in the mind and is merely recorded by manual operation. Painting, too, is based on "scientific and true principles," just as Alberti had argued. Painting's superiority to poetry rests on the superiority of its sense—vision—over the poet's dependence on the inferior sense of hearing. Leonardo also invokes the antique quotation, attributed by Plutarch to Simonides, that painting is mute poetry, poetry a speaking picture.[12]

Renaissance artists did not produce allegorical personifications of the visual arts akin to those of the liberal arts until after the time of Leonardo—in the mid-sixteenth century, when Giorgio Vasari decorated the Stanza della Fama of his Arezzo house with personifications of Painting, Sculpture, Architecture, and Poetry (1542).[13] Shortly after 1561, Vasari went on to paint an Allegory of the Arts within another Room of Fame, this time in his house in Florence. There he included scenes from the life of Apelles and portraits of famous painters along with the personifications of the arts. Vasari is renowned as the first great biographer and historian of Italian artists, and his allegories offer a striking parallel to the *apologia* for the fine arts formed by both his own book and by the establishment of the Florentine Academy in 1563. The culmination of this development of a form of art as propaganda for art itself is embodied in a later allegory, painted around the year 1600, that precisely depicts the theme of this essay—that is, the admission of Painting to the company of the traditional Liberal Arts—Hans von Aachen's *Athena Introducing Painting to the Liberal Arts.*[14]

Part of the process of legitimizing painting as a sister art and of demonstrating proper *inventio* is the literal recreation of ancient works of art known only through literary description: *ekphrasis.*[15] Alberti had used one famous example of ekphrasis in his treatise by citing Lucian's description of Apelles' allegory *Calumny* as a model to be emulated by the new learned painters. Indeed, Botticelli was to take up the challenge by painting the subject (Florence, Uffizi), and the theme of the *Calumny of Apelles* became a proving

ground for Europe's artists for a century and a half.[16] The *Calumny of Apelles* also lay at the heart of an entire cycle of ekphrases that adorned the house of Peter Paul Rubens in Antwerp, as Elizabeth McGrath has discovered.[17] In addition to the *Calumny*, Rubens re-created a frieze of lost or imagined classics of ancient art: Apelles' own *Alexander with a Thunderbolt*, Timanthes' *Sacrifice of Iphigenia*, Pausias's *Sacrifice of an Ox*, a *Chariot Race* (by Aristides?), *The Drunkenness of Hercules* (Parrhasius?), *Zeuxis and the Maidens of Croton* (already mentioned by Alberti), a *Departure of a Hero*, and, finally, the very image of the Triumph of the Artist, *Apollo's Contest with Pan*. Rubens's cycle, then, not only is a testimony to the erudition of the artist who more than any other in modern history can be said to personify the doctrine of the learned painter,[18] but it also exemplifies the importance Alberti accorded to invention, artistic excellence in the grand tradition. Unlike the sculptures, based on direct study of the antique, by the "divine" Michelangelo, Rubens had nothing but descriptions of authors to rely on for his emulation of Greek painters; but like Michelangelo, his completed task can be said to enable Rubens to rival the "grandeur of the ancients, those great spirits whom I honour with profoundest reverence."[19]

Of course, ekphrasis could be a two-way street, and when Elizabethan authors turned to describing works of art in their own right, they were effectively performing modern renditions of a worthy ancient task; significantly, they seem most often to have chosen to describe noble art works with suitable themes drawn from antiquity. Shakespeare, particularly in his *Rape of Lucrece*, sets out to rival painting with description and to tilt the scales of the paragone back in favor of poetry.[20] Indeed, the terms of the paragone are stated explicitly:

> Beauty itself doth of itself persuade
> The eyes of men without an orator (ll. 29-30)

The versified portrait of Lucrece (ll. 57-70), "her fair face's field," is admired by the lustful Tarquin later in the poem through "greedy eyeballs" (l. 367). But it is in the heroine's grief that the true encounter of the paragone is joined by Shakespeare:

> To see sad sights moves more than hear them told,
> For then the eye interprets to the ear
> The heavy motion that it doth behold,

> When every part a part of woe doth bear.
> 'Tis but a part of sorrow that we hear. (ll. 1324-28)

The objective correlative of Lucrece's own sorrow is that image (in ekphrasis) she beholds, "a piece / Of skillful painting, made for Priam's Troy" (ll. 1366-67). Not only is its subject—the rape of Helen and the ensuing destruction of a great civilization—venerable and appropriate as a model to her own plight, but its power to move in pictorial terms is the challenge to the poet:

> A thousand lamentable objects there,
> In scorn of nature, gave liveless life (ll. 1373-74)

Hagstrum has properly referred to the great source of such iconic poetry: Homer's shield of Achilles, as well as Virgil's Temple of Venus in the *Aeneid* or Ovid's tapestries of Minerva and Arachne in Book VI of the *Metamorphoses*.[21] Yet more than these other venerable objects, "Troy's painted woes" (l. 1492) offer Lucrece a mute poetry that she could enact with her own words, her own speaking picture:

> So Lucrece, set a-work, sad tales doth tell
> To pencill'd pensiveness and color'd sorrow:
> She lends them words, and she their looks doth borrow. (ll. 1496-98)

Shakespeare the poet is the man in control, but his modern ekphrasis makes painting into an active instrument of grief, akin to Alberti's tribute to his rival art, when he quotes Phidias, the sculptor, confessing that he learned from Homer, the poet, how to invest his famous Zeus with divine majesty.[22] At the same time, Shakespeare has turned the paragone into a true dialogue of the sister arts.

In later expressions, Shakespeare reopens the sibling rivalry of the sister arts. *Timon of Athens* begins with a dialogue between painter and poet.[23] Painting operates through "dumbness of the gesture" (I. i. 33) and produces works "livelier than life" (l. 38), and the painter claims supremacy in the contest:

> A thousand moral paintings I can show
> That shall demonstrate these quick blows of Fortune's
> More pregnantly than words. (ll. 90-92)

Ultimately, however, Shakespeare settles the debate in *The Winter's Tale* in favor of his own creative manipulations.[24] The triumph of nature over art in the form of Hermione's metamorphosis at the end of the play is, of course, the resolution of yet another of the classic

paragone contests: nature versus art. Yet after the traditional eulogies of an artist ("Julio Romano") who "would beguile Nature of her custom, so perfectly is he her ape" (V. ii. 104-08), the resolution of the play is a tribute to the power of the writer. The topos of a statue coming to life gives witness to the power of time, a fourth dimension, not available to either painter or sculptor, and to the playwright's superior craft in aping, even creating, nature.

As these examples demonstrate, however, the dictum of Horace, *ut pictura poesis*, which was to prove so powerful a stimulus to painters and poets of the Renaissance, was not a simple case of easy reciprocity. The very nature of their differing languages led to different goals by each of the sister arts in seeking to emulate the other. Hagstrum once again makes this divergence clear. For the painter, as conceived by Alberti and his followers, the goal presented by poetry and the basis of "history painting" is narrative. Painting strove to "move the mind," to evoke emotions appropriate to the noble tales of *istorie* through the motions of well-painted bodies.[25] Just as the Poet in *Timon of Athens* speaks of painting in terms of the "dumbness of the gesture," so classical treatises on rhetoric, such as Quintilian's, suggested an analogy between the visual arts and the gestures of orators.[26] Like Zeuxis, the painter strives to improve on nature and to imitate human action of even greater beauty or significance.[27] Herein lies the importance of imitation, not from unadorned nature, but rather from the antique, as conveyed both by surviving art works and by ekphrases.[28] The antique came to be regarded, too, as a repository of decorum, that is, appropriate features for each and every type of figure in a narrative;[29] of course, this notion of decorum eventually took on its more modern connotation of decency and tastefulness. The ideal nature of antique art perfectly conformed to decorum in both senses: both the typical, the representative, and the tasteful, the serious. Built into this veneration for the antique model was the tendency toward an invariant canon of beauty based on what was defined as "classic." Increasingly during the seventeenth century, the classic ideal of beauty was enshrined and promulgated by the new institutions of art, the academies.[30]

For writers, on the other hand, following models was not a major issue of contention, for Horace, among others, had long since counseled the imitation of great literary models of the past. But to writers, the maxim *ut pictura poesis* was a challenge to emulate a

picture's verisimilitude, one of Alberti's ambitions, and one of the glories of Renaissance art as a whole.[31] Hagstrum once again has stressed the importance of this goal of naturalism in literary theory of the Renaissance, particularly in connection with the notion of *enargeia*, the "vivid and lifelike reproduction in verbal art of natural detail."[32] An instructive image is the pictorialism of Shakespeare's Sonnet XXIX ("To find where your true image pictur'd lies"), even though the likeness is not sufficient except to capture external appearance:

> Yet eyes this cunning want to grace their art,
> They draw but what they see, know not the heart.

Roger Ascham's *The Schoolmaster* (1570) calls literary imitation a "faire, livelie, painted picture of the life of everie degree of man,"[33] even as he allows in the following lines that a second kind of imitation "is to follow for learning of tongues and sciences the best authors."[34] For literature, like painting, this twofold concept of imitation reigns supreme. Sidney's *Apologie for Poetrie* (1583) is the *summa* of Elizabethan literary theory, and it, too, invokes the comparison with painting as an axiom for writers. Indeed, in contrast to the philosopher, it is Sidney's poet who "giveth a perfect picture, for he yeeldeth to the powers of the minde an image of that whereof the Philosopher bestoweth but a woordish description."[35] Echoing Ascham, Sidney actually defines poetry as a "speaking picture":

> Poesie therefore is an arte of imitation, for so Aristotle
> termeth it in his word *Mimesis*, that is to say, a representing,
> counterfetting, or figuring foorth: to speak metaphorically, a
> speaking picture: with this end, to teach and delight.[36]

This is not the proper place for an authoritative discussion of what Sidney means by his image of an image, but the poet does go on a few lines later to compare "right Poets" to the "more excellent" sort of painters. Meaner painters only mimic what they see ("counterfet only such faces as are sette before them"), whereas their more noble colleagues, "having no law but wit," transcend literal imitation and "range, onely rayned with learned descretion, into the divine consideration of what may be, and should be."[37] They paint, like Zeuxis, what is "fittest for the eye to see . . . the outward beauty of such a vertue." The goal of both painters and poets, then, is the same: to instruct and to delight, "to move men to take

that goodnes in hande, which without delight they would flye as from a stranger."[38] Both should be morally uplifting and should derive from nature yet transcend the literal copying of nature. Yet Sidney is equally explicit that Poesie "should be *Eikastike*, which some learned have defined, figuring forth good things" in contrast to the fantastic, *Phantastike*, "which doth, contrariwise, infest the fancy with unworthy objects."[39] In Sidney's formulation, as in Shakespeare's *Lucrece*, the sister arts truly engage in friendly dialogue.

Just as Alberti's *istorie* were brought vividly and miraculously to life by the painter's art, so, too, could the Renaissance poet create visible figures for the mind through allegory, "fayning notable images of vertues, vices or what els." The period of Shakespeare and Spenser also saw the rise of the classic collection of visual personifications, Cesare Ripa's *Iconologia* of 1593.[40] Ultimately the sources for many of these personifications were the images, in both text and picture, of the ancients:

> The images meant to signify something different from what the eye can see have no briefer and more general rule than the imitation of the records to be found in the books, the coins, and the marbles of the artful Latins and Greeks or the earlier peoples who invented this artifice.[41]

In addition to his own dependence on the venerable precedent of antiquity, Ripa conforms to the humanist tradition of art, centering his definitions of moral qualities in images of human figures. Generalized, or essential qualities, rather than the illustrations of individuals or particular events, are the basis of his visual poetry, with a beauty and dignity suitable to their lofty subjects.

Such allegorical figures appeared most prominently within secular festivities, themselves based on triumphs from the ancient world and the modern reworkings of ancient triumphs, such as Petrarch's *Trionfi.*[42] For example, Dürer's woodcuts for Emperor Maximilian I included fantastic oversized images of both a *Triumphal Arch* (1515) and a *Triumphal Chariot* (1522), each replete with allegorical figures.[43] Such allegories were extended from imperial or regal pageants to Petrarchan programs in prints; a notable example is the Dutch artist Maarten van Heemskerck, who produced two series entitled the *Triumph of Patience* and the *Cycle of the Vicissitudes of Human Affairs.*[44] These parallels between allegories of literature and painting came together in pageants, with their textual images

realized in visual forms, but never more so than in the triumphal royal masques, jointly produced for English royalty by Ben Jonson and Inigo Jones.[45]

D. J. Gordon has demonstrated in several studies the relationship between these English masques and the program of Rubens's allegorical ceiling paintings for Banqueting House, Whitehall.[46] We have already encountered Rubens as the learned emulator of ancient painting with the ekphrases on his own house, and here the Antwerp master's prodigious learning combines with his own special sense of spectacle for his royal commissions, like Whitehall, for the princes of Europe. In addition to his Whitehall program, Rubens also created the extensive cycle for the Queen Mother of France, Marie de' Medici, as well as an uncompleted cycle for her deceased husband, Henry IV.[47] Yet perhaps the most ambitious of all Rubens's productions for royalty was his design and supervision of the 1635 Triumphal Entry of Cardinal-Infante Ferdinand of Spain into Antwerp.[48] Here again, the main themes of the program are praise of good government and appeals during wartime for restoration of peace as well as prosperity. For Rubens, personifications in the rhetorical service of royalty permitted the artist to make a visual tribute, complaint, or appeal about the nature of the ruler, the state, or even his native city of Antwerp. In permitting the painter to address a learned audience with shared, conventional visual language, these allegories and personifications again allow pictures to become rhetorical, like the "mute poetry" or "speaking pictures" of the *ut pictura poesis* tradition. Indeed, Gordon and Orgel have associated the Whitehall ceiling, which includes images such as *Peace Embracing Plenty* (plate 3-1; New Haven, Mellon Collection), with the Jonson-Jones masques *A Triumph of Peace* and *Salmacida Spolia*, whose motto repeats the visual argument: "The allusion is that his Majesty, out of his mercy and clemency approving the first proverb, seeks by all means to reduce tempestuous and turbulent natures into a sweet calm of civil concord." Another form of learning is displayed by Rubens in his massive canvas for the 1635 entry (plate 3-2; sketch, Fogg Art Museum, Harvard University)[49] of the *Voyage of the Prince from Barcelona to Genoa*. In the picture Rubens bases his figures of sea-gods and Neptune on the antique passage in Virgil's *Aeneid*, "Quos ego" (I. 135), describing Neptune calming the waves and quieting a fearful storm. By choosing this reference to Rome and her Empire, Rubens suggested by analogy the impor-

tance and divine sanction of the young Spanish prince. As the figure of Neptune demonstrates, Rubens often used the pantheon of classical gods within his programs as a kind of personification; his numerous allegories of the 1630s related to the theme of Peace and War are particularly vivid realizations of the human qualities and interactions of such figures as Minerva, Mars, and Venus.[50] Indeed, Rubens's own parse of the figures in his Uffizi *Horrors of War* includes a careful and learned mixture of Mars and Venus, the Fury Alecto, allegorical monsters of Pestilence and Famine, numerous attributes with their own emblematic significance (see below), and even the figure of "unhappy Europe."[51] Even in more modest undertakings, such as the learned and graceful allegorical adornments of bookplates and frontispieces, Rubens peopled his images with both personifications and classical deities, to incorporate the beauties and the lessons of poetry, history, and the liberal arts.[52]

Within the *Horrors of War*, Rubens had included such images as a "broken lute, signifying harmony, which is incompatible with the discord of war" and "a bundle of arrows with the cord which bound them together undone, they when bound together, being the emblem of Concord." These are figures of another kind; instead of personifications, they are disembodied attributes, visual images that serve as metaphors for the same kinds of qualities or ideas. Beginning with the 1531 publication of Andrea Alciati's *Emblematum liber*, this particular compilation of visual images, together with adages (popularized in the sixteenth century in Latin by the compilations of Erasmus, *Adagiorum Chiliades*) and epigrams, became a virtual thesaurus of metaphorical imagery for painters and poets alike during the sixteenth and seventeenth centuries.[53] Recent studies by scholars of Dutch painting have focused attention on the role that motifs from local Dutch emblem-books played within the essentially descriptive images of objects and characters from daily life. Without violating the fundamentally naturalistic character of the paintings, these emblematic objects, often hung on the wall or placed on a table, permit an additional level of allusion and meaning, sometimes even a reversal of the apparent character of the main image or activity.[54] Dutch art was hardly premised upon humanism or the tradition of *ut pictura poesis*. In fact, Rembrandt remained one of the main targets of art critics steeped in the classical tradition for centuries to come; he was pilloried by later Dutch

adherents to the humanistic theory of art as being a *pictor vulgaris* because he followed the natural appearance of things more closely than the learned ideal.[55] But emblems offered Dutch artists a compromise solution, a combination of didactic instruction and metaphor with pictures of everyday reality. Unlike the Renaissance fascination with hieroglyphics and *imprese,* conceived in terms of their occult heritage and their link to the ineffable world of the hermetic tradition,[56] these didactic emblems reverse the direction of reference or revelation. Instead of being paler earthly reflections of celestial splendor in a Neoplatonic cosmos, these seventeenth-century images, simultaneously visual and verbal, begin in the material world and serve, like a silent parable, for both instruction and meditation appropriate for Calvinist Holland.

In our context, the importance of emblems lies in their union of the sister arts as well as in their impulse toward moral instruction in the best humanist tradition, even if their humble forms are almost the opposite of the noble subjects called for by Alberti and other classicizing theorists. Emblems, however, were not merely subjects for the background of Vermeer interiors or items within the inventories of still-lifes. Emblems could also serve literature by bestowing pictorial imagery, *enargeia.* Poetry of the early seventeenth century, particularly the works of Herbert and Marvell, has yielded fruitful exegeses in connection with emblems; Lewalski has added examples from Donne, Vaughan, and Taylor.[57]

II. Hogarth versus History

With the advent of the eighteenth century, then, the relationship of the sister arts had developed in widely divergent directions. The principal formulations of Alberti had been elaborated into academies of art in Italy and France as well as into two centuries' worth of theory.[58] Eventually these ideas were to percolate into England. One notable instance is the poem by Charles Alphonse du Fresnoy, *De arte graphica*, published posthumously by Roger de Piles in 1668 and translated into English by Dryden with a preface on "The Parallel of Poetry and Painting" (1695).[59] With Dryden's opening lines, the humanistic theory of art had at last entered the English vernacular. At the same time, detailed observation and the meaningful, emblematic use in painting of the humblest objects of nature provided a powerful alternative tradition to the theorizing trends

just mentioned. As if in defiance of the doctrines of noble, human subjects and du Fresnoy's dictum that "it is not sufficient to imitate Nature in every Circumstance, dully, and, as it were literally, and minutely," these images instruct precisely *because* they have chosen humble or everyday subjects, conveying what Colie called "multo in parvo." This second, more "literal" vision of nature in art was the model for literary criticism in its own right in England, under the leadership of Joseph Addison.[60] Taking up ancient arguments that were so important to Leonardo's paragone, Addison praises sight as "the most perfect and delightful of all our senses," arguing for the vividness and universality of pictorial images in contrast to poetry: "description runs yet further from the things it represents then painting; for a picture bears a real resemblance to its original which letters and syllables are wholly void of."[61] As an author, Addison thus turns to naturalistic painting as a model, using Horace's phrase in the opposite sense of du Fresnoy's directive. As Hagstrum emphasizes, Addison highlights the powerful effects of this pictorialism on the viewer's emotions as a force for moral or political instruction. Even the emblematic dimension of interpretation is disparaged by Addison as merely an illustrated metaphor and an obstruction to clarity.[62]

The audience for pictures in eighteenth-century England seems to have been primarily disposed to find its fullest meaning in that which is visually apparent. This is an alternative system of knowledge, akin to our current phrase "seeing is believing," which culminates in the discussions of Bacon, Hobbes, and the Royal Society during the seventeenth century. In painting, the quintessential art of describing, even with its use of emblems, was seventeenth-century Dutch art, featuring the use of optical devices, such as the *camera obscura*.[63]

Jan Bruegel's early seventeenth-century allegory, *The Sense of Sight* (Madrid, Prado), evokes the same idea with its encyclopedic collection of paintings and objects, summarizing all knowledge of science and the arts, and its significant inclusion of optical instruments, such as telescope, sextant, and astrolabe. This was the very tradition disparaged by classicists, as we have seen above, for its unadorned "vulgar" naturalism.

Yet for Hogarth and the early eighteenth-century art world of England, this was the tradition of the clear and commonplace

that made sense, in contrast to the learned complexity of the humanist tradition.[64] The didactic emphasis of seventeenth-century art formed the basis of Hogarth's artistic "Progresses," but the subject was no longer a Ripa personification of a noble virtue or a heroic action. Instead, Hogarth's program features a Harlot, a Rake, a Marriage of Convenience, and Industry and Idleness. These figures are not drawn from the classics or from allegorical handbooks but from modern life (almost in anticipation of Baudelaire's call over a century later for a French Painter of Modern Life). They are still morally instructive general types, whose unfolding story imparts a seriousness fully as vivid as their individual characters and locales.

Despite his turn to the contemporary London scene for his subjects, Hogarth also utilizes a number of traditional visual formulas in constructing his images. References to familiar religious and mythical imagery pervade Hogarth's Progresses.[65] Scenes such as the Choice of Hercules or events from the Life of the Virgin, like the Visitation, underlie the staging of the *Harlot's Progress*. In addition, the presence of similar images on the walls of the interiors behind the main action of Hogarth's prints adds a dimension of commentary akin to the emblems on the walls of Dutch genre pictures. For example, the image of the *Sacrifice of Isaac* behind the image of the third plate, the *Arrest of the Harlot*, juxtaposes the earthly justice against the biblical example of divine justice. In the same print, a cheap portrait engraving on the Harlot's wall of the smooth-talking rogue, Captain Macheath, from John Gay's *Beggar's Opera* (1728) serves as a reminder of Hogarth's fascination with theater in general and with the *Beggar's Opera* in particular. One of Hogarth's earliest paintings offered a scene from Act III of the *Beggar's Opera*; the artist made six separate versions of this picture. Also unconventional as a source of Hogarth's modernized "history painting," Butler's mock-heroic *Hudibras* was the subject of twelve engraved Hogarth plates in 1725. The contrast between heroic poses and grotesque figures in Hogarth's prints offers a parallel to the mock-heroic literary forms of Dryden and Pope or of Butler himself. Hogarth also made a few illustrations for *Don Quixote* and a satiric *Punishment of Lemuel Gulliver*.[66] When Hogarth painted his *Self-Portrait* (London, Tate Gallery; plate 3-3) in 1745, he placed his oval

visage upon a pile of books—distinctly English-language books—in the lower center. The spines of those books read: Swift, Shakespeare, Milton. The anticlassical quality of the painter was further emphasized when he balanced his own face against the stolid portrait of his own Pug, named Trump—a satiric watchdog and emblem of stubborn determination like the painter himself, who was later known as Painter Pugg to his detractors.[67] Wendy Roworth has further discovered that the word "pug" in eighteenth-century England could also mean monkey or ape, another synonym for the artist himself, the "ape of nature." Roworth also points out that the proper term for a pug is "Dutch mastiff."[68] In this context, then, opposite the theoretical Line of Beauty in Hogarth's *Self-Portrait*, the pug thus becomes a symbol for unadorned realism like that of the Dutch, discussed above.

Hogarth's very decision to produce images in series and progresses in print is part of his conscious effort to produce visual images to be "read" like literary constructions. The background images, the character of the physical spaces, even the left-to-right arrangement of the actions and the succession of scenes are all intended to be part of a mental progress, a reading of each scene and all scenes together. This kind of construction took its model not from epics, but rather from the series of scenes in theatrical presentations. Hogarth also took as a model of assembly the emerging contemporary novel, such as those of his friend Fielding.[69] Hogarth himself explicitly compares his own characters to those of the drama:

> The figure is the actor
> The attitudes and his action together with which
> The face works an expression and the words must speak to the Eye
> and the scene.[70]

This attitude is in many respects a recasting of traditional notions of "expression," and it indicates once again Hogarth's debt to the theory he subverts. Theater continued to be a major interest throughout Hogarth's career, not only in his early works, like the *Beggar's Opera*, but also in images such as the satirical *Strolling Actresses in a Barn* (1738), *Southwark Fair* (1733), or the later portrait of *Garrick as Richard III* (1745).

Hogarth, in short, retains many of the older structures in his role as Comic History Painter. As he uses received conventions in the *Four Times of the Day* engravings, Hogarth infuses earlier forms of thought and poetry with modern, naturalistic settings and modern

figures or trivializations of classical personifications. The revitalization by his satire of older forms can be seen clearly in the subscription ticket to the *Harlot's Progress*, the engraving *Boys Peeping at Nature*.[71] The central image of the print is the many-breasted image of Nature, adapted from the classical sculpture of Diana of Ephesus. Rubens had featured the allegorical figure of Nature in his painting *Nature Adorned by the Graces* (Glasgow); within the classical tradition of the later eighteenth century, the same Nature had been central to the engraved frontispiece of the second edition of James Harris's *Three Treatises*.[72] In the earlier, standard treatments such as Rubens's, Nature is the rich source of nourishment for all the arts and sciences as well as the basis of Beauty itself, personified by the Three Graces. The cherubic putti of Harris's work are busily engaged in drawing, singing (with lyre), and reciting. Hogarth's boys, however, though based on the Rubens (owned at the time by his father-in-law, Thornhill), are much more unadorned and purely descriptive. No Graces are present; the action takes place in an empty yard in front of a humble brick wall. While one boy works at an easel to paint the figure of Nature, another one is sketching with his back completely turned to her. In the center, a lascivious faun attempts to lift the makeshift skirt around the base of Nature and peer up at her private parts; he is restrained by the third putto. An epigram from Virgil, originally the words of Apollo to Aeneas in reference to Beauty, or Venus, "Antiquam exquirite Matrem" ("Seek out your ancient mother"),[73] takes on an ironic twist as it appears on the ordinary bricks of the background, for the "search" of the faun is taking a distinctly seamy turn. Below, a quotation from Horace's *Ars Poetica* underscores Hogarth's consciousness of the *ut pictura poesis* analogy, even as it shows him to be striving for a fresh, new form of imitating Nature through his own Comic History: "It is necessary to present a difficult subject in new terms . . . and license will be allowed if it is used with care."

We see the same thoughts encapsulated in Hogarth's other major self-portrait, the 1758 painting, later engraved, *Self-Portrait Painting the Comic Muse* (plate 3-4).[74] Here, busy at work, the artist is painting a personification like an artist of the classical tradition, but, like Fielding, he turns to Comedy for inspiration. At the foot of the easel, presumably informing Hogarth's technique, lies the first illustration from Hogarth's own treatise the *Analysis of Beauty —*

not classical theory in the Alberti tradition, to be sure, but theory nonetheless.

If Hogarth made unconventional use of the traditions of classical art theory, he was not alone. He takes off from the view expressed by Addison in *Spectator* no. 413 of a novel art category, the "uncommon," between the Great and the Beautiful, which "fills the Soul with an agreeable surprise, gratifies its Curiosity, and gives it an idea of what it was not before possest," whose virtue was "to vary Human Life."[75] It was this principle of variety and intricacy that Hogarth elevated to an axiom of beauty in his own perplexing contribution to art theory, the *Analysis of Beauty* (1753).[76] He takes some pains to draw on the authority of the ancients at the very time he endeavors to eradicate any classical canon of beauty:

> Now, as everyone has a right to conjecture what this discovery of the ancients might be, it shall be my business to shew it was a key to the thorough knowledge of variety both in form, and movement. Shakespeare, who had the deepest penetration into nature, has sum'd up all the charms of beauty in two words, Infinite Variety.[77]

The man who sold his own cheap engravings to a larger audience by direct subscription approached tradition and the classical establishment as a bold outsider:

> Something therefore introductory ought to be said at the presenting a work with a face so entirely new; especially as it will naturally encounter with, and perhaps may overthrow, several long received and thorough establish'd opinions . . . it will also be proper to lay before the reader, what may be gathered concerning it, from the works of the ancient and modern writers and painters. . . . If I have acquired anything in my way it has been wholy obtained by Observation by which method be where I would with my Eyes open I could have been at my studys.[78]

To use art treatises or previous works of art as a guideline is to be misguided. "Who, but a bigot, even to the antiques, will say that he has not seen faces and necks, hands and arms in living women, that even the Grecian Venus doth but coarsely imitate?"[79] Hogarth was in fact quite opposed to the academic theories of ideal beauty; he called himself at war with the "connoisseurs."[80] Again, like Fielding, Hogarth took the theater rather than the epic poem as his model, and his important 1745 portrait of *Garrick as Richard III* (painted and engraved) can stand as an index of his attention to the power of dramatic acting in accord with nature rather than convention:

> Subjects I consider'd as writers do
> my Picture was my Stage and men and women my actors who were
> by Mean of certain Actions and express[ions] to Exhibit a dumb shew.[81]

Perhaps the finest tribute to Hogarth and the true testimony to his success in his chosen sphere is the play *The Clandestine Marriage*, composed after the artist's death by Garrick himself, with George Colman, and performed in 1766 ("tonight your matchless Hogarth gives the Thought . . .") with a nod to the artist's concept of the comedy of manners; it, too, pays homage, in its unique fashion, to the *ut pictura poesis* tradition of the sister arts:

> Poets and Painters, who from Nature draw
> Their best and richest Stores, have made this Law:
> That each should neighbourly assist his Brother,
> And steal with Decency from one another.[82]

It was in the expounding of a moral that Hogarth was most greatly admired by his contemporaries, and despite his inattention to the nobler aspects of mankind, that desire of his at once to instruct and delight is Hogarth's contribution to the ambitions of humanist painting. Choosing to address a broader audience through the mass medium of engraving and to live by small contributions instead of the largesse of the rich few, he drew his moral instruction through the steady gaze at vice, instead of the loftier images of virtue native to classical theory, through satire rather than the ideal. Garrick's epitaph for his friend conveys the more charitable view of Hogarth's achievement:

> Farewel, great Painter of Mankind!
> Who reach'd the noblest point of Art,
> Whose pictur'd Morals charm the Mind,
> And through the Eye correct the Heart.[83]

III. Reynolds and the Royal Academy

Hogarth's militant opposition during his entire career to the establishment of a Royal Academy of Art in England is the surest sign of his disdain for the classicists, and he, in turn, was attacked by them, in such satirical prints on Hogarth himself as those by Paul Sandby.[84] But it was at last England's turn to subscribe to the Albertian tradition and its artistic legacy and to emulate their brethren in France, who had, since 1635, their own Royal Academy of Painting and Sculpture to distinguish them from mere craftsmen.

While Hogarth was attacking the copying and imitation of earlier art and theory in his *Analysis of Beauty*, English artists went about establishing their own shrine to those very principles, to be set down in the *Discourses* delivered from the time of the inception of the Royal Academy in 1769 by its first president, Sir Joshua Reynolds.[85] Reynolds's own outlook on Hogarth can be discerned a mere six years after the latter's death in the text of Discourse III (1770):

> The painters who have applied themselves more particularly to low and vulgar characters, and who express with precision the various shades of passion, as they are exhibited by vulgar minds, (such as we see in the works of Hogarth) deserve great praise; but as their genius has been employed on low and confined subjects, the praise which we give must be limited as its object. (p. 51)

This is the echo of the elevated style; Reynolds uses Hogarth as a foil precisely to promote his own humanistic, classic theory of art,

> that one great idea, which gives to painting its true dignity, which entitles it to the name of a Liberal Art, and ranks it as a sister of poetry. (p. 50)

Indeed, that very third discourse is the *locus classicus* of Reynolds's hope to bring the Muses to England as instructors to painters in the Royal Academy. He attempts to lay down the principle that artistic perfection results from an ideal beauty, akin to that advanced by "poets, orators, and rhetoricians of Antiquity" and superior to what can be found in individual nature (p. 42). Intellectual dignity is what separates the painter from the "mere mechanick" and produces those effects "which eloquence and poetry . . . are scarcely able to attain" (p. 43). And artists must take ideal form, like Zeuxis in the famous tale recounted first by Alberti, from the sum of several perfections. Eventually, the goal of art will attain a level like the "best productions of ancient and modern poetry . . . of animating and dignifying the figures with intellectual grandeur, or impressing the appearance of philosophick wisdom or heroick virtue" (p. 50; also Discourse IX, pp. 169-71).

Such philosophical differences as their writings show are equally manifest in the self-portraits of Reynolds and Hogarth. When Sir Joshua painted his own, official likeness for the Royal Academy (1773; plate 3-5), he posed elegantly, glove in hand, capped with a bonnet (his Oxford tam), much in the mode of Rembrandt's *Aristotle Contemplating the Bust of Homer* (1653; New York, Metropolitan Museum). In similar fashion, Reynolds showed him-

self contemplating the bust of his great spiritual teacher, the "divine" Michelangelo. In contrast, the pugnacious Hogarth had undermined the seriousness of the occasion by visually equating himself with a dog, his own pug, and resting his image—as a painting-within-a-painting—on the literary tradition of exclusively English authors. Reynolds's career offers an irony with respect to his own ideals and with the hierarchy of painting that sees subject-matter as the crucial determinant of a picture's intellectual dimension. Reynolds was himself a portrait painter, a profession of which he speaks slightingly in the third discourse:

> All these painters have, in general, the same right, in different degrees, to the name of painter, which a satirist, an epigrammatist, a sonneteer, a writer of pastorals, or descriptive poetry, has to that of a poet.
>
> In the same rank, and perhaps not so great merit, is the cold painter of portraits. But his correct and just imitation of his object has its merit. . . . These, however, are by no means the views to which the mind of the student ought to be *primarily* directed. (p. 52)

In his fourth discourse, Reynolds speaks of the importance for the portraitist of raising or improving his subject by "approaching it to a general idea." In this manner the lower style of portrait painting may be elevated by borrowing from the grand:

> He leaves out all the minute breaks and peculiarities in the face, and changes the dress from a temporary fashion to one more permanent, which has annexed to it no ideas of meanness from its being familiar to us. But if an exact resemblance of an individual be considered as the sole object to be aimed at, the portrait-painter will be apt to lose more than he gains by the acquired dignity taken from general nature. It is very difficult to ennoble the character of a countenance but at the expense of the likeness. (p. 72)

One certainly cannot fault Reynolds for failing to follow his own directives in his portraits. In *Mrs. Siddons as the Tragic Muse* (1784; Huntington Art Gallery), Reynolds has not only chosen to portray the actress in the guise of the noblest form of theater, the very Muse Melpomene herself, but he has at the same time presented her enthroned in the clouds, surrounded by the personifications of Pity and Fear. In composing his figure on the great throne, Reynolds has also ennobled her pose through overt reference to the Prophets of Michelangelo's Sistine Ceiling.[86] Reynolds's portrait of the actress is thus enhanced through both visual reference and extraordinary

personification. Visual association with a "grand tradition" provides a foundation of high, moral seriousness for *Mrs. Siddons*, just as it had for Reynolds's own *Self-Portrait*, where both his costume and manner of paint handling had allied him with the great portraitist of the previous century, Rembrandt. At the same time, Reynolds deferred admiringly in his *Self-Portrait* to the bust of Michelangelo, described in the fifth discourse as the master of "Genius and Imagination . . . energy . . . Poetical Inspiration" (p. 83).

Even where the identification of a Reynolds sitter with a goddess or muse is not so bold as in *Mrs. Siddons*, her dress, locality, and action could still be fully displaced into a timeless and classical "general idea," like the portrait of *Lady Sarah Bunbury Sacrificing to the Graces* (1765; Chicago; plate 3-6). Hagstrum has quite aptly found an analogy in this portrait to the witty visual hyperbole invoked by Pope in describing Belinda's toilet.[87] Lady Sarah is here the same kind of priestess, but she contemplates not her own image but rather the figures of Venus' own handmaidens, the Graces. By implication, these loveliest of females may be taken to be the ideals and the attributes of the sitter herself: Aglaia ("bright"), Euphrosyne ("good cheer"), and Thalia ("festive"). The sculpture of the Graces contains a wreath of Venus' sacred myrtle, extended outward toward the pious supplicant as if to acknowledge Lady Sarah's own gifts. Here again, the contrast with Hogarth is manifest if we compare Reynolds's use of traditional imagery. Drawing on the same Rubens picture that had inspired the salacious frontispiece of Hogarth's *Boys Peeping at Nature*, Reynolds instead chose to paint in the grand manner of Rubens, but to show an overblown portrait where the Graces themselves are adored and adorned by a modern, living "paragon," dressed and acting in imitation of ancient priestesses.[88]

We can see another dramatic juxtaposition of Reynolds and Hogarth by contrasting Reynolds's portrait of *Garrick between Comedy and Tragedy* (1761) with Hogarth's portrait of *Garrick as Richard III*, showing the actor on stage. Hogarth's dramatic gestures provide a powerful but serious moment in the present, capturing with dignity a professional performance by the great actor. Reynolds's image, in contrast, is more relaxed and informal, despite its use of the classicizing theme of the Choice of Hercules. *Garrick between Comedy and Tragedy* presents a timeless allegorical

portrait context, akin to that of *Mrs. Siddons*. Garrick's choice can also be juxtaposed against Hogarth's use of the tradition of the Choice of Hercules (that is, between virtue and vice) in the initial plate of the *Harlot's Progress*, a "history" rather than a portrait.

IV. English History Paintings

Reynolds's portraits are intended to be poetic evocations that elevate modern figures into a heroic and noble ideal. During Reynolds's lifetime in England, the concept of the heroic found a variety of historical expressions, even for subjects that, like Hogarth's city scenes (and other decisive rejections of the grand manner), could literally be termed "modern." The great example of "heroicized" modern history painting in the grand manner is Benjamin West's *The Death of General Wolfe* (1771; Ottawa), painted by the transplanted American who was to become Reynolds's successor as President of England's Royal Academy. Charles Mitchell has compared this death scene to the death of Christ and to traditional Christian paintings of the Lamentation:

> West succeeded by sympathetically expressing the feelings of contemporary Englishmen about their own history in a formula based on the principles of classical aesthetics and on traditional Christian iconography. . . . West, however, attempted to combine—as de Piles prescribed for "perfect truth"—the simple truth of factual *vraisemblance* with the ideal truth of historical art; and he created a pictorial formula which both expressed the natural self-consciousness of Englishmen and perpetuated the Christian and pagan traditions of ideal virtue.[89]

This is history painting akin to Reynolds's concept of portraiture: casting the modern and the particular in the time-honored mold of the universal. West, however, was Reynolds's true successor at the Royal Academy in practicing the craft of history painting with the most venerable and dignified of themes from ancient literature, such as the Tacitus-inspired *Agrippina with the Ashes of Germanicus* (1768; Yale University). In addition, West introduced into Anglican England a project sponsored by King George III for a planned King's Chapel at Windsor Castle: a 35-canvas History of Revealed Religion. West was to labor on the project for some three decades (ca. 1780-1810), but it was ultimately doomed to failure because of the king's illness and the opposition of conservative Anglican bishops to the introduction of art into English churches.[90] Even the self-portrait

by West (plate 3-7), presented to the Royal Academy shortly after he succeeded Reynolds in 1792, establishes the younger artist's alliance with the same "grand tradition" expounded annually in Reynolds's *Discourses*; yet here it is an Anglophile orientation that in some ways resembles the books that adorned Hogarth's *Self-Portrait with Pug*: a volume entitled *History of England,* a large edition of the Bible, and a different bust, this time of his patron George III.

History painting in England was to receive its final flowering at the hands of another transplanted artist. Whereas Benjamin West had arrived from the American colonies, Henry Fuseli left his native Zurich as a young man to come to England, and it was in large part his 1768 meeting with Reynolds that persuaded him to become a painter.[91] Fuseli, too, published theoretical writings and became a full member of the Royal Academy in 1790, so it hardly surprises us to read his pronouncement that "the Greeks carried the art to a height which no subsequent time or race has been able to rival or even to approach."[92] Even more than the Italians themselves, Fuseli revered the model of Michelangelo, Reynolds's companion in his *Self-Portrait*:

> [Michelangelo] is the inventor of epic painting, in that sublime circle of the Sistine Chapel which exhibits the origin, the progress, and the final dispensations of theocracy. He has personified motion in the groups of the cartoon of Pisa; embodied sentiment on the monuments of St. Lorenzo, unravelled the features of meditation in the Prophets and Sybils of the Sistine Chapel; and in the *Last Judgment*, with every attitude that varies the human body, traced the master-trait of every passion that sways the human heart.[93]

In the truest sense of the history painter, Fuseli was almost slavishly obsessed with noble subjects drawn from literary masterworks, including classical Greek authors, Dante, and Germanic myths and legends, but his particular fascination was also embedded in the English canon with Shakespeare and Milton. This predilection was by no means uncommon; in fact, Fuseli was at the forefront of a major new movement in history painting in England, which focused on the figure of Shakespeare.

The principal patron and entrepreneur of the Shakespearean art movement was Alderman John Boydell (d. 1804), who sponsored an exhibition gallery on Pall Mall exclusively devoted to Shakespearean subjects, beginning in 1789 and lasting until 1805. Boydell

commissioned paintings of Shakespearean themes from all of the notable English artists of his day—including Reynolds, West, and Fuseli—and their paintings were reproduced in engraved prints sold by subscription, just as Hogarth's had been. Here, of course, the literature chosen is native English rather than Greco-Roman (another close kinship with Hogarth), but the motivation of Boydell is explicit: he wishes to foster a new, English school of history painting

> to advance that art towards maturity, and establish an *English School of Historical Painting*, was the great object of the present design. . . . In this progress of the fine Arts, though foreigners have allowed our lately acquired superiority of Engraving, and readily admitted the great talents of the principal Painters, yet they have said, with some severity, and, I am sorry to say, with some truth, that the abilities of our best Artists are chiefly employed in painting Portraits of those who, in less than half a century, will be lost in oblivion—while the noblest part of the Art—HISTORICAL PAINTING—is much neglected. To obviate this national reflection was, as I have already hinted, the principal cause of the present undertaking.[94]

Fuseli was to echo the same sentiments, somewhat ruefully, when he complained that there is

> little hope of Poetical painting finding encouragement in England. The People are not prepared for it. Portrait with them is everything.[95]

Boydell's Shakespeare Gallery was the first and foremost of a cluster of such picture galleries in London at the end of the eighteenth century, such as the more comprehensive Poets' Gallery of Thomas Macklin (est. 1787) or the Historic Gallery of Robert Boyer (est. 1793), based on David Hume's *History of England.*[96] Fuseli himself went on to a bold entrepreneurial venture of his own: a Milton Gallery, which was unique not only in its subject but also in being the sole product of one artist. After a decade of work, the Milton Gallery opened in 1799.[97] In addition to paintings with Miltonic themes, particularly those drawn from *Paradise Lost*, Fuseli included images of the poet as well, such as *Milton Dictating to his Daughter* (plate 3-8). Fuseli had already executed nine paintings for the Boydell Shakespeare Gallery; he even went so far as to design a room in Rome in emulation of the Sistine Ceiling with frescoes of Shakespearean themes.[98]

Yet with the images of Fuseli's powerful and active epic heroes lay the roots of an altered conception of the purpose of painting,

ultimately to be the undoing of the humanistic theory of painting. We have seen how Reynolds, as the retrospective spokesman of the tradition we have been considering, designated the ultimate function of art to be moral and ethical, with beauty as its object and its means of instruction.[99] Yet for Fuseli, though he, too, was a member of the Royal Academy and a follower of Reynolds in many ways, this central axiom about the role of art had lost its meaning. According to Gert Schiff, Fuseli followed the writings of Rousseau, determining that the arts potentially endangered the state and corrupted morality (rather than bestowing Taste and Virtue, as Reynolds claimed).[100] Fuseli thus speaks as a skeptic or a pessimist who believed in the corruption of civilization and who emphasized the importance of divorcing art from morality:

> It is ludicrous to give a consequence to the arts which they can never possess. Their moral usefulness is at best accidental and negative. It is their greatest praise to furnish the most innocent amusement for those nations to whom luxury is become as necessary as existence, and amongst whom alone they can rear themselves to any degree of eminence.[101]

Despite his classicizing theories and subjects, then, Fuseli draws sharp boundaries between the moral sense and the sense of beauty.[102] The emphatic presence of the supernatural in Fuseli's art also evokes another important doctrine in late eighteenth-century theory: the appeal to the spectator's imagination.[103] An extension of this desire to appeal to the emotions in the arts is the developing notion of the "sublime," yet another term that could be credited to the influence of Longinus.[104] Even Reynolds had acknowledged the importance of the doctrine of the sublime in his final discourse, providing us with a definition of its effects: "The Sublime in Painting, as in Poetry, so overpowers, and takes such possession of the whole mind, that no room is left for attention to minute criticism."[105] This new realm of the imagination formed an antithesis to the sense of tradition and beauty underlying classical theory. Fuseli attempted in vain to rescue the dichotomy, drawing a distinction between the legitimate depiction of terror and the undesirable depiction of horror:

> We cannot sympathize with what we detest or despise, nor fully pity what we shudder at or loathe . . . mangling is contagious, and spreads aversion from the slaughterman to the victim.[106]

V. Epilogue

With increasing emphasis on the sublime and the search for it in untamed rather than in civilized realms, the old values that underlay the classical theory of art from Alberti to Reynolds could not be sustained. Fuseli's endorsement of Rousseau's separation of art from its moral foundations and aspirations was a kind of death knell—even amidst his love for Michelangelo and the Greeks—for the human body as the basis of art, and for the English Royal Academy. The inevitable conflict of values and the transformation of art are summarized, with a hint of nostalgia, by Rensselaer Lee:

> Opposed to the humanistic point of view was the growing interest in external nature, with whose freshness and irresponsible freedom Rousseau, the apostle of emotion, was to contrast the life of human beings freighted with custom and constrained by the 'false secondary power' of the reason. . . . It was also a part of that general movement in thought and art away from concentration on the supreme significance of the human image.
>
> Another source of danger to the humanistic point of view during the eighteenth century was the growing importance of the doctrine of original genius which was encouraged by the pervasive influence of the treatise of *Longinus on the Sublime*. . . . As the century progressed it came to be associated in the minds of critics with the subjective and emotional in artistic expression, and with a special class of sublime subjects that were obviously congenial to the romantic temperament and to that alone. And these were non-traditional subjects: scenes for instance of terror, or of vast, wild and formless nature which had submitted to the laws of order no more than genius itself . . . was expected to do. Such a point of view was not one to encourage the ideal representation of human action that had been the theme of humanistic painting, and the doctrine of original genius is, moreover, the ancestor of modern expressionism which is necessarily hostile to the doctrine *ut pictura poesis*.[107]

The emancipation of painting from the manual crafts or "mechanical arts" of the Middle Ages had given the claims of painting equal status with the traditional "liberal arts." The basis of the claims lay in the analogies of the sister arts, in the varying responses to the inherited phrase *ut pictura poesis*. Yet with the final conquest of learned respectability in the eighteenth century, with the

development of the "Fine Arts" and a concomitant new philosophical system of "Aesthetics," painting (like sculpture, architecture, music, even poetry) had become an isolated entity, divorced from traditional purposes and social functions. Integration of the arts within the moral, religious, and philosophical universe of the medieval and Renaissance periods gave way to detached, purely aesthetic questions, to considerations of originality rather than tradition. Art in its pristine isolation began to seek novelty for its own sake and to cultivate a self-referential taste for the *avant-garde*. Having finally acquired by persistence the status of a muse on her own, Art, with her adopted step-sisters, seemed to become confined to quarters on the rarefied heights of Parnassus.

As Delacroix's careful, animated, but essentially isolated copies after Rubens's allegories make clear, the original language and context of personification had been lost; only animated brushwork, color, and figural dynamism remained—the pure objects of vision.[108] In similar fashion, Coleridge felt an insuperable barrier between his world and the heritage of allegory; he made his criticism explicit in his contrast of the more "organic" symbol with the "mechanical," conscious, and logical system of allegory.[109] Daumier's mocking series of cheap lithographs entitled *Ancient History* (1841-43) used irony, much as Hogarth had done, as the final attack on the classical pantheon, substituting grotesquerie for beauty, pettiness and grossness for the noble action of the gods and heroes themselves—all of these by the nineteenth-century artist whose dictum was "One must be of one's time."[110] The *coup de grâce* to the humanist visual tradition was finally delivered in the perceptive appreciation of this same series of prints by Baudelaire in 1857:

> The *Histoire ancienne* seems to me to be important because it is, so to say, the best paraphrase of the famous line [by Delacroix], "Who will deliver us from the Greeks and the Romans?"[111]

Fortunately for his many students and readers, Jean Hagstrum chose to persist with his own "honest delights" in admiring the legacy of neoclassical poems and pictures, and all that they embody: "the values of society, the dignity of man, and civilization itself."[112]

Notes

1. Ernst Robert Curtius, *European Literature and the Latin Middle Ages*, trans. Willard R. Trask (New York and Evanston, Ill.: Harper and Row, 1953), pp. 228-46; see

also the magisterial survey by Paul Kristeller, ''The Modern System of the Arts,'' in *Renaissance Thought II* (New York: Harper and Row, 1965), pp. 173-74.

2. Curtius, pp. 36-39; Kristeller, pp. 172-73; Emile Mâle, *The Gothic Image*, trans. Dora Nussey (New York: Harper and Row, 1958), pp. 75-90; Adolf Katzenellenbogen, *The Sculptural Programs of Chartres Cathedral* (New York: Norton, 1959), pp. 15-21.

3. The standard edition of *De pictura* is Leone Battista Alberti, *On Painting and Sculpture*, trans. Cecil Grayson (London: Phaidon, 1972). For convenience, however, I shall refer throughout this paper to documents contained together in *A Documentary History of Art*, ed. Elizabeth Holt (Garden City, N.Y.: Doubleday, 1957). On Alberti as a theorist, a useful introduction is Anthony Blunt, *Artistic Theory in Italy 1450-1600* (Oxford: Clarendon Press, 1940), pp. 1-22.

4. Holt, I, 206.

5. Joel Snyder, ''Picturing Vision,'' *Critical Inquiry* 6 (1980): 514-26; Richard Krautheimer, *Lorenzo Ghiberti* (Princeton: Princeton Univ. Press, 1956), pp. 229-53; Samuel Edgerton, Jr., *The Renaissance Discovery of Linear Perspective* (New York: Harper and Row, 1971).

6. Holt, I, 217.

7. Ibid., I, 207.

8. Rensselaer Lee, *Ut Pictura Poesis: The Humanistic Theory of Painting* (New York: Norton, 1967); see also Kristeller.

9. Lee, pp. 16-21; Jean H. Hagstrum, *The Sister Arts: The Tradition of Literary Pictorialism and English Poetry from Dryden to Gray* (Chicago: Univ. of Chicago Press, 1958), pp. 57-58.

10. Holt, I, 215. ''Invention'' is used here in the technical sense, meaning the disposition and interpretation of (usually noble) subjects.

11. Lee, pp. 56-61; Hagstrum, pp. 66-70; Robert Klein and Henri Zerner, *Italian Art 1500-1600: Sources and Documents* (Englewood Cliffs, N.J.: Prentice-Hall, 1966), pp. 4-16; Leonardo da Vinci, *Paragone: A Comparison of the Arts*, trans. I. A. Richter (Oxford: Oxford Univ. Press, 1949). Most recently, the issue of the paragone has been discussed by Leonard Barkan, ''Living Sculptures: Ovid, Michelangelo, and *The Winter's Tale*,'' *ELH* 48 (1981): 639-67.

12. Lee, p. 3; Hagstrum, p. 10.

13. Mary Garrard, ''Artemisia Gentileschi's Self-Portrait as the Allegory of Painting,'' *Art Bulletin* 62 (1980): 97-102. Also, Matthias Winner, ''Die Quellen der Pictura-Allegorien in gemalten Bildergalerien des 17. Jahrhunderts zu Antwerpen'' (Ph.D. diss., Cologne, 1957).

14. Garrard, p. 102, n. 23, fig. 8. Winner, esp. p. 88.

15. Hagstrum, p. 18, n. 34; Svetlana Alpers, ''Ekphrasis and Aesthetic Attitudes in Vasari's *Lives*,'' *Journal of the Warburg and Courtauld Institutes* 23 (1960): 190-215. On the central significance of narrative, or history painting, for Alberti and Renaissance artists, see Alpers, ''Describe or Narrate? A Problem in Realistic Representation,'' *New Literary History* 8 (1976): 17-18.

16. Robert Förster, ''Die Verläumdung des Apelles in der Renaissance,'' *Jahrbuch der königlichen preussischen Kunstsammlungen* 8 (1887): 29-56, 89-113; 15 (1894), 27-40; David Cast, *The Calumny of Apelles* (New Haven: Yale Univ. Press, 1981).

17. Elizabeth McGrath, ''The Painted Decorations of Rubens's House,'' *Journal of the Warburg and Courtauld Institutes* 41 (1978): 245-77.

18. Emil Kieser, ''Antikes im Werke des Rubens,'' *Münchner Jahrbuch der bildenden Künste*, N.F. 10 (1933): 110-37; Wolfgang Stechow, *Rubens and the Classical Tradition* (Cambridge, Mass.: Harvard Univ. Press, 1968); Julius Held, *Rubens: Selected Drawings* (London: Phaidon, 1959), I, 49-53; Michael Jaffé, *Rubens and Italy* (London: Phaidon,

1977). For other Rubens re-creations of ekphrases, see the references in McGrath, notes 1-3.

19. McGrath, p. 245, n. 1.

20. Hagstrum, p. 79. I am grateful to Professor Elizabeth Hageman for numerous exchanges on this general subject, including several of her fine unpublished papers: "In Praise of Poet's Wit: Spenser and the Sister Arts," and "The Many Faces of Collatine's Fair Love, Lucrece the Chaste." See also S. Clark Hulse, "'A Piece of Skilful Painting' in Shakespeare's 'Lucrece,'" *Shakespeare Survey* 31 (1978): 13-22; David Rosand, "'Troyes Painted Woes': Shakespeare and the Pictorial Imagination," *Hebrew University Studies in Literature* 8 (1980): 77-79. My quotations refer to *The Riverside Shakespeare*, ed. G. B. Evans et al. (Boston: Houghton Mifflin, 1974).

21. Hagstrum, p. 79.

22. Cited by Hagstrum, p. 58.

23. Ibid., pp. 69, 82, 86; also Anthony Blunt, "An Echo of the 'Paragone' in Shakespeare," *Journal of the Warburg and Courtauld Institutes* 2 (1938-39): 260-62.

24. Discussed in full in Barkan, "Living Sculptures."

25. Lee, pp. 23-32, 60. See the notable experiments of Titian, appropriately dubbed *poesie*, considered in this light by David Rosand, "*Ut Pictor Poeta*: Meaning in Titian's *Poesie*," *New Literary History* 3 (1972): 528-46.

26. Michael Baxandall, *Giotto and the Orators* (Oxford: Clarendon Press, 1971), pp. 97, 121; John Spencer, "*Ut Rhetorica Pictura*," *Journal of the Warburg and Courtauld Institutes* 20 (1957), 26-44; Creighton Gilbert, "Antique Frameworks for Renaissance Art Theory," *Marsyas* 3 (1943-45): 187.

27. For discussion of the significance of the "virtuous style" in art, see Peter Parshall, "Camerarius on Dürer — Humanist Biography as Art Criticism," in *Joachim Camerarius (1500-1574)*, ed. Frank Baron (Munich: Fink, 1978), pp. 11-29, esp. pp. 15-19.

28. Lee, pp. 11-13.

29. Ibid., pp. 34-41.

30. Ibid, pp. 17-19, 28-32; Nikolaus Pevsner, *Academies of Art, Past and Present* (Cambridge: Cambridge Univ. Press, 1940); an early prototype was the Academy of St. Luke, founded in Rome by Federigo Zuccaro, or the less formal "Academy" of the three Carracci brothers in Bologna during the 1590s; cf. Charles Dempsey, "Some Observations on the Education of Artists in Florence and Bologna during the later Sixteenth Century," *Art Bulletin* 62 (1980): 552-69.

31. Lee (pp. 11, n. 41; 17, n. 68; 12) discusses the emulation of antique literary models.

32. Ibid., pp. 9-16; Joel Snyder, "Picturing Vision," p. 526, lays proper stress on Alberti's powerful effect on his viewers, giving visual (mental) images a new, pictorial form.

33. Hagstrum, pp. 11, 62-64.

34. Quoted from *English Literary Criticism: The Renaissance*, ed. O. B. Hardison (New York: Appleton-Century-Crofts, 1963), pp. 60-61.

35. Ibid., p. 111.

36. Ibid., p. 105.

37. Ibid., p. 106.

38. Ibid., p. 107.

39. Ibid., pp. 129-30.

40. Ernst Gombrich, "Icones Symbolicae," in *Symbolic Images* (London: Phaidon, 1971), pp. 139-45; D. J. Gordon, "Ripa's Fate," in *The Renaissance Imagination*, ed. Stephen Orgel (Berkeley and Los Angeles: Univ. of California Press, 1975), pp. 51-74; Emile Mâle, *L'art religieux après le Concile de Trente* (Paris: Colin, 1932), p. 383. A modern translation of Ripa has been edited by Edward Maser: Cesare Ripa, *Baroque and Rococo Pictorial Imagery* (New York: Dover, 1971).

41. Quoted by Gombrich, p. 139.

42. On Petrarch and the arts, Werner Weisbach, "Petrarca und die bildende Kunst," *Repertorium für Kunstwissenschaft* 26 (1903): 265-87; Adolfo Venturi, "Les 'Triomphes' de Pétrarque dans l'art representatif," *La Revue de l'art ancien et moderne* 20 (1906): 81-93, 209-21; Raymond van Marle, *Iconographie de l'art profane au Moyen-Age et à la Renaissance* (The Hague: Nijhoff, 1932), II, 111-30. For the theme of royal triumphs, see Roy Strong, *Splendour at Court* (London: Weidenfeld and Nicolson, 1973). For the English scene in particular, Sydney Anglo, *Spectacle, Pageantry, and Early Tudor Policy* (Oxford: Clarendon Press, 1969), and Frances Yates, *Astraea* (Harmondsworth: Penguin, 1975). For the seventeenth century, see Gordon, "Roles and Mysteries," in *The Renaissance Imagination*, pp. 3-23.

43. Erwin Panofsky, *The Life and Art of Albrecht Dürer* (Princeton: Princeton Univ. Press, 1955), pp. 172-81. Also comparable are the later developments of Habsburg ceremonies and art, discussed by Thomas Kaufmann, *Variations on an Imperial Theme: Studies in Ceremonial Art and Collecting in the Age of Maximilian II and Rudolph II* (New York: Garland, 1978).

44. Ilja M. Veldman, *Maarten van Heemskerck and Dutch Humanism in the Sixteenth Century* (Amsterdam: Schwartz, 1977), pp. 55-93, 124-41. Similar allegories and cycles are collected by Samuel Chew, *The Pilgrimage of Life* (New Haven: Yale Univ. Press, 1962).

45. A point suggested by Hagstrum, pp. 88-92, and developed in recent years by Stephen Orgel. See Orgel, *The Illusion of Power* (Berkeley and Los Angeles: Univ. of California Press, 1975); Orgel and Roy Strong, *Inigo Jones: The Theatre of the Stuart Court* (Berkeley and Los Angeles: Univ. of California Press, 1973); and three essays by Gordon in *The Renaissance Imagination*: "Roles and Mysteries," pp. 3-23; "Poet and Architect: The Intellectual Setting of the Quarrel between Ben Jonson and Inigo Jones," pp. 77-101; and "The Imagery of Ben Jonson's *Masques of Blacknesse and Beautie*," pp. 134-56.

46. Gordon, "Roles and Mysteries," pp. 3-23; "Rubens and the Whitehall Ceiling," pp. 24-50; Roy Strong, *Brittania Triumphans* (London: Thames and Hudson, 1981); Oliver Millar, *Rubens: The Whitehall Ceiling* (London: Oxford Univ. Press, 1958).

47. Jacques Thuillier and Jacques Foucart, *Rubens' Life of Marie de' Medici*, trans. Robert Wolf (New York: Abrams, 1973); Ingrid Jost, "Bemerkungen zur *Heinrichsgalerie* des P. P. Rubens," *Nederlands Kunsthistorisch Jaarboek* 15 (1964): 175-219; Otto von Simson, *Zur Genealogie der weltlichen Apotheose in Barock* (Strassburg: Heitz, 1936).

48. J. R. Martin, *The Decorations for the Pompa Introitus Ferdinandi* (London: Phaidon, 1972; Corpus Rubenianum Ludwig Burchard XVI); Elizabeth McGrath, "Le Declin d'Anvers et les décorations de Rubens pour l'entrée du Prince Ferdinand en 1635," in *Les Fêtes de la Renaissance III*, ed. Jean Jacquot and Elie Konigson (Paris: Editions Centre National de la Recherche Scientifique, 1972), pp. 172-86; McGrath, "Rubens's Arch of the Mint," *Journal of the Warburg and Courtauld Institutes* 38 (1974): 191-217.

49. Martin, pp. 49-56, cat. no. 3.

50. For these pictures, see Frans Baudouin, *Rubens* (New York: Abrams, 1977), pp. 247-59.

51. *The Letters of Peter Paul Rubens*, ed. Ruth Magurn (Cambridge, Mass.: Harvard Univ. Press, 1955), pp. 408-9 (no. 242); also cited by Gombrich, pp. 126-29; Gordon and Orgel, pp. 28-30.

52. Julius Held, *Rubens and the Book*, exh. cat., Williamstown, Chapin Library, 1977; J. R. Judson and Carl van de Velde, *Book Illustrations and Title Pages* (London: Harvey Miller, 1978; Corpus Rubenianum Ludwig Burchard 21).

53. Mario Praz, *Studies in Seventeenth-Century Imagery*, 2nd ed. (1939; Rome: Storia e Letteratura, 1964); Rosalie Colie, "Small Forms: Multo in Parvo," in *The Re-*

sources of Kind (Berkeley and Los Angeles: Univ. of California Press, 1973), pp. 32-67; Arthur Henkel and Albrecht Schöne, Emblemata Handbuch zur Sinnbildkunst des 16e. und 17e. Jahrhunderts (Stuttgart: Metz, 1967); William Heckscher and Karl Wurth, "Emblem, Emblembuch," Reallexikon zur deutschen Kunstgeschichte (Stuttgart: Druckenmüller, 1959), V, col. 88; Gombrich, pp. 160-67; Gordon and Orgel, "Roles and Mysteries," pp. 14-19. For handbooks of national emblem traditions, see Rosemary Freeman, English Emblem Books (London: Chatto and Windus, 1948), and John Landwehr, Dutch Emblem Books (Utrecht: Haentjens, Dekker, Gumbert, 1962). Also discussed by Hagstrum, pp. 94-98.

54. The essential studies on this topic have been written by Eddy de Jongh: Zinne-en Minnebeelden in de Schilderkunst van de zeventiende Eeuw (Amsterdam, 1967); Tot Leering en Vermaak, exh. cat., Amsterdam, Rijksmuseum, 1976; "Realisme en Schijn-realisme in de Hollandse Schilderkunst van de 17e Eeuw," Rembrandt en zijn Tijd, exh. cat., Brussels, Paleis van Schone Kunsten, 1971. Also basic are K. Renger, Die Sprache der Bilder, exh. cat., Braunschweig, Herzog Anton Ulrich-Museum, 1977; R. H. Fuchs, "Virtue Explained," in Dutch Painting (Oxford: Oxford Univ. Press, 1978), pp. 36-61.

55. Jan Emmens, Rembrandt en de Regels van de Kunst (Utrecht: Haentjens, Dekker, Gumbert, 1968); Seymour Slive, Rembrandt and His Critics 1630-1730 (The Hague: Nijhoff, 1953).

56. On hieroglyphs, see most recently Rudolph Wittkower, "Hieroglyphics in the Early Renaissance," in Allegory and the Migration of Symbols (London: Thames and Hudson, 1977), pp. 113-28; Erik Iverson, The Myth of Egypt and its Hieroglyphics in European Tradition (Copenhagen: Gad, 1961); George Boas, The Hieroglyphics of Horapollo (New York: Pantheon, 1950); Karl Giehlow, "Die Hieroglyphenkunde des Humanismus in der Allegorie der Renaissance," Jahrbuch der Kunsthistorischen Sammlungen der allerhöchsten Kaiserhauses 32 (1915): 1-232. The Neoplatonic intellectual background to imprese is surveyed by Gombrich, "Icones Symbolicae," and by Robert Klein, "The Theory of Figurative Expression in Italian Treatises on the Impresa," in Form and Meaning (New York: Viking, 1979), pp. 3-24. This alternative vision of the didactic, metaphoric emblem is what Gombrich calls the Aristotelian, rather than Neoplatonic, theory of metaphor, and he compares these emblems to Ripa's use of personifications (pp. 143, 160-68).

57. Hagstrum pp. 94-100, also pp. 112-20; Colie; Barbara Lewalski, "Protestant Emblematics," in Protestant Poetics and the Seventeenth-Century Religious Lyric (Princeton: Princeton Univ. Press, 1979), pp. 179-212. In addition to Lewalski's work, for English Protestant emblems see Ernest Gilman, "Word and Image in Quarle's Emblemes," Critical Inquiry 6 (1980): 385-410.

58. In addition to Lee and Pevsner, see Denis Mahon, Studies in Seicento Art and Theory (London: Warburg Institute, 1947).

59. Hagstrum, pp. 174-77; Holt, II, 164-65.

60. Hagstrum, pp. 134-40; Lee, pp. 58-60; Ronald Paulson, Emblem and Expression (Cambridge, Mass.: Harvard Univ. Press, 1975), pp. 48, 55-56.

61. Joseph Addison, Spectator nos. 411, 416; quoted by Lee, p. 58.

62. Dialogue on the Usefulness of Ancient Medals (1726), pp. 30-31; cited by Paulson, Emblem and Expression, p. 55.

63. This seventeenth-century descriptive trend was introduced in broader terms by Svetlana Alpers, "Describe or Narrate?" On optical devices, see Arthur Wheelock, "Carel Fabritius: Perspective and Optics in Delft," Nederlands Kunsthistorisch Jaarboek 24 (1973): 63-83; Walter Liedtke, "The 'View of Delft' by Carel Fabritius," Burlington Magazine 118 (1976), 61-73; Susan Koslow, "'De Wonderlijke Perspectyfkas.' An Aspect of Seventeenth Century Dutch Painting," Oud Holland 82 (1967): 32-56; Daniel Fink, "Vermeer's Use of the Camera Obscura," Art Bulletin 53 (1971): 493-505; Charles Seymour, "Dark Chamber and Light-filled Room: Vermeer and the Camera Obscura," Art Bulletin 46

(1964): 323-31; Heinrich Schwarz, "Vermeer and the Camera Obscura," *Pantheon* 24 (1966): 170-80. The device of the *camera obscura* is placed in context by Joel Snyder, "Picturing Vision," pp. 512-14.

64. Paulson, *Emblem and Expression*, pp. 35-78.

65. Ibid., "The Hogarthian Progress," pp. 35-47; Paulson, *Hogarth: His Life, Art, and Times* (New Haven: Yale, 1971).

66. Paulson, *Hogarth*, I, 146-54, 161-73.

67. Ibid., I, 450; II, 4, 392-93.

68. Roworth's observations are advanced in her unpublished lecture, "Hogarth's Art Theory and the Reform of Painting in England," which surveys much of the same ground as this essay, laying special stress on the normative position of Annibale Carracci in early seventeenth-century Italy. I am grateful to Professor Roworth for permission to consult her lecture prior to its publication.

69. Robert E. Moore, *Hogarth's Literary Relationships* (Minneapolis: Univ. of Minnesota Press, 1948); Ronald Paulson, "Life as Journey and as Theatre: Two Eighteenth-Century Narrative Structures," *New Literary History* 8 (1976): 43-58.

70. William Hogarth, *Autobiographical Notes*, quoted by Paulson, "Life as Journey," p. 57, n. 12, and compared there with similar thoughts by Addison from *Spectator* no. 86.

71. Paulson, *Hogarth*, I, 259-61.

72. Hagstrum, plates 4, 5a,b.

73. Paulson, *Hogarth*, I, 259-61.

74. Ibid., II, 258-62.

75. Ibid., II, 176, 165-68.

76. William Hogarth, *The Analysis of Beauty*, ed. Joseph Burke (Oxford: Clarendon Press, 1955).

77. Quoted by Holt, II, 268.

78. Holt, II, 261.

79. Paulson, *Hogarth*, II, 175.

80. William Hogarth, *The Analysis of Beauty*, ed. Burke, p. xiii.

81. Ibid., p. 209.

82. Moore, *Hogarth's Literary Relationships*, p. 57.

83. Moore, p. 68. For a sensitive awareness of Hogarth's satire as an analogue to his own, see Swift's verses from the *Legion Club*, quoted by Moore, p. 69: "Were but you and I acquainted, / Every monster should be painted."

84. Hogarth, *The Analysis of Beauty*, pp. xxv-xxvi; Paulson, *Hogarth*, II, 144-52.

85. Sir Joshua Reynolds, *Discourses on Art*, ed. Robert Wark (1959; New Haven: Yale Univ. Press, 1975), p. 51. Further references to this edition will appear within the text.

86. Wark, p. xxxii; Paulson, *Emblem and Expression*, pp. 83-85. See also Wendorf's essay below.

87. Hagstrum, pp. 221-22.

88. Ernst Gombrich, "Reynolds's Theory and Practice of Imitation," in *Norm and Form* (London: Phaidon, 1966), pp. 129-34, discusses the influence of the Rubens picture on another Reynolds portrait, *Three Ladies Adorning a Term of Hymen* (London, National Gallery). See also Edgar Wind, "Humanitätsidee und heroisiertes Porträt in der Englischen Kultur des 18. Jahrhunderts," *Vorträge der Bibliothek Warburg* (1930-31): 156-229; Wind, "Borrowed Attitudes in Reynolds and Hogarth," *Journal of the Warburg and Courtauld Institutes* 2 (1939): 183-85; Charles Mitchell, "Three Phases of Reynolds's Method," *Burlington Magazine* 80 (1942): 35-40. Also see Paulson, *Emblem and Expression*, pp. 80, 37-40.

89. Charles Mitchell, "Benjamin West's 'Death of Wolfe' and the Popular History Piece," *Journal of the Warburg and Courtauld Institutes* 7 (1944): 20-33; the quotation is

from p. 21. See also Wind, "The Revival of History Painting," *Journal of the Warburg and Courtauld Institutes* 2 (1939): 116-27, and "Benjamin West and the Death of Wolfe," *Journal of the Warburg and Courtauld Institutes* 10 (1947): 159-62.

90. John Dillenberger, *Benjamin West, The Context of His Life's Work, with Particular Attention to Paintings with Religious Subject Matter* (San Antonio: Trinity Univ. Press, 1977); Jerry Meyer, "Benjamin West's Chapel of Revealed Religion: A Study in Eighteenth-Century Protestant Religious Art," *Art Bulletin* 57 (1975): 147-65.

91. *Henry Fuseli*, exh. cat., London, Tate Gallery, 1975, with full bibliography.

92. Ibid., p. 44. The Fuseli essay was originally published in 1801.

93. Ibid.

94. Richard Hutton, *Alderman Boydell's Shakespeare Gallery*, exh. cat., Chicago, Smart Gallery, 1978, p. 12. Also Winifred Friedman, *Boydell's Shakespeare Gallery* (New York: Garland, 1976).

95. Quoted by Nikolaus Pevsner, "Hogarth and Observed Life," in *The Englishness of English Art* (Harmondsworth: Penguin, 1964), p. 31.

96. Hutton, *Shakespeare Gallery*, p. 9.

97. Ibid., p. 9; *Henry Fuseli*, pp. 42-3; Gert Schiff, *Johann Heinrich Füsslis Milton-Galerie* (Zurich: Fretz and Wasmuth, 1963); a specific discussion of the Chicago *Milton Dictating* appears in Schiff, pp. 110-11, 158, cat. no. 40.

98. *Henry Fuseli*, pp. 58-73, esp. pp. 72-73, including other designs after the plays.

99. Wark, p. 71 (Discourse IX), and pp. xviii-xxii.

100. *Henry Fuseli*, pp. 10, 39.

101. Ibid., p. 42.

102. Kristeller, pp. 208-24. This concept was certainly not without parallels in England and elsewhere. As Kristeller makes clear in his study of the modern notion of the "fine arts," this kind of separation between aesthetics and ethics can be traced in part to the English writings of Francis Hutcheson, then later developed in the writings of Hume, Diderot, and Kant.

103. Wark, p. xxvii. On Fuseli and the imagination, see Nicholas Powell, *Fuseli: The Nightmare* (New York: Viking, 1973).

104. See Addison's early remarks in *Spectator*, no. 411. Hagstrum, pp. 136-39, characterizes the development: "in the eighteenth century the locus has shifted from the work to the mind, from canvas and page to the imagination." Longinus' *Treatise on the Sublime* was translated into French by Boileau in 1674; in England its principal exponent was to be the same Burke who had isolated art from morality in *An Enquiry Concerning the Principles of Morals* (1751). Burke published his *Philosophical Enquiry into the Origin of our Ideas of the Sublime and Beautiful* in 1757. For recent scholarship on the sublime see the following: Samuel Monk, *The Sublime* (Ann Arbor: Univ. of Michigan Press, 1960); W. J. Hipple, *The Beautiful, the Sublime, & the Picturesque in Eighteenth-Century British Aesthetic Theory* (Carbondale: Southern Illinois Univ. Press, 1957); Andrew Wilton, *Turner and the Sublime* (London: British Museum, 1980). For later American painting, see the work of Earl A. Powell, "Luminism and the American Sublime," in *American Light*, ed. John Wilmerding (Washington: National Gallery, 1980), pp. 69-70.

105. Wark, p. 276.

106. *Henry Fuseli*, p. 45.

107. Lee, p. 68.

108. Barbara E. White, "Delacroix's Painted Copies after Rubens, ' *Art Bulletin* 49 (1967): 37-51; *Rubenism*, exh. cat., Providence, Rhode Island School of Design, 1975, pp. 241-73.

109. Summarized by Angus Fletcher, *Allegory* (Ithaca: Cornell, 1964), pp. 15-19.

110. Howard Vincent, *Daumier and his World* (Evanston: Northwestern Univ. Press, 1968), pp. 101-9.

111. Vincent, p. 105. The ambition of Romantic poets to avoid imitation of painting is a doctrine discussed in context by Roy Park, "'Ut Pictura Poesis': The Nineteenth-Century Aftermath," *Journal of Aesthetics and Art Criticism* 28 (1969): 155-64.

112. Hagstrum, p. 317.

THE GROUNDS OF
MIMETIC AND NONMIMETIC ART
The Western Sister Arts
in a Japanese Mirror

Earl Miner

> Wer den Dichter will verstehen
> Muss in Dichters Lande gehen;
> Er im Orient sich freue
> Dass das Alte sei das Neue.
> —Goethe, *West-Östlicher Divan*

The concept of the sister arts is familiar to us as a way of relating the "speaking picture" of poesy to the "silent poetry" of painting.[1] What is familiar seems clear, something to be presumed without further question. But just what kinds of claims are being entered? What is the nature of these long-standing Western presumptions? To deal as it were with the prior assumptions of the familiar, one of the most useful procedures is alienation: the bringing to bear on the familiar of what differs but is comparable. The alien factor made use of in what follows is a late eighteenth-century Japanese work combining successive frames of pictures and story. This alienation may tell us something about the nature of mimetic art—and also something about the nonmimetic kind used to alienate what is familiar.

The work, *Edu Mumare* (pron. "Umare" or "N'mare") *Uwaki no Kabayaki*, appeared in Edo, now Tokyo, in 1785, brought out by the publisher Tsutaya Jūzaburō (who also published later editions with somewhat different pictures, as was usual). In its end (see figures, Episode 22), it specifies the author of the story as (Santō) Kyōden and the artist of the pictures as Kitao Masanobu. The work appeared

in three thin fascicles, each with its yellow cover (see figure 4-1). The yellowness assigns the work to one in a series of kinds of little books that began to appear toward the end of the seventeenth century. The successively different colors of the covers—red, black, green, yellow—reflected fashions in popular fiction and indicated certain subjects and styles appropriate to each. The yellow books flourished from about 1770 to about 1805, appearing at New Year's time. They were small, on the order of four inches wide and just under six inches tall. The publisher, best known then by the abbreviation or nickname Tsutajū, would print the volumes from wooden blocks. (The publisher's insignia, an ivy-with-mountain device, will be found at the top of the first cover as well as of figure 4-2.) Each block had been carved with the narration of a given episode and a picture illustrating something striking in it. For such books the two arts were not so much sisters as Siamese twins.[2]

Before concerning ourselves with the story and the issues posed by combined arts of story and picture, something must be said about the author and the artist. Their names are "styles" rather than names in the Western sense. The designation, "Santō Kyōden," is a name or style of a writer of fiction. It means something like Mountain-East Capital-Teller. Another author-artist took the style Koikawa Harumachi (Love-River Spring-Town). The name of the artist, Kitao Masanobu, is a style derived from tutelage to a master artist, Kitao Shigemasa (1739-1820). In a common fashion of deriving names from a parent or styles from a master, Kitao Masanobu took on the surname, Kitao, and adapted *Masa*nobu from Shige*masa*. It must be emphasized that the author, Santō Kyōden, and the illustrator, Kitao Masanobu, are one and the same physical, historical self. But what if the concept of "self" is not ours? Few Japanese at the time knew, and even fewer now know or care, that the name of the historical individual was Iwase Sei (surname, then given name, in Japanese order), who lived from 1761 to 1816. We do not look up Iwase Sei in literary reference books, but Santō Kyōden, and in pictorial references, Kitao Masanobu. Under his name as an artist, he illustrated stories by such another as Koikawa Harumachi (1744-89), who sometimes illustrated his own books and sometimes those of others. Santō Kyōden wrote a number of books. Moreover, he used such other names as Rissai and Seisai (the "Sei-" being that of the Chinese character of his formal name given as an adult—he had another as a boy). For that matter, under the name Kyōya Denzō, he prospered

as a merchant. If, in an Edo room with many people in the late eighteenth century, we called for Kyōden, Masanobu, Kyōya Denzō, Rissai, Seisai—and Iwase Sei—to appear, only one individual would step forth.

It is not that book illustration is confined to Japan. Hogarth illustrated *Hudibras* in two sets of pictures, and he did independent work of narrative pictorialism such as *The Rake's Progress* (see figure 4-14). "Phiz" illustrated Dickens. But if we called out their names, different people would appear. Thackeray might indeed illustrate his novels, but not under another name. No doubt there is some Western example of an individual who was accomplished both in pictures and in writing and who wrote and drew under different names. But what I grant is possible in the West has many actual instances in Japan. A differing conception of the artist, indeed of selfhood, and therefore of arts and their nature is obviously involved.

To account for such matters, one must turn to *Edo Mumare*. The title itself is a mild joke. The best translation I know of is *Grilled Playboy, Edo-Style*.[3] "Edo Mumare" is a deliberate archaism for "Edo Umare," born in Edo. "Kabayaki" is the Edo style of grilling eels for serving them on rice. "Uwaki" is well rendered as "playboy," meaning a dashing man who is a frequenter of the Edo pleasure-quarters, the licensed district for courtesans. In particular, "Uwaki" means a man who, in Kyōden's time, was fashionable to the point of being up-to-the-minute in this knowledge of a whole, almost arcane set of customs, details, and expectations. And so on to the story.

The mock-hero is one Enjirō, a millionaire's son, a point established in the first sentence, since one had to command wealth to pay the extraordinary prices charged by geisha of real standing. Enjirō is identifiable in the pictures by the "En" he has to mark his sleeves and by his absurd nose. (The man shown on the cover of the first volume has a different nose, body, and character: to express a more experienced hero? a salacious story? what Enjirō aspires to be?) At one point, Kyōden refers to Enjirō as Peony Nose. In fact, Masanobu had been drawing such noses earlier. When the feature became popular in subsequent years, the author became known as Kyōden the Nose—so far did concepts of artists, author, and characters overlap, and did this person acquire yet another name.

Enjirō's ambition to become notorious as a playboy is engendered by plays read at home or seen on the stage. We hear little of books after the first episode (although we see evidence of them in pictures).

Clearly Enjirō is stage-struck, in the sense of wishing to play a role. Having decided to cut such a figure, he consults with two young men who live nearby. One is Kitari Kinosuke ("Kitari" means nothing other than the Yoshiwara quarters) and Warui Shian ("Warui" means "evil" or "bad," and "Shian" means something like "schemes"). Kinosuke tells Enjirō that he must know the songs currently popular from plays set in the licensed quarters. In a Rabelaisian catalog, he mentions more than sixty-five such songs, adding that there are others, but that these will do for a start.

The climax comes when Enjirō buys his woman out of her service in a Yoshiwara house and, like a tragic love hero of the stage, takes her off to commit a double suicide (figure 4-10, Episode 19). This is got up in the story with a formal *michiyuki* or travel-piece such as was recited on the puppet stage. There is, however, room for anti-climax. Enjirō makes sure that he does not take a dangerous sword, and arranges with Kinosuke and Shian that they will rush in at the signal of certain words to prevent the disaster. Much to the surprise of Enjirō and his Ukina ("Scandal"), instead of Kinosuke and Shian two ruffians charge them and steal all their clothes except Ukina's petticoat and Enjirō's ten-yard long silken loincloth (figures 4-11 and 4-12, Episodes 10, 21).

The nature of the plot can be represented by a few episodes from Enjirō's ridiculous quest. A real playboy must be tattooed, even if it hurts (see figure 4-4, Episode 3.) No matter how he tries to keep his affairs hidden, he must become notorious throughout the town. So Enjirō hires a news-vendor to shout his name in the headlines, as it were, and even to distribute the gossip sheets free (figure 4-5, Episode 6). He learns from plays that an uwaki has at home a woman jealous of his fickleness and nocturnal excursions, so he hires a woman from the quarters to act out resentment (figure 4-6, Episode 9). Hearing that he should buy a fancy lantern for the house in which his favorite courtesan is kept, he ineffectively tries to do so (figure 4-7, Episode 13). Since he hears that an uwaki arouses the jealousy of other playboys, who hire bullies to beat him up, he dutifully hires his own two toughs to pummel him (figure 4-8, Episode 14). A playboy's parents should tire of his dissolute, spendthrift ways and threaten him with disinheritance. On the stage, the indulgent mother typically pleads with the angry father not to take such drastic action. Here, Enjirō gets his mother to intercede with his father to *disinherit* him—but for only ninety days (figure 4-9, Episode 15).

Making their way to his house, Enjirō huddles under covers for warmth and Ukina worries over herself (figure 4-13, Episode 22). He seems, finally, to listen to Father's prudential talk: a certain amount of imprudence can be expected from the young, but there comes a time, etc.; you must part from Kinosuke and Shian; there is such a thing as the way of the world. Enjirō's last comment can be read in a couple of ways. I take it to mean that he is going to send off the mistress he had hired to be jealous of him at home (we had not heard of her this while); and he will settle down with Ukina. The sequence of the ending is marvelously if not exactly like that at the end of *Paradise Lost*; here the authority-figure speaks his last speech; then the hero; and at last the heroine. What does Ukina say? "I've caught an awful cold." A Japanese Gullible's Travails?[4]

We discover here a real sense of beginning and a fine, deflated comic ending. In between, many of the episodes could be arranged differently, and there is little sense, if any, that one begets or causes another. This is no Aristotelian plot (although the work is indebted in many ways to the drama of the time). In addition, within an episode, a distinct break usually occurs between the narration at its beginning and the dialogue that follows. The proportion of one to the other varies, with dialogue predominating after the opening. On the woodblock texts, the distinctions may be shown by a break in the lines of writing or in positions in the illustration. But there is no punctuation and nothing like an "Enjirō said." Whether the narrator or a character is talking seems to make less difference than what is being talked about. Finally, any single element differs from others less than it connects with them in a relational whole, an ensemble.

The concept of the ensemble of words-pictures deserves special emphasis, because certain features of our entire understanding of the issues involved depend on the implications of the fact. For one thing, words and pictures are not distinct, discrete elements. In Episode 6 (figure 4-5) when the gossip-mongerer hawks his story of the would-be playboy, what he says in the words is reflected pictorially on the newssheet in his right hand. And what the woman says (this is good-for-nothing, and not worth reading if it is free) is reproduced by the writing just under the window from which she looks.

In Episode 2 (figure 4-3) Enjirō consults with Kinosuke and Shian. Behind Enjirō to the right is a book box labeled:

$$\text{The Tales of} \quad \begin{cases} Genji \\ Ise \end{cases}$$

These two great classics involve heroes who are, among other things, famous lovers, men who in their world of the court nobility do not need to resort to the silly dodges of a present-day rich townspeople's pampered son. In other words, an important literary allusion is supplied by a detail of the picture done by Kitao Masanobu rather than the text by Santō Kyōden.

Behind Shian and Kinosuke is a framed and standing picture— a picture within a picture, more of the *mise en scène*. Although drawn of course by Masanobu, artist of the pictorial part of *Edo Umare*, the writing says, "Painted by Hanabusa Itchō." A real painter (1652-1724), founder of the Hanabusa school, used that name. Well known for his depictions of flora, fauna, and human figures, he was regarded in his time for other things—as a poet, for example. But the picture given here alludes to his fame as a painter of King Emma, ruler of the Buddhist Hell. It is Emma shown here, looking on a scroll. Now in the slang of the time, "Hell" ("jigoku") referred to one kind of whore and to that very Yoshiwara at which Enjirō wishes to make a name as he now consults his wicked neighbors. Just what Emma is meant to be doing in the picture is not clear. The best guess is that he is making certain that the names of the young men in front of him are on his list of sinners. As Kyōden and others knew, Itchō had been a familiar of the Yoshiwara, as the person called Kyōden was, for that matter. The ironies cut many ways, with Itchō's and Masanobu's (or Kyōden's, or whoever?) names also on Emma's list. Of course such speculation begins to collapse differing levels or rival depictions of life—something we are no doubt being teased into doing, to a point.

Episode 9 (figure 4-6) will furnish a last example. Behind Enjirō is a kind of placard with four large Chinese characters and three smaller ones. The gist of the writing is:



DO NOT URINATE HERE

By Kazan



The characters for "Kazan" mean "flower-mountains," but they also designate a royal name, since Kazan reigned 984-86. In fact, the placard alludes to a famous stanza by the gifted haikai poet, Takarai Kikaku.[5]

Kono tokoro	In this location
shomben muyō	refrain from urinating
hana no yama	a mountain of flowers

That is, the whole mountain or hill is covered with cherry trees in blossom. (In Kazan's time, the simple mention of flowers would have meant plum blossoms.) "Hana no yama" uses the same characters as "Kazan," giving them their Japanese readings and joining them by the possessive particle *no*. This talk of urinating, moreover, is worked into Kyōden's dialogue, the literary "text," by use of a proverb of the time—as Enjirō seeks to hire the woman to stay home and be jealous of the other women he buys.

It should be obvious that this is not mimetic art. For mimesis, we require a reasonably stable sense of what is art, what is nature, who is the artist—and a definable relation betewen them. No such problem exists in Hogarth's *Hudibras* (he is in fact an excellent critic of what is important in the poem) or in Phiz's illustrations of Dickens. Their pictures can be shown to have subtle touches and even emblematic features, but we are always aware of the separate realms of the two sister arts and of their connections to presumed reality. There is never confusion or even leakage between them. We *know* who Hogarth or Dickens is. Our story much more resembles something by Jorge Luis Borges, who sets about deliberately to undermine mimetic presumptions. His motive for this is clear in one of his fine remarks: "The world, alas, is real; I, alas, am Borges."[6] When it is no longer possible to presume the reality or accessibility of the world (which is of course what Borges really means) or of the self (which is what he says), then mimesis is infeasible. Suppose such a sentiment to have been written by one of the Japanese we have been considering: "The world, alas, is real; I, alas, am ————." But who? Santō Kyōden, Kitao Masanobu? Kyōya Denzō? Iwase Sei? Or some other name or style he possessed? It is the essence of a name to give one social existence. Lacking names for people, Donne's poems are far more radically private than are Jonson's, which include names in titles and poems, and refer to relationships such as "my first son." The problem with the Japanese instance is that so many names exist that overdetermination creates doubt as to what or whom we are speaking of: unless we assume a relative, functional connection in an ensemble.

There is more than one way to account for the nonmimetic quality of *Edo Mumare* and indeed of traditional Japanese assumptions about aesthetics. One way might employ currently fashionable Western ideas.[7] *Edo Mumare* may well seem to call for a deconstructive analysis, to show the untrustworthiness of assumptions about the relation of verbal or pictorial "languages" to anything other than themselves or, perhaps, the joined verbal-pictorial language of the work. In this view, we would take the work as a kind of casebook example of "écriture," "textuality," and certainly also of "intertextuality" as we observe the play between word and picture, picture and word, words on a picture within a picture, allusion, etc. In the end, we have only "reflexivity." The "language" refers only to itself (or the "languages" refer also to each other, if we posit both a pictorial and a verbal). In any event they do not refer to reality.

Such an explanation of *Edo Mumare* has the virtue of making clear its nonmimetic character. I for one see nothing of Aristotle's universals, of abstract Truth, or of Morality in the work. But various considerations lead me to reject the "post-modernist" view. To begin with, I see both a logical and a historical difference between the *anti*mimetic nature of "post-formalist" criticism and a *non*mimetic artistic and literary tradition. Never having supposed the necessity for mimesis, Japanese never had to oppose it. In fact they could not attack or undermine a concept they neither knew nor needed.

Many other considerations can be discussed, of which the central and the most difficult for a Westerner to understand is this: although nonmimetic, *Edo Mumare* is perfectly assured art as far as referentiality is concerned. The pictures show the architecture of the time accurately. Women's kimono have the widened sleeve ends of the time rather than the straitened ones of a generation or so before. In the first frame, Enjirō is reading how to be a playboy while smoking a pipe of the right design and length for the time; near him are a then fashionable tobacco tray, along with a charcoal brazier and a lamp precisely like those known to have been in use then. Similarly, the many songs whose titles Kinosuke gives Enjirō are actual songs from plays. The dialogue is current, with its representation of Edo talk—man's talk, women's talk, mother's talk, male friend's talk—slang, dialect, faddish terminations. The degree of plain-speaking would have given Richardson apoplexy and was

impossible even for Fielding. The ninth episode begins: "Although Enjirō went about buying prostitutes. . . . " In some sense of a term difficult to use responsibly, *Edo Mumare* is "realistic" without being mimetic; it is referential without Western presumptions of what referentiality means, and without Western techniques of referring. To sort out these matters, we shall have to consider both details and general features of two different aesthetic systems, using each to alienate the other in the hope of understanding both more fully.

Systematic views of literature and of the other arts seem to arise from encounter by a major critical intelligence with a contemporaneously esteemed genre.[8] Aristotle's esteemed genre was clearly drama, and it is natural that representation, mimesis, would therefore constitute his systematic view of literature and the other arts. As far as can be determined, however, the Western view is not shared by other critical systems throughout the world, all of which appear to derive by definition from lyric.

In Japan, criticism is founded on an affective-expressive system. (Such matters as technical skill and sophistication were assumed.) The poet is affected by things in the world or in the heart or the mind (in response to the world and human affairs) and so expresses in words the nature of the affective arousal. It was further presumed that the expression would move its reader and perhaps lead to another expression. Although its vocabulary may seem alien to our critical language, the Preface to the *Kokinshū* by Ki no Tsurayuki (868-945; ca. 905-20) makes these matters clear.

> The poetry of Japan takes the human heart as seed and flourishes in the countless leaves of words. Because human beings possess interests of so many kinds, it is in poetry that they give expression to the thoughts of their hearts in terms of the sights appearing before their eyes and the sounds coming to their ears. Hearing the warbler sing among the blossoms and the frog that lives in the waters—is there any living thing not given to song? It is poetry that, without exertion, moves heaven and earth, stirs the feelings of divinities and spirits invisible to the eye, softens the relations between men and women, calms the hearts of fierce warriors.

As we bear this in mind, we may recall that Aristotle compared poetry favorably to history. The degree of favor is really less important than the premise that both poetry (literature) and history are classes of *knowledge*. Only on that presumption is Aristotle able to perform his logical analysis of the "parts" of a play, or

distinguish between the means and the end of imitation, etc. We need not pursue the matter fully, but in fact in Japan as in China the concept of literature (at least of *bun*, Chinese *wen*) included history, which was, after lyricism, the prime exemplar, much as Aristotle concerned himself even more extensively with drama but also pays some attention to epic. If the Japanese presumed that literature was one kind of knowledge, they thought in particular that it was moving, affective human expression. If Aristotle presumed that poetry moves people, he thought more typically that it was an imitation, because what moved was not to him a radical *differentia*; after all, the philosophy of the Academy and the rhetoric of the Sophists also moved people.

The resemblances and differences require, in more than one sense, a Psyche's effort to sort out, but in terms of the assumption that knowledge moves us or that we wish to know what moves us, there is a correspondence between the prior assumptions of the two literary systems that is greater than that between the systems themselves. That is, both the mimetic and the Japanese view assume that the world the poet considers, including other people, is knowable. If it cannot be known, it would not move the Japanese poet in the heart-mind-spirit (*kokoro*). If it cannot be known, no Western poet could imitate it. Such aesthetic realism (whether as in the reasoned philosophical position or as in naive realism) is something very different from idealism, nominalism, or assumptions about a meaningless world. The comforting nature of the realistic premise no doubt helps explain why the traditional Western and Japanese systems have endured so long against efforts at various times to reject the system when some individuals found the realistic premise unacceptable.

Aristotle and Tsurayuki are at one in the realistic assumptions, even if they hold it on grounds that differ. A major difference betokening another contrast of underlying principles in these aesthetic systems will be found in the method employed by the two critics. Aristotle's obvious intent is to break the whole into constituents, to analyze, anatomize parts. He needs to find out, as it were, what it is that mimesis holds together, what it works out in his much-prized actions. Tsurayuki's obvious intent is to join different entities into shared motives, to bring together, synthesize, relate. He needs to find out, as it were, what the affective-expressive system joins from entities that might be considered discrete in another view.

So he posits an ensemble of relationships that ranges from frogs to divinities. The frog is a singer itself and therefore stirs human hearts or minds; the divinities are stirred by human expression and are given to composing poems themselves. Without reciprocity or relation, there is only suffering or meaninglessness, as an anonymous old Japanese poem suggests.



Yuku mizu ni	More yet than writing
kazu kaku yori mo	numbers upon flowing water
hakanaki wa	is the emptiness
omowanu hito o	of longing for a person
omou narikeri.	who does not love one in return.[9]



"Hakanaki" has a wide range of meanings (dead, tenuous, sad, unreliable, unreal, without meaning, inexplicable, empty, trivial), all of which give us some sense of what is lost when relation cannot be presumed. Similar kinds of "emptiness" arise in modern Western literature when the presumptions of mimesis no longer seem valid.

Not that mimesis and its counterparts in other systems undergo no change. Emphases may vary drastically as old principles are applied to new experience. So it is that in a major pronouncement on the sister arts, Dryden both affirms Aristotle on the issue of imitation at the crucial point and adjusts him to what every generation thinks of as its modern need. The passage from his "Parallel Betwixt Poetry and Painting" is somewhat lengthy, but it sets forth the traditional Western views with a degree of explicitness for which another example is far to seek.

> The imitation of nature is therefore justly constituted as the general, and indeed the only, rule of pleasing, both in poetry and painting. Aristotle tells us that imitation pleases, because it affords matter for a reasoner to inquire into the truth or falsehood of imitation, by comparing its likeness or unlikeness, with the original. But by this rule, every speculation in nature whose truth falls under the inquiry of a philosopher [scientist], must produce the same delight, which is not true. I should rather assign another reason. Truth is the object of our understanding, as good is of our will; and the understanding can no more be delighted with a lie than the will can choose an apparent [glaring] evil. As truth is the end of all our speculations, so the discovery of it is the pleasure of them; and since a true knowledge of nature [*res naturae*, reality] gives us pleasure, a lively imitation of it, either in poetry or painting, must of necessity produce a greater. For both these arts, as I said before, are not only true imita-

tions of nature, but of the best nature, of that which is wrought up to a nobler pitch.[10]

We observe that Dryden makes use of Western faculty psychology, especially of reason (or understanding) and will, emphasizing truth and good, distinct abstractions (as the artist's imitation and nature are also discrete, abstract counterparts). His discrete entities, his abstractions, his concern with Truth and Good are so rare as almost to be nonexistent in Japanese critical discussions. Given such radically different presumptions, we shall understand the terms on either side only by concern with comparable passages.

Like Dryden in his "Parallel" and elsewhere, Aristotle had an interest in comparing literature to painting. The poet is, he says, "just like the painter or other makers of likenesses."[11] Aristotle is well aware that imitation by words is very different from imitation by colors and forms (ch. 1; pp. 624-25) or other means, but in addition to the passage quoted from, several others are of importance, including this:

> And it is also natural for all to delight in works of imitation. The truth of this second point is shown by experience: though the objects themselves may be painful to see, we delight to view the most realistic representations of them in art, the forms for example of the lowest animals and of dead bodies.[12]

There happens to be a Japanese passage that corresponds well to this last by Aristotle and yet differs so much as to give us some insight into the presumptions that underlie Western and Japanese systematic concepts. The remarks come in the first part of *Naniwa Miyage*, reporting ideas about drama enunciated by Chikamatsu Monzaemon (1653-1724). Once again, the quotation is lengthy, but its pertinence will be clear.

> Art is that which occupies the narrow margin between the true and the false. . . . It participates in the false and yet is not false; it participates in the true and yet is not true; our pleasure is located between the two. In this connection, there was a lady serving at the palace who developed a passionate relation with a certain lord. The lady's chamber was in the depths of a splendid apartment, and since he was unable to enter there [probably because it belonged to the high-born lady whom she attended], she only had a look at him from time to time through a gap in the blinds. So great was her yearning for him that she had a wooden image of him carved. The countenance and other features differed from those of usual

images in representing the lord to a cat's whisker. The coloring of the complexion was indescribably exact, each hair was in place, the ears and nose and the teeth in their very number were faultlessly made. Such was the work that if you placed the man and the image side by side the only distinction was whether one or the other had a soul. But when she regarded it closely, the sight of a living person exactly represented so chilled the lady's ardor that she felt distaste at once. In spite of herself, she found that her love was gone, and so unpleasant was it to have the model by her side that before long she got rid of it. As this shows, if we represent a living thing exactly as it is, for example even [the legendary Chinese beauty] Yang Kuei-fei herself, there would be something arousing disgust. For this reason, in any artistic representation, whether the image be drawn or be carved in wood, along with exact resemblance of the shape there will be some deviance, and after all that is why people like it. It is the same for the design of a play—within recognizable representation there will be points of deviance . . . and since this is after all the nature of art, it is what constitutes the pleasure people take in it.[13]

Where could we find a more complete rejection of the delight Aristotle contemplated in exact representation of a cadaver? It is an extraordinary, mirror-image and negative version of the Pygmalion story, detail by detail. If we can trust his story of Pygmalion in *Metamorphoses*, 10, Ovid would have been astounded.

The most remarkable feature of Chikamatsu's remarks is that they come in discussion of drama. Discussions of art in Japan are usually just nonmimetic, but here one of Japan's greatest dramatists is openly antimimetic. An earlier dramatist, Zeami (?1364-1443) did indeed write of the importance of imitation (*monomane*) in his early *Fūshikaden*.[14] But he was then most concerned with expressing his father's ideas derived from a career as actor and producer. When he wrote on his own, Zeami anticipated Chikamatsu in holding that (for example) merely hobbling along like an old man gave no artistic version of old age for the theater. He accommodated representation to the affective-expressive poets by hypostasizing his ideal of normative theatrical art, or art of all kinds, in his favorite symbol, the "flower" (*hana*).[15] Japanese critics have shunned imitation when we might have most expected them to embrace it. Aristotle's kind of realistic imitation is not their way. Although they would have treated his principle of representing universals with more respect, they would have related it to their traditional lyric idea of essential nature (*hon'i*). Chikamatsu's concept of deviance from exact representation,

like Zeami's symbolic flower, is something that rises from the countless leaves of words that Tsurayuki says find the human heart as seed (or cause), and it is not without significance that Chikamatsu uses the same word (*tane*, seed or cause).

Although it is difficult to maintain a cool impartiality in treating such crucial literary issues when disagreement runs so high, I hope that I have represented both views fairly. If the foregoing may have seemed to give Japanese views greater play, here is a passage from Aristotle, not the most memorable perhaps, but one that every reader of this essay will think quite characteristic of the master — and perhaps also quite correct.

> The truth is that, just as in the other imitative arts one imitation is always of one thing, so in poetry the story, as an imitation of an action, must represent one action, a complete whole, with its several incidents so closely connected that the transposal or withdrawal of any one of them will disjoin and dislocate the whole. For that which makes no perceptible difference by its presence or absence is no real part of the whole.[16]

I do not know how to argue for "the whole" in *Edo Mumare* on the basis of this presumption. Episodes could be rearranged, as has already been said. Kyōden's plot is of a kind that Aristotle as well as we could call episodic.

> Of simple Plots and actions the episodic are the worst. I call a Plot episodic when there is neither probability nor necessity in the sequence of its episodes. Actions of this sort bad poets construct through their own fault, and good ones on account of the players.[17]

Mimesis is, then, not only founded on the prior assumption that the world is knowable and imitable — an assumption shared in nonmimetic terms by Japanese. It is also an ordering, tidying system, using logic — and morality. This idea comes through in a striking way throughout the *Poetics*, particularly in a passage on characters, not often selected for attention.

> In connection with the characters, there are four things one should aim at. First, and most important, that they be good. Now they will have character if in the way already mentioned their speech or their action clearly reveals a moral choice (whatever it may be), and good character if a good choice. But goodness exists in each class of people: there is in fact such a thing as a good woman and such a thing as a good slave, although no doubt one of these classes is inferior and the other, as a class, is worthless.[18]

It is a matter of no little interest that we are shocked morally by remarks dealing with morality. Do we not find it possible to forgive Kyōden his indecencies and comic world?

Renaissance views of Aristotelian imitation (normally dyed by neo-Horatianism) also held to moral, philosophical, and rhetorical presumptions. The presumptions include such ideas as the Great Chain of Being that some literary students have been so sentimental about. That was a lovely enough scheme, no doubt, provided you happened to be adult, male, wealthy, and socially secure. It is part of the Great Chain that children obey parents, wives husbands, inferiors their superiors by birth. Such are the pits in the dark side of the mimetic moon. They do not alter the truth that it may shine with beauty, or that moral matters are among those thought most affecting by the human race.

In this respect, Japanese affectivism, as we can see from *Edo Mumare*, might also be thought problematic or even downright deficient. That is, the affectivism in the Japanese critical system differs not merely from the Horatian, with its teaching as well as delight, but also from the Chinese and Korean, which presume moral as well as aesthetic, emotional moving. The continental presumptions were founded on a Confucian order that was imported to Japan but did not influence writers as it did the officials of a repressive regime. It is striking and illustrative that the poets seldom show the slightest interest in Confucianism, that a Confucian moralist like the writer of prose narrative Kyokutei Bakin (1767-1848) is such a rare exception, and that the very different Buddhist ethic should have permeated Japanese thought in ways that it did not Chinese or Korean.

The negatives tell us less than the positive features we descry. Mimesis has lasted so long because it combined with the aesthetic certain philosophical, moral, and rhetorical matters—as well as because it provided useful underpinning for certain kinds of social order. It offers a realist philosophy—the world is real, knowable, imitable—whose importance can hardly be stressed enough. As for the moral and rhetorical, Aristotle shows in chapter 2 how they can be combined:

> The objects the imitator represents are actions, with agents who are necessarily either good men or bad—the diversities of human character being nearly always derivative from this primary distinction, since the line between virtue and vice is one dividing the whole of mankind. It follows, therefore, that the agents represented must be either above our own level

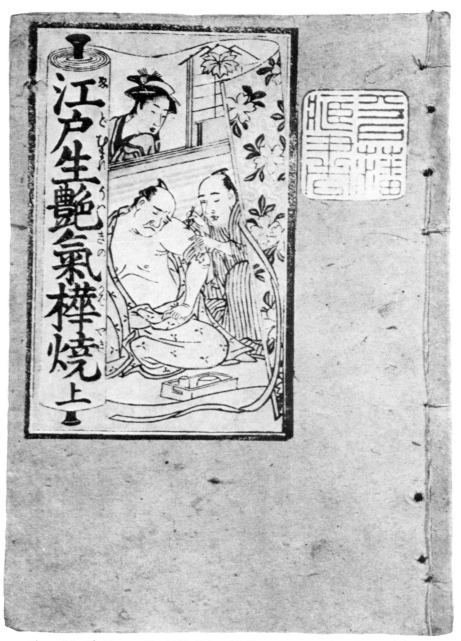

Figure 4-1. Edo Mumare Uwaki No Kabayaki. The cover, approximately actual size, of the first fascicle of three. This shows a man, who does not look like Enjirō, being tattooed (see Episode 3). The title is given in the scroll design to the left. Between the picture and stitching of the binding to the right is an owner's seal. *Note:* episode numbers derive only from modern editions but fairly represent the original.

Figure 4-2. Edo Mumare, Episode 1. Enjirō's reading of plays makes him wish to cut a figure as a playboy.

Figure 4-3. Edo Mumare, Episode 2. Kinosuke, shown to the left with Shian, tells Enjirō the tunes he must learn to be thought a proper playboy by the town.

Figure 4-4. Edo Mumare, Episode 3. Enjirō is tattooed as his initiation into life as a playboy.

Figure 4-5. Edo Mumare, Episode 6. Learning that a playboy should have his secret amours become town gossip, Enjirō hires a news-vendor to broadcast his name and distribute scandal sheets free. The woman in the window is not interested.

Figure 4-6. Edo Mumare, Episode 9. Learning that a playboy should have a wife who resents his amours, Enjirō hires a woman from the licensed quarters to stay at his home and fret. The placard in the upper left is discussed in the text.

Figure 4-7. Edo Mumare, Episode 13. Since a playboy should present lanterns for the front of the house of his favorite geisha, Enjirō seeks to order one from a lantern-maker, who spurns him, already having too many orders. An example of the remarkably exact visual detail—at once disordered by, and harmonized with, the text of the story. One lantern shows part of the "den" of Kyōden.

Figure 4-8. Edo Mumare, Episode 14. A playboy's jealous rivals hire toughs to beat him up; learning this, Enjirō hires two ruffians to pummel him and takes masochistic or aesthetic delight. The crowding of the writing perhaps mars this frame — or does it suggest the tumble of the hero's thoughts?

Figure 4-9. Edo Mumare, Episode 15. Because a playboy's family should tire of his spendthrift ways and disinherit him, Enjirō gets his mother to convince his father to cut him off — for three months.

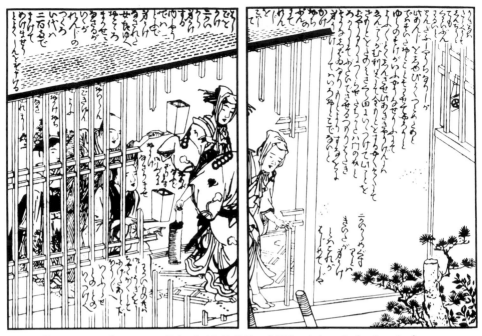

Figure 4-10. Edo Mumare, Episode 19. Enjirō and Ukina (whom he has bought from service) set out on a mock lovers' double suicide.

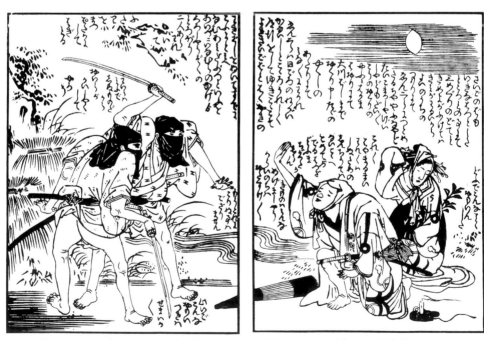

Figure 4-11. Edo Mumare, Episode 20. Instead of being stopped from suicide by Kinosuke and Shian, Enjirō and Ukina are beset by burly thieves and stripped of their clothes. The men have actually been hired by his father.

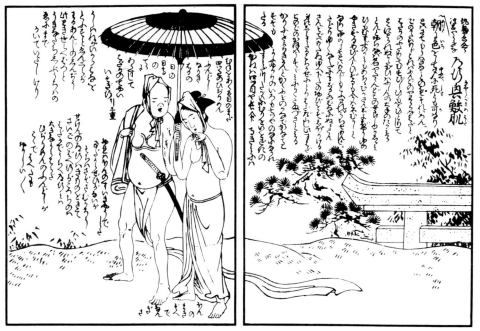

Figure 4-12. Edo Mumare, Episode 21. The discomfited Enjirō and Ukina make their way to his house in the chill of morning, he sporting his lengthy silken loincloth.

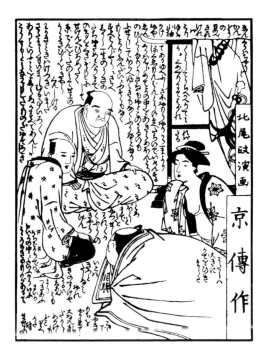

Figure 4-13. Edo Mumare, Episode 22. Conclusion. Enjirō warms himself under a quilt, while papa preaches morality in the presence of a household steward and the self-concerned Ukina. The upper, narrow cartouche says "Pictures by Kitao Masanobu," the lower, wider one says, "Story by Kyōden."

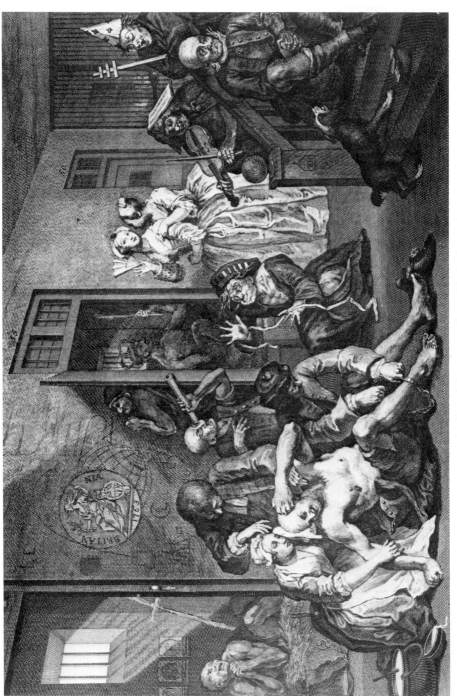

Figure 4-14. William Hogarth, *The Rake's Progress*, plate 8 (the last). See the text, pp. 85-86.

of goodness, or beneath it, or just as we are . . . with the painters, the personages of Polygnotus are better than we are, those of Pauson worse, and those of Dionysius just like ourselves. . . . Homer's personages . . . are better than we are; Cleophon's are on our own level; and those of Hegemon of Thasos, the first writer of parodies, and Nichochares, the author of the Diliad, are beneath it. . . . This difference it is that distinguishes Tragedy and Comedy also; the one would make its personages worse, and the other better, than the men of the present day.[19]

If the rhetorical features in this are not evident, they would be after reading Quintilian, or for that matter after Erich Auerbach's consistent positing of the classical hierarchy of styles in his *Mimesis*.[20] It need not be emphasized that what I have just described so briskly is in fact a complex set of cultural assumptions, and that the stability of this view involves, in no small measure, the strength derived by one feature from others in the set, as also from the stable identity of each member of the set.

The traditional Western philosophical, moral, and rhetorical terms of art can be shown as it were parenthetically, and in contrast to *Edo Mumare*, by consideration of a counterpart example of narrative pictorialism, William Hogarth's *Rake's Progress* (third state, 1763), which must be about the closest possible English equivalent to the doings of Enjirō. After losing his fortune by his profligate life, the Rake marries (*Rake's Progress*, plate 5) a rich, old one-eyed woman to recoup his fortune. This he also dissipates in gambling (plate 6), so that he lands in debtors' prison (plate 7), attended only by Sarah Young, whom he had long ago seduced and got with child. In plate 8 (see figure 4-14), we find him in his last stage, committed to Bethlehem (Bedlam) Hospital, grown mad from his profligacy and disease. He reclines to the left of the picture, still attended by Sarah Young, and now by two warders, who are chaining him to prevent him from doing further violence to himself. Sarah Young is herself the object of sexual attention by one of the warders. In cell 54 to the left a religious fanatic has turned almost bestial, and in the next cell to the right another madman thinks himself king while he urinates. To his left, two fine ladies observe the scene. To their lower right squats a mad tailor, and to his right there is a mad astronomer. By the stairs a mad musician stands with his violin, and on the steps sits a man who thinks himself pope and a man gone out of his senses for love of a prostitute.

The rhetoric of all this is clear: the images of degradation show what condition the Rake's ways have led him into. The morality is yet more insistent. If any doubt existed, one could compare this scene with the last episode of *Edo Mumare* (figure 4-13). Or we might compare its closing words (spoken by Ukina) about her catching a terrible cold with Hogarth's doggerel and moralizing verse beneath his picture.

> O Vanity of Age! here See
> The Stamp of Heaven effac'd by Thee—
> The headstrong Course of Youth thus run,
> What Comfort from this darling Son!
> His Rattling Chains with Terror hear,
> Behold Death grappling with Despair;
> See Him by Thee to Ruin Sold,
> And curse thy self, & curse thy Gold.

The rhetorical rattle serves the moral end of criticizing a venal, false golden age. (The same moral is in the pictorial touch added by Hogarth in 1763, the Britannia on the wall, distracted as all England seems to be with madness and cupidity.) The philosophical element of course has religious origins:

> Poverty and shame shall be to him that refuseth instruction: but he that regardeth reproof shall be honoured.
> The desire accomplished is sweet to the soul: but it is abomination to fools to depart from evil.
> He that walketh with wise men shall be wise: but a companion of fools shall be destroyed.
> Evil pursueth sinners; but to the righteous good shall be repayed. (Proverbs 13:18-21)

And:

> For the wages of sin is death. (Romans 6:23)

If we judge *Edo Mumare* by the triple standard of philosophy, morality, and rhetoric, only rhetoric offers any very apparent standard. That is, we see at once that the world of the work is "low." Aristotle would call its characters worse "than the men of the present day." Yet what is of more significance still, the world of *Edo Mumare* must be judged unreal by Western standards: its central figure is, mimetically speaking, a role without a character, as are the others. Because each seems to lack a (Western) self as moral agent, the counterpart of the (Western) self, a real world, also ap-

pears to be absent.[21] Yet we do come to consider Enjirō to be
human, that he was modeled on certain historical and literary
characters, and that Kyōden put something of himself into his
feckless hero.[22]

I am not offering *Edo Mumare* as one of the masterpieces of
Japanese literature. Yet in this well executed series of book-pictures
we see the same features that we also see, in far greater complexity,
in *The Tale of Genji, The Tale of the Heike,* linked poetry, and
other exemplars. The task therefore becomes one of accounting for
the various elements in *Edo Mumare* (and by implication also in the
other examples mentioned). Some further details of *Edo Mumare*
can lead us to conclusions about the nature of the Japanese alter-
native to mimesis.

We may begin with the beginning of the work (figure 4-2, Episode
1). What follows gives as close a version of the Japanese original as
English and my abilities permit; to it I add a more paraphrastic or
idiomatic translation.

> Here Enjirō, the only son of a shop worth a million and called Fickle
> Feeling, is grown to about eighteen or nineteen, and—"The disease of
> poverty causes no suffering here; / It is well if no other ill befalls"—
> taking pleasure in the life of a playboy, looking at books of plays of the
> puppet theatre, thinking with envy of such exemplars as Idahachi of the
> Tamakiya or amorous Inosuke, having the yearning of his entire life to
> devote to being a playboy and acquire the name of a lady-killer, thinking
> in due course to throw away his life in this, imagining such notions of a
> fool, decided to devote his life in that way—it would be real pleasure to
> become like such people—that's being counted among those born with
> a great karma.

Or, in more normal translationese:

> Here in the picture is Enjirō, the only son of a millionaire shop called
> Fickle Feeling. He is now grown to about eighteen or nineteen and, in
> the words of the song, "The disease of poverty causes no suffering here; /
> It is well if no other ill befalls." He takes pleasure in the thought of living
> as a playboy, spending his time reading scripts from the puppet theatre
> and thinking with envy of such current heroes as Idahachi of the Tamakiya
> or amorous Inosuke. He is overcome by the whole yearning of his life
> to be a playboy and acquire the name of a lady-killer. He even thought of
> throwing away his life in due course in this behavior—such a fool he was
> in his imaginings. But so he resolved.
>
> [Enjirō]. "It would be the greatest pleasure in the world if I could

become such a playboy. I must be one of the few born with an outstanding karma."

Kyōden begins: "Koko ni" — "Here in the picture," with a reminder at the outset that the verbal expression is accompanied by Masanobu's pictures. The two interplay, and no appreciation of the one is adequate without considering the other (although the words are more necessary to plot and the pictures more realistic). This beginning is a deliberate parody of old stories. The episodes of *The Tales of Ise* (which appear pictured in Episode 2) usually begin, "Mukashi otoko arikeri [or arikeru]." That old beginning and its counterpart, "Ima mukashi," mean something like, "A long time ago" or "A long time ago now." The *keri* or *keru* final perfective inflection is a narrative means of setting an aesthetic distance between the narrator and the reader on the one hand and the world of the characters and story on the other. The perfective cannot be so translated into English in a syntactic unit that goes on so long. But Kyōden clearly parodies and elongates that old formula to give us "Koko ni . . . Enjirō . . . omoitsuki o shi*keru*." The point of the parody partly involves recollection of the old stories, whose cultural distance plays off against the modernity of what comes in the ellipsis of the Japanese just given. But it also entails a transformation of what is old in literary convention to what is up-to-the-moment and richly specified for present reality by the pictures.[23]

Another matter that Western readers are not used to involves the presentation of the words without any punctuation or other pointing whatsoever: not one comma or capital letter (in any event capitals do not exist in Japanese). The Japanese of *Edo Mumare* does not have any sign to set off the initial narrator's presentation from Enjirō's quoted words/thoughts. Given Masanobu's picture, we should probably think that Kyōden meant us to apprehend the words as Enjirō's thoughts, but as in so much other Japanese narrative the distinction is not wholly clear. (Is he speaking aloud?) Another feature of the Japanese is that it employs not a single personal noun except names: Enjirō, Idahachi, Inosuke. The second translation introduces English pronouns, as natural English — but *not* natural Japanese — requires. Aristotle's and Dryden's concern with agents better than, like, or worse than ourselves fades when no one is kept clearly before us, when a supposed agent does not even have his thoughts distinguished from the narrator's account,

in any way other than the parody of an old formula. According to the model of *The Tales of Ise*, we should have a poem after the narrator's account. Instead, we get Enjirō's mulling, and the version of the poem, two lines from a popular song, comes in the narrator's account ("The disease of poverty," etc.).

Just as Enjirō seems lost to sight in a narrative singularly undifferentiating by our standards, so is it difficult to pin down a narrator who intrudes to present Enjirō's person and thoughts. If we take comfort in this as some pure blend of narrative, we are jolted by the suddenness with which Kyōden intervenes with a judgment on Enjirō that he obviously expects his readers to share: "such a fool is he in his imaginings."

This assembly or harmony of elements does not put together Aristotelian parts, if only because Kyōden's narrative elements are not discrete. For that matter, who *is* Kyōden? As we look at the frame for Episode 1 we may think it easy to identify who Enjirō is: that pipe-smoking, funny-nosed, would-be lady-killer stretched out reading plays. But reading the Japanese, we discover that in his mind (which is in some sense what we are after) Enjirō plans to become another Idahachi or Inosuke. The problem—and of course the delight as well—is that our minds must encompass the comedy imagined by the narrator's mind (or the author's, as Japanese would think), which in turn encompasses what passes for Enjirō's mind, which in its turn tries to alter his world so that he can pass as one of the leading lady-killers of his time. When the narrator intervenes to say, in effect, that Enjirō is an ass, we sense a sudden shift in the poise of ourselves as readers in relation to the narrator and Enjirō. Relation remains but is altered. Another, more general, way of putting this point is to say, what is certainly true, that the pictures and words also possess their engagements and disengagements. Yet these undoubted differences and sudden alterations nonetheless allow for a harmony of psychological subjects: ours as readers, the narrator's, and Enjirō's. These psychological subjects are not conceived of as the radically discrete, separate entities assumed in traditional mimetic Western literature, nor are they the transgressings and negations of Western antimimesis. The differences (as when the narrator intrudes to call Enjirō a fool in his imaginings) are indeed differences in the narration, but they betoken an alteration in a set of relationships rather than the breakdown of a mimetic illusion that was never posited.[24] This can be shown in terms of the

relation between "text" and pictures. The words say nothing about Enjirō's smoking. The picture cannot show that he is reading play scripts. The differences are as real as ordinary narration and author intervention. Yet they do not conflict. One supports the other in a relational existence.

The opening is useful to consider because openings and endings always tell us a good deal about literary and philosophical assumptions, and also because that first frame is a good deal simpler than most of the later ones. Later on, the interplay, the interpictorialism or interverbalism, or whatever it is, grows more complex. We *do* have recognizably different artistic media. But in Asia, calligraphy offers a middle ground between words and pictures, being in some sense both—just as the disposition of the written lines of text in the picture is itself part of the pictorial effect, just as the pictures contain numerous examples of writing. We have observed how the artist has been stylized into components (Masanobu and Kyōden) who somehow sit at once as one and yet two persons. What we have been seeing is that the verbal and pictorial expressions are similarly stylized into ensemble, into parts different but not wholly discrete.

Much as we may find the concept of narrative point of view oversimplified, it remains true that narrative (unlike drama) presumes a narrator. Only in modern jargon with personification of "the text" are stories said to tell themselves. This requirement of a narrator is as great for *Edo Mumare* as in a story by Austen, Dickens, or Borges. We know that the Western examples are terribly difficult to sort out, and we have seen one reason for it: "I, alas, am Borges."

The comparable inscription for *Edo Mumare* is: "I—ho, ho!—am Kyōden." Or Masanobu, or Kyōden-Masanobu. Or possibly Santō Kyōden / Kitao Masanobu / Iwase Sei. There is as palpably an author and narrator as there is an artist and a pictorialism. The problem lies with the lack of the discrete agency and consistency familiar to Western readers. Enjirō is named once, as are Idahachi and Inosuke. But there are no personal nouns (equivalent to our pronouns) in the first episode. There is no "I" for him or the narrator. There is no "he said." Among the missing punctuation marks are those for quotation, and even that slippery thing—the Japanese quotative particle *to*—is missing.

Japanese narratives require narrators, and Japanese minds—like ours—require intelligibility, an ultimate understanding, in some real sense a certitude that what goes on can be understood, even

if it is a mystery. To speak solely about the point of view or the narrator is, therefore, not enough, either for Japanese narrative or any other. Narration is about something, focuses on something identifiable, pays attention to something. For lack of an existing term, I shall call this the point of narrative attention. The chief point of attention in the pictures as narrative is either places or characters, although numerous complexities exist in terms of allusions to the verbal narrative or the other elements preexisting this narrative. The chief point of attention in the verbal narrative is Enjirō, as it is Emma in *Emma*. Just as a Japanese narrative like *Edo Mumare* can shift without a by-your-leave from narrative proper to dialogue, so can the point of attention suddenly shift from attention to the narrative account of Enjirō's activity to attention to an explicit judgment by the narrator on the folly of it all. Western narrative must have as much a point of attention as it must have a point of view. But as Aristotle's strictures make clear, we expect Western narrative to have a logic of consistency and causation— or else we presume the antimimetic, antilogical, inconsistent gestures of much contemporary Western narrative.

The Japanese assumption clearly differs. Point of view and point of attention are variables, correlatives of each other; neither is the same as the other nor possible without the other—and the relationship between the two is more significant because it is also more flexible than in Western narrative. In Japanese narrative, the point of attention has more importance than in the West. And because representation is less important than expression and affect, there is no need to fix the relation between point of view and point of attention. In *The Diary of Izumi Shikibu (Izumi Shikibu Nikki)*, there is one lengthy sentence, including both thoughts and speech by the Lady and by her lover, in which four shifts in point of attention occur. Such shifting about poses no problems of consistency when mimetic standards of consistency are not presumed. Different ontologies, different philosophies, if not metaphysics, and different psychological assumptions make for different kinds of literary and pictorial art.

The affective-expressive poetics of Japan also presumes the reader to be a radical and a variable, giving a reader's point of view. In the narrative of *Edo Mumare*, a constant harmonious variance exists between the story as verbal expression and the story as pictorial expression. *Both* the harmony and the variance call for interpretation

by the reader. The pictures may show a more or less rounded triangular nose, and the words may tell of a peony nose, but the reader's role is to use the one kind of narrative to supplement, qualify, particularize, and otherwise develop the other. There are also elements in the verbal expression whose English counterparts belong to syntax and tone rather than to diction. For example, questioning or exclamatory particles such as *ya* and *ka* emphasize the point of attention by a little grammatical intervention testifying to narrator presence and point of view, and also evoking the reader's view. Certain verbal terminations (whether the traditional *-keri* or the faithful Edo dialect) have also been referred to. Japanese affectivism does not posit readers finding a *dulce* and *utile*, but a constant interplay of reader with poet and matters attended to. At times, although not in *Edo Mumare*, Japanese literature is marred by the heavy-handedness with which generalized conclusions are presented by a narrator or lyric speaker. At times, and more often, Japanese readers take to what is simple or even sentimental, because then they are able to participate as readers more fully in the life of the narrator as author. No literary system seems immune to the defects of its virtues. But readers of this essay will surely wish to have their own aesthetic literary presumptions more fully alienated than those of the Japanese.

In Japanese literature it is always "seed" and "leaf" time for the reader, no matter how complex or mannered the author's style may become. The poet's access to the world involves an effect that leads to expression that in turn has its effect on the reader. The virtue of this explanation is surely its accuracy. Older Western "formalist" notions of "the literary object" as discrete and self-sufficient mean nothing in the Japanese view. How can we know there are words (kotoba) if we do not read them? How can there be words without a poet moved in mind or heart (kokoro) to provide them? The recent Western personifications of "the text" so that it "enacts" or "requires" or "hovers on the abyss of nonsense" make no sense in traditional Japanese terms. What does make sense are the three correlatives discussed as "points": of view (the narrator), of attention (character, place, and so on), and of understanding and affect (reader). The fourth element in any complete literary explanation, the world, is assumed as the interrelation of the three correlatives, and more particularly as the setting of what is under attention.

It is now time to sort out the components and arrive at some notion of their psychological, ontological, and philosophic status. In all three senses, the narrator is a subject—a perceiver, feeler, knower, expresser. In the same terms, the matter of attention—a place or an Enjirō for our consideration—is a philosophical and psychological object, something perceived, felt, known because expressed by a narrator and perceived, felt, known by us. Of course a psychological and philosophical object of the narrator and reader's attention may be an Enjirō who, being human, is also a subject— but only within the terms of the story, which is to say within the terms of the author's and the reader's subjectivity. To the extent that a reader is considered a subject to be acted upon cognitively and affectively, the reader is an indirect object of the aesthetic process. But of course the dominant role of the reader is the willing and active one of being affected, understanding. On mimetic terms, both the narrator of *Edo Mumare* and its dim-witted hero can only seem insubstantial as persons. Mimesis requires discrete agencies responsible and consistent in representation. The alternative is breakdown, either in the quality of the artistic result or in the presumptions giving the mimetic thesis its axiomatic character.

The Japanese aesthetic, with exemplars such as *Edo Mumare*, rests not on the imitation of discrete agencies but on *relation*. The relational aesthetics presumes that the narrator and the reader and the object of attention take on their being in respect to each other. Once this three-radical set of relationships is presumed, the world can be found as real and knowable in the affective knowledge provided by those relationships as the world is knowable in mimetic practice. Enough has been said of the indefiniteness of "author" and narrator. But Enjirō also does not have precisely the same selfhood as does the hero of a Western novel. He is defined for us in the first sentence, not so much as a *self*, but as a *person*, by a phrase that suggests two relationships in his world: he is "the only son of a shop called Fickle Feeling." Without that family and that mercantile background of wealth, he has no existence. So we are not to be surprised when his parents make a sudden appearance in the story. After all, the very relation that gives Enjirō his existence relative to them is that giving them theirs relative to him.

The relational aesthetics has its own assured foundations in terms of Japanese society, in which one is defined less by the Western sense of self than by a personhood defined in terms of relation to others

and by social role: "the only son of a shop called Fickle Feeling." There are also the metaphysical or cultural assumptions derived, at whatever remove, from Buddhism. In Buddhist thought common to the various faiths or sects, metaphysics holds that nothing can be said to have discrete existence. To take an extreme example, swallows do not exist without neon lights. All existence is posited upon relation, on dependence and interdependence.[25] By Kyōden-Masanobu's time, the Buddhist sense of the radical illusory character of all that exists by relation had been attenuated to the point of minimal belief. The presence of so many *things* in the pictures testifies in one way to the growing sense of phenomenal existence. Yet for all the other evidence that might be invoked, the basic metaphysical assumption of relation remains inviolable. Just as Enjirō exists in terms of definition by his sonhood and his mercantile, Edo birth, so the larger aesthetic premise of the narrative is relation.

Japanese aesthetics simply has an explanatory power that talk of the "literary object" or of "textuality" does not possess. In fact, the very richness and soundness of a Japanese relational aesthetics so hospitable to detail makes it relatively thin in abstraction. The beginning of the long quotation from Chikamatsu is about as abstract as Japanese criticism becomes. By the same token, the power of abstract conceptualizing in Western aesthetics comes at a cost of particulars and above all of relational capacities.[26]

In Japan the sister arts have no such name. But the idea of sisterhood or sonhood is one the Japanese would be among the first to understand. Japanese aesthetics has no use for the image of "the mirror of nature" to designate a mimetic process. Yet the mirror does exist as an image, finding its way into titles. Beginning with *The Great Mirror* (*Ōkagami*, late eleventh century), there appeared four historical tales (*rekishi monogatari*) featuring prodigiously old characters recounting events they were supposed to have lived through. *The Great Mirror* involves a narrator and two or three elderly dialoguists as surrogate narrators who tell of the past in ways as relational and as little mimetic as *Edo Mumare*. Centuries later one of the greatest of all Japanese scholars, Motoori Norinaga (1730-1801), wrote a study of the first of the twenty-one royal poetry collections, the *Kokinshū*. To it he gave the title, *A Distant Mirror of the Kokinshū* (*Kokinshū no Tōkagami*, 1787). These titles presume a sense such as "an access to the past," "a telescope for the past," or "a perspective on the past." We must realize that there

are literary mirrors that do not reflect in the mimetic way, or anti-
mimetic way, just as there are also kinds of literature, and of rela-
tions between the sister arts, that do not presume mimesis. If "the
sister arts" is a Western conception, the relation implied between
the two in *Edo Mumare*—like the relation presumed by Japanese
aesthetics—is certainly very different from, and certainly at least
equally profound, as anything dreamt of in the philosophies of two
of the most influential Western critics, Aristotle and that other
Horatio of Rome's *De Arte Poetica.*

Notes

1. The standard study remains that by Jean H. Hagstrum, *The Sister Arts: The
Tradition of Literary Pictorialism from Dryden to Gray* (Chicago: Univ. of Chicago Press,
1958). Besides Hagstrum's other magisterial work, certain theoretical speculation may be
mentioned. See Max Imdahl, "Overstepping Limits in Visual Art," included in *New Per-
spectives in German Literary Criticism*, ed. Richard E. Amacher and Victor Lange (Prince-
ton: Princeton Univ. Press, 1979), pp. 278-92; and, from "The Language of Images" issue
of *Critical Inquiry* 6 (1980), particularly Elizabeth Abel, "Redefining the Sister Arts,"
pp. 363-84.

A number of people have read this essay in an earlier form, making valuable comments.
Hagstrum and Lawrence Lipking raised questions, suggested amplifications, and urged the
inclusion of an example from Hogarth. This was made possible by my colleague, E. D. H.
Johnson, whose loan of the last picture from *The Rake's Progress* from his collection has
enabled me to include it here; he made a number of valuable comments as well. People
versed in *Edo Mumare* also have assisted. These include particularly Sumie Jones (see
n. 3) and three Princeton graduate students: James Shields (who also vetted my prose),
Norma Field, and Adriana Delprat, with whom I studied the work. Masao Miyoshi read
the essay as sympathetically as one could from very different critical presumptions. Konishi
Jin'ichi and Kenneth Yasuda gave me help in some deciphering. The result will not please
them all, but I appreciate such welcome assistance.

2. See James T. Araki, "The Dream Pillow in Edo Fiction, 1772-81," *Monumenta
Nipponica* 25 (1970): 43-105, for the first important account in English and for some
examples of Edo fiction of these kinds. He also read this essay, making valuable suggestions
and corrections.

The edition used for commentary as well as the figures reproduced here is that of Hamada
Giichrō et al., ed., *Kibyōshi, Senryū, Kyōka* (Tokyo: Shōgakkan, 1971; vol. 46 in the
Nihon Koten Bungaku Zenshū series). I have also used "*Edo Mumare Uwaki no Kabayaki*:
Sakuhin Kanshō" by Nakano Mitsutioshi, pp. 80-91 in *Kyōden, Ikku, Shunsui* (Tokyo:
Shūeisha, 1980; vol. 18 in *Zusetsu Nihon no Koten*).

3. This translation is by Sumie Jones, who introduced the work to me and others
in 1979. I have benefited from being able to read her University of Washington thesis
(1979), "Comic Fiction in Japan During the Later Edo Period," which has chapters both
on Santō Kyōden and Hiraga Gennai.

4. A close analogy to *Gulliver's Travels* had been written by Hiraga Gennai (1728-
79), *Fūryū Shidōken Den* (1763); see n. 3. The hero, Shidōken, is taught to fly by a celes-
tial being, visits all parts of Japan, and goes through southeast Asia, even to Holland. Among
the peoples he visits are those distorted in body somewhat like Swift's Lilliputians, and

the book closes with an episode on Shidōken's return, involving the founding of an ideal state. The author did not know *Gulliver's Travels.*

5. Kikaku (1661-1701) was a follower of Matsuo Bashō (1644-94) and after Bashō one of the two greatest poets of the time. As the stanza next quoted in the text shows, he had a streak of naughty and brilliant wit. Since something has been said of Japanese names, it may be remarked of Kikaku that he was born with the surname Takarai, which he later changed to Enomoto. One cannot be sure which to use in looking him up in a given dictionary. He was known in succession by about half a dozen given names, a number only slightly more than usual for someone of his status. Also, besides "Kikaku," he used such other styles as "Hōshinsai," "Shinshi," "Yōsen," etc. It will be clear that the Japanese sense of identity differs from ours. It is as if Blake was called John, Henry, Thomas, and William in succession, had two competitive names as surnames and, as a poet and painter, worked under, and was only to be identified by, a number of differing artistic styles for verbal and pictorial art.

6. Borges, *Other Inquisitions, 1937-1952,* trans. Ruth L. C. Sims (New York: Simon and Schuster, 1968), p. 115.

7. Although I can do justice neither to this position nor to Masao Miyoshi, one of its holders, I feel obliged to raise it as a critical possibility. See also n. 22.

8. My hypothesis is elaborated, both in terms of Western and non-Western "systems" and their development, in "On the Genesis and Development of Literary Systems," *Critical Inquiry* 5 (1970): 339-53, 553-68.

9. *Kokinshū,* 11:522. Because numbers involve straight lines rather than the cursive ones of the syllabary, the attempt to write them on water is particularly futile.

10. Dryden, "Parallel," in *Of Dramatic Poesy and Other Critical Essays,* ed. George Watson, 2 vols. (London: Dent, 1962), II, 193-94. Aristotle on the pleasure we take in imitation will be found in *Poetics,* ch. 4 (48b4-19). For a discussion of the difficult problem of what Aristotle means, see Gerald F. Else, *Aristotle's Poetics: The Argument* (Cambridge, Mass.: Harvard Univ. Press, 3rd printing, 1967), pp. 82-89.

11. *Poetics,* ch. 25, quoted from Ingram Bywater, trans., in *Introduction to Aristotle,* ed. Richard McKeon (New York: Modern Library, 1947), p. 661. Hereafter "McKeon."

12. *Poetics,* ch. 4; McKeon, p. 627. Else makes "dead bodies" clearer with his "cadavers" (p. 124). Dryden, who was obviously thinking about this chapter (see n. 10), disagreed about responses to this kind of imitation, as he would have about the substance of some of Aristotle's other references to painting (or should one say chiefly carved and painted vases?): see McKeon, p. 628 (ch. 4 again); p. 632 (ch. 6); and p. 644 (ch. 15).

13. See *Chikamatsu Jōruri Shū,* ed. Shuzui Kenji and Ōkubo Tadakuni (Tokyo: Iwanami Shoten, [1959] 1974), pp. 358-59. (*Nihon Koten Bungaku Taikei,* vol. 50.)

14. Zeami's name is also pronounced Seami, and he is known as well as Kanze Motokiyo. His father, Kannami (Kan'ami, Kanze Kiyotusgu; 1333-84) was less a critic than the genius behind the blend of various arts that produced *nō,* as well as a major author and actor.

15. This is not the place for full explanation. But see the article cited in n. 8 for a context.

16. McKeon, p. 635 (ch. 8).

17. Ibid., pp. 636-37 (ch. 9).

18. Ch. 15; Else, p. 455. Bywater (McKeon, p. 643) pretties this up.

19. McKeon, pp. 625-26; the bulk of this short chapter has been given here. Else objects (pp. 68-89) to the middle kind on various grounds that classicists will have to argue over. But even if he is right, the basic better-worse distinction holds (see also ch. 2 [48a9-18] and ch. 4 [48b24-34]). For Dryden on "a better or worse likeness to be taken," etc., see his "Parallel," Watson, II, 202.

20. How often, I wonder, does his subtitle get the recognition it deserves, with attention to the assumptions implied in its first phrase and the limits tacit in the last word but one ("The Representation of Reality in Western Literature")?

21. The crucial issue of selfhood was first identified by Masao Miyoshi in his book on modern Japanese prose narratives, *Accomplices of Silence* (Berkeley and Los Angeles: Univ. of California Press, 1974). In addition to the insights of this pathmaking book, further explorations are made in *As We Saw Them* (Berkeley and Los Angeles: Univ. of California Press, 1979). In the earlier book, he sometimes seems to suggest that Japanese have no sense of self. In the latter he seems to believe, as I certainly do, that Japanese hold a different view, one that makes far more of *person*.

22. See Nakano (as in n. 2), pp. 81-82, for these matters.

23. Even this needs some qualification. Sufficient evidence, literary and pictorial, exists to show that by the end of the tenth century, and perhaps earlier, a prose narrative might be read aloud by a skillful person while some or all the listeners savored a picture of the episode. In fact this tradition lasted on with itinerant tale-tellers (some who might use puppets instead of pictures) and has survived to this day in popular story-telling for children, and on television.

24. Many people have remarked recently on the apparent resemblance in techniques and effects of traditional Japanese literature and contemporary Western literature. The resemblances are often extraordinary; but the differences are fundamental. Contemporary Western literature has come to resemble traditional Japanese after our authors have lost, or chosen to reject, the assumptions and techniques associated with mimesis and its "realism." Japanese writers never held such assumptions but, as I am seeking to show, did have "realist" presumptions based on a different psychology, ontology, and metaphysics.

25. The briefest, most cogent account I know of concerning the relevance to literature of Buddhist metaphysics is that by Konishi Jin'ichi in *Sōgi* (Tokyo: Chikuma Shobō, 1971), pp. 120-22. For a brief, clear technical discussion of the doctrine of the void, see Nakamura Hajime, *Shin Bukkyō Jiten* (Tokyo: Seishin Shobō, [1962] 1972), *s. v. kūkan*.

26. These remarks, like certain others before them, represent an attempt to honor the necessary principle of falsification. Because if propositions are not susceptible to that principle, they are not in theory establishable as true. My aim, then, has been to use Japanese and Western literary conceptions in dialectical fashion to provide judgment on each other. I am unable to provide a higher order of truth that can verify/falsify both at once.

UT PICTURA BIOGRAPHIA
Biography and Portrait Painting as Sister Arts

Richard Wendorf

When Samuel Johnson described the difficulty of writing biography, he drew his terminology not from the art of "life-writing" but from its sister art of "face-painting": "We know how few can portray a living acquaintance, except by his most prominent and observable particularities, and the grosser features of his mind; and it may be easily imagined how much of this little knowledge may be lost in imparting it, and how soon a succession of copies will lose all resemblance of the original."[1] The parallel Johnson implicitly draws between biography and portraiture is one that had often been made, both in theory and in practice, throughout the seventeenth and eighteenth centuries. This parallel between the two arts is a natural extension of the doctrine of *ut pictura poesis*: just as the poet strives to duplicate the effects produced by the visual arts, so the biographer will also be able to find specific models for his work among the various forms of portraiture.

This does not mean, however, that the biographer must slavishly imitate the painter, nor the painter the writer. The parallel simply suggests that the functions of the two arts, the impulses that lie behind them, some of their methods (and many of their effects) are often strikingly similar, and that what the painter accomplishes with his brush and what the biographer achieves with his pen deserve the same kind of comparative analysis that has been devoted to poetry and painting. As Jean Hagstrum emphasizes in his study of the sister arts tradition, Horace did not specifically warrant the

interpretive "Let a poem be like a painting"; he meant by his phrase only "As a painting, so also a poem" or "As sometimes in painting, so occasionally in poetry."[2] This distinction is crucial to a study of painting and biography because of the very different means of imitation they employ. Hagstrum points out that in Aristotle's discussion of painting and poetry the two arts are cousins rather than sisters—"Each of the mimetic arts achieves its proper pleasure in its proper medium. Each must take into perpetual account its own peculiar limitations"—and this modified family relationship may also best characterize the two arts I propose to compare.[3] The following essay therefore attempts to survey some of the common grounds of comparison between biography and portrait painting, primarily during the period in which both arts flourished and developed; but it should be borne in mind that the differences between these two arts may tell us as much about them as do their similarities.

I. Parallels Between the Arts

The extension of the *ut pictura poesis* formula to include biography and portrait painting was natural largely because portraiture had already served as one of its terms. In the *Poetics* Aristotle singles out portrait painting when he compares dramatic plots to pictorial design and the portrayal of character to the painter's use of color: the "most beautiful colors laid on without order will not give one the same pleasure as a simple black-and-white sketch of a portrait." In other remarks, as we shall see, he emphasizes the parallel manner in which dramatists and painters are able to create an ideal beauty that ennobles nature without destroying the principle of resemblance or "likeness."[4] This is a particularly influential argument, also espoused by Socrates and Zeuxis, which Dryden takes up in his "Parallel Betwixt Painting and Poetry" (1695). Dryden attempts to adapt the principle of ideal beauty ("perfect nature"), and the breadth of characterization it implies, to the practice of drama:

> Now, as this idea of perfection is of little use in portraits (or the resemblances of particular persons), so neither is it in the characters of comedy and tragedy, which are never to be made perfect, but always to be drawn with some specks of frailty and deficience; such as they have been described to us in history, if they were real characters, or such as the poet

began to shew them at their first appearance, if they were only fictitious (or imaginary).[5]

The perfection of these dramatic characters, Dryden insists, lies only "in their likeness to the deficient faulty nature, which is their original." In painting, for example, warts and moles add "a likeness to the face" and are therefore not to be omitted by the painter who wishes to balance imperfections with beauty or virtue. But the portrait painter will not normally "take that side of the face which has some notorious blemish in it; but either draw it in profile (as Apelles did Antigonus, who had lost one of his eyes), or else shadow the more imperfect side."

Dryden therefore argues for considerable freedom in the depiction of all characters, even those drawn directly from history. As he wrote to his friend Sir Godfrey Kneller, the preeminent portrait painter of the age:

> Thou paint'st as we describe, improving still,
> When on wild Nature we ingraft our skill:
> But not creating Beauties at our Will.[6]

He also joins du Fresnoy in equating the conception of likeness in portraiture with characterization in poetry: "In the character of an hero, as well as in an inferior figure, there is a better or worse likeness to be taken; the better is a panegyric, if it be not false, and the worse is a libel."[7] By "better" and "worse" Dryden means not more or less exact a resemblance, but a resemblance that is either more or less flattering to the original model. He illustrates his argument by surveying Greek tragedy: Sophocles always drew men as they ought to have been, better than they were; another, whose name Dryden has forgotten, drew them worse than they naturally were; and Euripides altered nothing in the character, "but made them such as they were represented by history, epic poetry, or tradition."

Dryden's theory of characterization here is once again adapted from Aristotle, but Dryden differs significantly from Aristotle in his emphasis on the breadth of characterization that any individual figure invites. Aristotle neither mentions a "worse" likeness nor commends the "better" likeness of Sophocles. He simply states that the artist, as an imitator, may describe characters and objects in one of three ways: as they were or are, as they are said or thought to be, or as they ought to be. Aristotle reasons that any of these

conditions may be used as poetic justification for describing a character in a certain way.[8] Dryden, on the other hand, believes that in the character of every figure "there is a better or worse likeness to be taken." This change in emphasis is significant not only because it suggests that a historical figure may be described in different ways for different purposes (as Aristotle said), but also because it contends that these different likenesses, while they may be relatively flattering or damning, may at the same time remain essentially valid. Artistic manipulation or deviation does not necessarily threaten the principle of faithful representation, "for an ingenious flattery is to be allowed to the professors of both arts, so long as the likeness is not destroyed."[9]

It should be clear that the claim Dryden makes for imaginative characterization in portrait painting, poetry, and drama is appropriate to the art of biography as well; but the explicit parallel was drawn by other writers and not by Dryden himself (in spite of his own interest in portraiture's sister art). Plutarch, the acknowledged father of biography (whose life Dryden wrote in 1683), drew a direct comparison in the introduction to his life of Alexander. Following his famous observation that he was writing "Lives," not "Histories," and his remark that "a slight thing like a phrase or a jest often makes a greater revelation of character than battles where thousands fall," Plutarch notes that

> just as painters get the likenesses in their portraits from the face and the expression of the eyes, wherein the character shows itself, but make very little account of the other parts of the body, so I must be permitted to devote myself rather to the signs of the soul in men, and by means of these to portray the life of each, leaving to others the description of their great contests.[10]

It has recently been argued that although Plutarch appreciated the quality of pictorial vividness, of *enargeia*, in the works of Thucydides, he did not depend on this quality in his own lives of the Greeks and Romans, whose virtues were meant to speak directly to the reader. According to this argument, Plutarch presents an analogy that emphasizes only the writer's and painter's parallel focus on essential characteristics; he does not state that biography and portrait painting have the same goals.[11] The problem with this interpretation of Plutarch's remarks, however, is that although it is consistent with statements made by other ancient writers, it is not supported by the few theoretical comparisons Plutarch actually

drew. Cicero argued that statues and portraits are "likenesses not of the soul, but of the body," and Isocrates preferred biography to portraiture because men pride themselves more on their deeds and wisdom than on their physical beauty, because pictorial images are stationary, whereas written accounts can be disseminated throughout the world, and because narratives are more capable of engendering virtue in their readers.[12] But in his own statements on portraiture, Plutarch made no disparaging distinctions between the "character" that reveals itself in painting and the "soul" that is embodied in biography. His remarks in the life of Cimon indicate, in fact, that although he was aware of the limitations to be found in some kinds of painting, he nevertheless equated the more exacting forms of visual portraiture with his own biographical methods:

> since we believe that a portrait which reveals character and disposition is far more beautiful than one which merely copies form and feature, we shall incorporate this man's deeds into our parallel lives, and we shall rehearse them truly.[13]

Plutarch found a sympathetic follower in the painter and theorist Jonathan Richardson, who believed that "Painting is another sort of writing, . . . subservient to the same ends as that of her younger sister." Richardson drew one of his many direct parallels between portrait painting and biography in his *Essay on the Art of Criticism*, published in 1719:

> A portrait is a sort of general history of the life of the person it represents, not only to him who is acquainted with it, but to many others, who upon occasion of seeing it are frequently told, of what is most material concerning them, or their general character at least; the face; and figure is also described and as much of the character as appears by these, which oftentimes is here seen in a very great degree.[14]

In his characteristically rambling manner, Richardson (like Plutarch) isolates what is perhaps the central affinity between these two arts: at its best, a portrait, like the "general history" of a life, represents not only a faithful likeness of its subject but an expression of character as well. Individualized character will appear through the painter's handling of face and figure; the appeal of this portrait, moreover, will extend not only to those who are acquainted with the person it represents, but also to those strangers who see "of what is most material concerning them." In its ability to reveal general human qualities, the portrait—like the history of an individual—has the

potential to rise above the particular circumstances that gave it birth.

Richardson focuses on the moral aspect of portraiture more directly in his *Essay on the Theory of Painting* (1715): "Upon the sight of a Portrait, the Character, and Master-strokes of the History of the Person it represents are apt to flow in upon the Mind. . . . So that to sit for one's Picture, is to have an Abstract of one's Life written, and published, and ourselves thus consign'd over to Honour, or Infamy."[15] It is thus not enough for a painter to produce a canvas that is "prodigious Like" the original; he must "enter into their Characters, and express their Minds as well as their Faces. . . ."[16] And because most of the subjects he draws will be men of accomplishment and social standing, he too must learn to think as a gentleman. Once again he draws a direct comparison between the tasks of the painter and the writer: "*Painting* gives us not only the Persons, but the Characters of Great Men. The Air of the Head, and the Mien in general, gives strong Indications of the Mind, and illustrates what the Historian says more expressly, and particularly. Let a Man read a Character in my Lord *Clarendon*, (and certainly never was there a better Painter in that kind) he will find it improv'd by seeing a Picture of the same Person by *Van Dyck*."[17] Later, in *The Science of a Connoisseur* (1719), Richardson will again invoke Clarendon as a representative verbal portraitist, this time in the context of the improved countenance that the painter also strives to achieve: "a character by my lord Clarendon" is nature, "but it is nature very differently managed."[18]

When Richardson refers to Clarendon's characters, he suggests both their affinities with portraits and their possible improvement through visual illustration. This second point is particularly appropriate because Clarendon, like Walton, took little interest in the outward appearances of men; or, when he did, he usually created a visual impression only to draw a forceful contrast between a man's internal and external characteristics. In his character of the Earl of Arundel, for instance, Clarendon writes that "It cannot be denied, that he had in his person, in his aspecte and countenance, the appearance of a greate man, which he præserved in his gate and motion. He wore and affected a habitt very different from that of the tyme, such as men had only beheld in the pictures of the most considerable men, all which drew the eyes of most and the reverence of many towards him, as the image and representative of the primitive nobility,

and natife gravity of the nobles, when they had bene most venerable." But Clarendon adds that "this was only his outsyde, his nature and true humour beinge so much disposed to levity, and vulgar delights, which indeede were very despicable and childish."[19] This does not mean, however, that Clarendon was unaware of the similarities between biography and portraiture, nor uninterested in the great portraits that were being painted by Van Dyck and Lely: "portraiture was one of his passions, though he left its practice to the painters."[20] With the assistance of John Evelyn, Clarendon in fact accumulated one of the largest and most impressive collections of portraits of "our Antient & Modern *Witts, poets, philosophers* famous & learned English-men."[21]

Most character writers of the seventeenth century did, however, draw prominent attention to the visual appearance of their subjects. In his character of James I, Sir Anthony Weldon begins by stating that "This Kings Character is much easier to take then his Picture, for he could never be brought to sit for the taking of that, which is the reason of so few good peeces of him; but his Character was obvious to every eye," and Weldon proceeds to analyze that character by examining the external countenance of the king.[22] Halifax's character of Charles II opens in similar fashion, but with an increased self-consciousness of the parallel between the two arts: "A Character differeth from a Picture only in this, every Part of it must be like, but it is not necessary that every Feature should be comprehended in it as in a Picture, only some of the most remarkable."[23] This is in fact a fairly accurate description of the limited scope of the character sketch, which, as its name suggests, seizes only those "remarkable" features that reveal the essential character of a person. But Halifax's character of Charles II is not as selective as it might at first appear. Halifax raises searching questions about the king, and he modifies his own responses so often that the final portrait he draws is intriguingly complex. And if he accomplishes this by occasionally "softening" his portrait of the king, he nevertheless does so with a full consciousness of the liberties he has taken: "After all this, when some rough Strokes of the Pencil have made several Parts of the Picture look a little hard, it is a Justice that would be due to every Man, much more to a Prince, to make some Amends, and to reconcile Men as much as may be to it by the last finishing."[24]

One of the prominent features of the seventeenth-century character sketch is that it was written by historians who knew their subjects well, sometimes intimately; and yet because these portraits were rarely published within a writer's own lifetime it is relatively difficult to establish a direct line of influence or descent. But the parallel between the character and the portrait was clearly a strong one, enough so that when John Sheffield, Duke of Buckingham, wrote his own character sketch of Charles II he also began with conscious portraiture. His own picture may be ill drawn, he admits, but the agreeability of its subject will prove it to be more popular "than the best piece of Raphael."[25] Like Halifax, Buckingham intends his character to be objective and balanced, but the sketch shares with other early forms of biography—Walton's *Lives*, for example—a clearly commemorative function. If men are everywhere the same, in the uniformitarian view, then the example of a virtuous person will have a permanent as well as a contemporary value. Like Richardson's portraits, the character will present "an Abstract of one's Life," even if it encapsulates personality traits that are often dramatized within the larger historical work in which it usually appears.

Closely allied with the commemorative function of the character or portrait is the biographer's or artist's impulse to preserve the essential features of historical character. After the death of Colonel John Hutchinson, for instance, his widow Lucy completed a character of her husband that was intended to provide consolation for herself and instruction for her children. She includes a full description of her husband for "such of you as have not seene him to remember his person," but she finally concedes that "in all his naturall and ordinary inclinations and composure, there was something extraordinary and tending to vertue, beyond what I can describe, or can be gather'd from a bare dead description. . . ." There was, she states, "a life of spiritt and power in him that is not to be found in any copie drawne from him."[26] It is precisely this sense of frustration at being unable to capture the past fully and permanently—either on paper or canvas—that creates an elegiac as well as a celebratory tone in commemorative portraiture. In biography this elegiac mood is necessarily stronger because the writer, entrusted with the life, must also acknowledge a death that makes his own task all the more difficult. In planning his "Great Biographical Monument"

of Johnson, Boswell often cast himself in the role of an embalmer: "I tell every body it will be an Egyptian Pyramid in which there will be a compleat mummy of Johnson that Literary Monarch." [27] In the *Life* itself Boswell laments that had Johnson's "other friends been as diligent and ardent as I was, he might have been almost entirely preserved." [28]

A more complete preservation could be accomplished, of course, by combining portraits with written narratives, and the models for this kind of composite art are the second edition of Vasari's *Vite* (1568) and Perrault's *Les Hommes Illustres*, published in 1696 and translated into English in 1704 (but lacking the engraved portraits). [29] This joint appearance of portraiture and biography was a feature of a few English books in the eighteenth century, such as Thomas Birch's *Heads of Illustrious Persons of Great Britain* (1743), but the more popular form combining the two arts is one that continues to flourish today, in which the portrait of a writer serves as the frontispiece to his own work or to a book written about him. This is a practice that became respectable even for living writers by the middle of the seventeenth century: Milton, displeased with William Marshall's engraved portrait of him for the *Poems* of 1645, appended four lines in Greek that pointed out the artist's incompetence. [30] Later engravings were more accurate (and more flattering), and by the turn of the century the pictorial frontispiece had become an established feature of literary works. As Addison pointed out in the first number of the *Spectator*, "I have observed, that a Reader seldom peruses a Book with Pleasure, 'till he knows whether the Writer of it be a black or a fair Man, of a mild or cholerick Disposition, Married or a Batchelor, with other Particulars of the like nature, that conduce very much to the right Understanding of an Author." [31]

As Addison's remarks imply, the pictorial frontispiece serves merely as an introduction (and perhaps not a fair one at that) to an author's works. In a biography, however, the same frontispiece forms part of a composite function: both the writer and the artist have attempted to preserve the most prominent features of their subject. It was natural for Boswell to choose Reynolds's early portrait of Johnson (plate 5-1) as the frontispiece for his *Life*, for instance, because Reynolds's painting had also served as Boswell's own introduction to Johnson's appearance. He appropriately mentions this portrait during his description of his first meeting with

Johnson, at the shop of Tom Davies: "I found that I had a very perfect idea of Johnson's figure, from the portrait of him painted by Sir Joshua Reynolds soon after he had published his Dictionary, in the attitude of sitting in his easy chair in deep meditation, which was the first picture his friend did for him, which Sir Joshua very kindly presented to me, and from which an engraving has been made for this work."[32] At its best, the pictorial frontispiece emphasizes the way in which biography and portrait painting can be complementary as well as sister arts.

II. The Dilemma of Historical Characterization

Dryden's observations concerning representation in portraiture point directly to the painter's and writer's dilemma. Fidelity to nature compels the artist to balance virtues and imperfections, beauties and blemishes; but the artist may at the same time ennoble nature without entirely counterfeiting it (he or she may "shadow the more imperfect side"). But where, exactly, is the line to be drawn; how does the painter or writer reconcile the contending forces that dictate both faithfulness to the minute particulars of his subject (deficient as they may be) and fidelity to the more general and abstract qualities that define a person's essential nature (and thus his affinities with other men)? In the *Rambler*, Johnson instructed his readers to search for the minute and private circumstances that set a man apart from other individuals; we can learn more about a man's real character, he argued, by studying his conversations with his servants than by perusing a formal narrative that begins with a pedigree and ends with a funeral. But in his own biographies, Johnson seldom practiced what he preached, and when he did so (as in his life of Savage) his success lay more in his general characterization of his friend than in the inaccurate and incomplete particulars he assembled.

The same dilemma is to be found in Richardson. The business of painting, he states, "is not only to represent nature, but to make the best choice of it; nay to raise, and improve it from what is commonly, or even rarely seen, to what never was, or will be in fact, though we may easily conceive it might be."[33] A portrait cannot be too flattering, for "the Character must be seen throughout, or it ceases to be a Compliment";[34] but, like Reynolds after him, Richardson argues that something must be left to the

imagination. The paradox here, however, lies in the unimaginative nature of Richardson's own portraits, which rarely rise above the literal.

The biographer and the portrait painter must both respond to these double—and sometimes contradictory—obligations. The biographer must first satisfy the demands of accuracy and authenticity; only by fulfilling this obligation and then transcending it can he create an imaginative work that will revitalize his subject's character. The same is true of the successful painter of faces: the artist must preserve the individuality of a sitter and yet at the same time enhance it by making it part of a larger pictorial design.[35] This inherent tension between factual accuracy and imaginative shaping is central to both arts because they serve not only as mimetic images but as "indexes" as well: they point directly to their subjects, providing both information and interpretation.[36] In David Piper's perceptive phrase, the painter must "portray, in short, not merely the sitter's identity, but his entity,"[37] and this task is essentially the biographer's as well. Each struggles to create a portrait that is both a historical document and an imaginative work of art.

Considered either as an imaginative or as a documentary work, each portrait or biography is influenced by at least three contending forces: by its subject, by its maker, and by aesthetic conventions that are closely associated with moral or social conduct and hence with the artist's attempt to please and edify a particular audience.[38] Each of these forces is capable of reflecting the tension between the general and the particular, between imaginative shaping and factual documentation. The subject of the work, for instance, may be an imposing figure who necessarily forces his or her own character on the painter or writer (one thinks immediately of Boswell's and Reynolds's portraits of Johnson). On the other hand, the sitter may be an inconsequential figure who is all too easily lost in the characteristic poses and attitudes of the times; and even a forceful subject may, like Cromwell, insist that he be portrayed as plainly and accurately as possible.

The artist brings a similar degree of pressure to bear upon his work. Johnson, considered now as an author, dominates many of the biographies he wrote in the sense that what we find of most significance and weight in these narratives are his opinions and evaluations of other men, or his own affinities with the men whose

lives he chronicles (one thinks of his lives of Barretier and Boerhaave, or of Hogarth's portraits of Bishop Hoadly and Captain Coram). But the artist may, on the other hand, aspire to play an essentially objective role (like Samuel Cooper, the painter of miniatures, or John Aubrey, who compiled small, factual portraits to be used in other writers' works).[39] To a certain extent each work of biography or portraiture represents a struggle between its subject and its maker as well as between the demands of documentation and art.

Both the subject and the artist may, however, find themselves overshadowed by the force of convention. In Walton's *Lives*, for instance, we encounter both imposing biographical subjects and a characteristic authorial style; but these sketches are predominantly ruled by biographical conventions that are related both to hagiography and to the popular characters that were built upon various psychological types. Walton occasionally supplies us with the particulars of his characters' lives, but his emphasis is primarily on the exemplary type in which his particular character is cast and against which it must finally be measured. The same kind of uniformity can be found in portrait painting in the 1630s and 1640s: our response to a Van Dyck canvas is often less to an individualized subject than to a highly stylized—even stereotyped—reflection of a general courtly attitude, replete with uniform backgrounds and standard poses. Even the various beauties painted later in the century by Lely and Kneller have their own iconography, each cast in the role of a mythological character or exemplifying an abstract virtue.[40]

But aesthetic conventions change with the societies they reflect, and it is also possible to chart a movement away from emblematic representation and toward a more natural and particularized characterization of individuals. Reynolds may have achieved that general and ennobling characterization about which Richardson could only theorize, but his success nevertheless depended heavily on his reformation of an art addicted to stock poses and stale attitudes. If a person's distinctive character was to be portrayed, it could be depicted—like Admiral Keppel's—in action, in a specific place, reflecting a particular moment. In England, perhaps only in the work of Reynolds and Boswell do we finally discover a concern with individualized character that rivals and ultimately subordinates these other influential forces.

III. Distinctions

The statements painters and biographers make about the limitations of their own genres throw both their similarities and their differences into high relief. In a character of Johnson prepared for Boswell while he was writing his *Life*, Reynolds pointed out what he thought were the major restrictions of portraiture:

> The habits of my profession unluckily extend to the consideration of so much only of character as lies on the surface, as is expressed in the lineaments of the countenance. An attempt to go deeper and investigate the peculiar colouring of his mind, as distinguished from all other minds, nothing but your earnest desire can excuse the presumption even of attempting.[41]

Reynolds certainly underestimates his own habits and interests here, even if he deftly characterizes the limited powers of his contemporaries. A painter of Reynolds's stature does not search for "so much only of character as lies on the surface"; he attempts to reveal as much of the complexity of his subject's character as he can in his own representation of his sitter's appearance. But even granting this distinction, it is still clear that Reynolds considered the distinguishing features of *mind* to be the proper subject of biography rather than portraiture.

Writing in his journal in 1775, Boswell noted corresponding limitations in his own art:

> The great lines of characters may be put down. But I doubt much if it be possible to preserve in words the peculiar features of mind which distinguish individuals as certainly as the features of different countenances. The art of portrait painting fixes the last, and musical sounds with all their nice gradations can also be fixed. Perhaps language may be improved to such a degree as to picture the varieties of mind as minutely. In the mean time we must be content to enjoy the recollection of characters in our own breasts, or by conversation and gestures with people acquainted with the particular persons as much as we are.[42]

These two statements are strikingly similar, and their importance is all the greater when we consider that this common sense of deficiency was experienced by the two eighteenth-century artists who were best able to convey the distinguishing features of historical character. The point Boswell makes most forcefully concerns

the comparative precision and permanence of painting. Although portraits may only distinguish the different features of countenance, at least they do so with an assurance and finality that Boswell finds lacking in biography. As Johnson had remarked in the *Rambler*, "the incidents which give excellence to biography are of a volatile and evanescent kind, such as soon escape the memory, and are rarely transmitted by tradition."[43]

We need not look far for other important distinctions between these two arts. Most portraits, for example, are painted of men and women who are still living, who are usually, in fact, portrayed at a triumphant stage in their careers. Portraits are usually commissioned by the sitter—or by those who wish to honor him or her—and thus considerable pressure is often brought to bear on the painter to be as flattering as possible. But a portrait that is too flattering, as Richardson pointed out, will soon lose its credibility; and Johnson, in any case, bluntly remarked that the same pressures affect biography: "He that writes the life of another is either his friend or his enemy, and wishes either to exalt his praise or aggravate his infamy. . . ."[44] A portrait, moreover, need not be taken from the life, nor even presented to the person it represents. Johnson probably did not sit for Reynolds's second portrait of him, completed in 1769, which represented a more idealized version than the earlier "Dictionary Johnson" portrait of 1756. The full-length sketches we have of Pope were clandestinely drawn and secretly circulated.[45] But it is nevertheless true that a portrait is more "occasional" than a biography: it can mark both a special event and a specific age in the sitter's life. Biographies, on the other hand, almost always celebrate—or at least chronicle—the dead. We sense a fullness and a perspective in biography that are lacking in portraiture: the *oeuvre* or career is complete; the lives often close with miscellaneous tributes, even inscriptions from the tomb.

One of the occasions a portrait captures is the sitting itself; biographical subjects, on the other hand, rarely stand still. The degree of self-consciousness is thus greater in the creation of portraiture: the sitters usually know that their portrait is being painted, and that they are officially posing for it. The self-consciousness forced upon the sitter in this arrangement is nicely captured in James's *The Europeans*, where Felix Young's request to paint his Bostonian uncle's portrait brings his uncle an unwelcome and uncomfortable moment of self-awareness:

"I should like to do your head, sir," said Felix to his uncle one evening, before them all. . . . "I think I should make a very fine thing of it. It's an interesting head; it's very mediæval."

Mr. Wentworth looked grave; he felt awkwardly, as if all the company had come in and found him standing before the looking-glass. "The Lord made it," he said. "I don't think it is for man to make it over again."

"Certainly the Lord made it," replied Felix, laughing, "and he made it very well. But life has been touching up the work. It is a very interesting type of head. It's delightfully wasted and emaciated. . . . You have been very—a—very moderate. Don't you think one always sees that in a man's face?"

"You see more in a man's face than I should think of looking for," said Mr. Wentworth coldly.[46]

This heightened self-consciousness is not restricted to portraiture, however, even if it is more predominant there; it can also be found in biography, and in the relationship between the biographer and his subject. The most famous example is of course Boswell, who by 1768 had received Johnson's permission to publish his letters posthumously, and who by 1772 was entertaining "a constant plan to write the *Life* of Mr. Johnson."[47] Johnson was therefore in effect "sitting" for his portrait—at first unconsciously, later fully aware of Boswell's designs—until his death in 1784. We must therefore consider Boswell's manipulation of major events and scenes in these years in a double context: when Boswell drew Johnson out on fanciful subjects—as in their tour of the Hebrides—or when he forced Johnson into uncomfortable situations—the dinner at Dilly's, or the prolonged conversation with Edwards—he was both learning about Johnson's character and at the same time manufacturing episodes that would be dramatically re-created in the *Life*. And in the process of understanding Johnson, Boswell was himself learning best how to portray his friend in the biographical mode Johnson favored.[48]

IV. Spatial and Temporal Design

It could also be argued that portrait painting is a more fully mimetic or "iconic" art than biography; its representation of its subject is both more palpable and more immediate.[49] A portrait is a more readily identifiable image of its subject; it strikes the viewer with what Richardson called "velocity," and produces its effects, Reynolds added, at "a single blow."[50] Dryden also recognized this

distinction in his "Parallel Betwixt Painting and Poetry": "I must say this to the advantage of painting, even above tragedy, that what this last represents in the space of many hours, the former shows us in one moment. The action, the passion, and the manners of so many persons as are contained in a picture are to be discerned at once, in the twinkling of an eye. . . . "[51]

But this iconic immediacy may also have its disadvantages. Boswell was impressed by the way in which the features drawn in a portrait were firmly "fixed," but he might also have pointed out that this very act of fixing character must exclude the dramatic, conversational, and temporal elements that would most enliven his own work. By achieving its iconic effects more quickly and directly, the portrait imposes strict limitations upon its ability to represent a character's development, inconsistencies, or complexity. Like the character sketch, the portrait attempts to encapsulate the essence of its subject; but unlike the character, it freezes its subject at a particular time. As Richardson noted, "In Picture we never die, never decay, or grow older."[52]

This distinction has recently been stressed by critics who object to any casual comparison of these two arts. Jean Starobinski argues that "Biography is not portrait; or if it is a kind of portrait, it adds time and movement. The narrative must cover a temporal sequence sufficiently extensive to allow the emergence of the contour of life."[53] This same point is made by Georges May in his discussion of autobiography and self-portraiture: "Entries in a diary, or . . . texts of the kind of Montaigne's disconnected, probing looks at himself, are more akin to self-portraits than to autobiography. The reason for this statement is that, in order fully to deserve its name, autobiography must, like biography, encompass an entire life, or at least a good part of a life. Short of this, a crucial element is missing, namely the experience of the passing of time."[54]

Comments such as these reflect the fundamental difference that exists not only between biography and portrait painting, but between any literary (temporal) and visual (spatial) art. This dichotomy has been drawn most stringently by Lessing in his *Laocoön* (1766), where he argues that painting combines its symbols in space only, and poetry its symbols in time.

> I reason thus: if it is true that in its imitations painting uses completely different means or signs than does poetry, namely figures and colors in space rather than articulated sounds in time, and if these signs must

indisputably bear a suitable relation to the thing signified, then signs exist-
ing in space can express only objects whose wholes or parts coexist, while
signs that follow one another can express only objects whose wholes or
parts are consecutive.

 Objects or parts of objects which exist in space are called bodies. Ac-
cordingly, bodies with their visible properties are the true subjects of
painting.

 Objects or parts of objects which follow one another are called ac-
tions. Accordingly, actions are the true subjects of poetry.[55]

How then does the poet, for instance, describe any complex body
or object? Lessing argues that the poet does so by representing
the object in the process of being formed: "Homer does not paint
the shield [of Achilles] as finished and complete, but as a shield
that is being made . . . transforming what is coexistent in his sub-
ject into what is consecutive, and thereby making the living picture
of an action out of the tedious painting of an object."[56]

The rigidity of Lessing's distinctions has continually been at-
tacked, and modern commentators in particular have attempted to
temper his conclusions by emphasizing the role of spatial form in
literary works. W. J. T. Mitchell has recently modified Joseph
Frank's pioneering work on spatial form in modern literature by
arguing that "far from being restricted to the features which Frank
identifies in those works (simultaneity and discontinuity), spatial
form is a crucial aspect of the experience and interpretation of
literature in all ages and cultures."[57] We rely on spatial conceptions
in order to tell time, to order plots, to construct images, and to
map out "temporal or other organizational patterns in any work of
literature." This method of analysis has interesting applications for
biography if we consider the importance of setting and locale (John-
son's London for example), or if we give full weight to Boswell's
portrayal of Johnson within a tightly defined "circle" of friends.[58]
We should also notice that temporal and spatial conceptions often
merge in the terminology we use to indicate the artist's attitude
toward his subject, especially the biographer's or painter's "per-
spective" or "point of view." The temporal and the spatial are also
united in the conception of a "prospect," as in "A Distant Prospect
of Eton College," where Gray's distance is measured both in years
and in miles. Boswell captures this fusion of spatial and temporal
motifs early in his *London Journal* when he simultaneously views
London from Highgate Hill and rejoices in his "certain prospect of
happy futurity."[59]

It is perhaps more difficult to analyze temporal design within the plastic arts, especially in a "pure" portraiture in which there is no historical or allegorical action. But it is nevertheless clear that any graphic work invokes both a "time of contemplation" (akin to "reading time" in literature) and an "intrinsic" time that is inherent in the texture itself of a picture, in its composition, or in its aesthetic arrangement.[60] This intrinsic time—which Etienne Souriau calls the "prerogative moment" and Reynolds characterizes as the sublime, single blow—may obviously be linked with past and future moments in a harmoniously continuous movement, or it may be strikingly divorced from any sense of temporal continuity. In either case the selection of the individual moment is a crucial one. "A painter must compensate the natural deficiencies of his art," Reynolds told his students. "He has but one sentence to utter, but one moment to exhibit. He cannot, like the poet or historian, expatiate, and impress the mind with great veneration for the character of the hero or saint he represents."[61]

The portrait painter must therefore make the best use of the single moment that is his. The artist may wish to capture a distinct and significant moment in a subject's life, similar to the "breakthrough" stage that is associated with crucial episodes in biography or autobiography,[62] or may choose to suspend time by creating an idealized portrait in which the subject is released from temporal contingencies. These alternatives can be seen in two well-known paintings by Reynolds. In Reynolds's first portrait of Johnson (plate 5-1), we find the painter depicting his subject at a moment that clearly marked a watershed in Johnson's career. The portrait was finished in 1756; a year earlier Johnson had published his monumental *Dictionary of the English Language*, which was to serve as the foundation of his literary reputation.[63] Reynolds consequently portrays Johnson as a writer: he sits at a small table with pen and paper in hand; his head, slightly tilted, reflects the tradition of portraying literary men, especially poets, in a moment of creative reverie.

But if Reynolds succinctly captures a specific moment in Johnson's career, there is also a certain temporal ambiguity in the portrait: what, exactly, is Johnson composing here? One commentator has suggested that the picture is a "portrait of the Lexicographer as poet on the brink of the perfect definition,"[64] but how can this be true if the *Dictionary* itself has already been published? (The *Dictionary*, an inkstand, and a larger table were in fact added to the painting

sometime before Boswell had it engraved for the *Life of Johnson*.)[65]
Surely more than one moment of time is implied in this portrait,
even if Johnson is not portrayed at work on the *Dictionary* itself.
Reynolds portrays his friend as he appeared in the middle of the
decade, but he simultaneously emphasizes the process of writing
that links this specific moment with the broader contour of John-
son's life. In Lessing's terms, it is both a portrait of a significant
moment with coexistent images, and a portrait of the consecutive
activity that makes this particular achievement possible.

Reynolds manipulates temporal (and spatial) design quite differ-
ently in his portrait of *Mrs. Siddons as the Tragic Muse* (plate 5-2).[66]
This painting suggests a particular time only in the sense that it
represents Sarah Siddons as the reigning queen of the English stage.
She is not, however, portrayed in a specific role, nor is she even por-
trayed *as herself* in 1784. Instead she is shown personifying the
tragic muse, both the Melpomene of earlier portraiture and the
tragic spirit in general. Reynolds attempts to elevate her above the
ordinary circumstances of life: "the whole beauty and grandeur of
the art consists, in my opinion, in being able to get above all singular
forms, local customs, particularities, and details of every kind."[67]
He therefore portrays her in a traditionally regal pose, situated
upon a conventionally lofty throne, surrounded by the icono-
graphical figures of tragedy (Pity and Fear), and impersonating a
generalized, archetypal figure. The cloudy foreground of the paint-
ing, and the equally indeterminate background (are the figures at-
tendants or statues?), reveal an intentional suppression of any dis-
tinct spatial design that would divert attention from the central
figure. In similar fashion, time appears to have been abolished
here, or at least infinitely extended. Reynolds suggests the transcen-
dence of his figure by portraying her "out of herself," having relin-
quished her own individuality as she takes on a more ambitious role.
Reynolds in fact uses the equivalence (or equivocation) of "as"
here as one possible solution to the dilemma of representing his-
torical character (his subject is Sarah Siddons, and yet it is not).[68]
But for all of his emphasis on ideal characterization in this famous
portrait, Reynolds still manages to depict an individual character,
appropriately captured in the dramatic activity that gave Siddons
her distinctive vitality.

In neither of these portraits, however, can Reynolds completely
suggest the actual development of character or even the gradual

unfolding of unchanging characteristics. If we wish to sense "the experience of the passing of time" we must turn to a series of portraits of the same character, painted at different times in his career, such as Reynolds's three portraits of Keppel or his five paintings of Johnson. But even here Reynolds apparently sensed that he could not entirely capture the essential features of his subject; it is significant that he wrote not only a character sketch of Johnson but several typical (if imaginary) Johnsonian conversations as well. Perhaps only in the final fusion of portraits and biography can the complexity and immediacy of character be fully portrayed. Boswell, as we have seen, was eager to have the 1756 portrait of Johnson engraved as the frontispiece for his biography; his modern editors, Hill and Powell, have taken his suggestion one step further by reproducing all of Reynolds's portraits of Johnson (and one of Boswell) as frontispieces for their six-volume edition of the *Life*.

The limitations of temporal form in portraiture have their counterpart, moreover, in the restrictions placed upon spatial form in biographical works. Boswell's visual metaphors for the *Life* are well known: in his journal he noted that "I draw him in the style of a Flemish painter. I am not satisfied with hitting the large features. I must be exact as to every hair, or even every spot on his countenance," and in the *Life* itself he wrote that even a trivial detail might serve as "a small characteristick trait in the Flemish picture which I give of my friend, and in which, therefore, I mark the most minute particulars."[69] But we must remember, in spite of this prominent and intriguing metaphor, that Boswell's full-dress portraits of Johnson are not *visually* minute. Neither are the images he creates to convey a sense of the distinctiveness of Johnson's mind. Here, for instance, is one of Boswell's most famous descriptions, embedded in a moving discussion of Johnson's fear of death:

> His mind resembled the vast amphitheatre, the Colisæum at Rome. In the centre stood his judgement, which, like a mighty gladiator, combated those apprehensions [of death] that, like the wild beasts of the *Arena*, were all around in cells, ready to be let out upon him. After a conflict, he drove them back into their dens; but not killing them, they were still assailing him.[70]

Surely this episode, in which Boswell maintains (against Johnson himself) that the fear of death filled his friend with "dismal apprehensions," is one of the most successful in Boswell's entire

narrative. But Boswell's metaphor is detailed only in the sense that it invokes a specific image—the Roman coliseum—that is subsequently broken down into its smaller (but more frightening) components: those compartmentalized cells that house the wild beasts of Johnson's imagination. The primary emphasis in this passage falls on more general notions of danger, combat, and heroism that the mere mention of the coliseum evokes ("We who are about to die salute you"). Boswell explicitly chooses a "vast" image to convey his own sense of Johnson's grandeur; to borrow Carlyle's phrase, he depicts Johnson as "Brave old Samuel: *ultimus Romanorum!*"[71] We have already seen that Boswell intended to raise a biographical "Monument" in Johnson's honor; here we view him portraying Johnson himself as a monument of equal stature.

Even a specific and complex spatial image, in other words, can be counted upon to raise traditional, abstract associations in the reader's mind; and the tension Boswell suggests in his visual metaphor—between the judgment and its apprehensions—is also the product of a temporal scheme in which this scene of psychological combat is one of perpetual strife. Boswell's careful choice of tenses emphasizes his conviction that Johnson, successful as he may be in any single encounter with these fears, must content himself with victories that are temporary at best: Johnson "ever looked upon" this subject with horror; his judgment "combated" those apprehensions that "were all around" in cells; he "drove" them back, "but not killing them, they were still assailing him." Boswell's metaphor thus insists that Johnson's fears are constantly present, in spite of the finality of Johnson's pronouncements in his writings (written when he was "in a celestial frame") and in conversation with his intimate friends: "'The act of dying is not of importance, it lasts so short a time.' He added, (with an earnest look,) 'A man knows it must be so, and submits. It will do him no good to whine.'" Even the conclusion of this passage bears out Boswell's characterization of his friend. When Boswell attempts to continue their conversation, Johnson, knowing that further talk will only revitalize his own fears, abruptly terminates their meeting: "'Give us no more of this; . . . Don't let us meet to-morrow.'"

Boswell's strategy in this powerful passage corroborates what Paul Alkon and others have skillfully drawn attention to in the *Life of Johnson* as a whole: Boswell manipulates both spatial and temporal design to produce a portrait of Johnson that is both static

and complex.[72] If Boswell views his subject with a painter's eye, he nevertheless suppresses any exact description that might distract the reader-viewer from the importance of his central image. Just as Reynolds's most pronounced effects in his portrait of Johnson are produced by spatial design—the construction of strong masses and lines, the play of light and shadow, the implied tension between a relaxed and an exercised hand or a focused and a vacant eye— so Boswell's most distinctive experiments lie in his handling of time, especially in his attempt to re-create the experience of accompanying Johnson throughout his life. Biography is iconic not so much in the visual metaphors it creates as in its emphasis on conversation, in its dramatization of action, and in its ability to provide a sense either of the passing of time or of an emotion fearfully and perpetually present. It is largely through these devices that the biographer approaches what Hagstrum has described as rhetorical *enargeia*: "the ability of the writer to achieve palpability, to make readers believe that objects, persons, and scenes actually appeared before their eyes."[73]

Thus in this famous scene Boswell makes Johnson come alive for us by letting us know how greatly Johnson's abrupt behavior has upset him. He tells us that Johnson "was thrown into such a state of agitation, that he expressed himself in a way that alarmed and distressed me." Johnson's apprehensions of death are thus balanced by Boswell's own fears that he has offended his friend—that he might even lose his intimate footing with him—and his description of his own predicament extends the metaphor with which he has already portrayed Johnson's: "I seemed to myself," he writes, "like the man who had put his head into the lion's mouth a great many times with perfect safety, but at last had it bit off." In this new scenario, Johnson becomes the lion and Boswell—the perpetual lionizer—becomes the gladiator. And it is precisely this quality of dramatic reenactment and even emotional transference that charges Boswell's narrative with the immediacy and palpability that he considered to be the preeminent qualities of biography's sister art.

I raise these qualifications not to dismiss the importance of spatial design in biography—or temporal design in portraiture—but to put each in its proper perspective. Souriau has argued that because time is the "palpable stuff" of literature and the performing arts, it is therefore aesthetically more important in sculpture or paint-

ing.[74] My own fear, however, is that this kind of reasoning, pushed too far, will slight the essential mode in which each artistic form functions. Like all verbal and visual arts, biography and portrait painting necessarily suffer from the inherent restrictions of their forms; but each aspires to create fully fledged characters by exploiting both temporal and spatial properties. The biographer normally attempts to disclose character by showing his subject within a sequence of events; similarly, the painter normally reveals depth of character by placing his subject within a carefully contrived spatial design. At times the two forms will almost merge. The painter may introduce literary motifs into his canvas, suggest a past and a future for his characters, and even make these explicit in a series of portraits that rivals the carefully differentiated episodes in a biographical text. The biographer may emphasize appearance and setting, create central visual images and analogies, and disrupt his chronology by employing spatial form; like Jonathan Richardson (in his life of Milton) he may even combine a written narrative with a visual characterization of his subject. Both arts, in other words, will attempt to compensate for their own inherent limitations. But the most distinctive similarity between biography and portrait painting—the relationship that most fully justifies thinking of them as sister arts—lies in their central focus on human identity and achievement, and in their different if complementary ways of representing historical character.

Notes

1. *The Rambler*, ed. W. J. Bate and Albrecht B. Strauss, *The Yale Edition of the Works of Samuel Johnson*, vol. 3 (New Haven: Yale Univ. Press, 1969), p. 323 (*Rambler* No. 60).

2. Jean H. Hagstrum, *The Sister Arts: The Tradition of Literary Pictorialism and English Poetry from Dryden to Gray* (Chicago: Univ. of Chicago Press, 1958), p. 9.

3. Ibid., p. 6.

4. *Aristotle on the Art of Poetry*, ed. Ingram Bywater (Oxford: Clarendon Press, 1909), 1450b. 1-3, 1454b. 9-11.

5. *"Of Dramatic Poesy" and Other Critical Essays*, ed. George Watson (London: Dent; New York: Dutton, 1962), II, 184. Hereafter cited as Watson.

6. "To Sir Godfrey Kneller," ll. 112-14, *The Poems of John Dryden*, ed. James Kinsley (Oxford: Clarendon Press, 1958), II, 861.

7. Watson, II, 202.

8. *Poetics* 1454b. 10-11.

9. Watson, II, 184. Dryden actually concludes his "Parallel" by comparing his own incomplete essay with a more ambitious study of the two arts: "But if I have really drawn a portrait to the knees, or an half-length, with a tolerable likeness, then I may plead, with

some justice to myself, that the rest is left to the imagination. Let some better artist provide himself of a deeper canvas, and taking these hints which I have given, set the figure on its legs, and finish it in the invention, design, and colouring'' (II, 208).

10. "Alexander," I. 2-3, in *Plutarch's "Lives,"* trans. Bernadette Perrin (Cambridge, Mass.: Harvard Univ. Press; London: Heinemann, 1919), VII, 224-25.

11. See Alan Wardman, *Plutarch's "Lives"* (Berkeley and Los Angeles: Univ. of California Press, 1974), pp. 25-26.

12. Cicero, "Pro Archia Poeta," 30, in *The Speeches*, trans. N. H. Watts (Cambridge, Mass.: Harvard Univ. Press; London: Heinemann, 1923), pp. 38-39; Isocrates, "Evagoras," 73-77, in *Isocrates*, trans. Larue Van Hook, III (Cambridge, Mass.: Harvard Univ. Press; London: Heinemann, 1945), 44-47.

13. "Cimon," II.2-4, in *Plutarch's "Lives,"* trans. Perrin, II (1914), 408-11. In the following passages, which are presumably indebted to Aristotle, Plutarch discusses ideal and faithful characterization in painting and biography. For more modern discussions of the parallel between biography and portrait painting, see, in addition to Steiner (cited below, n. 36), André Maurois, *Aspects of Biography*, trans. Sydney Castle Roberts (New York: Appleton, 1929), pp. 50, 110, 176-77, and Leon Edel, "The Figure Under the Carpet," in *Telling Lives: The Biographer's Art*, ed. Marc Pachter (Washington, D.C.: New Republic Books and the National Portrait Gallery, 1979), pp. 16-34.

14. *Works* (Strawberry-Hill ed., 1792), p. 119.

15. *An Essay on the Theory of Painting*, 2nd ed. (London, 1725; rpt. Menston, Yorkshire: Scolar Press, 1971), pp. 13-14.

16. Ibid., p. 22.

17. Ibid., p. 10.

18. *Works*, p. 177.

19. *Characters from the Histories & Memoirs of the Seventeenth Century*, ed. David Nichol Smith (Oxford: Clarendon Press, 1918), p. 31. Hereafter cited as Smith.

20. Smith, p. xliv.

21. *The Diary of John Evelyn*, ed. E. S. de Beer (Oxford: Clarendon Press, 1955), III, 520.

22. Smith, p. 3.

23. *The Complete Works of George Savile, First Marquess of Halifax*, ed. Walter Raleigh (Oxford: Clarendon Press, 1912), p. 187.

24. Ibid., p. 206. For a more complete analysis of Halifax's sketch, see my article on "Dryden, Charles II, and the Interpretation of Historical Character," *Philological Quarterly* 56 (1977): 82-103, from which my remarks on Dryden are also adapted.

25. *The Works of John Sheffield . . . Duke of Buckingham*, 3rd ed. (London, 1740), II, 75.

26. Smith, pp. 294, 156-57.

27. *The Correspondence and Other Papers of James Boswell Relating to the Making of the "Life of Johnson,"* ed. Marshall Waingrow (New York: McGraw-Hill, n.d. [1969]), p. 96. On Boswell as preserver, see Paul Alkon, "Boswellian Time," cited below (n. 72).

28. *Boswell's Life of Johnson*, ed. G. B. Hill, rev. L. F. Powell (Oxford: Clarendon Press, 1934-50; 2nd ed., 1964), I, 30. Hereafter cited as *Life*.

29. See T. S. R. Boase, *Giorgio Vasari: The Man and the Book*, Bollingen Series 35, No. 20 (Princeton: Princeton Univ. Press, 1979), pp. 66-72, and Einur Rud, *Vasari's Life and Lives: The First Art Historian* (London: Thames and Hudson, 1963), pp. 15-21. For a recent work modeled on Perrault, see Rémy G. Saisselin, *Style, Truth and the Portrait* (Cleveland: Cleveland Museum of Art, n.d. [1963]).

30. See David Piper, "The Development of the British Literary Portrait up to Samuel Johnson," *Proceedings of the British Academy* 54 (1968; pub. 1970): 51-72.

31. *The Spectator*, ed. Donald F. Bond (Oxford: Clarendon Press, 1965), I, 1.

32. *Life*, I, 392.

33. *The Science of a Connoisseur*, in *Works*, p. 176.

34. *An Essay on the Theory of Painting*, p. 79.

35. See Ralph W. Rader, "Literary Form in Factual Narrative: The Example of Boswell's *Johnson*," in *Essays in Eighteenth-Century Biography*, ed. Philip B. Daghlian (Bloomington: Indiana Univ. Press, 1968), pp. 3-42, and David Piper, *The English Face* (London: Thames and Hudson, 1957), esp. p. 103.

I want to point out that although I occasionally refer in a general sense to the eighteenth-century biographer or portrait painter as "he," there were several important female artists in both fields (especially Hester Thrale Piozzi and Angelica Kauffmann). For a discussion of the problems they often faced, see Germaine Greer, *The Obstacle Race: The Fortunes of Women Painters and Their Work* (New York: Farrar, Straus, and Giroux, 1979), and Richard Wendorf and Charles Ryskamp, "A Blue-Stocking Friendship: The Letters of Elizabeth Montagu and Frances Reynolds in the Princeton Collection," *Princeton University Library Chronicle* 41 (1980): 173-207.

36. See Wendy Steiner, *Exact Resemblance to Exact Resemblance: The Literary Portraiture of Gertrude Stein* (New Haven: Yale Univ. Press, 1978), ch. 1, esp. p. 6.

37. "The Development of the British Literary Portrait," p. 52.

38. I adopt (and adapt) these distinctions from M. H. Abrams's model in *The Mirror and the Lamp: Romantic Theory and the Critical Tradition* (1953; rpt. New York: Norton, 1958), pp. 6-29.

39. See Piper, *The English Face*, p. 118, who points out that Cooper and Aubrey were also close friends.

40. See J. Douglas Stewart, "Pin-ups or Virtues? The Concept of the 'Beauties' in Late Stuart Portraiture," in *English Portraits of the Seventeenth and Eighteenth Centuries* (Los Angeles: William Andrews Clark Memorial Library, 1974), pp. 1-43.

41. Reynolds, *Portraits*, ed. Frederick W. Hilles (London: Heinemann; New York: McGraw-Hill, 1952), p. 66.

42. *Boswell: The Ominous Years, 1774-1776*, ed. Charles Ryskamp and Frederick A. Pottle (London: Heinemann; New York: McGraw-Hill, 1963), p. 168.

43. *The Rambler*, III, 323.

44. *The Idler and the Adventurer*, ed. W. J. Bate, John M. Bullitt, and L. F. Powell, *The Yale Edition of the Works of Samuel Johnson* (New Haven: Yale Univ. Press, 1963), II, 263 (*Idler* No. 84).

45. See William Kurtz Wimsatt, *The Portraits of Alexander Pope* (New Haven: Yale Univ. Press, 1965), pp. 298-99.

46. *The Europeans: A Sketch* (Boston: Houghton Mifflin, 1878; rpt. 1920), pp. 96-98.

47. Waingrow, *The Correspondence . . . of James Boswell*, p. li.

48. Cf. Gertrude Stein's intriguing comment on how Boswell and Johnson both achieved recognition through "merging": Lecture 4, *Narration*; quoted by Steiner, p. 23.

49. I employ the word "iconicism" in Steiner's sense (pp. 12-23): a portrait, unlike a biography, physically resembles its subject; "Writing can never be iconic of a visual object in the same way painting can."

50. Richardson, *The Science of a Connoisseur*, in *Works*, p. 178; Reynolds, *Discourses on Art*, ed. Robert R. Wark (1959; rpt. New Haven: Yale Univ. Press, 1975), p. 65 (Discourse IV).

51. Watson, II, 189.

52. *An Essay on the Theory of Painting*, p. 7.

53. "The Style of Autobiography," in *Autobiography: Essays Theoretical and Critical*, ed. James Olney (Princeton: Princeton Univ. Press, 1980), p. 73.

54. "Autobiography and the Eighteenth Century," in *The Author and His Work: Essays on a Problem in Criticism*, ed. Louis L. Martz and Aubrey Williams (New Haven: Yale Univ. Press, 1978), pp. 323-24. May is criticizing William L. Howarth, "Some Principles of Autobiogaphy," *New Literary History* 5 (1974): 363-81, rpt. by Olney, pp. 84-114.

55. Gotthold Ephraim Lessing, *Laocoön*, ed. Edward Allen McCormick (Indianapolis: Bobbs-Merrill, 1962), p. 78.

56. Ibid., p. 95. For an interesting commentary on this passage, see Hagstrum, p. 19 n.

57. "Spatial Form in Literature: Toward a General Theory," *Critical Inquiry* 6 (1980): 541.

58. Boswell drew attention to this aspect of the book in his subtitle, where he mentioned Johnson's "conversations with many eminent persons" and claimed that he was "exhibiting a view of literature and literary men in Great-Britain, for near half a century, during which he flourished."

59. *Boswell's London Journal, 1762-1763*, ed. Frederick A. Pottle (London: Heinemann; New York: McGraw-Hill, 1950), p. 44.

60. See Etienne Souriau, "Time in the Plastic Arts," *Journal of Aesthetics and Art Criticism* 7 (1949): 294-307. Dryden also considers this "time of contemplation" in his "Parallel" (Watson, II, 189).

61. *Discourses on Art*, p. 60 (Discourse IV).

62. See, for instance, Karl J. Weintraub, "Autobiography and Historical Consciousness," *Critical Inquiry* 1 (1975): 821-48, and May, "Autobiography and the Eighteenth Century," pp. 324-26.

63. For a full discussion of this portrait, to which I am indebted at several points, see Herman W. Liebert, "Portraits of the Author: Lifetime Likenesses of Samuel Johnson," in *English Portraits of the Seventeenth and Eighteenth Centuries*, pp. 50-53.

64. Piper, "The Development of the British Literary Portrait," p. 71.

65. See Bettina Jessell, "A Study of the Paint Layers of a Portrait of Dr. Johnson by Sir Joshua Reynolds P.R.A.," *The Conservator* 5 (1981): 36-40, who reports that "after Johnson's death Reynolds gave the painting to Boswell who apparently employed a painter to add the two volumes, a dictionary and another book, an ink pot with a quill and an arm to the chair." But it is certainly possible, on the other hand, that these additions were painted in Reynolds's own studio, perhaps by Reynolds himself.

66. Of the many important discussions of this painting in the context of Reynolds's theory and practice of portraiture, see in particular those by Robert E. Moore, "Reynolds and the Art of Characterization," in *Studies in Criticism and Aesthetics, 1660-1800*, ed. Howard Anderson and John S. Shea (Minneapolis: Univ. of Minnesota Press, 1967), pp. 332-57, and Robert R. Wark, *Ten British Pictures, 1740-1840* (San Marino: Huntington Library, 1971), pp. 43-57.

67. *Discourses on Art*, p. 44 (Discourse III).

68. Joel Weinsheimer, "Mrs. Siddons, The Tragic Muse, and the Problem of *As*," *Journal of Aesthetics and Art Criticism* 36 (1978): 317-28, argues that "as" marks a "double absence of relation" because a portrait itself is only a likeness. Reynolds certainly creates an intentional distance between his representation and the actual Mrs. Siddons, but the terms in which Weinsheimer defines this distinction are not entirely clear: "as" means similarity or likeness" and a "portrait is a likeness," but these are really two different kinds of similarity. Reynolds is more interested in the tension produced by his audience's realization that there is something *different* about Mrs. Siddons in this painting, and something *familiar* about "The Tragic Muse."

69. *Boswell: The Ominous Years*, p. 103; *Life*, III, 191. For an interesting analysis

of spatial form in the *Life*, see David L. Passler, *Time, Form, and Style in Boswell's Life of Johnson* (New Haven: Yale Univ. Press, 1971), ch. 2.

70. *Life*, II, 106.

71. *On Heroes, Hero-Worship and the Heroic in History*, ed. Carl Niemeyer (Lincoln: Univ. of Nebraska Press, 1966), p. 184.

72. "Boswellian Time," *Studies in Burke and His Time* 14 (1973): 239-56; Passler, pp. 14-15, 32-33, and passim.

73. Rev. of Hugh Witemeyer, *George Eliot and the Visual Arts*, in *Nineteenth-Century Fiction* 34 (1979): 218; see also *The Sister Arts*, esp. pp. 11-12.

74. "Time in the Plastic Arts," p. 307.

6

METAMORPHOSES
OF THE VORTEX
Hogarth, Turner, and Blake

W. J. T. Mitchell

The history of art and literature, indeed of culture itself, is scarcely conceivable apart from a history of images and forms. This history, which Erwin Panofsky calls "iconology," is bounded at one pole by the realm of images, the concrete things or pictorial signs of things that accrue human significance, and at the other pole by forms, the abstract structures or spaces in which images reside. The following essay traces the history of a phenomenon encompassing both poles—what Adrian Stokes called an "image in form"—the configuration of the vortex, or spiral, in the art and literature of the late eighteenth and early nineteenth century in England.[1] Focusing on the art and writing of three major artists of the British school, Hogarth, Turner, and Blake, the essay makes three basic arguments of increasing generality: first, that these three artists regarded the spiral or vortex as a crucial element in the perception and representation of space, and that they saw themselves as clarifying or (in the case of the Romantics) revising its form, function, and meaning in relation to a central tradition in Western aesthetics; second, that the particular interpretations these artists gave to the spiral configuration provides insight into a widely felt historical shift in patterns of conceptualization and representation in the early nineteenth century; and finally, that the story of the vortex can help us to understand the manner in which images have a history that involves their changing significance, not just as representations of objects, but as the under-

lying forms or constitutive structures in which particular images achieve intelligibility.

I. A Phenomenology of the Vortex

Two classic models for the study of "pure" form in art and literature are Henri Focillon's *The Life of Forms in Art* and Georges Poulet's *Metamorphoses of the Circle*. Poulet begins his study of the poetics of the circle by quoting Focillon on the general problem of formal patterns in art:

> These forms, shaped with a powerful precision and as though stamped in some very hard substance, traverse time without being affected by it. . . . What can be altered is the manner in which they are interpreted by the generations which pour into them diverse varieties of content.[2]

Immutable forms contrast with and thus provide us a stable measure that reveals the nature of mutable intentions, interpretation, and content. And yet in practice Poulet's circle seems continually to dominate and abolish history rather than to reveal its nuances, a tendency that is declared in the concluding sentence of his book: "if the history of the circle begins with Parmenides, one can end it with Guillen. With one as with the other, the circle is the form of perfection of being."[3] Is this ahistorical tendency a consequence of Poulet's method of postulating a transcendental consciousness or cogito for each writer he studies? Or is it in the very nature of the form he has isolated for consideration? It is hard to resist the thought that, in this case, the image has infected the method, and that the circle is itself the emblem of Poulet's assumptions about the permanent qualities of the human mind:

> There is no more "accomplished" form than the circle. No form more lasting either. The circle that Euclid describes and the one which modern mathematics traces, not only resemble one another but merge with one another. The dial of the clock, the wheel of fortune, traverse time intact, without being modified by the variations which they register or determine. Each time the mind wants to picture space, it sets in motion a selfsame curve around a selfsame center.[4]

The characteristic geometric and metaphoric properties of the vortex can be defined at least partly by contrast to Poulet's notion of the circle. There is no *less* "accomplished" form than the vortex or spiral; it cannot "last" in any self-identical shape because its very

structure suggests continuous transformation and denial of closure, coiling inward toward a perpetually vanishing center and outward toward a never attained boundary. If the circle evokes the rational spatializing of time represented in the face of a clock, the vortex reminds us of the main-spring, the asymmetrical, kinetic form that cannot "traverse time intact," but changes its shape with every passing moment. It would be tempting to summarize the contrast between circle and spiral as the difference between rational, symmetrical form and irrational, asymmetrical, but the fact is that the spiral is no less accessible to rational inquiry and geometrical analysis than the circle. The spiral simply demands a higher order of abstraction in geometrical intuition, a mode of thinking that sees the world, in Alfred North Whitehcad's words, as "forms of transition" rather than "static forms."[5] The contrast between the circle and the vortex is, in a rather precise sense, emblematic of the historic shift from classic to modern geometry described by the French mathematician Poncelet in 1822:

> the various sensuously possible cases of a figure are not, as in Greek geometry, individually conceived and investigated, but all interest is concentrated on the manner in which they mutually proceed from each other. In so far as an individual form is considered, it never stands for itself alone but as a symbol of the system to which it belongs and as an expression for the totality of forms into which it can be transformed under certain rules of transformation.[6]

The vortex or spiral must be regarded in this light, not as a single, individual form, but as a family or group of forms that describes a continuous series of transformations ranging from two-dimensional S-curves to cylindrical helixes to conical vortices (see figure 6-1). From the standpoint of a synthetic, transformational geometry, notions such as "line," "circle," and "point" may be seen as simple limiting cases of the group of spiral forms: the straight line, for instance, may be seen as an S-curve with infinitesimal curvature, or as the limit toward which an exponential spiral is tending, or (as Nicholas of Cusa first suggested) as the side of an infinitely large circle.[7]

It is not my intention to argue that painters and poets of the nineteenth century were "influenced" by, or even aware of these highly sophisticated changes in mathematical thinking; it strikes me as more likely that any influence went in the other direction. All I wish to suggest here is that it makes sense to speak of "poetics

Figure 6-1. The Family of Vortices or Spirals. (A) The two-dimensional S-curve (cf. Hogarth's Line of Beauty) with the straight line at the left as a limiting case. (B) The balanced S-curve in three dimensions becomes a helix, a spiral wrapped around a cylinder. (C) The conical spiral (cf. Hogarth's Line of Grace). (D) Two versions of the vortex, the figure on the left an Archimedean Spiral, which increases diameter arithmetically, as in the coils of a rope, the figure on the right a Logarithmic Nautilus. From the standpoint of a geometry that studies "forms of transition," straight lines, circles, and points are simply limiting cases in the range of transformations of the vortex.

of geometry," a system of emotional, acculturated associations with certain abstract images or forms, and that this poetics, like the geometry it evokes, has a history that does not end with the well-documented Pythagoreanism of Renaissance art, architecture, music, and poetry.[8]

Although the terms "vortex" and "spiral" denote representative images from the same geometrical family of forms, they have rather distinct connotations, which are reflected in their respective etymologies. The spiral image is, as its origin in the root word "spire" would suggest, generally associated with vertical, upwardly thrusting versions of the form (shoots and "spears" of vegetation, conical and pyramidal forms in geometry and architecture). When grafted to the alien etymology of the Latin "spirare" (to breathe), the term is often applied to the coiling upward motion of smoke of fire "aspiring" to the heavens. With the vortex, on the other hand, the emphasis is on the lateral, rotary aspect of the form, as the etymology (*vertere*, to turn) would indicate. A point of connection with the spiral image is suggested in the related image of the "vertex," the peak of a cone, pyramid, or dome, the point about which a compass rotates. But the vortex itself is, in its root sense, not so much linked with the relatively stable spiraling forms of architecture and

vegetation as with the world of fluids and gases. It denotes the phenomena of whirlpools and whirlwinds, and is thus often linked with scenes of destruction, flux, and dissolution, literally in natural disasters, metaphorically in the "whirlwinds" of political revolution or psychological disorientation. The image has not been exclusively associated with destructive forces, however. It also plays a crucial role in the anti-Newtonian tradition of cosmological physics, serving as a basic structural pattern from Descartes's theory of vorticular planetary motions to Lord Kelvin's theory of vorticular atoms.[9] In general we can say that the vortex has more exotic and controversial overtones than the plain, domestic spiral, carrying suggestions of mystical mathematics, esoteric physics, and vast, dangerous patterns of energy.

Once we become conscious of the whole family of forms typified by spirals and vortices, we realize that there is hardly any realm of our experience in which it does *not* appear in some form. In the world of "external" nature we find it as a structural pattern in macrocosmic forms such as the Great Spiral Nebula and in the sub-microscopic forms of such molecular structures as the double helix of DNA. The spiral is clearly a fundamental configuration in the realm of organic nature; the phenomenon of "phyllotaxis," or spiral leaf formation, has been a focus of botanical research since the eighteenth century. It is hardly surprising, then, that the image of the spiral is so widespread in the visual and plastic arts, appearing with especially prolific luxuriance in highly mannered, virtuosic styles such as Mannerism, Rococo, and Art Nouveau. The image also appears in religious art and architecture as a symbol of the spiral ascent to transcendence, the labyrinthine descent into the under-world, or as a mandala of conflicting energies in the *tai-chi-tu*, the "Great Map of the Poles" popularly known as the "yin-yang" symbol. In modern art, the vortex is clearly an important image for the Expressionist tradition (the painterly maelstroms of Van Gogh and Jackson Pollock immediately spring to mind), and in the English movement known as Vorticism we find it serving as emblem and slogan for poets, painters, sculptors, photographers, and critics of the arts.

It should be clear from this whirlwind tour that the image of the vortex has no "universal meaning," that its interpretation is as protean and flexible as its set of geometrical properties. A primary characteristic of the form, in fact, would seem to be its capacity

for meaninglessness. The image of the spiral is so ubiquitous in art and nature, so flexible in its manifestations, that the form is quite capable of becoming absolutely banal, a merely decorative, ornamental device devoid of special meaning or content. In this guise, I would suggest, we find it in contemporary culture, where Mannerism, Rococo, and Art Nouveau are enjoying strong revivals of interest, and where formerly sacred and numinous versions of the form, such as the *tai-chi-tu* mandala, appear on bumper stickers, levi patches, and in kitsch poster art. I would like to begin the story of the vortex with a period that approached this condition of banality, the age of the Rococo, which loved to display versions of the spiral or arabesque as a visually decorative motif in architecture, interior design, landscape gardening, and as a verbal, temporalized motif in the ornamental, periphrastic strategies of eighteenth-century literature and music. The very ubiquity of the form seems to have provided the conditions for its first systematic isolation and elaboration as a fundamental aesthetic structure, a notion articulated by Hogarth in his *Analysis of Beauty* of 1753.

II. The Line from the Beautiful to the Sublime

Hogarth was fascinated by two versions of the vortex: the two-dimensional S-curve or "Line of Beauty," and the three-dimensional spiral wrapped around a cone, which he called the "Line of Grace" (plates 6-1 and 6-2).[10] The essential value of these forms Hogarth defined as "Variety," a quality of mutable, asymmetrical intricacy that gratifies curiosity or the "love of pursuit," an instinct of both the eye and the mind. Hogarth delights in the serpentine track that leads the eye a merry, elusive chase, or into an elaborate dance through intricate, intervolved mazes that demand oblique, eccentric points of view. The spiraling lines or "threads" define both the tactile contours of physical bodies and the track of the eye over them, and are located most "naturally" in the human figure itself, especially the female form, disposed in the graceful S-curve of the *contrapposto*. But they are also found to be the essence of our aesthetic pleasure in landscape (hence, the famous serpentine path or river that winds through the prospect of the typical English garden—see plate 6-3). The waving, sinuous, *figura serpentinata* is also identified as the source of beauty in movement, "attitude" or gesture, and in the mental and verbal pleasures of reading:

> It is a pleasing labour of the mind to solve the most difficult problems; allegories and riddles, trifling as they are, afford the mind amusement: and with what delight does it follow the well-connected thread of a play, or novel, which ever increases as the plot thickens, and ends most pleas'd, when that is most distinctly unravell'd.[11]

But Hogarth is careful to keep these rather exuberant, one might almost say "Romantic," values framed in a strictly classical perspective.[12] The Line of Beauty must not be used in excess, but must be mixed judiciously with other kinds of lines. It must not be too fat or rotund, nor too lean or elongated, but must conform to a precise mean between these extremes (plate 6-1). It must not be put in the wrong place, must not violate "fitness" and use; thus, for instance, weight-bearing pillars must not be designed as spiral forms, since the ornamental, decorative grace of the form is inappropriate for an element that must provide structural stability.[13] Hogarth sees the S-curve as the variety that is the spice of life, the beauty that ameliorates the human condition and overcomes boredom. It is not the essence of life, but that which gives it grace. A graphic demonstration of Hogarth's ultimate fidelity to stable, classical canons of order is his framing of the serpentine line within the pyramid or triangular structure (plate 6-4), the symbol of solidity and structural endurance against time. If the serpentine is the track of the eye pursuing nature's infinite variety, the pyramid is the firm optical and spatial structure of rational, mathematical vision, the Albertian "visual pyramid" that provides a measure of epistemological certainty, a "natural perspective" for painters and viewers.[14]

But even as we note Hogarth's balancing of antithetical values and summarize his position as a *concordia discors*[15] —a classical balancing of unity and variety in the manner of Pope—we sense elements in his argument that tend to subvert the stability of this synthesis. The instability may arise partly from Hogarth's rhetorical position; the serpentine form and its values are those which emerge most assertively in the argument, and Hogarth often seems to be arguing, not for a balance of unity and variety, but for variety as the primary value, unity as a merely secondary consideration. The sense that classical norms are being subverted may also have something to do with the fact that Hogarth begins the *Analysis* with a firm rejection of the classical notion that beauty is linked with morality, and argues throughout for a nonmoral or amoral con-

ception of beauty as sensual and intellectual pleasure grounded in an instinctual drive (curiosity or "the love of pursuit"). One suspects, in other words, that the intellectual unity of Hogarth's *Analysis* is subverted by implications in his thesis of which he was only dimly aware. These implications become clearer when we look a little more closely at the emblem of the Line of Beauty on Hogarth's title-page (plate 6-4) and begin to notice that this is not an innocently abstract or neutral S-curve, but a representation of a serpent, and a very particular one, as the epigraph beneath it tells us:

> So vary'd he, and of his tortuous train
> Curl'd many a wanton wreath, in sight of Eve,
> To lure her eye.

Hogarth does nothing to develop the association of Satan with the Line of Beauty in the text of the *Analysis*; the association remains an enigma to be pondered or explained away. Does the Satanic character of the serpentine line suggest that beauty is simply independent of moral status? Or does it suggest that beauty is actively *subversive* of morality, order, and rationality, and that the "curiosity" aroused by beauty is the same that lured Eve into her wanton, lustful fall? Commentators on Hogarth reassure us that he intended only the first reading, and that the "wanton" character of the serpentine line refers only to its freedom from restraint, its sportive, playful quality, and not to the lascivious, mischievous, lawless "wantonness" of Milton's Satan.[16]

This question may be what current critical jargon would call a "radically indecidable" interpretation, rather than a controlled ambiguity. Whatever we call it, we cannot avoid noticing a historical irony: within a generation the serpent was to become the emblem of revolution in England's American colonies (in the "Don't Tread on Me" insignia), and by the 1790s Englishmen like William Blake were bringing the revolution home under the sign of a serpent called Orc, the first notice of the Romantic transvaluation of Milton's Satan (plates 6-5 and 6-6). For Blake, the image of the pyramid no longer has any vestigial appeal as a guarantee of order; it is an emblem of "Egyptian bondage," the tyranny of "mathematic" or "classical" form in aesthetics, and of the rational perspective systems based in the three dimensions of "length, bredth, & highth."[17] More important, no single "medium" version of the

S-curve is singled out as "the" Line of Beauty; for Blake "Every Line is the Line of Beauty," and the family of spiral forms becomes interfused with the structure of reality.[18] It is no longer the spice of life but its essence, and its recognition may be linked with feelings of sublimity—wonder, awe, terror, revelation—as well as with the agreeable sensations of a pleasant variety.

A good index to the change in sensibility imbedded in interpretations of the serpentine line may be seen in Wordsworth's description of his response to the most utterly banal and familiar sight in the picturesque English countryside:

> Who doth not love to follow with his eye
> The windings of a public way? the sight,
> Familiar object as it is, hath wrought
> On my imagination since the morn
> Of childhood, when a disappearing line,
> One daily present to my eyes, that crossed
> The naked summit of a far-off hill
> Beyond the limits that my feet had trod,
> Was like an invitation into space
> Boundless, or guide onto eternity.[19]

Wordsworth does not celebrate the pleasures of a variety contained in and sustained by a stable, familiar, and closed perspective (the unifying pyramid that encloses Hogarth's serpentine), but rather the *defamiliarizing* of the ordinary sight, its transformation into the infinite or eternal mode of sublimity.

Even more striking than the subtle changes in the interpretation of spiral forms, however, is a sense that the very structure of the form is being perceived and represented differently. The change may be described most simply as the movement from the form as a spiral, arabesque, or serpentine line that cuts across our line of vision, to the image of a vortex or maelstrom that surrounds the line of vision and seems to suck us in with a force that may be simultaneously alluring and threatening. Ronald Paulson notes the emergence of this form in the labyrinthine "vortical hallucinations" of Piranesi, and in the dark pools of Gainsborough, which suggest "a displacement of the complex Euclidian universe with one constructed on the simple principle of a vortex or maelstrom with a vacuum at its center which draws to it whatever it can effect."[20] Gainsborough's vortices seem to draw us downward, dropping the bottom foreground out of the picture as if (Paulson suggests) we

were "looking back from the centre of the vortex rather than from the outer rim inward."[21] This motif of the whirlpool or maelstrom becomes a crucial feature of the landscape of Romantic painting and poetry, acquiring a special force and significance in the work of (to name only the obvious examples) Byron, Shelley, Poe, Coleridge, Melville, Turner, Blake, and John Martin.

One of the most elaborate literary uses of the vortex occurs in Shelley's *Alastor*, in which the poet is driven through a series of landscapes that provides a sort of compendium of variations on the spiral image. Propelled by waves whose "fierce necks writhed beneath the tempests scourge / Like serpents" (ll. 324-25) toward the cliffs of Caucasus "around / Whose cavern'd base the whirlpools and the waves / Bursting and eddying irresistably / Rage and resound for ever" (ll. 354-57), the Poet's bark enters an underground river and pursues the "winding of the cavern" (l. 370) only to emerge into the following scene:

> the flood's enormous volume fell
> Even to the base of Caucasus, with sound
> That shook the everlasting rocks, the mass
> Filled with one whirlpool all that ample chasm;
> Stair above stair the eddying waters rose,
> Circling immeasurably fast . . .
> I' the midst was left,
> Reflecting, yet distorting every cloud,
> A pool of treacherous and tremendous calm.
>
> (ll. 376-81; 384-86)[22]

The Poet escapes from the treacherous center of this maelstrom by catching "a wandering stream of wind" that pushes his bark out from the perimeter of the vortex into a protected cove where new images of the spiral are displayed: on the "pyramids / Of the tall cedar" hang intertwined or "implicated" lattices of vegetation; the vines "like restless serpents . . . flow around / The grey trunks" and "twine their tendrils with the wedded boughs." But this refuge at the circumference of the vortex turns out to be just as treacherous as the "tremendous calm" at the center. The quiet cove is a Narcissus landscape where "yellow flowers / For ever gaze on their own drooping eyes / Reflected in the crystal calm" (ll. 406-8), an action which the poet finds himself emulating:

> His eyes beheld
> Their own wan light through the reflected lines

Of his thin hair, distinct in the dark depth
Of that still fountain; as the human heart,
Gazing in dreams over the gloomy grave,
Sees its own treacherous likeness there.

(ll. 470-74)

The deadly calm reflecting pools with their mirrored eyes, which Shelley locates at the center and circumference of his vortex, suggest that he is developing a new variation on the optical symbolism of the spiral we have seen in Hogarth and Wordsworth. What was for Hogarth the line of the eye's pursuit of visual variety and for Wordsworth a "guide to eternity," becomes for Shelley an emblem of narcissistic solipsism. The vortex is the abyss of idealism and self-consciousness that sucks the poet into a deadly quest for his own reflected image.

Even more fundamental than the Romantic use of the vortex as a symbolic motif in representations of objects, images, or perceptual experiences, is the sense that this form is no longer simply an image *within* the work, but has become the very structure *of* the work. One symptom of the presence of spiral structural principles in Romantic poetry is the tendency of narrative lines to resist closure, to push outward or inward toward some goal that lies beyond the poem, beyond poetry, language, or even the imagination itself. Another symptom is the tendency of Romantic poetry to advance by some movement of return (to the primitive, the unconscious, the medieval, the "natural"), to return upon itself without ever fully possessing itself, to progress through a dialectical movement between contraries, a movement that may advance upward on a spiral staircase toward the ideal, or downward into a dizzy maelstrom that annihilates the selfhood of the hero. Partial recognitions of this fundamental pattern in Romantic literature are scattered throughout the criticism, but are rarely related to one another in a consistent way. Thus a recent commentator on changing patterns of literary form can observe that Goethe's *Faust* is structured as "an upward moving, expanding spiral between varying polarities," but then go on to assert that, despite Romantic theories of "organic" or "nonsymmetrical" literary form, this sort of structure seems "to have been successfully realized in only a few cases."[23] I suspect that the Romantic theory of form was realized in more than "a few cases," and that James Bunn is right to argue that the characteristic pattern of thought and literary form in the nineteenth

century combines circle with sequence in a rhythmic continuity of return and progressive transformation. "The most helpful schema for charting this transition is," as Bunn suggests, "the combined circle and sequence, some aspect of the spiral."[24]

We might summarize the geometrical or topological difference between classic and Romantic form, then, as the inversion of the structural and semantic implications of the vortex. In Rococo and classical art, the spiral form is everywhere, a commonplace decorative image contained and rationalized by symmetrical, rectilinear contexts such as classical architectural form, or the pyramidal box of linear perspective. In Romantic art the spiral is defamiliarized, reserved for images of special intensity or energy, the awe, terror, and revelation of sublimity. But even more crucial is the structural "sublimation" of the vortex, its disappearance from the decorative, ornamental foreground or surface, and its immersion into the structural background or underpinnings that inform works of visual and verbal art. The form that Hogarth saw hedged in by the bounds of rational decorum (symbolized in the image of the pyramid) has itself become the new framing principle of decorum, an image of artistic form that is fluid and organic rather than solid and tectonic, and whose boundaries are approached as infinite or infinitesimal limits.

To say all this is, of course, merely to make geometrically explicit what has often been said about the difference between classic and Romantic art. I am less interested, however, in constructing vast dialectical generalizations about classic and Romantic form than in probing the unique accomplishments of particular artists grappling with a traditional problem in a historical continuum. It should be clear, for instance, that although Wordsworth and Shelley both work within a "Romantic" conception of the vortex, their differences are as important as their similarities, and that Shelley's treatment of the spiraling line of vision is in many ways a critique or parody of Wordsworth's. Let us turn, then, to the work of two artists who use the image of the vortex both as explicit motif and implicit structure, and whose use of the form in their graphic art may be explicated by their comments on it in poetry and art theory.

III. Turner's Visionary Geometry

Like Blake, Turner seems to have rejected Hogarth's notion of a single, determinate line of beauty in favor of a more flexible and

pluralistic conception. In a manuscript poem on the origins of draw-
ing (entitled "The Origin of Vermilion," i.e., the red chalk used
in preliminary drawings), Turner suggests that painting was born
in response to the need to give music a "homely proof" in visible
imagery, "And chance to Vermilion gave first place / As snails trace
oer the morning dew / He thus the lines of Beauty drew."[25] We
notice not only that the lines of beauty are plural, but that the
tool that traces them is compared to a snail whose shell, of course,
contains the vortical structure, which is a sort of frontal version of
the sinuous trace the snail leaves in the morning dew. We also notice
that the lines of beauty are not simply opaque "threads" or marks,
as in Hogarth, but are colored, prismatic, and luminous, like the
wet trail of the snail seen in morning light. For Turner line and light
are not rigidly distinct or antithetical—at least not in the original
mythic state when painting was invented—"in days that's past
beyond our ken / When Painters saw like other men."[26] This ideal
unity of line, color, and light in Turner's theory of art needs to be
kept in mind by those who regard his misty, indistinct style as
somehow formless, lacking in structure, or "nonlinear." Turner
was fascinated with geometrical patterns, and contended that "Art
reclaims . . . their fleeting footsteps from the waste / Of Dark
Oblivion; thus collecting all / The various forms of being to present /
Before the curious aim of mimic Art."[27] This is not to deny the
role that "Dark Oblivion," the obscure, formless froth, plays in
Turner's painting. It is simply to see the realm of obscurity and
mutability as Turner did, in a struggle with its contrary:

> Such the use of forms
> Peculiar in the realms of Space or Time:
> Such is the throne which Man for truth amid
> The paths of mutability hath built
> Secure, unshaken, still; and whence he views
> In matters mouldering structures, the pure forms
> Of Triangle or Circle, Cube or Cone.[28]

Turner does not mention the vortex or spiral in this list of "pure
forms," and this omission would seem to accord with the general
view among Turner scholars that his vortex is antithetical to form,
that it is employed in the representation of nature as a realm of
hostile, destructive forces, and that it symbolizes Turner's pessimism
about the possibility of any enduring human order.[29]

We can hardly rest content with this view, however, as an explanation of Turner's continuing fascination with the form, his insistence on placing himself in circumstances where he would be subjected to the vorticular energies of nature. The very existence of Turner's paintings is presumptive evidence that he felt these energies are in some way continuous with, not just antithetical to, the human imagination, and that they might be represented and grasped, if only in the faint simulacra of paint on canvas. Like Byron and Shelley he saw the destructive, sublime aspects of nature as the locus of a heroic quest that might well be hedged in by ironic futility, a quest into both the empirical facts of external nature and into the unexplored recesses of the human mind. Turner's paintings are the record of risks accepted and welcomed, a double risk involving physical death in the maelstroms of nature, and mental annihilation of the sort experienced by Childe Harold, who "thought / Too long and darkly, till his brain became / In its own eddy boiling and over-wrought, / A whirling gulf of fantasy and flame."

Turner was haunted by the spectre of madness throughout his career, from the early insanity of his mother to the aspersions cast on his mental, visual, and technical competence by uncomprehending reviewers (a fate he shared with Blake).[30] Amateur psychoanalyses of Turner by modern critics seem wide of the mark, however, insofar as they reduce his paintings to symptoms of "schizoid regression" or other pathological conditions.[31] Far from being mere symptoms of madness or pessimism, the paintings strike one as triumphant evidence of mental health (not to mention physical stamina) achieved in the face of conflicts that would have destroyed lesser men. For Turner, as for Shelley and Byron, the vortex was both an objective and subjective phenomenon; it could not, therefore, be avoided, but had to be faced and mastered in the forms of art. Turner was highly skeptical and cautious about the limits of this mastery; he was so ambivalent about the adequacy of his paintings as renderings of the original experience that he found it difficult to look at them.[32] But no force in mind or nature or society seems to have been strong enough to stop him from painting with ever-increasing mastery the subjects that engaged his imagination.

Far more central to Turner than any supposed "pessimism," then, is his dogged insistence on enduring and recording the moment of crisis in landscape or mindscape. The emphasis on "enduring" must be underlined here, for Turner, unlike many of his contem-

poraries, refused to adopt the Romantic image of the hero as youthful martyr or idealistic Adonis slain in his budding years. Turner's mythic prototype is Ulysses, the rugged, wily seafarer, the secretive "man of many turns." Turner would, at the age of sixty-five, expose himself to the fury of a Channel snowstorm in mid-January, and then speak of the resultant painting (plate 6-7) in the following terms:

> I did not paint it to be understood, but I wished to show what such a scene was like. I got the sailors to lash me to the mast to observe it. I was lashed for four hours, and I did not expect to escape; but I felt bound to record it if I did.[33]

Like Ulysses asking the sailors to bind him to the mast so he could listen to the sirens (who were often allegorized, incidentally, as "intellectual temptation"), Turner insists on observing and returning to tell in paint of the images of nature at peak intensity.[34] His vortex has little to do with the beautiful (Turner said that "no one had any business to like the picture"), nor even with comprehension ("I did not paint it to be understood"). The moment of intensity is not a "spot of time" to be recalled as a benevolent influence on later life; it is rather a glimpse into the eye of annihilation, an attempt to explore the boundary between form and chaos.

For critics schooled in traditional notions of form and space Turner had violated this boundary, and produced a painting that looked like "soapsuds and whitewash."[35] Amateurs were more likely to respond sympathetically, especially if they had gone through a similar experience. The most revealing criticism came, however, from Ruskin, who felt that Turner had preserved *too much* of a sense of form, and made the linear structure of the storm too explicit: "the sea . . . is not yeasty enough; the linear wave-action is still too much dwelt upon, and confused with the true foam."[36] For Ruskin, the abstract geometrical structure of the painting, the spiraling lines "dwelt upon" in the representation of the action of the storm, has begun to interfere with the "foaming mystery" of Turner's subject, and with the decorum of dazzling obscurity that must deny all linear boundaries or clear forms of any sort. For a modern viewer, however, it is hard to resist the suspicion that Turner was conscious of another decorum, the linear and geometrical structure of the vortex, and that the painting is about this form as much as it is about a snowstorm on the Channel.

We say that Turner's picture is "of" a storm at sea, but it would be more precise to use his words: the painting shows "what such a scene was like." That is, the picture tries to show what it was like to be *in* the scene, enveloped by its energies, and not to be detached from that experience by the security of a cabin, a frame, or a secure sense of perspective. The vortex in this painting whirls out toward the viewer, surrounding the visual field and thus usurping the stable closure of the frame (Turner sometimes actually framed his canvases with the spiraling cords of anchor cable, a witty comment on the need to "tie down" the turbulent subject with a form that has a corresponding strength and structure).[37] The spiraling lines that articulate the structure of the storm's energy can be "read" with equal validity, then, as the visual effects of vertigo in the viewer, the so-called "spiral aftereffect" that perceptual psychologists have observed in persons subjected to whirling motion.[38] This aftereffect is not simply a symptom of disorientation, however, but an expression of one of the ways in which our perceptual apparatus seeks to stabilize the visual field. Gestalt psychologists have known for some time that "the optical field is in a state of flux or movement, and that optic perception arises in it from the vortical movement, which becomes progressively organized."[39] Our perceptual apparatus is "wired" to rotate visual stimulus patterns—perceptually, in our ability to rotate the inverted image on the retina, and to compensate for rapid movement or whirling in the visual field, and conceptually, in our ability to perform willed mental rotation of images.[40]

Naturally some people have better wiring than others; Turner had an amazing resistance to vertigo, and took a positive delight in situations that were conducive to it. He is described by his contemporaries as reveling in the rough seas that left his weaker companions reeling with nausea. One account tells of him sitting "like Atlas, unremoved" in the stern sheets of a small boat in a squall, "intently watching the sea, and not at all affected by the motion. When we were on the crest of a wave, he now and then articulated to myself—for we were sitting side by side—'That's fine!—fine!' "[41] We have to look at Turner's painting of the snowstorm, then, not just as the record of a vertiginous, disorienting experience, but as a representation of perceptual resistance to disorientation. The important fact—too often ignored by landlubbers—is that Turner was able to see what few others could have in that stormy night

on the channel: exactly how close (perhaps fifty yards) his own vessel came to a collision with a steamer, because he was capable of keeping his eye and mind steady through the storm. The monstrous "eye" of the hurricane, the vortex of nature, met its match in the vortex of human vision.

Turner's insistence on facing the "one-eyed monster" in nature is all of a piece with his self-dramatization as Ulysses, who faced just such a challenge in Polyphemus, the one-eyed giant. In Turner's painting *Ulysses Deriding Polyphemus* (plate 6-8), we see the giant in his "natural" form, as the smoky peak of an erupting volcano. Ulysses stands on the deck of his ship hurling his defiance or perhaps, like Turner himself, simply observing with fascinated delight "what such a scene was like." The contrast between the smoky obscurity of Polyphemus' realm and the dazzling sunrise on the right side of the painting suggests that Turner is alluding to the optical symbolism associated with the Ulysses-Polyphemus encounter. Fulgentius' commentary provides a typical moralizing of the episode:

> The Cyclops is said to have one eye in its forehead because this wildness of youth takes neither a full nor a rational view of things, and the whole period of youth is roused to a pride like that of Cyclops. So with the one eye in the head that sees and comprehends nothing but vanity. This is what the most wise Ulysses extinguishes: vainglory is blinded by the fire of the intellect.[42]

One could read the dazzling sunrise, then, as the celestial and Apollonian "eye of the intellect," which rises as Ulysses puts out the subterranean, volcanic "eye of ignorance." And yet it seems doubtful that this simple moral is adequate to Turner's invention, for he is showing us not just the moment of Ulysses' triumph over Polyphemus, but also the moment of his fatal mistake, when Ulysses forgets his usual caution and vaingloriously exults over Polyphemus, laughing derisively and revealing his name to the blinded giant— a mistake that will bring down the curse of Neptune. Do we read Turner's picture, then, as a "pessimistic" interpretation of the Ulysses-Polyphemus encounter? That would be as mistaken, in my view, as a reduction of the work to an optimistic statement about the victory of rationality and light. The real power of the composition, I would suggest, lies in its perfect but precarious balancing of these contrary readings, an expression of a kind of "dialectical irony" that subverts any attempt to reduce the picture to a univocal statement. To know that Ulysses' moment of glory (like that of

the Phaeton whose horses drive across the sun in the right background of the picture) is also his fatal moment of error is not to negate the former reading, but to see it coexisting with its contrary. A similar kind of dialectical reading of the snowstorm painting shows it both as a moment of chaos in nature and as the triumph of consciousness over chaos.

I am suggesting, then, that Turner's genius lay in his ability to render his own ambivalence, expressed in mutually subversive ironies, about the encounter of mind and nature (let us call this a "conceptual vortex") in concrete optical and pictorial terms. Turner compounds and literally "overlays" this visual, pictorial encounter with a rich web of literary associations in which the mythological lore of light, optics, and vision (Apollo, Polyphemus, Regulus) plays a central role. Turner's poetics of vision always begins, however, from an empirical study of how we see. Perhaps the best clue to what his pictures are "of" is contained in Hazlitt's remark that they are "abstractions of aerial perspective, and representations not properly of objects of nature as of the medium through which they were seen."[43] By "medium" Hazlitt meant the translucent atmosphere of clouds, water, mist, and air whose gradations of color and light are the characteristic subject of a Turner composition, providing an "aerial perspective" that defines depth in terms of clarity and obscurity, rather than through the foreshortening of lineally defined objects, the technique of linear perspective. But the remark has an unintended significance, which is of equal importance for Turner's conception of his own art. The medium through which objects are seen is also the eye, and the complex system of transformations that constitutes visual perception. The fact that Turner's vortices are often the figurative "eye" of hurricane forces is symptomatic, not just of a preference for stormy subjects, but of an eye-centered notion of pictorial space. The vorticular eye of the hurricane is congruent with the perceptual vortex that allows mind and nature to make contact.

Turner's eye-centered notion of pictorial space is manifested most directly, however, not in the turmoil of the vortex compositions, but in the tranquil landscapes that he structured in the elliptical shape of images reflected in a curved lens or mirror, rather like photographs taken with a wide-angle or "fish-eye" lens. In his painting *Petworth Park: Tillington Church in the Distance* (plate 6-9), for example, the landscape appears as if it were reflected in

an eye, with the sun on the horizon centered in the pupil, and the aura of shade and color surrounding it like the concentric ellipses of the iris. The tranquillity of this oblong perspective is likely to be felt as slightly disturbing and eccentric to a viewer accustomed to the pyramidal perspective box of the picturesque. Geometrically, the elliptical structure suggests an unstable equilibrium, as though a circle had been deformed into an oval with two centers. Turner's elliptical compositions often have two vanishing points, or two competing centers of interest flanking an empty or "false" center. They display a curious ambiguity in depth, the picture sometimes seeming to wrap around the viewer like a panorama, at other times seeming to bulge out at the center (Turner did studies of his own studio, as seen reflected in polished steel balls, that explore this curved perspective). The elliptical composition also produces an effect of indeterminacy about the boundaries of the picture, breaking down the rectangular "window-frame" structure and replacing it with optical boundaries that are mobile, uncertain, and tending to increase in distortion at the edges.[44]

The vortex, then, is not simply the violent opposite to the serenity of Turner's tranquil, elliptical landscapes, but is a logical derivation from that format. If the elliptical field displays the precarious equilibrium of two disparate centers, the vortex is simply the patterned disturbance of that equilibrium.[45] With the vortex, the conflict of the two centers is no longer stabilized, but expresses itself in rotary movements that seem to converge on a common center or fly apart to a vanishing circumference. The ambiguity of depth and the indeterminacy of framing that characterize the elliptical structure simply become explicit and dynamic in the vortical composition. And both the ellipse and vortex, we must remember, grow historically and structurally out of Turner's mastery of the picturesque formula of the serpentine optical track inside the Albertian visual pyramid. Turner saw more clearly than any of his contemporaries that this pyramidal box with its norms of linear, tectonic definition of forms and transparent space was not the eternal norm of "Nature," but simply a convention whose artificial character had come to seem natural. The vortex was both a device for destroying this convention and a way of articulating a new principle of order.

Turner's vortex is not just an image of the destructive, obscure sublime, and certainly not an unequivocal emblem of "pessimism."

It is also a clarifying, structuring gesture. Charles Stuckey has suggested that in the late paintings the vortex may be a punning signature, a graphic way of writing the name of the revolutionary "Over-Turner" in paint.[46] Jack Lindsay sees the copulating bodies of lovers, after-images of Turner's erotic drawings, sublimated in the writhing embrace of sea and atmosphere and in the light-dark interplay of chiaroscuro.[47] More abstractly, we can relate the vortex to the manifestly dialectical and contrarious nature of Turner's thinking, the "conceptual vortices" we have seen in the symbolism of his paintings. Most fundamentally, the vortex for Turner is a form of what and how we see, a structural homology of mind and world. Thus, it involves the sublime of intellectual delight in discovery, or revelation. Turner quotes Akenside:

> The various forms which this full world presents
> Like rivals to his choice, what human breast
> E'er doubts, before the transient and minute,
> To prize the vast, the stable, the sublime.[48]

Is the vortex one of these forms, one of the pure, stable structures of geometry like the cube, cone, or cylinder? Turner seems not to have said so in his writing, unless we take his painting to be a kind of writing. In the text of his paintings he could say what never became explicit in his poetry, that the vortex is the vast, stable, sublime form of instability itself, the image of forms, like hopes and empires, being created and destroyed.

We glimpse in Turner's visionary geometry, in his love of abstract, eternal forms, the resolution of the main dilemma that has exercised Turner criticism: how to reconcile his modernity, his romantic expressivity and abstraction, with his undoubted classicism—his tendency to depict historical subjects, his rigorous study of and competition with past masters, and his moralizing, allegorizing, and literary trickstering. The fact is that Turner is both classic and romantic; or, more precisely, he reveals in his work the way in which romanticism has become our classicism.[49] Turner saw the old paradigms of vision and pictorial space, mastered them in the forms of art, and overturned them in favor of new ones, particularly in favor of the form of "overturning" itself, an image that was to become paradigmatic for post-romantic thought. To see the masterful self-confidence and eloquence with which he articulated this image, we need to look more closely at those controversial late paintings, the work (we are told) of a disappointed,

sick old man who was losing his eyesight and his touch with the paintbrush.

IV. Turner's New Covenant: *Light and Colour; Shade and Darkness*

In the last few years of his life Turner seems to have found the perfect thematic "match" for his formal experiments with vorticular form in mythic subjects such as the Deluge and the Apocalypse. Given his notorious indifference to religion, it is difficult to say exactly how Turner felt about these Biblical subjects. John Gage suggests that "Turner had lost belief in the possibility of redemption" and that the Christian symbols in his paintings are turned to a "negative and un-Christian use."[50] Jack Lindsay makes it seem doubtful that Turner ever had much of a faith to lose.[51] Charles Stuckey sees the late works as evidence of "a mind deeply disturbed" by a sense of increasing isolation and betrayal (the savage attacks of critics; the failure of his fellow members to elect him president of the Royal Academy). The apocalyptic subjects are to be seen, then, as "poignant" expressions of Turner's outrage and desire for revenge on his enemies: "they arouse our pity for a disappointed old man," and "make us feel a sense of shame for those around Turner who could neither sense his pain nor act to alleviate it."[52] Without disregarding the private and perhaps pathological symbolism of these late paintings, however, it seems to me that we can read in them the triumphant solution to the problem Turner had been grappling with throughout his career, the perfect union of literary and pictorial form, a resolution of the split between the classical, verbal conception of painting, and the modern impulse to compose and explore form for its own sake.

Turner declared his conviction that this synthesis had been achieved in the title—perhaps the most ambitious title ever attached to a picture—of his most famous painting of the 1840s: *Light and Colour (Goethe's Theory)—The Morning after the Deluge—Moses writing the book of Genesis* (plate 6-10). The "subject" of this painting is both an event (the Deluge) and the process of recording that event (Moses writing); both the "medium" in which that event is represented (light and color) and a theory (Goethe's), which purports to explain that medium. Turner makes it clear that his painting is not simply about events or perceptual phenom-

ena, but about the way events are recorded and the way phenomena are explained. It is a history painting that reflects on the writing of history, and an abstract study in visual phenomena that reflects on the science of vision.

These, at any rate, are the implicit claims made for the painting by Turner's title. The question is, does the canvas deliver on its promise to synthesize history and science, reason and revelation? Let us begin by looking at the historical, mythic, and literary side of the picture—the treatment of the Deluge theme—and inquire into its meaning purely as a representation of a morally significant action. The conventional wisdom on Turner's "pessimism" would have it that *Light and Colour* together with its companion piece *Shade and Darkness: The Evening of the Deluge* (plate 6-11) present a picture of "the expendability of man," and that "the vortex movement . . . suggests that, on a deeper level, all is not well with the human race."[53] The question we must raise of Turner's treatment of the theme as a historical painter, however, is whether the pictures say all is "not well" with the *entire* human race, or whether they express a vision of a morally intelligible universe in which disobedience is punished and fidelity rewarded. The composition and caption of *Shade and Darkness* decisively support this moral reading. The dim shape of the ark stands in a flood of white light at the center of the vortex in the distance, a serpentine line of animals stretching out toward it. In the foreground we see the indistinct shapes of people and animals who fail to heed the signs of impending disaster:

> The moon put forth her sign of woe unheeded;
> But disobedience slept; the dark'ning Deluge closed around
> And the last token came: the giant framework floated,
> The roused birds forsook their nightly shelters screaming,
> And the beasts waded to the ark.[54]

Turner does not intend to suggest in these lines the condemnation of the entire human race, and the ark is not being presented as a "fallacious hope"; the only fallacy Turner shows in the picture is that of sleeping disobedience, which hopes that the judgment day will never come. In many ways, Turner's treatment of the Deluge seems utterly orthodox.

As we turn to *Light and Colour*, however, the departures from orthodox renderings of the Deluge theme seem to multiply. Instead of the rainbow of the covenant we are confronted by a

tumultuous whirl of reds and yellows around the dark mountain peak in the center. On the top of the mountain we find, not the ark that (Turner tells us in the accompanying verse) "stood firm on Ararat," but the figure of Moses writing his book, his staff with the brazen serpent implanted in the mountain peak. Below this peak, the waves of the receding flood sweep up numerous bubbles with human faces, a motif completely unprecedented in Deluge iconography, and explained only in the verse Turner linked with this painting:

> The ark stood firm on Ararat; th' returning sun
> Exhaled earth's humid bubbles, and emulous of light,
> Reflected her lost forms, each in prismatic guise
> Hope's harbinger, ephemeral as the summer fly
> Which rises, flits, expands, and dies.[55]

John Gage's suggestion that the bubbles are "emblems of fallacious hope" seems accurate enough.[56] The difficulty arises when this element of the composition is generalized to suggest that Turner is expressing a negative reading of the entire Deluge legend, and suggesting that the new covenant is itself a fallacious hope. Both the picture and its accompanying verse suggest that the bubble-images of ephemeral hope have a more complex role to play. In the first place, their transience is presented in contrast to the firmness of the ark, and to the stability of the Moses figure at the center of the vortex. The "bubble-heads" are images of the lost, disobedient souls who hoped the flood would never come. In the second place, even in their transience and ephemerality, these "bubble-heads" reaffirm a vision of permanence and stability, for they "reflect" the "lost forms" of earth and light, if only for their moment of brief life. A pair of scientific facts (the exhalation of bubbles of marsh gas after a flood, and the prismatic nature of bubbles) is coordinated with mythical, literary suggestions (the bubble as an image of man and his hopes, the renewal of life after the flood) to produce a sort of natural-supernatural reading of the Deluge theme. This reading rewrites the Biblical story in a way that preserves its moral essence while giving free play to Turner's modern scientific knowledge and his skepticism about hopes and promises. Turner may well have regarded himself and all humanity as mere bubbles, some with the luck or will to be more durable than others. But the meaning he seems to have drawn from this image was not simply a pessimistic sense of futile ephemerality or fallacious hope, but an

affirmation of the capacity to *reflect*, and thus to record the "lost forms" that stand firm amid the flux. We need only step back a few feet from *Light and Colour* to realize that the entire composition can be seen as a prismatic reflection in a bubble—or as a fragile, fading shred of canvas that dimly reflects the original conception of its creator. This realization does not negate the value or significance of the picture, but increases our respect for its intellectual and imaginative integrity.

There is at least one more twist in the interpretive vortex Turner constructs in the literary iconography of *Light and Colour*. That is the presence of Moses writing the book of Genesis with the brazen serpent implanted on the mountain beneath him. Kenneth Clark tells us that this central detail "is not so easy to take seriously . . . because even Turner must have known that Moses was not present on the morning after the Deluge."[57] But Turner (and Kenneth Clark) also know that religious painters often take liberties with strict chronology to create typological parallels between events that occur at different historical moments (the pairing of the Crucifixion with the sacrifice of Isaac in a single painting is the most famous example of this allegorical technique). We need to admit at least the possibility, then, that the anachronism of *Light and Colour* is not ignorance or whimsy on Turner's part, but something more like Blake's "allegory addressed to the intellectual powers," which is "fittest for instruction" because it "rouzes the faculties to act." The presence of Moses reminds us that the subject of the painting is not simply the Deluge, but the "medium" (i.e., both the book of Genesis and its visionary author) through which we come to know the story of the Deluge. We can see the whole painting, in fact, without any anachronism as a portrait of Moses surrounded by the vision that he narrates: we read the space "outside" or around Moses as actually "inside" his head (a reading which makes the bubblelike structure of the composition doubly intelligible). In a similar way we can regard this as a relatively unmediated picture of a basic set of phenomena—Light and Colour—or as a highly contrived interpretation, an illustration or critique of "Goethe's Theory" about those phenomena. (The fact that this theory was centrally concerned with prismatic effects in bubbles further sustains the sense that this image controls the whole picture, not just the detail of the ephemeral "bubble-heads").

Plate 3-1. Peter Paul Rubens, *Peace Embracing Plenty.* Yale Center for British Art, Paul Mellon Collection.

Plate 3-2, below. Rubens, *"Quos Ego" (Neptune Calming the Waves).* Fogg Art Museum, Harvard University.

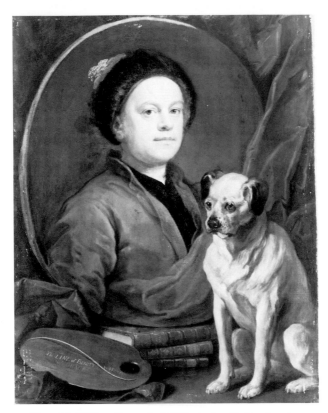

Plate 3-3. William Hogarth, *Self-Portrait with Pug.* London, Tate Gallery.

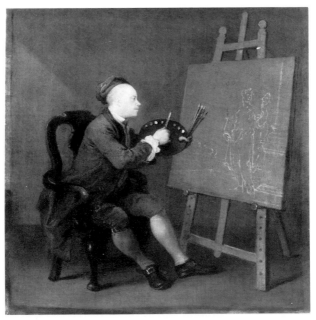

Plate 3-4. Hogarth, *Self-Portrait Painting the Comic Muse.* London, National Portrait Gallery.

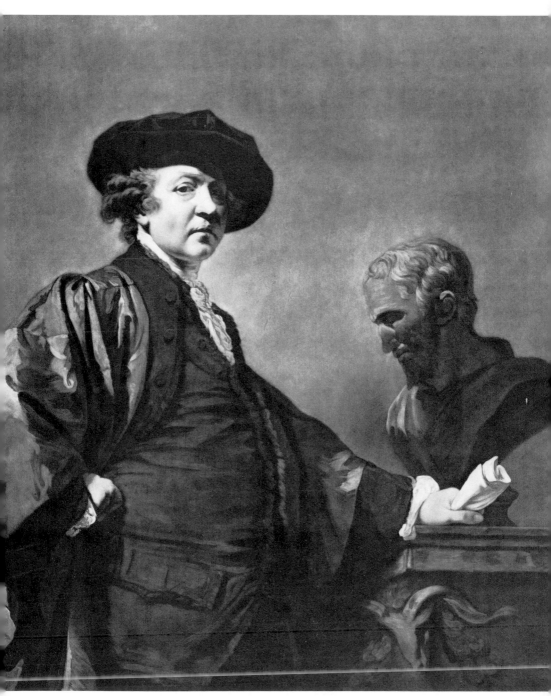

Plate 3-5. Sir Joshua Reynolds, *Self-Portrait*. Mezzotint reproduction by Valentine Green.
Courtesy of the Art Institute of Chicago.

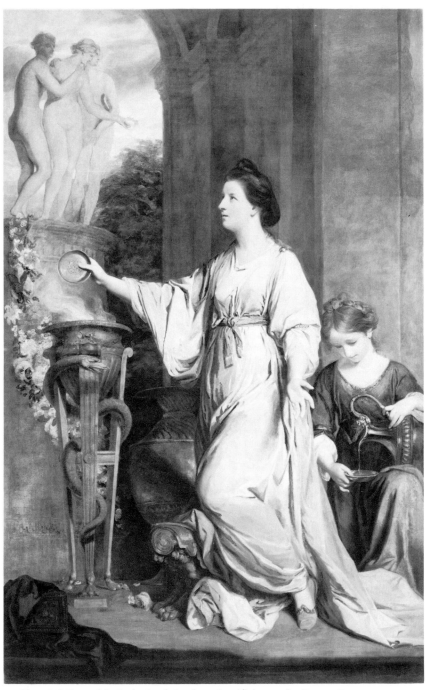

Plate 3-6. Reynolds, *Lady Sarah Bunbury Sacrificing to the Graces.* Courtesy of the Art Institute of Chicago.

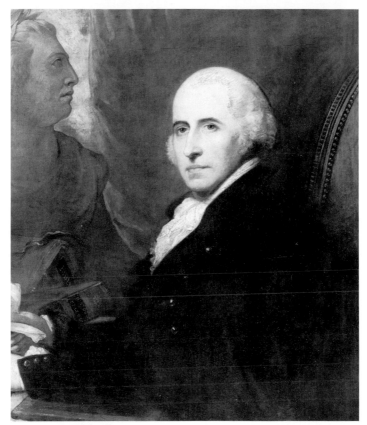

Plate 3-7. Benjamin West, *Self-Portrait.* Fogg Art Museum, Harvard University.

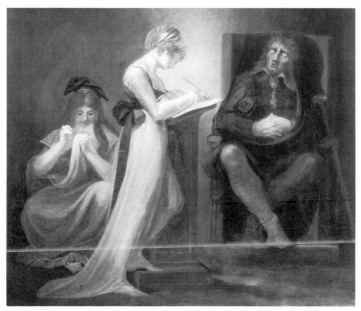

Plate 3-8. Henry Fuseli, *Blind Milton Dictating to his Daughter.* Courtesy of the Art Institute of Chicago.

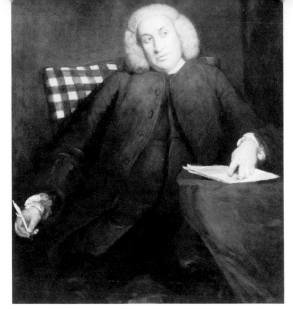

Plate 5-1. Sir Joshua Reynolds, *Samuel Johnson*
(1756). London, National Portrait Gallery.

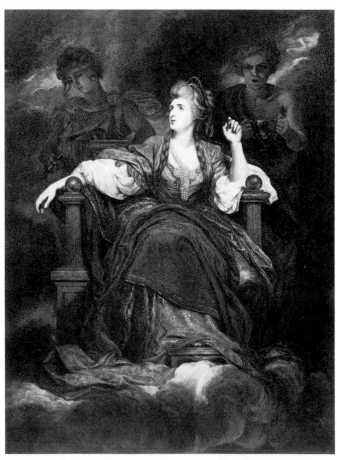

Plate 5-2. Reynolds, *Mrs. Siddons as the Tragic Muse*
(1784). The Henry E. Huntington Library and Art Gallery.

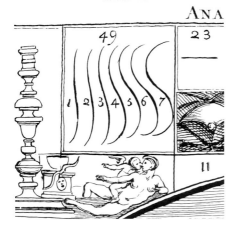

Plate 6-1. William Hogarth, *Analysis of Beauty* (1753), plate I (detail). "The Line of Beauty."

Plate 6-2, below. Hogarth, *Analysis of Beauty,* plate I (detail). "The Line of Grace."

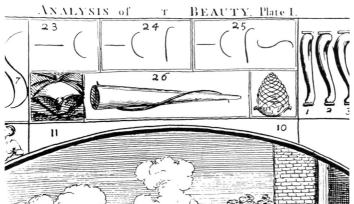

Plate 6-3. Engraving from Richard Payne Knight, *The Landscape* (1794). "The Improved Landscape."

THE
ANALYSIS
OF
BEAUTY.

Written with a view of fixing the fluctuating IDEAS of
TASTE.

BY *WILLIAM HOGARTH.*

So vary'd he, and of his tortuous train
Curl'd many a wanton wreath, in sight of Eve,
To lure her eye.------- Milton.

VARIETY

L O N D O N:
Printed by *J. REEVES* for the *AUTHOR,*
And Sold by him at his House in LEICESTER-FIELDS.
MDCCLIII.

Plate 6-4. Hogarth, *Analysis of Beauty,* title page.

DON'T TREAD ON ME

Plate 6-5. Gadsden Flag (1775). From
Encyclopedia Britannica.

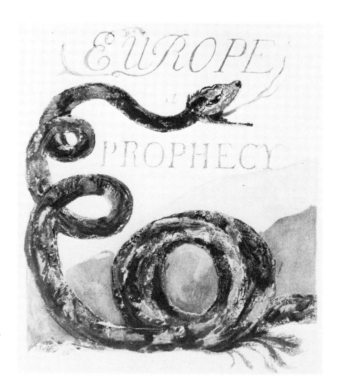

Plate 6-6. William Blake,
Europe: A Prophecy (1794),
copy I, title page. Auckland
Public Library, New Zealand.

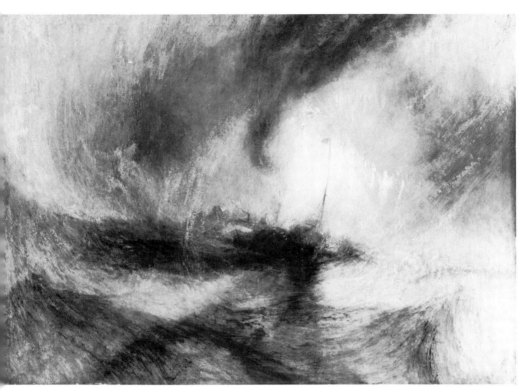

Plate 6-7. Joseph Mallord William Turner, *Snow Storm: Steam-boat Off a Harbor's Mouth* (1842). Tate Gallery, London.

Plate 6-8, below. Turner, *Ulysses Deriding Polyphemus* (1829). National Gallery, London.

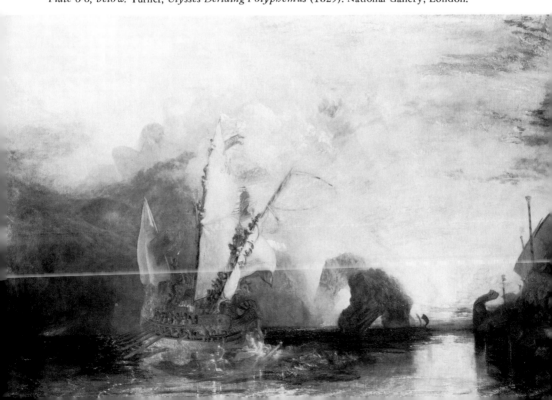

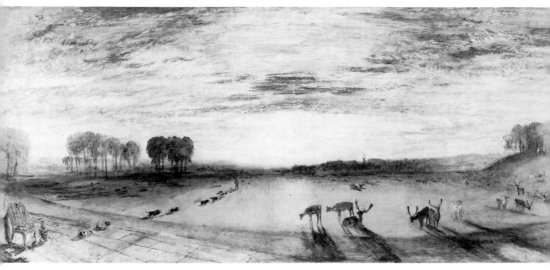

Plate 6-9. Turner, *Petworth Park: Tillington Church in the Distance* (c. 1828). Tate Gallery, London.

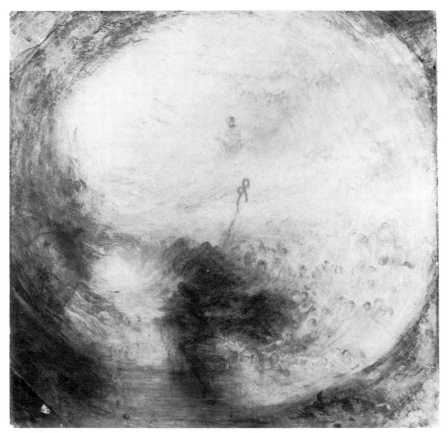

Plate 6-10. Turner, *Light and Colour (Goethe's Theory) — The Morning after the Deluge* (1843). Tate Gallery, London.

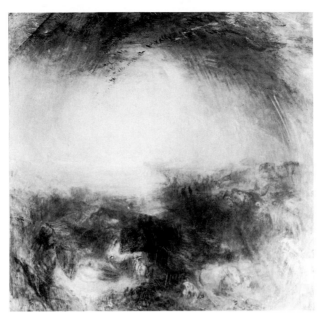

Plate 6-11. Turner, *Shade and Darkness— The Evening of the Deluge* (1843). Tate Gallery, London.

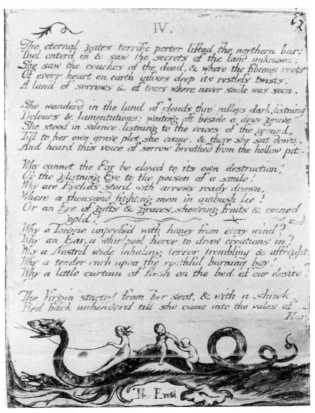

IV.

The eternal gates terrific porter lifted the northern bar:
Thel enterd in & saw the secrets of the land unknown;
She saw the couches of the dead, & where the fibrous roots
Of every heart on earth infixes deep its restless twists:
A land of sorrows & of tears where never smile was seen.

She wanderd in the land of clouds thro valleys dark, listning
Dolours & lamentations: waiting oft beside a dewy grave
She stood in silence. listning to the voices of the ground,
Till to her own grave plot she came, & there she sat down.
And heard this voice of sorrow breathed from the hollow pit.

Why cannot the Ear be closed to its own destruction?
Or the glistning Eye to the poison of a smile!
Why are Eyelids stord with arrows ready drawn,
Where a thousand fighting men in ambush lie?
Or an Eye of gifts & graces, showring fruits & coined
 gold!
Why a Tongue impress'd with honey from every wind?
Why an Ear, a whirlpool fierce to draw creations in?
Why a Nostril wide inhaling terror trembling & affright.
Why a tender curb upon the youthful burning boy!
Why a little curtain of flesh on the bed of our desire?

The Virgin started from her seat, & with a shriek.
Fled back unhinderd till she came into the vales of
 Har.

The End

Plate 6-12. Blake, *The Book of Thel* (1789), copy O, plate 6. Auckland Public Library, New Zealand.

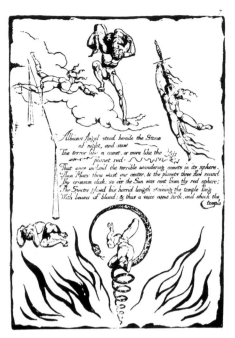

Plate 6-13. Blake, *America* (1793), copy N, plate 5. Auckland Public Library, New Zealand.

Plate 6-14. Turner, *The Angel Standing in the Sun* (1846). Tate Gallery, London.

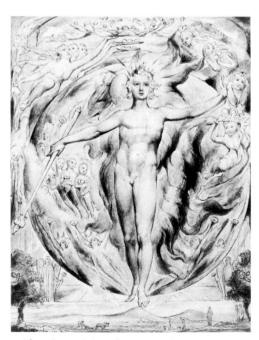

Plate 6-15. Blake, *The Sun at His Eastern Gate* (1816-20). From a series of illustrations to Milton's "L'Allegro." The Pierpont Morgan Library.

Plate 6-16. Blake, *The Book of Thel*, (1789), copy O, title page. Library of Congress, Rosenwald Collection.

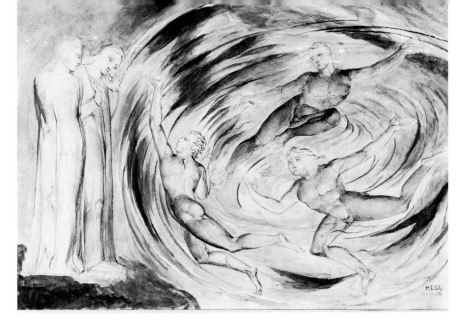

Plate 6-17. Blake, *The Punishment of Rusticucci and His Companions* (1824-27).
Fogg Art Museum, Harvard University. Grenville L. Winthrop Bequest.

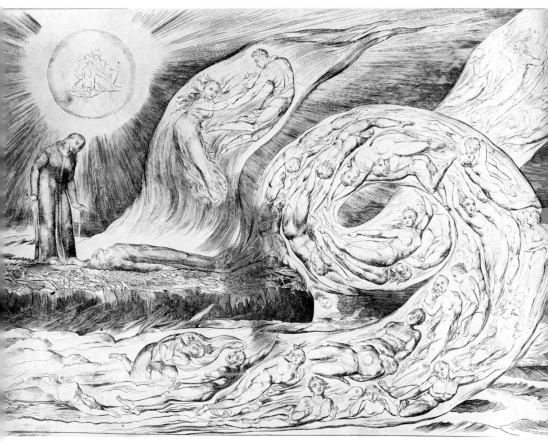

Plate 6-18. Blake, *The Circle Of the Lustful: Francesca da Rimini* (*"The Whirlwind of Lovers"*) (1824-27). Engraved copper plate from a series of illustrations to the *Divine Comedy*. National Gallery of Art, Rosenwald Collection.

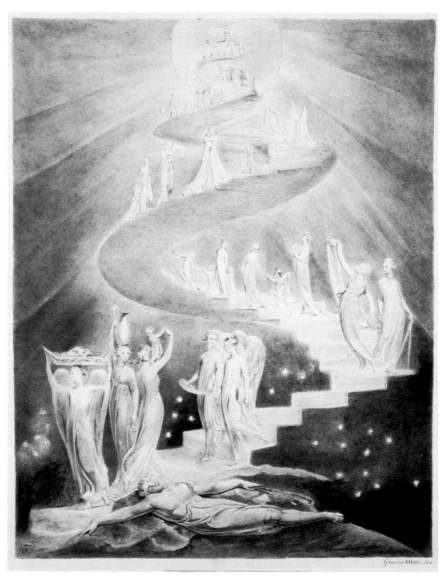

Plate 6-19. Blake, *Jacob's Dream* (c. 1805). British Museum.

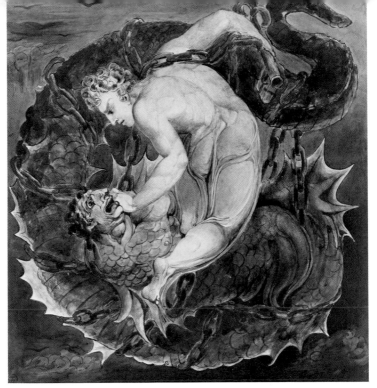

Plate 6-20. Blake, *The Angel Michael Binding the Dragon.* Fogg Art
Museum, Harvard University. W. A. White Collection.

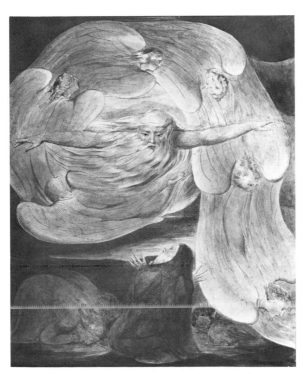

Plate 6-21. Blake, *Job Confessing His Presumption to
God Who Answers from the Whirlwind* (1803-5).
National Galleries of Scotland, Edinburgh.

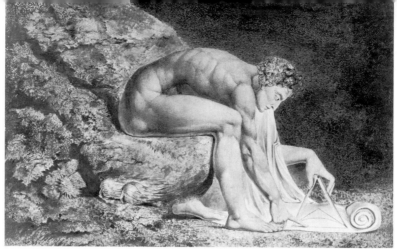

Plate 6-22. Blake, *Newton* (1795). Tate Gallery, London.

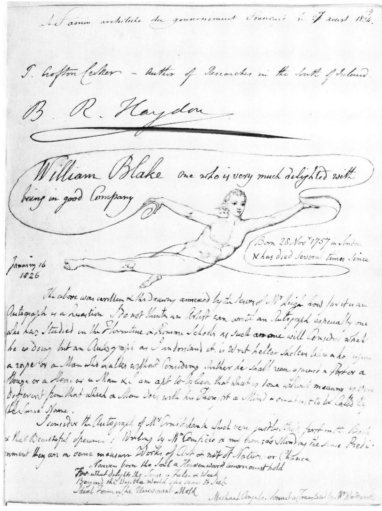

Plate 6-23. Blake, Autograph in the Album of William Upcott (1826). New York Public Library, Berg Collection.

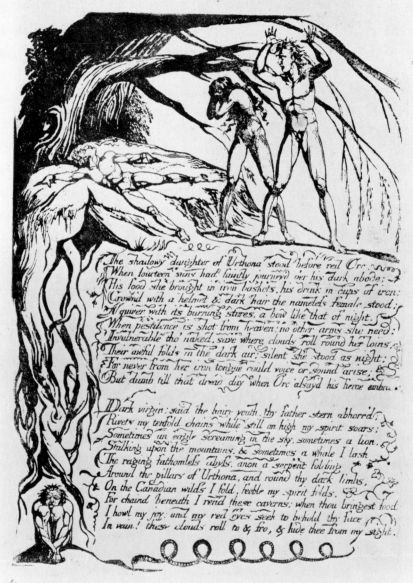

Preludium

The shadowy daughter of Urthona stood before red Orc.
When fourteen suns had faintly journey'd o'er his dark abode:
His food she brought in iron baskets, his drink in cups of iron;
Crown'd with a helmet & dark hair the nameless female stood;
A quiver with its burning stores, a bow like that of night.
When pestilence is shot from heaven; no other arms she need:
Invulnerable tho' naked, save where clouds roll round her loins,
Their awful folds in the dark air; silent she stood as night;
For never from her iron tongue could voice or sound arise;
But dumb till that dread day when Orc assay'd his fierce embrace.

Dark virgin; said the hairy youth, thy father stern abhorr'd;
Rivets my tenfold chains while still on high my spirit soars;
Sometimes an eagle screaming in the sky, sometimes a lion,
Stalking upon the mountains, & sometimes a whale I lash
The raging fathomless abyss, anon a serpent folding
Around the pillars of Urthona, and round thy dark limbs,
On the Canadian wilds I fold, feeble my spirit folds.
For chaind beneath I rend these caverns; when thou bringest food
I howl my joy; and my red eyes seek to behold thy face
In vain! these clouds roll to & fro, & hide thee from my sight.

Plate 7-1, William Blake, "Preludium" to *America* (1793). The Henry E. Huntington
Library and Art Gallery.

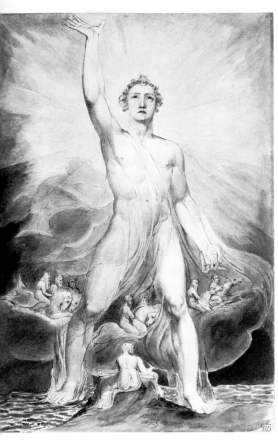

Plate 8-1. William Blake, *The Angel of the Revelation.* Watercolor with pen and ink. The Rogers Fund, Metropolitan Museum of Art.

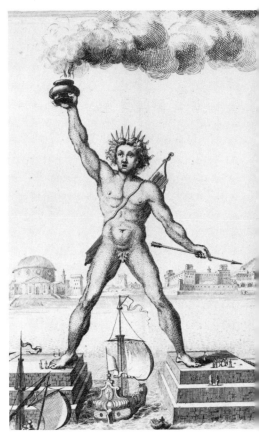

Plate 8-2. The Colossus of Rhodes (detail). Unsigned engraving after J. B. Fischer von Erlach, from *Entwurff einer historischen Architectur.* University of California, Berkeley.

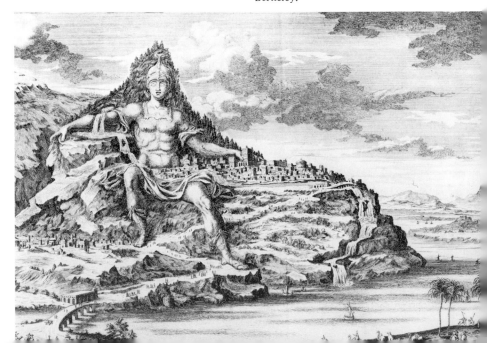

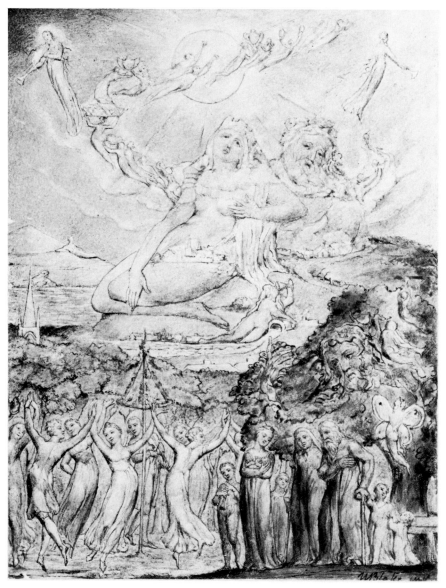

Plate 8-4. Blake, *The Sunshine Holiday.* Watercolor. The Pierpont Morgan Library.

Plate 8-3, left. Mount Athos. Unsigned engraving after J. B. Fischer von Erlach from
Entwurff einer historischen Architectur. University of California, Berkeley.

Plate 8-5. Stonehenge (detail). Unsigned engraving after J. B. Fischer von Erlach, from *Entwurff einer historischen Architectur.* University of California, Berkeley.

Plate 8-6. Blake, *Milton,* plate 4. The Henry E. Huntington Library and Art Gallery.

Plate 8-7. Blake, engraving after a design by Francis Stone, *A View of St. Edmund's Chapel in the Church of East Dereham,* from *The Life and Posthumous Writings of William Cowper Esq.* by William Hayley. The Bancroft Library, University of California, Berkeley.

Plate 8-8. Blake, *Jerusalem*, plate 100. The Pierpont Morgan Library.

Plate 8-9. Blake, *Milton*, plate 36 (detail). The Henry E. Huntington Library and Art Gallery.

Plate 8-10. James Basire, engraving, *A Description of the Temple of Solomon*, from *A Chronology of Ancient Kingdoms Amended* by Isaac Newton. The Henry E. Huntington Library and Art Gallery.

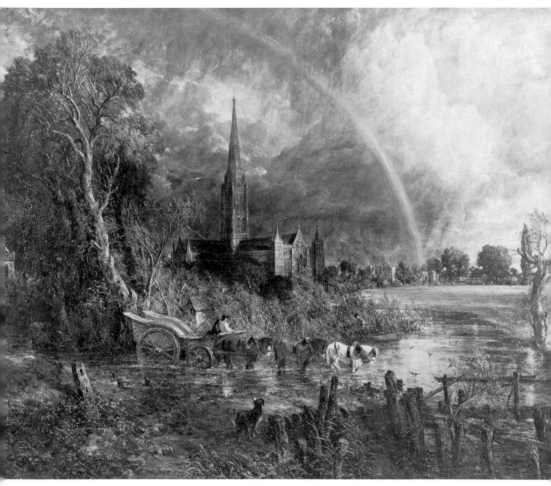

Plate 9-1. John Constable, *Salisbury Cathedral, From the Meadows.* Private Collection.

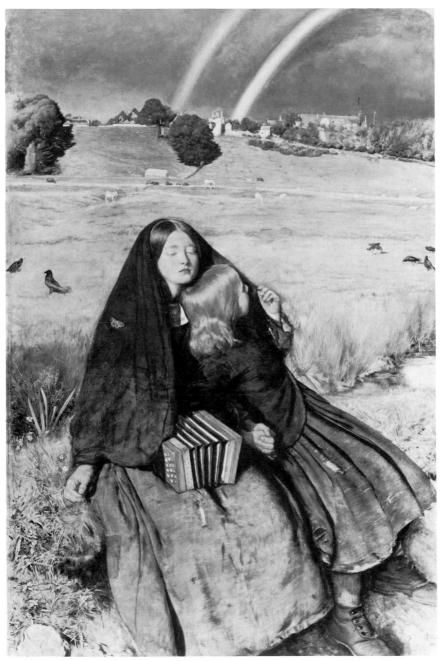

Plate 9-2. John Everett Millais, *The Blind Girl*. By courtesy of Birmingham Museums and Art Gallery.

We still have not accounted, however, for the presence of the Brazen Serpent in the composition. It is clearly another anachronism, which doesn't belong in the literal moment of the morning after the Deluge, or in the moment of Moses' writing down the story, but in an episode of Moses' own life when he cures the plague of fiery serpents by a kind of homeopathic magic, erecting a brazen image of the serpent: "and it came to pass, that if a serpent had bitten any man, when he beheld the serpent of brass he lived" (Numbers 21:9). Does this serpent have similar restorative powers for the victims of the Deluge, raising them from their watery graves like the redeemed souls emerging from the earth in a Last Judgment? We know that the Brazen Serpent had already been reinterpreted in this fashion long before Turner:

> The brazen serpent which Moses raised up on a pole to heal the people was already mentioned in the Gospels as a figure for the Elevation on the cross. . . . Isidore of Seville, quoted by the Glossa Ordinaria, . . . says that Jesus is the new serpent who has vanquished the old, and adds that brass, the most solid and durable of metals, was chosen by Moses to express the divinity of Jesus Christ and the eternity of His reign. [58]

Turner's "anachronisms" are more properly viewed as playful, unorthodox, but highly controlled variations on the medieval technique of typological juxtaposition. Instead of pairing off Old Testament "type" against New Testament "antitype" (e.g., serpent on pole as Christ on cross), Turner assumes our awareness of these metaphors and compounds them by a series of substitutions. The Brazen Serpent that cures the plague of the Israelites and prefigures the curative sacrifice of Christ also "post-figures" the cleansing, regenerative significance of the Deluge. In a similar fashion Moses takes the place of the ark atop Mt. Ararat, preserving a record of the "lost forms" swept away by the flood, and thus ensuring their regeneration. The absent images of ark and rainbow are replaced by their antitypes, Moses and the Brazen Serpent.

To say all this, however, is still to leave open the gap between Turner the classical history painter, the lover of literary and mythological allusion, and Turner the formal abstractionist, the modern painter of pure forms. We can close this gap, I would suggest, by reminding ourselves of the formal revolution in which this painting participates, and by noting in particular the implicit structural analogy between the vortex that envelopes the composition and the one that stands at its center in the form of the Brazen Serpent.

I will not claim that this serpent is a direct allusion to Hogarth's serpentine Line of Beauty; only that Turner's entire career as a technician of pictorial space is bound up with the mastery and transcendence of the picturesque formulas that were summarized by this serpent. If we look carefully at *Shade and Darkness*, we note the persistence of the formula in the brown foreground, cool background, and most particularly, as Graham Reynolds notes, in the "serpentine line of animals wading toward" the ark "like a jetty stretching out into a cone."[59] The picture *The Evening of the Deluge*, showing the world before the revolutionary transformation, is structured in terms of the old spatial paradigm of the picturesque, the old order that is passing away. By contrast, the hot reds and yellows of *Light and Colour* seem to rush toward us, and the spiral structure of the vortex no longer suggests the depth of spatial recession into the visual cone, but brings all the imagery and energy forward into the foreground plane. If the theme of the Deluge is death and renewal, Turner has completely assimilated it to his own vision of the progress of pictorial representation, showing us the "new serpentine" of the sublime, enveloping vortex replacing the "old serpentine" of the picturesque Claudian formula.

What do we call this replacement of one structural icon by another? As a classical, literary painter, Turner presents it as a momentous, revolutionary, or apocalyptic transformation, the institution of a new covenant. As a modernist, a skeptic and scientist of vision, he presents it as an act of self-conscious originality, a demonstration of the way a paradigm of pictorial and metaphoric space is replaced and transformed. Turner's Romanticism consists in his ability to stand at this precarious moment between the sacred and secular interpretation of historical change, and to unite these interpretations in a single system of forms. The idea of two irreconcilable Turners looks more and more like a Victorian or modern invention, which is resisted by the paintings and everything Turner had to say about them. The moment we try to explain *Light and Colour* as modernist abstraction or illustration of optical theory, the painting insists on being seen in relation to the tradition of religious iconography. If we try, on the other hand, to reduce it to the norms of orthodox religious art, it declares its playful subversion of this tradition by its resolutely modern insistence on the centrality of the imagination and the imaginer as the measurer and instituter of these momentous changes. The final typological displacement

in *Light and Colour* is toward Turner himself, who places himself in the position of Moses as the seer and recorder at the center of the vortex. The Brazen Serpent is, in this light, another of "Turner's little jokes"—his own signature, inscribed with an extra twist in the serpent's body to suggest how far he has gone beyond Hogarth and Apelles.

We have difficulty measuring this distance, bred on suspicion about notions of "progress" in art. Turner's own skepticism and dislike for humbug probably prevented him from taking his identification with Moses (like his identification with Ulysses, or, in his final years, with the *Angel Standing in the Sun*) too seriously.[60] He certainly had no illusions that his new pictorial paradigm was the perfection of visual truth; it might be as little as another twist in the picturesque serpentine, a slight adjustment of our angle of vision. It might be as much as a new sense of reality. In either case it brought to light the historicity of style, and a self-consciousness about transformations in the basic paradigms of cultural space. If Turner's exploration of the vortex led him to the conclusion that all forms are dissolved in its flux, it also led him to the opposite conclusion that it is the womb out of which all new forms are born. Blake, as we shall see, arrived at this paradox by another route.

V. Blake's Bounding Line

Unquestionably, the spiral and vortex are central to Blake's graphic style. All his affinities are with virtuosic linear styles that employ variations on the waving line—the *figura serpentinata* of Mannerism, the symbolic and ornamental interlace of medieval illumination, the flowing arabesques of Rococo book illustration.[61] In contrast to Turner, who used explicit versions of the spiral form in relatively few compositions, Blake employs it quite often, and in every possible version. In the early illuminated books, particularly in *Songs of Innocence*, the coiling tendrils of vegetation, benign serpents ridden by children, and flame-flower arabesques reveal an artist still under the spell of the Rococo (see plate 6-12). In the post-revolutionary illuminations, the serpent assumes an ambiguous energy and takes on the sublime *terribilita* of the Leviathan whose coils are congruent with the whorls of the maelstrom (plate 6-13). Throughout his work, Blake seems to have regarded the form as the bearer of mythic

and prophetic associations, a basic configuration of religious experience embodied in such phenomena as the "ever-varying spiral ascents to the heavens of heavens" and the whirlwind whose funnel is God's speaking trumpet.[62] Blake's vortex, in contrast to Turner's, is primarily aural, not optical, associated with the "Ear, a whirlpool fierce" coiled "in close volutions."[63] It seems to originate in verbal, emblematic considerations rather than optical, perspectival concerns, and alludes to the realm of hieroglyphics, the ur-writing that unites poetry and painting, the ur-speech of "Visionary Forms Dramatic."

The peculiar life and quality of Blake's linear style may best be summarized in the oxymoronic pun on "bounding" (i.e., closing, holding in, confining; or, contrarily, leaping, springing over boundaries), which he loved to play with verbally and which informs his graphic technique. The ability to engrave the smooth, lively contours of the spiral in the resistant medium of copper was the "signature" of the master craftsman, a demonstration of the very considerable hand strength required to be a journeyman engraver, combined with the steady eye of the master draughtsman.[64] It was also a sign of the resolution of the "boundary" paradox in Blake's aesthetics: every line must define, set off, enclose a form in a firm, determinate "bounding line"; but every line must also leap, and cause the pictured form to leap into life. Blake's slow development as an engraver and draughtsman indicates just how difficult this goal could be. He was no virtuosic prodigy like Turner, but a stubborn laborer who waged a long love-hate struggle with the craft of engraving. Small wonder that one of the central "plots" of his major epic poem, *Jerusalem*, is the struggle to compel a character called "Hand" to serve the human imagination.[65]

In other respects, the struggle seems to have been easier for Blake than for Turner. He was a verbal genius and is now generally recognized (despite some troglodyte opposition) as a major figure in the greatest age of English lyric poetry. Turner was notoriously inarticulate, and his verses, unlike Blake's pictures, do not reveal a successful struggle with a recalcitrant medium. Blake seems also not to have been afflicted with the ambivalence about his paintings that plagued Turner. He had no trouble looking at his pictures and regarded them as quite adequate to the experience on which they were based. Turner saw his paintings as, at best, faint similes of the original experience, hopelessly inadequate attempts to show

"what it was like." [66] Blake's success in the compositional process gave him the assurance that "invention" (the pictorial idea in the artist's mind) and "execution" (the realization of that idea in graphic form) were indistinguishable parts of a single creative process, and that the form did not really exist until it had been embodied in "firm determinate outline." [67] The finished product is, for Blake, not a faint simile of a lost experience, not a faint and rapidly fading record of the nuances of light and shade, but a living embodiment or "definition" of that experience that validates and preserves its life. Blake would have seen Turner's hazy, indeterminate style, his obsession with "that infernal machine. called Chiar Oscuro," as symptoms of the over-emphasis on purely visual, optical experience in painting since the Renaissance—especially the Venetian Renaissance. [68] Blake's answer to the "tyranny of the eye" represented by painterly emphasis on light and color and the mathematical proportions of linear perspective ("Single Vision and Newton's Sleep") was the tactility and synesthesia of the wiry bounding line, a style addressed to the "enlarged and numerous senses" and the "Intellectual Vision" of the entire field of human perception.

Yet, for all the disparities between their styles and theories of art, and despite the lack of any evidence that they were influenced by one another, we cannot help but feel a strong underlying affinity between Blake and Turner, the two great poet-painters of Romantic England. By the end of his life Turner's departures from the conventions of the picturesque into abstractions of color and form were so pronounced that the *Illustrated London News* could refer to him as "the very William Blake of Landscape Painters," and expect the reference to be understood. [69] The comparison was, of course, a negative one, uniting Blake and Turner in eccentricity and in "the defiance of every principle of art or appearance in nature." [70]

With the advantage of hindsight we can reverse the judgment and measure the positive significance of their common defiance of convention. Both painters were cockneys, emerging from a working-class London background into the polite world of fine art. Both were primarily self-taught, and continued throughout their careers to work out their own solutions to technical and intellectual problems. Blake invented new graphic processes and assembled a syncretic mythology out of his critique of a multitude of religious traditions; Turner invented new techniques in the representation of light and shade, and grappled with both mythic and scientific theories of

vision, light, and representation to clarify his own understanding of art and the world. Both painters were tinged with the English radicalism that distrusts established authority in the name of a deeper tradition of native liberties: Turner was a skeptic and probably an atheist with Republican sympathies; Blake was a heterodox enthusiast who loved to speak on behalf of "The Devil's Party" in theological matters, and who wore the revolutionary cap all his life. Both men were intellectual magpies, reading widely in philosophy, science, literature, and the arcana of religious and mystical thought; both regarded painting as a literary—indeed, a prophetic—art. Most fundamentally, both men were "visionary empiricists"; that is, they both regarded painting not merely as a decorative, ornamental art, but as a profound cognitive act, an expedition into the phenomena of perception and thought. With Turner, the emphasis would be on empiricism (a term often used by critics to describe his violations of "Nature"—i.e., the prevailing conviction), leading toward intellectual vision or apprehension of form. Blake begins with the vision of form and moves toward the empirical in his study of the way form struggles into graphic realization.

It would be tempting, of course, to postulate some point of convergence in the stylistic oppositions of their work. Indeed, one feels a kind of uncanny similarity between Turner's late apocalyptic canvases in which human figures stand glowing at the center of the vortex and Blake's "Giant Forms" dancing amid a phantasmagoria of luminous water-colors (cf. plates 6-14 and 6-15). But the convergence never in fact occurs: Turner remains a colorist with an increasing sense of abstract form; Blake remains a linearist who employs color as a "contrary" to his graphic starting point. Blake's color is not, by any means, a dispensable after-thought, but it is a "super-added" element, coming after the incision and printing of lines. Turner's compositional practice was precisely the opposite: he begins with a chaos of color poured freely on the canvas and adds linear, denotative details, moving from the undifferentiated to the articulate, a process that culminates in the addition of tiny emblematic details and a proliferation of verbal appendages—lengthy captions and explanatory verses. The problem art historians face with Turner is, then, precisely opposite to the one they face with Blake. With Turner, there has never been any question of his rank as a painter; he is still the Paganini of the palette, a technical virtuoso in the class of Rembrandt, Rubens, and Delacroix. The

stumbling-block in the appreciation of Turner has been in recognizing the intellectual, verbal integrity of his work. The usual procedure among art historians has been to dismiss Turner's poetry as unreadable, his theories as incoherent, and his pictorial allegories as "little jokes," private, and probably pathological expressions of personal grievances which distract attention from his "real" value as a "pure painter." Thus, the "meaning" of Turner's painting is generally reduced to a kind of circular formula revolving around the notion of "pessimism": he was a pessimistic fellow, evidently, and his pictures are of violent, destructive subjects that must therefore "express" this pessimism.

With Blake, the opposite kind of problem arises. Blake has *too much* meaning. His iconographic and poetic inventions are so complex, wide-ranging, and over-determined that allegorical interpretation seems endless. The problem is whether he is really a painter, really an artist at all, or just some kind of excessively well-read visionary and intellectual who had too many ideas to contain in any pictorial or poetic form. In rhetorical terms, the problem for the critic of Blake is to make the *pleasures* of his subject manifest. This task can be accomplished only if the stubborn doubter who regards the painterly, virtuosic tradition as definitive in western art is willing to relinquish a number of prejudices about painting: (1) that technical virtuosity is, if not a measure, at least a necessary condition for artistic merit; (2) that painting is primarily a sensuous, not intellectual art; (3) that optical considerations are foremost in painting. Blake's whole career may be seen as a prolonged struggle with these assumptions, manifested in the connoisseurs' preference for smooth tonality and "touch" in engraving (as opposed to Blake's hard, "dry," and "primitive" style, founded in Dürer and Raimondi), and in the epistemological tyranny of the eye, mechanically extrapolated in single-point perspective and in the emphasis on light and shadow (as opposed to Blake's Gothic treatment of pictorial space as a relatively flat surface, adorned with the translucent lattices of linear form).[71]

The proper appreciation of Blake's picture is, in other words, inseparable from the adoption (at least provisionally) of his theory of perception, his insistence that we see "not with" but "thro" the eye, that the thing that sees is the *mind*, not the eye, and that what it sees are forms the mind *identifies* or *defines*, a process manifested in the graphic arts by the "wirey bounding line" of

definite and determinate identity. This process of perceptual identification is treated by Blake (as indeed by most of the Romantic poets) as a dialectical engagement of subject with object, or in modern terms, as a phenomenological encounter. The "identity" that the mind encounters is "half-created, half-perceived," partly an invention of the mind and partly a reception of the otherness that is "really there." In a similar way the linear form that the viewer encounters in a picture is, for Blake, a "receptacle of intellect," expressing in its "infinite inflexions and movements" a particular "character" or "identity" that the artist has conceived/copied, and that now becomes a dialectical object for the viewer—a "message" from Blake, a "receptacle" for the viewer's intellect.

The vortex is such a crucial image in Blake's art because it is a metaphor for this interplay of contrary polarities in the act of perception. If Turner explored the aerial and optical vortex, the eye of the hurricane and the process of perceptual rotation of visual stimuli, Blake focuses on the mental vortex of cognition:

> The nature of infinity is this: That every thing has its
> Own Vortex; and when once a traveller thro' Eternity
> Has passed that Vortex, he percieves it roll backward behind
> His path, into a globe itself infolding; like a sun:
> Or like a moon, or like a universe of starry majesty,
> While he keeps onwards in his wondrous journey on the earth
> Or like a human form, a friend with whom he livd benevolent.
> As the eye of man views both the east & west encompassing
> Its vortex; and the north & south, with all their starry host;
> Also the rising sun & setting moon he views surrounding
> His corn-fields and his valleys of five hundred acres square.
> Thus is the earth one infinite plane, and not as apparent
> To the weak traveller confin'd beneath the moony shade.
> Thus is the heaven a vortex passd already, and the earth
> A vortex not yet pass'd by the traveller thro' Eternity.[72]

We might note first that the idea of the vortex could easily be replaced in this passage by Blake's notion of identity: the vortex is not a property of "everything," regarded as a general, abstract mass, but of "every thing" defined as a distinct, unique identity. To "pass the vortex" of an object is to perceive its particular essence or "whatness," but also (as the passage will go on to suggest) to see it in relationships, in similes contributed by the perceiver's mind. Thus the perceptual vortex is articulated in a

series of dialectical images. The first view stresses the object "in itself," a world with its own self-contained logic ("a globe itself unfolding"); then as a thing with external relations, a source and receiver of energy, radiating and reflecting ("like a sun: / Or like a moon"); then as a whole system of relations and subworlds ("a universe of starry majesty"), the totality of the object-world. The final step in the exploration of the object-world is to reverse polarity and to see the object as a subject, "like a human form, a friend with whom he livd benevolent." Then the entire series of images likened to the perception of a "thing" is enveloped in a summary comparison that focuses on the spaces between things, the perception of land-scape or spatial structures, in which "the eye of man views both the east & west encompassing / Its vortex." Is Blake telling us that the eye is encompassed by its environment, or that the eye encom-passes the space it views? A similar question arises in the following line: when "the rising sun & setting moon he views surrounding / His corn-fields," does "he" surround his vision, or does it surround him? Blake makes it impossible for us to abolish one alternative in favor of the other: a thing or space is what it is, and what we see it as. True vision does not travel in a straight line, but through dialectical, spiraling explorations of these alternative fictions. Thus, every vision is already a "re-vision," an imaginative act involving memory, emotion, and intellect—the entire consciousness of the perceiver. That is why Blake can claim that the infinite is, in a very precise sense, located in the definite, bounded, particular "thing," rather than (as we normally assume in a Cartesian or Newtonian world-view) in the endless, unbounded extension or repetition of space or time—what Blake calls the "Indefinite" or the "void." For Blake, the infinite is equivalent to the definite, conceived as the dialectical apprehension of particular things, and is opposite to the "indefinite." "Thus is the earth one infinite [not indefinite] plane," a field of immediate particulars whose imaginative, dialectical, or in-finite nature has not yet been explored by modern man. "Thus is the heaven a vortex passd already," in that heaven, whether it is the celes-tial paradise of mythology or the infinite universe of modern science, has already been recognized as infinite in some sense, whereas the earth, the field of immediate, particular experience in culture and his-tory, is "a vortex not yet pass'd by the traveller thro' Eternity."

What is the relation between this mental, metaphoric vortex and the actual loops, spirals, and arabesques of Blake's graphic art? It

would be a mistake, I think, to abstract the literal, graphic vortex as a univocal, invariant symbol of the infinite. Blake seems to have been on the same track as Ezra Pound and the English Vorticists of a century later in regarding the vortex as the mental activity that arises in relation to any powerful living *image* in art or nature, whether or not it displays a literal manifestation of the vorticular pattern (in fact the Vorticists tended not to use the graphic vortex in their art).[73] Blake does not use this "literal" vortex everywhere; what he does is to employ the wiry bounding line of identity everywhere in order to create the conditions for mental, interpretive vortices, dialectical visions and re-visions of the forms in his conceptual-pictorial-verbal universe. The actual graphic vortex is used in a wide variety of symbolic situations, and seems not so much to be a symbol in itself as a syntactic connector that allows us to see the relationship between different images. Thus, Blake can use the image as a structural pattern for compositions that articulate contrary ideas. In *The Book of Thel*, for instance, the vortex is suggested in the vegetative coils enveloping the healthy, innocent sexual encounter of the Cloud and Dew; in Blake's illustrations to Dante's *Inferno*, on the other hand, he used it to depict the torments of lust and violent passion in *The Punishment of Rusticucci and his Companions* and *The Circle of the Lustful* (plates 6-16, 6-17, 6-18). In *Europe* the spiral form of the serpent is used to depict the maelstrom of revolution that swallows up tyrants; in other designs the spiral becomes an ascent to heaven, a coiled version of Jacob's Ladder (plates 6-13, 6-19). Sometimes Blake used the form as a direct illustration of the encounter of contraries, as in the yin-yang format of *The Angel Michael Binding the Dragon* (plate 6-20; note that the "eternal" nature of this struggle is indicated in Michael's entanglement in the same chain that he uses to bind Satan; no victory of one principle is depicted here). In other pictures, Blake uses the vortex to suggest a resolution of conflict, as when he depicts God speaking to Job out of the whirlwind (plate 6-21). If we look for the common denominator in all these instances of the vorticular pattern we would find, I suppose, that they are all manifestations of energy — in vegetative growth, physical struggles, sexual encounters (cf. Turner's vortex of copulating bodies), revolutionary destruction, and spiritual or intellectual epiphanies. The vortex is not exactly a "symbol" of this energy. It is the form or identity energy reveals when it encounters consciousness, a phenomenological pattern or

structure that is partly perceptual Gestalt, partly "real, objective form," partly pure geometrical idea.

Blake's witty and playful use of the vortex as idea, as thing, and as the perceptual encounter between the two, may be seen in his color print of *Newton* (plate 6-22). As thing, the vortex is simply the coil in the scroll on which Newton is inscribing his geometrical diagram. As idea, it suggests the antithesis to the thesis that Newton inscribes in that diagram, displaying an asymmetrical, three-dimensional, material form in contrast to the symmetrical, two-dimensional, abstract form that Newton has drawn. As "encounter" between idea and thing, it suggests not just the antithesis between Newton's ideal projections of abstract consciousness and the real facts of matter and energy, but the continuity and interpenetration of the mental and the material. Newton's diagrams reflect an ideal, mental universe, but that universe must be embodied in the material tracings of geometry on the physical medium of the parchment scroll. This incongruous congruity between mind and world, abstract models and their objects, is reflected in the numerous formal "rhymes" in the picture between the arc and triangle that Newton inscribes, and the shapes assumed by his body and his environment.[74] The most telling congruence is, of course, between the form of the compass, which forms an equilateral triangle whose base is the chord intersecting the arc, and the inscribed triangle, which seems to recede from us in the foreshortened plane of the drawing surface. Like Saul Steinberg's pictures of his drawing tools, the design affirms the inextricable connectedness of the virtual and the actual, the representation, illusion, or vision, and the methods of its realization.

The sense that this picture, like Turner's *Light and Colour*, is about vision is substantiated when we reflect on the meaning of compass, triangle, and arc in Newton's most widely read work in the eighteenth century, the *Opticks*. The images do not echo any particular diagram in the *Opticks*, but they do recall Newton's essential tools (prisms, lenses, and compasses) and geometrical concepts (the visual cone or pyramid, representing the convergence of rectilinear rays on a focal point). Blake depicts the compass in a significantly equivocal role, as extension of both the eye (Newton seems to be sighting down along it) and the hand. The hand that rotates the compass about its vertex repeats and confirms the scanning of the visual cone, "As the eye of man views both the east

& west encompassing / Its vortex." The rectilinear and circular per-
fection of Newton's physical and conceptual tools are thus presented
by Blake in a way that does not simply contrast them with his own
eccentric, vorticular notion of vision, but reveals their inescapable
involvement in the vortex.

Newton's geometrical figures may be seen, of course, as varia-
tions on the theme of the signature that we have traced in Hogarth,
Turner, and Blake. But Blake inscribes Newton's forms within his
own, suggesting that the pure, rational forms of geometrical abstrac-
tion are enveloped in a world that continually subverts their purity.
This does not mean, as many Blake scholars have mistakenly as-
sumed, that the picture is a simple satire on reason and mathematics.
Blake depicts Newton as a prophetic visionary who explores the
mathematical model of reality with such intense and thorough
genius that he makes it possible to glimpse the limits of that para-
digm. The scroll, which Blake often depicts as an image of prophetic
or revolutionary *writing* (in contrast to the dead literalism of the
book),[75] is a way of declaring the paradox that the perfection of
Newton's system "blows the last trumpet" for the tyranny of that
system in western thought.[76] Blake uses a similar strategy in his
later prophetic writings when he depicts Urizen's attempts to ratio-
nalize the world as succeeding only in generating their contrary,
"Creating many a vortex fixing many a science in the deep."[77]

Blake's own signature, on the other hand, expresses a conscious
and willed articulation of the vortex rather than an unwitting com-
plicity with one's own contrary. Blake's autograph (plate 6-23)
inscribed in the album of William Upcott the year before his death,
is clearly the result of long thought on an appropriate signature to
summarize his own career. The inscription is, appropriately enough,
a composite verbal-pictorial form, showing us a visionary self-portrait
of the seventy-year-old painter as a soaring, youthful nude whose
hands emanate lines that converge on the "W" of "William Blake."
Is the "authentic" signature of the poet-painter, the creator of the
illuminated books, to be seen in the word (the calligraphic line),
in the image (the pictorial outline of the youth), or in the ornamen-
tal "abstract" line that links them together? If we focus on the
abstract connecting line we note that the figure's hands emanate
two different kinds of linear forms, the right hand cupping down
around a coiled, frontal vortex, the left hand stretched open and
upward to a feathery, S-curved surface, a version of the lateral

serpentine. Blake represents himself as the ambidextrous artist, capable of "handling" both the serpentine line of beauty and the vorticular sublime in the paradoxical bounding line that unites word and image, infinite and definite.[78]

Blake's signature is a declaration that he has "framed" the fearful symmetry of the vortex. Like Turner, he identifies the new paradigm of pictorial and conceptual space; unlike Turner, he articulated (in both words and wiry bounding lines) the significance of this form as a symbol for the very process of paradigm transformation. In *The Structure of Scientific Revolutions*, Thomas Kuhn describes a perceptual experiment that reproduces this experience of transformation:

> An experimental subject who puts on goggles fitted with inverting lenses initially sees the entire world upside down. At the start his perceptual apparatus functions as it had been trained to function in the absence of goggles, and the result is extreme disorientation, an acute personal crisis. But after the subject has begun to learn to deal with his new world, his entire visual field flips over, usually after an intervening period in which vision is simply confused. Thereafter, objects are again seen as they had been before the goggles were put on. The assimilation of a previously anomalous visual field has reacted upon and changed the field itself. Literally as well as metaphorically, the man accustomed to inverting lenses has undergone a revolutionary transformation of vision.[79]

One could argue of course that the transformation is as much a metaphoric and literal exhibition of a highly conservative tendency in our perceptual apparatus, which seeks to construct a familiar order rather than to construct a revolutionary new one. This search for a restoration of stability and identifiable form in the midst of vertiginous impressions seems to me characteristic of Turner's treatment of the vortex. He brings us into the maelstrom from this side, into that "intervening period in which vision is . . . confused" but struggling for resolution. Blake seems to have passed the vortex so many times that he can represent it with the cheerful cockney assurance that rings out in the concluding note of his autograph: "Born 28 Nov 1757 in London & has died several times since."

VI. Coda: The Modern Vortex

The story of the vortex cannot end, of course, on this or any other note, but continues to insinuate itself into the most surprising

structures of thought, from the Viconian spirals of evolutionary historical models to the configuration of the DNA molecule (Hogarth would no doubt have smiled at J. R. Watson's remark that he pursued the double helix hypothesis because "a structure this pretty just had to exist").[80] In the arts, the form regained some of its former beauty and agreeableness (along with a renewed banality) in the arabesques of Art Nouveau. It achieved a new *terribilita* in the sinewy impasto of van Gogh's vortices, a new mystique in Yeats's gyres. The most notable resurgence of the form in English culture was its adoption as the emblem, slogan, and principal metaphor of the Vorticist movement just before the first world war. Curiously enough, the Vorticists were not particularly interested in representations that manifested the "literal" vortex, the actual use of graphic spirals. Their art is rather more like an energized Cubism, an art of hard edges and colliding masses. For the Vorticists the vortex served primarily as a metaphor for the mental energy captured in and stimulated by the artistic image. Thus, Ezra Pound used the term not as a particular image whose structural properties might inform certain patterns of thought, but as a symbol for the power of images *as such*: "the Image is more than an idea. It is a vortex or cluster of fused ideas and is endowed with energy."[81]

At this point we notice that our story has turned itself inside out, and that we are talking not about the vortex as a certain kind of image, but about the image—any true Image, in Pound's terms—as a vortex. If a certain irony is to be seen in this reversal, it pales in comparison to the one that offers itself when we pursue the question of images and vortices a little further in modern history. The most notorious metamorphosis of the vortex in our century has been, or course, the appropriation of the ancient symbol of the "solar wheel" or swastika (a rectilinear or "Cubist" abstraction of the vortex) as the emblem of fascism. There is nothing mysterious about the power of this image to affront and disgust human sensibilities, and for that reason it provides us with some insight into the general problem of the image in modern culture. We sometimes credit ourselves with having outgrown the superstitious or mystical attribution of special power to "mere images." Yet in many ways our time has seen the image attain a power undreamed of by the ancient idolaters. One need only mention the deployment of the image as a tool of psychological manipulation in advertising and propaganda, or the wild irrationality of values in the contemporary

art market to sense the dimensions of modern image-magic. If we live in a prison-house of language, a babel of tongues, jargons, and "terministic screens" that filter out reality, we too easily assume that images are windows that, compared with words, provide a relatively unmediated or unprejudiced view of things. The image, typified most dramatically in the mystique of the photograph as a privileged access to the real, is regarded as an "authentic" presence in contrast to the arbitrary or conventional representations of language. Perhaps this is why so many modern poets and literary theorists, following the lead of Ezra Pound and the Imagists, have sought an aesthetic ideal for literature in the "verbal icon" or "spatial form," as a way of tapping, counteracting, or humanizing modern image-magic in the forms of verbal art. If so, we may need to remind ourselves now that the magic is not in the image but in the imaginer, imbedded in culture, language, and history—the human imagination which Hogarth, Blake, and Turner located at the center of the vortex. We may also need to remind ourselves that image-magic operates not just at the explicit level of iconographic representation, but in those structures or spaces that organize the way we think about history, logic, or the human condition itself. The demystification of these subliminal idolatries will be the goal of a truly historical iconology.

Notes

1. Panofsky's notion of iconology is discussed in his *Meaning in the Visual Arts* (Garden City, N.Y.: Doubleday, 1955), p. 31. My use of the term, like Panofsky's, defines the "icon" or "image" as a broader idea than the mere representation of objects, treating such spatial configurations as perspective, framing, and "abstract" or nonrepresentational schemata as images. Cf. Adrian Stokes's contention that "formal relationships themselves entail a representation or imagery of their own though these likenesses are not as explicit as the images we obtain from what we call the subject-matter." From *Reflections on the Nude* (1967), reprinted in *The Image in Form*, ed. Richard Wollheim (New York: Harper and Row, 1972), p. 123.

2. *Metamorphoses of the Circle*, trans. Carley Dawson and Elliott Coleman (Baltimore: Johns Hopkins Univ. Press, 1966), p. vii.

3. Poulet, p. 350.

4. Poulet, p. vii. The formal identity of classical and modern versions of the circle is, however, more problematic than Poulet suggests, for the two forms exist in radically different geometrical spaces, and are far from expressing a conceptual identity

5. *Modes of Thought* (New York: Macmillan, 1938), p. 112.

6. From *Traite des proprietes projectives des figures*, quoted in William M. Ivins, Jr., *Art & Geometry: A Study in Space Intuitions* (Cambridge, Mass.: Harvard Univ. Press, 1946), p. 120.

7. See Ivins, p. 95. For a discussion of "straight line and circle" as "limiting cases of the logarithmic spiral," see Hermann Weyl, *Symmetry* (Princeton: Princeton Univ. Press, 1952), pp. 69-70.

8. The classic study of numerical and geometrical harmony in Renaissance art is Rudolf Wittkower's *Architectural Principles in the Age of Humanism*, Studies of the Warburg Institute, vol. 19 (1949; new ed., London: Alec Tiranti, 1952).

9. See E. J. Aiton, *The Vortex Theory of Planetary Motions* (London: MacDonald, 1972). Aiton discusses nineteenth-century attempts to explain atomic and electrical phenomena in terms of the vortex hypothesis in his chapter on "The Last Days of the Vortex Theory," pp. 244-56. Versions of the vortex theory in Greek Atomism (Leucippus, Anaximenes, Anaxagoras, and Democritus) and folkloric associations are discussed on pp. 33-34.

10. All Hogarth references are to *The Analysis of Beauty*, 1753, ed. Joseph Burke (Oxford: Clarendon Press, 1955), hereafter cited as *Analysis*.

11. *Analysis*, p. 42. The "verbal vortex" is a commonplace of Mannerist rhetoric. See David Summers, "*Maniera* and Movement: The Figura Serpentinata," *Art Quarterly* 35 (1972): 269-301.

12. One must avoid, of course, the false teleology of seeing Hogarth as a "pre-Romantic," but it is difficult in retrospect to evade the feeling that, as Joseph Burke suggests, the whole Rococo sensibility and the *Analysis of Beauty* in particular "help to prepare the way for the romantic movement" (p. lxi).

13. *Analysis*, p. 32: "twisted columns are undoubtedly ornamental. but as they convey an idea of weakness, they always displease, when they are improperly made use of as supports to any thing that is bulky, or appears heavy."

14. For an account of Alberti's development of the visual pyramid, see John White, *The Birth and Re-Birth of Pictorial Space* (New York: Harper and Row, 1967), pp. 121-26.

15. See Ronald Paulson, *Hogarth: His Life, Art, and Times*, 2 vols. (New Haven: Yale Univ. Press, 1971), II, 181, for a discussion of Hogarth's aesthetic as a *concordia discors*.

16. Joseph Burke, for instance, contends that the "wanton" wreath of the serpent "means, not 'dissolute,' but 'free and frolicsome.'" *Analysis*, p. li.

17. Blake links classical and Egyptian form in the inscriptions to his *Laocoon* engraving: "The Gods of Greece & Egypt were Mathematical Diagrams." See David Erdman, *The Poetry and Prose of William Blake* (New York: Doubleday, 1965), p. 271, hereafter cited as "Erdman." Blake's opposition to the parameters of "length, bredth, and highth" is expressed frequently in his later prophetic works. See *Milton* 4:27 and 32:18, and *Jerusalem* 14:18 and 36:35. On Blake's idea of perspective, see my *Blake's Composite Art* (Princeton: Princeton Univ. Press, 1978), pp. 38 and 58.

18. "Public Address," Erdman, p. 564.

19. *The Prelude*, XIII, 142-51, ed. Ernest de Selincourt; 2nd ed. rev. Helen Darbishire (Oxford: Clarendon Press, 1959), p. 463. Note that the enjambment of "space/Boundless" is a metrical and typographic performance of the winding penetration of boundaries that Wordsworth is describing.

20. *Emblem and Expression* (Cambridge, Mass.: Harvard Univ. Press, 1975), p. 229.

21. Ibid.

22. Shelley quotations are from *Shelley's Poetry and Prose*, ed. Donald H. Reiman and Sharon B. Powers (New York: W. W. Norton, 1977). Line numbers in parentheses after each quotation.

23. R. G. Peterson, "Critical Calculations: Measure and Symmetry in Literature," *PMLA* 91:3 (May, 1976): 374.

24. "Circle and Sequence in the Conjectural Lyric," *New Literary History* 3:3 (Spring, 1972): 512. See also M. H. Abrams's description of "the ascending circle or spiral"

as "a distinctive figure of Romantic thought," in *Natural Supernaturalism* (New York: W. W. Norton, 1971), p. 184.

25. All quotations of Turner's poetry are from *The Sunset Ship*, ed. Jack Lindsay (Lowestoft, Suffolk: Scorpion Press, 1966). "The Origin of Vermilion" appears on pp. 121-22. See also pp. 71-74 for Lindsay's discussion of Turner's knowledge of Hogarth's *Analysis*.

26. Cf. John Gage's observation that "Turner was concerned with the three primary colors because he believed that they were of the essence of natural structure, of the same order as the basic geometrical forms." *Colour in Turner* (London: Studio Vista, 1969), p. 117.

27. *The Sunset Ship*, p. 128.

28. Ibid., p. 129.

29. Kenneth Clark has been the most influential spokesman for the "pessimistic" reading of Turner's vortex: "The vortex was the expression of Turner's deep pessimism, for he thought of humanity as doomed to a senseless round, which ultimately sucked man in to his fate." *The Romantic Rebellion* (New York: Harper and Row, 1973), pp. 236-37. As will become evident in the following, I regard this as a seriously mistaken view of both Turner and his use of the vortex.

30. See Jack Lindsay, *J. M. W. Turner: A Critical Biography* (Greenwich, Conn.: New York Graphic Society, 1966), pp. 96-97 on Turner's "madness."

31. See R. F. Storch, "Abstract Idealism in English Romantic Poetry and Painting," in *Images of Romanticism*, ed. Karl Kroeber and William Walling (New Haven: Yale Univ. Press, 1978), pp. 189-209, for an example of this sort of application of psychoanalysis to Turner's work.

32. Ruskin notes Turner's remark to William Kingsley that he did not like to look at his own work "because the realization was always immeasurably below the conception." *Life, Letters, and Works of John Ruskin*, ed. E. T. Cook and A. Wedderburn, 39 vols. (London: Allen, 1900-1911), XIII, 535.

33. Ruskin had this story from Kingsley. See Lindsay, *J. M. W. Turner*, p. 191.

34. The symbolism of the sirens as "intellectual temptation" is discussed by William Stanford in *The Ulysses Theme* (Ann Arbor, Mich.: Univ. of Michigan Press), pp. 77-78.

35. Lindsay, *J. M. W. Turner*, p. 191.

36. Quoted in *The Art Criticism of John Ruskin*, ed. George L. Herbert (Gloucester, Mass.: Peter Smith, 1969), p. 371.

37. On Turner's fascination with rope-twisting, see Lindsay, *The Sunset Ship*, p. 67.

38. The first scientific observations of the "Spiral Illusion" and its general set of related phenomena, the aftereffects of apparent movement, took place during Turner's lifetime. For a historical account and a compendium of modern research, see H. C. Holland, *The Spiral After-Effect* (London: Pergamon Press, 1965), p. 3. For an account of the effect of motion and excitation of the inner ear on the movement of retinal images, see Ernst Mach, *Space and Geometry* (Chicago: Open Court Publishing Co., 1906), p. 27.

39. Lauretta Bender, "A Visual Motor Gestalt Test and Its Clinical Use," *Research Monographs No. 3, American Orthopsychiatric Association*, 1938, p. 58.

40. See Roger N. Shephard and Jacqueline Metzler, "Mental Rotation of Three-Dimensional Objects," *Science* 171 (19 February 1971): 701-3.

41. This account by Cyrus Redding, a journalist whom Turner met during a visit to Devonshire, is quoted in A. J. Finberg, *The Life of J. M. W. Turner, R.A.* (Oxford: Clarendon Press, 1961), p. 198.

42. *Fulgentius the Mythographer*, tr. Leslie G. Whithread (Columbus, Ohio. Ohio State Univ. Press, 1971), p. 127.

43. Quoted in Finberg, *Life*, p. 241, from one of Hazlitt's "Round Table" essays in *The Examiner*.

44. Adele M. Holcomb suggests that Turner's oval vignettes illustrating Walter Scott and Samuel Rogers in the 1830s led him toward the elliptical and vortical organization of his later paintings. Although the historical claim seems a bit forced (Turner employed the vortex structure as early as *Hannibal Crossing the Alps*, exh. 1817), Holcomb's observation that the vignette allowed Turner to explore "a form which does not imply a window onto space but is created by the relative emergence of forms from an indeterminate matrix" seems quite accurate. See "The Vignette and the Vortical Composition in Turner's Oeuvre," *Art Quarterly* 33: 1 (Spring, 1970): 16-29.

45. The binary equilibrium of the ellipse is no metaphor. The form is defined geometrically as "the locus of points the sum of the distances of each of which from two fixed points is the same constant." We might also note that the ellipse is also an oblique conic section (i.e., a planar cut or section that is neither parallel to nor perpendicular to the circular base of the cone). The cone, of course, is the close relative of Alberti's visual pyramid. Turner's practice of curving the square edges of the base of this pyramid, or bending the visual cone into an elliptical section that cuts across it obliquely, is all part of his exploration of and transformation of picturesque structure; recall here that Hogarth recommended oblique views in preference to frontal and symmetrical perspectives.

46. "Turner, Masaniello, and the Angel," *Jahrbuch der Berliner Museen* 18 (1976): 172. The idea of the spiral line as a signature would, of course, be entirely in keeping with Hogarth's suggestion that this form was the mysterious "signature of Apelles" that identified him to Protogenes. See *Analysis*, p. 16. On the reviewer's coining of the nick-name "Over-Turner," see Finberg, p. 101. Stuckey makes an excellent case for reading puns (e.g., a duck suggesting "mallard" suggesting "Joseph *Mallord* William Turner") in Turner's paintings.

47. *J. M. W. Turner*, pp. 162-63.

48. Turner used these lines from *The Pleasures of Imagination*, ll. 228-31, in his perspective lectures of 1818. See John Gage, *Colour in Turner*, p. 120.

49. The current tendency in Turner scholarship is to react against the view of him as Romantic, modern, or proto-impressionist, and to make him a pure classicist. See, for example, Philipp Fehl, "Turner's Classicism and the Problem of Periodization in the History of Art," *Critical Inquiry* 3:1 (Autumn, 1976): 93-129.

50. *Colour in Turner*, p. 187.

51. *J. M. W. Turner*, p. 35: "Throughout his life Turner maintained this total lack of interest in religion, as if it were something so unimportant that he need not even indicate his blank unconcern." Although it is certainly true that Turner was no churchgoer, nor a militant atheist like Shelley, the evidence of his religious paintings and writings suggests something more complex than a "total lack of interest in religion."

52. Stuckey, p. 175.

53. Kenneth Clark, *The Romantic Rebellion* (New York: Harper and Row, 1973), pp. 261-62.

54. Quoted in Finberg, p. 507.

55. Finberg, p. 508.

56. *Colour in Turner*, p. 186.

57. *The Romantic Rebellion*, p. 260.

58. Emil Mâle, *Religious Art from the Twelfth to the Eighteenth Century* (New York: Farrar, Straus, and Giroux, 1949), p. 75

59. Graham Reynolds, *Turner* (New York: Harry Abrams, n.d.), p. 196.

60. See Stuckey, p. 162, for an account of Turner's identification with the Angel of the Apocalypse.

61. For a fuller account of Blake's use of traditional styles see my chapter on "Blake's Pictorial Style" in *Blake's Composite Art* (Princeton: Princeton Univ. Press, 1978), pp.

40-77, and Jean Hagstrum, *William Blake Poet and Painter* (Chicago: Univ. of Chicago Press, 1964), pp. 23-58.

62. *Europe* 10:13; Erdman, p. 62.

63. *The Book of Thel* 6:17, Erdman, p. 6. For an account of the relation between Blake's geometrical schemata and his ideas of sensory structures, see my "Style as Epistemology: Blake and the Movement toward Abstraction in Romantic Art," *Studies in Romanticism* 16:2 (Spring, 1977): 145-64, and *Blake's Composite Art*, pp. 53-74.

64. Blake alludes in his "Descriptive Catalogue" to the story which Hogarth's *Analysis* had helped to circulate (see note 46 above) that "Protogenes and Apelles knew each other by this line." Erdman, p. 540.

65. See *Blake's Composite Art*, pp. 202-3, for more on the figure of Blake's "Hand" in *Jerusalem*.

66. See note 32 above.

67. Blake's insistence on the inseparability of "invention" and "execution" is elaborated in his "Public Address," where, appropriately enough, he cites Hogarth as an artist who has been defamed and undervalued by the separation of technical "copy" values from the values of original invention: "Englishmen rouze yourselves from the fatal Slumber into which Booksellers & Trading Dealers have thrown you Under the artfully propagated pretence that a Translation or a Copy of any kind can be as honourable to a Nation as an Original Be-lying the English Character in that well known Saying Englishmen Improve what others Invent. This Even Hogarths Works Prove a detestable Falshood. No Man Can Improve An Original Invention . . . Nor can Original Invention Exist without Execution Organized & minutely delineated & Articulated Either by God or Man I do not mean smoothd up . . . but Drawn with a firm and decided hand at once with all its Spots & Blemishes which are beauties & not faults." Erdman, p. 565.

68. *Descriptive Catalogue*, Erdman, p. 537.

69. 10 May 1845. See Martin Butlin, "The Very William Blake of Landscape Painters," *Blake Newsletter 37* 10:1 (Summer 1976): 33-34.

70. Ibid., p. 34.

71. On Blake's use of "Gothic" space, see *Blake's Composite Art*, pp. 58-59.

72. *Milton*, 15:21-35; Erdman, p. 108.

73. More on this to come in the "coda" to this essay.

74. I use "rhyme" here to suggest the simultaneous presence of contrast and similarity of form. For a detailed reading of *Newton* in these terms, see Donald Ault, *Visionary Physics: Blake's Response to Newton* (Chicago: Univ. of Chicago Press, 1974), pp. 2-4.

75. This point can be made on the basis of Blake's own iconography and his statements about books and writing, and without the help of Jacques Derrida—who, nevertheless, helped us to see the importance of the distinction. Blake usually associates the book with patriarchal figures such as Urizen (see *The Book of Urizen*, title-page) and links the scroll with prophetic writing (see *The Marriage of Heaven and Hell*, plate 10). Nevertheless, the temptation to establish this as a strict allegorical code is subverted by the fact that writings have a way of becoming books, and Blake himself is a book-maker who works in the tradition of sacred books such as the illuminated manuscript. The important point in the distinction for Blake is, I suspect, in the quality of reading that goes on, and the capacity of the writing (whether recorded in books or scrolls) to energize and reward imaginative reading.

76. See *Europe* 13: 1-5 where Blake describes the "red-limbed Angel" of revolution who tries and fails to blow "the Trump of the last doom," whereupon "A mighty Spirit leap'd from the land of Albion, / Nam'd Newton; he siez'd the Trump, & blow'd the enormous blast!" Erdman, p. 63.

77. See *The Four Zoas*, Night VI, for a description of Urizen's attempt to escape the world of flux, and his continual formation of new vortices, especially Erdman, pp. 342-43.

78. For a subtle and stimulating analysis of Blake's autograph, see Peggy Meyer Sherry, "The 'Predicament' of the Autograph: 'William Blake,'" *Glyph 4* (Baltimore: Johns Hopkins Univ. Press, 1978), pp. 130-55.

79. Kuhn (Chicago: Univ. of Chicago Press, 1962), p. 112.

80. *The Double Helix* (New York: Atheneum, 1968), p. 205.

81. "Affirmations," in *The New Age* (28 January 1915), p. 349.

7

BLAKE'S REVOLUTIONARY TIGER

Ronald Paulson

T he "Preludium" to Blake's *America* (dated 1793, midway through the French Revolution [see plate 7-1]) opens with a chained youth being fed by the daughter of Urthona, his tyrant captor; he snaps the chains and takes her:

> The hairy shoulders rend the links, free are the wrists of fire;
> Round the terrific loins he seiz'd the panting struggling womb;
> It joy'd: she put aside her clouds & smiled her first-born smile.

In fact, "Soon as she saw the terrible boy then burst the virgin cry," and her joyous cry connects him with the spirit of freedom "who dwells in darkness of Africa" and has succeeded in a revolution "on my American plains."[1]

I have discussed this scene before.[2] I want now to focus on the large discrepancy between word and image. The text talks about the revolution in America and the antislavery movement in England, with the image of the boy, "fiery Orc," chained down, rising, and breaking his chains. The illustration, however, shows something else. He is helplessly chained to the ground, wept over by a pair of parental figures who resemble Adam and Eve. (Pity, in the *Songs of Experience*, was one of the chains binding the downtrodden.) The youth is involved in a complicated system of lines that make him appear entangled in the roots of a great tree, which evokes the Tree of Knowledge (as well as Edmund Burke's symbol of political evolution).

169

The lines in which (a few pages later) Albion's Angel addresses him as "Blasphemous Demon, Antichrist, hater of Dignities; Lover of wild rebellion, and transgresser of Gods Law" are accompanied by an illustration of children sleeping peacefully with a sheep. Erdman interprets this scene as a projection backward in time—"an emblem of peace before the [American] war and prophesied to follow the [French] revolution"—but clearly the main point is the violence of the juxtaposition of visual and verbal texts. It is a stronger version of the discrepancy we feel between the words about Orc, Urthona, and his daughter and the illustration of Orc, Adam, and Eve—one of a son, master, and daughter, the other of a son with his father and mother who have themselves already rebelled and fallen (and thus make an incongruous pair of lamenting witnesses to his chaining under another tree).

This is a kind of visual catachresis that is centered on the representation of the French Revolution. I shall begin by examining it as a transvaluation of accepted images of the Revolution and then go on to examine it as a representation of the revolutionary process itself.

Perhaps what we associate more than anything else with revolution is renaming. The revolution made words mean something else. "So revolutions broke out in city after city," Thucydides wrote in a famous passage; "To fit in with the change of events, words, too, had to change their usual meanings."[3] Thus the French re-created a calendar starting with a new Year One, renamed streets (and people renamed themselves Gracchus or Brutus), turned Notre Dame into a "Temple of Reason," and reversed the meaning of conventional images like the red flag. The transvaluation of sun/light, from the king to the free human reason that exposes the darkness of ignorance or tyranny, is only one of many examples that could be adduced from the French Revolution. This re-creation of meaning is a characteristic of the revolutionary spokesmen in France, but we should not be surprised to find it even more glaringly, because more desperately, employed in nonrevolutionary (counterrevolutionary) England by a sympathizer of revolution, William Blake. In England, however, Blake's response was conditioned by Edmund Burke's *Reflections on the Revolution in France* (1790), which took the utopian rhetoric of spreading illumination/fire in Richard Price's address to the Society for the Commemoration of the Glo-

rious Revolution, and with the aid of common sense returned the renaming to its original signification of uncontrolled destruction. Thomas Paine then went about the same process of common-sense analysis in *Rights of Man* (1791, 1792), his critique of Burke's "renaming" of the events in France.[4] And it is essentially in the same spirit that Blake demystifies the rhetoric of Burke and the counter-revolutionary polemicists—with the exception that his demystification is posited, as a revolutionary's vision, on a resting point that is a higher mystification, a mystery that *cannot* be solved by common sense.

My example is one of the *Songs of Experience*, "The Tyger," which in the annotation of college texts is usually explained as a poem addressing the question of how we are to reconcile the wrath of God and punishment of sin (the tiger) with the forgiveness of sin (the lamb of *Songs of Innocence*).[5] This interpretation sees the tiger as another of the wrathful father figures in *Experience*; he is, however, more closely akin to the natural energy of the tigers in *Innocence* who may also, among other energetic acts, devour sheep or children.

On a primary level the tiger reflects Blake's intention to place the word "tiger" in its 1790s context. The *London Times* of 7 January 1792 tells us that the French people are now "loose from all restraints, and, in many instances, more vicious than wolves and tigers." Of Marat the *Times* reports: "His eyes resembled those of the *tyger cat*, and there was a kind of ferociousness in his looks that corresponded with the savage fierceness of that animal" (26 July 1793).

John Wilkes, after his initial support of the Revolution, spoke of "this nation of monkeys and tigers," conflating the double caricature of French fashion and French savagery, and Sir Samuel Romilly, another disillusioned supporter, wrote in 1792: "One might as well think of establishing a republic of tigers in some forest in Africa, as of maintaining a free government among such monsters." Even Mary Wollstonecraft admitted that the Paris "mob were barbarous beyond the tiger's cruelty." Burke described the Jacobins in 1795 as so violent that "Even the wolves and tigers, when gorged with their prey, are safe and gentle" by comparison; and in a famous passage the next year he compared them to a "tiger on the borders of PEGU" (where it may have been considered safe) that suddenly makes its appearance in the English House

of Commons. Years later Wordsworth looked back on the Paris of 1792 as

> a place of fear
> Unfit for the repose which night requires,
> Defenceless as a wood where tigers roam.[6]

The image thus was very much in the air in the 1790s. On the one hand, the French themselves sang the words in their "Marseillaise" (1792): "Tous les tigres qui sans pitíe / Déchirent le sein de leur mèrex!"; and on the other the tiger was an image that naturally came to English minds in the effort to describe the strange events across the Channel. Had Burke recalled Ripa's *Iconologia* he would have had a learned authority for the signification of tigerish cruelty. Burke and Blake probably shared one source in Burke's own *Philosophical Enquiry into the Origin of our Ideas of the Sublime and Beautiful* (1757), where he chose the tiger as well as Leviathan, the horse, the bull, and the wild ass as "sublime" animals. Blake, like Paine, saw to the bottom of Burke's aesthetic/dramatic representation of the Revolution, in which the "beautiful" passive queen, Marie Antoinette, is threatened sexually by the active, male, "sublime" force of the revolutionaries—a plot Blake reversed in the joyful reciprocation of Urthona's daughter.[7]

In *The Marriage of Heaven and Hell* (1790?), he connects Leviathan and tigers in the vision of the French Revolution seen (conjured up) by a Burkean angel (p. 18). The angel sees a storm with "Leviathan": "his forehead was divided into streaks of green & purple like those on a tygers forehead" (like the "fearful symmetry" of the tiger in *Experience*). As soon as the angel leaves, however, the vision dissolves into a pastoral scene, with a harper singing a song about natural change: "a harper who sung to the harp, & his theme was, The man who never alters his opinion is like standing water, & breeds reptiles of the mind" (p. 19). In short, both Leviathan and the tiger are only in the mind of the angel.

Blake's "The Tyger" is such an angelic formulation, spoken by a Burke who sees the French Revolution, politically and aesthetically, as a sublime spectacle/threat; or by someone like the *Times* correspondent who, adding fantasy to the facts of the storming of the Bastille and lynching of the governor and commandant, described "one man tearing from the mangled body of another pieces of flesh, and dipping the same into a cup, which was eagerly drained

by the executioners.''[8] The references in the poem to the creator (of the Revolution) and to the revolt of the fallen angels ("When the stars threw down their spears") tell the story. The tiger is a natural force, but *what* sort of force depends on the beholder. The Job passage that Burke evokes in his discussion of sublime animals is also (with "The Lamb" of *Innocence*) the syntactic model for "The Tyger": a series of questions addressed by God speaking from the whirlwind to poor Job, ending:

> Canst thou draw out leviathan with a hook? or his tongue with a cord which thou lettest down? Canst thou put a hook into his nose or bore his jaw through with a thorn? Will he make any supplications unto thee? Will he speak soft words unto thee?[9]

Burke's animals are sublime precisely when they will *not* answer with Job, No I cannot; when they will not serve the wills of their masters. The wild ass, for example, "is worked up into so small sublimity, merely by insisting on his freedom, and his setting mankind at defiance."[10]

When in this context we look at the drawing that illustrates the verses, we see a tiger that looks more like a lamb. We see before us on the page, in the Urizenic words and the Blakean image, the angel's vision and the reality. Blake is making the contrast with his visual image in much the same way that he contrasts (in *America*) the words of Albion's Angel, excoriating Orc for his revolutionary proclivities, with the image of children lying down to sleep alongside a peaceful sheep. He is not denying the vigor of the tiger— one of those "tygers of wrath" in *The Marriage of Heaven and Hell* that "are wiser than the horses of instruction"—but only redefining a counterrevolutionary image of revolutionary cruelty. The catachresis indicates not only a contrast with the words of Albion's Angel but something positive about revolution. It is a kind of innocence confronting experience, best seen in the brief scenarios of the *Songs of Experience*. These *Songs* transform the gentle children of contemporary children's verses into the little rebels of Freud and Melanie Klein who appear to their elders as devils (or, as in the case of the little boy who is burnt at the stake in "A Little Boy Lost," possessed by devils).

What "The Tyger" and all the *Songs of Experience* show us is how Blake demystifies the word. *The Marriage of Heaven and Hell*, contemporary with the poems of *Experience*, is a much larger, more

direct statement. When he writes that "the Eternal Hell revives," he means that the French Revolution is taking place. "Hell" here is the counterrevolutionaries' (and in particular Burke's) word for it. In the same way these people exalt "all Bibles or sacred codes" and detest energy, exalt the Messiah and detest Satan. Blake collects his "Proverbs of Hell" during his walk "among the fires of Hell . . . as the sayings used in a nation, mark its character": in other words, in France. But he is a visitor, an Aeneas in the underworld, a Dante in hell, and his writing is not about the Revolution in France but about the repression—the imaging of the Revolution as diabolic—that is being carried out at home in England. Satan is transvalued into Christ because this is the way Christ looked to the Pharisees and Levites, who noted that he healed on the Sabbath and kept company with wine-bibbers and harlots—just as the French Revolution seemed to Burke and as children appeared to their parents in *Songs of Experience*.

If the questions of "The Tyger" are parallel to those of Job's God in the Leviathan passage, then we have something like the same context Burke elicited in the passage on Job in his *Philosophical Enquiry*. God pitted against his creature is a "sublime" confrontation. In the tiny revision of the story of the Fall called "The Poison Tree," however, the relation of creator to created is hardly sublime. The speaker plants his tree (of the sort Blake visualizes differently in the preludium to *America*) as a trap:

> And I waterd it in fears,
> Night & morning with my tears:
> And I sunned it with smiles,
> And with soft deceitful wiles.
>
> And it grew both day and night,
> Till it bore an apple bright.
> And my foe beheld it shine,
> And he knew that it was mine.
>
> And into my garden stole,
> When the night had veild the pole;
> In the morning glad I see,
> My foe outstretched beneath the tree.

Fallen man, like the revolutionary tiger, is in fact simply the product of God as tyrannical creator/destroyer. The speaker is the Old Testament God, renamed by Blake Urizen, and the poison tree is his Tree of the Knowledge of Good and Evil. Man is forced, or

tempted, into the act of resistance, which is a Fall, accompanied by death, but also by knowledge—and with it *double entendre*, ambiguity, and irony.

For Blake's reading of the Temptation in the Garden also extends the original Fall, from sexuality (the revolt of a repressed Orc) to language. The second problematic of man in relation to the revolutionary situation, language elicits this response from God: "Behold, the people is one, and they have all one language; and this they begin to do: and now nothing will be restrained from them, which they have imagined to do." And He concludes: "Go to, let us go down, and there confound their language, that they may not understand one another's speech" (Genesis 11:6-7). Their oneness is broken and scattered, their threat to their master dissipated. Even the English language, as Blake referred to it, is but a "rough basement," a floor Los or Jesus puts under the fall as a limit, a minimal end to falling. Blake refers in *Jerusalem* to "the stubborn structure of the Language, acting against / Albion's melancholy, who must else have been a Dumb dispair" (36:58-60).

There is, of course, a sense in which Blake privileges the word— the Prophet's or Bard's voice. As he gives time priority over space, he prefers the ear to the eye. This is because the ear is an internal source of reference, whereas the eye is subject to outward distractions. The dichotomy is therefore internal/external, not strictly verbal/visual. The eye is despotic insofar as its viewing is determined by perceptual structures imposed by convention: Urizen's sense is the eye because he measures space, lays out caves, rationalizes darkness, and writes books. Urizen is the "I" of the one-point perspective system. Insofar as the word too formulates and charters experience, as for example the Ten Commandments do, it is fallen.

Blake, after all, as an artist-engraver who lived by his eye, had to recognize a truth in the seen—whether *seen* by the ear or by the inner eye. His designs are totalities that inhabit a visionary world meant to be perceived by all five senses. The word and the image interact in a multiple-sensory space. His designs are anything but perspectival; nor for that matter do they rely on chiaroscuro or certain kinds of illusionism such as the use of "paltry Blots" that suggest three-dimensional space. If chiaroscuro is the spatial dimension of painting, the outline is the mental—but still visual. It is

the verbal aspect that counteracts and compresses in perspective and chiaroscuro.

Before we explore the implications of this Fall into language, we must observe that Blake uses at least two other forms of the revolutionary metaphor of discrepancy or catachresis: to describe his own process as artist and to describe the actual process of the historical revolution in France. For in the process of transvaluation he moves from a representation of revolution (in the English misconceptions about the French Revolution) to what we might call a revolutionary art: an art of "hell," of the tiger, of (as he describes it in *The Marriage of Heaven and Hell*) acid burning and corroding, a radical return to Gothic forms and illumination; and so he raises the question of the relationship between political and artistic revolution.

His initial image of the French Revolution was the etching "Albion Rose," dated 1780 to recall the American Revolution and the Gordon Riots of that year, but probably executed closer to 1790. It shows, quite simply, a naked youth (like the Orc of *America*) as the center of a sunburst, breaking the circle that circumscribes him, with the center of gravity his loins. Light, youth, sexuality join in Blake's image of revolution. But art is also involved: the rising out of slavery is equated with youth bursting Scamozzi's textbook diagram of the proportions of the human body—breaking out in an expansive sunburst, his hair twisted into flamelike points. The sun's energy, as opposed to the geometrical shape, is part of the meaning. The "Marseillaise" included the lines: "The rays of the sun have vanquished the night, / The powers of darkness have yielded to light." In his poem *The French Revolution* (1791), Blake still refers to the king of France as the sun, but he is not obscured by clouds, and a new sun is rising to replace him.

As the works of Burke and Coleridge (among others) show, however, the sun was a radically ambiguous symbol:[11] it burned and destroyed as well as illuminated. In Plate 20 of *Urizen* Blake describes Orc in the verse as born in flames and portrays him visually as Icarus falling in flames, from too close contact with the sun. Thus the fall of Orc, or revolutionary energy, is implicit in his birth, or at least in his rebellion. In Plate 10 of *America* Blake shows "fiery Orc" amidst flames, either—depending on the coloring of different copies of the book—emergent or being consumed. In

this case, Blake makes his point even more striking by juxtaposing this image of Orc in Plate 10 with Urizen in Plate 8: he shows them posed as mirror images. Moreover, he places a speech of Orc under the image of Urizen, and the Urizenic evocation of Albion's Angel and his convocation of angels under the image of revolutionary Orc, rendering them interchangeable.

Blake has now passed from the catachrestic image as transvaluation of counterrevolutionary terms to its representation of the ambiguous or paradoxical process of revolution itself. Epistemologically, these double images are different ways the revolution is seen, or different aspects of it, but historically they are also temporal stages in its development. The interchangeable image of Orc and Urizen, or indeed of the lamb and the tiger, indicates a compressed relationship that in the book that followed *Urizen* Blake exfoliates into a narrative structure.

Looking back at his "Bible of Hell," we can say that Blake arrives at his plot by transvaluing the conventional progression of Old Testament to New (or Law to Gospel, Fall to Redemption) by making the relationship one of liberation rather than typological fulfillment. Law is to Gospel as confinement is to freedom. But then, as Blake discovers by observing the events in France, freedom moves back to confinement again, as New becomes Old Testament, coexisting in the confrontation of Orc and Urizen.

The Biblical model of the single cycle of the Son who redeems his Father proves unsatisfactory, however, beside the classical one, which has already been introduced by Paine (in *Common Sense*), of the vicious and continuing cycle of the son castrating his father, devouring (internalizing) him, and oppressing his own son until that son becomes powerful or artful enough to kill him. Historically, a Robespierre votes to kill the king and then becomes more powerful and cruel than any Bourbon. Blake mythologized him in *The Book of Ahania* (1795), and in the *Four Zoas* (1796-1807?) he made Napoleon the definitive protagonist of the Orc cycle.

Even before he was aware of history's irony that successful revolution will fail from internal flaws, Blake foresaw its failure from external restraints. At the very beginning of *America* he placed a frontispiece that contradicted the progression of both "Preludium" and the narrative that followed it. The narrative leads to a happy ending in which liberty is established in America and revolution is threatened (promised) throughout Europe, while the frontispiece

shows the giant Orc now meekly serving to patch the very breach he has made in the tyrant's wall. The visual image tells us that the process has by this time led (or is going to lead) only back to the rebel serving as his own counterrevolutionary, either as a huge, stupid Gulliver (or a Theotormon in *Visions of the Daughters of Albion*) or as a tyrant in his own right.

We may conclude that there was a turn in the historical revolution in France that rendered conventional signifiers of revolution inadequate.

If *America* celebrated the Pittite repression within England that greeted the Revolution, the later illuminated books reflected the cyclic pattern of revolutionary process that revealed itself in France from the autumn of 1792 on. The result is that the Revolution and Blake's poems have become models for each other. This is a relationship in which the referent has begun to determine the signifier, and the artist is moving beyond the conventional images of sunrise, erupting volcanoes, hurricanes—even the Sublime—to equivalents that depend on the actual turn of events or that indicate the unreliability of any image as a guide to truthful representation of the revolutionary phenomenon.

Blake's scepticism about the language of revolution may derive as much from revolutionary as from counterrevolutionary rhetoric (versus event). He transvalues the Bible stories and the accepted meanings of words. He shows that words have power when they are freed from such formulations as "Ten Commandments" or the charters or contracts he talks about in "London." But he acknowledges that they are still words, ever ready to slip off into antitheses of the Divine Logos, to conceal meaning—or to produce "meaning" that conceals the reality of human desire, the Orc in us.

It is not surprising then that in the illuminated books of the 1790s the word and the image are in various ways at odds. One is not quite reliable without the other; more needs to be conveyed than can (under the present Pittite censorship or man's fallen state) be conveyed by either one or the other. Blake is also demonstrating, however, that they certainly do not make a unity; they are simply "illustrative" of each other or constitutive of some absent existent object such as "revolution."

Not only the cynical play with words in both France and England, but all the concern with language systems following the upheavals of the Thirty Years' War on the continent and the Civil War in England fed into Blake's central realization of the discrepancy between word and image. Whenever revolution is a phenomenon to be described, mimesis fails, as do the other normative assumptions laid down by academies of literature and art, and in particular the principle of *ut pictura poesis*, the notion that painting and poetry were "Sister Arts." Blake knew it is neither the portrait painter's function of making present what *was* present but is now absent, nor the history painter's of making present what is yet only dimly present in the words of the poet, but the "revolutionary's" function of making present what was not present before— what has been distorted by the words of Commandments or the rules of the academies. The words alone are ironic utterances; the images are direct and descriptive. The words censor, the images naïvely expose.

In linguistic terms we might explain the "Orc Cycle" as Blake's initial reversal of hierarchical oppositions, giving priority to the "oppressed" member of the hierarchy, and then as his process of denying the "revolutionary" member its newly privileged "sovereignty" by revealing that it was in fact implicit within its antagonist-master. This formulation applies to the visual lamb under the verbal tiger. It also applies to the general relationship of the "Sister Arts" in the "Bible of Hell."

Perhaps I can suggest one more reason why Blake uses a tiger to complement the lamb. It is an unexpected word, because in the context of Innocence *and* Experience the lamb has been presented, and so we anticipate as its contrary a lion or a wolf. The prophetic source, once again, tells us that "the wolf and the lamb shall feed together" (Isaiah 65:25), which came into common usage as "the lion and the lamb shall lie down together"—but never the tiger and the lamb. As Blake himself put it in *America*, there will be a time when "Empire is no more, and now the Lion and Wolf shall cease." But "Tiger" *is* the correct word, and Blake's literary source in Burke's *Philosophical Enquiry* and counterrevolutionary polemic was supplemented, I propose, by the lines from the opening of Horace's *Ars Poetica*, the locus for the whole traditional understanding of the doctrine of *ut pictura poesis* or the "Sister

Arts." That passage describes the painting of comically monstrous creatures roughly resembling centaurs and mermaids:

> Humano capiti cervicem pictor equinam
> iungere si velit, et varias inducere plumas
> undique collatis membris, ut turpiter atrum
> desinat in pescem mulier formosa superne,
> spectatem admissi risum teneatis, amici?
> Credite, Pisones, iste tabulae fore librum
> persimilem, cuius, velut aegris somnia, vanae
> fingentur species, ut nec pes nec caput uni
> reddatur formae. "Pictoribus atque poetis
> quidlibet audendi semper fuit acqua potestas."
> Scimus, et hanc veniam petrimusque damusque vicissim;
> sed non ut placidis coeant immitia, non ut
> serpentes avibus geninentur, tigribus agni.

Most of the seventeenth- and eighteenth-century English translations remain faithful to the Latin "tigribus agni," and the prose renderings of Samuel Patrick, Samuel Dunster, and Christopher Smart transmitted that reading to the English common reader. The Earl of Roscommon's version ends:

> But nature, and the common laws of sense
> Forbid to reconcile antipathies,
> Or make a snake engender with a dove,
> And hungry tigers court the gentle lambs.

The lyric of Blake's "Tyger" superficially poses the question of how evil energy can coexist with meek goodness in God's universe. Blake is saying that they do coexist in his poetic universe of contraries, which is also that of the French Revolution. We must submit to the purpose of "The Tyger," as of the French Revolution, which is to raise the paradoxes of the world of experience, and not to allow one side to cancel the other.

The Sister Arts is a persistent metaphor in Blake's illuminated books. One idea he uses it to express is the bleak separation of visual and verbal meanings in the world of experience (revolution and counterrevolution), which is simultaneously a world of rebellion and repression. In the *Songs of Innocence* there is no significant level of supraliteral meaning. In *Experience*, however, Blake introduces an authorial voice, self-consciousness, and the literary Fall that is—in irony, satire, punning—ambiguity of meaning. *Experience* forces us into the position of the self-conscious reader, trapping us

in the labyrinth of its possible meanings. The unity of textual meaning and literary form in *Innocence* represents the unfallen word, a divine or a prelapsarian logos before the advent, perhaps, of the written lyric (or just at the moment of transition); *Experience* is demonstrably the realm of the fallen word. In terms of the history of the French Revolution, the poems express an education, a process that requires Experience, including the loss it entails. In terms of the poetic development from Innocence to Experience, as described in the "Introduction" to *Innocence*, Blake traces the progression of the lyric (lyros=lyre) from a piped, spontaneous song to a literary form. The piper's pipe, which was once filled with the breath of life and art, now becomes the "hollow reed" of the amanuensis: the piper becomes a poet and hence falls from innocence in the production of his art.

The transformation of lyric song into a completely and deliberately literary form is necessary for the work's preservation and dissemination (so "every child may joy to hear"), but the act of writing robs the piper of his artistic innocence—it severs him from his lyrics, when previously the artist and the poem had been inseparable and the lyric *was* the breath of the lyricist. One other element that distinguishes experience from innocence is the loss of the mutual dependence of text and design in *Songs of Innocence*. In *Experience*, the lyric is noticeably separate from the design; their potential disengagement seems apparent from the way the text floats in front of the infinitely receding void of the pictorial framework—time works against space in a strict dichotomy. In "London," for example, the illustration seems to be an emblematic representation of what is *not* stated in the poem: the old Urizen and the young Orc are a simplification, or displacement, of the dense connotations of the words into a different world altogether.

In plate after plate, Blake presents the natural antipathy between the Sister Arts, as between the polar interpretations of the Revolution; but at the same time he demonstrates that the apparently unresolvable antipathy can be transcended. He places them in a new relationship that is metaphoric rather than illustrative or merely mimetic—that creates in a "revolutionary" way rather than merely repeats or substantiates. He is in fact reaffirming—or rather redefining—the unity of the Sister Arts of poetry and painting; he is seeking a continuity with that old tradition as a model for the unity he sees in art (or in revolution as an artistic experience) as

opposed to the Burkean separation of the arts. Burke, recall, in the passage he illustrated with Milton's description of Death, tries to demonstrate the superiority of the poet's words over the artist's visual image.[12] Blake uses the visual image to correct and complement the fallible repressive word, but both have to stand if the transaction is to be complete.

For Blake, paradox seems to be the characteristic feature of revolution itself, as well as the interpretation of it. The French Revolution offered the concrete case in which words have antithetical meanings ("tiger" or "devil," but also "General Will" or "traitor") and in which the actors prove to be both good and evil at the same time (a Lafayette, a Robespierre, or a Napoleon). These contradictions could be read either as a double-bind (as by Romilly and others) or as a paradox, where we accept the paradox itself, repudiating Aristotle's—and Burke's—law of contraries (*this* alternative excludes its opposite) as we repudiate the separation of the Sister Arts. The Revolution, like his art, inhabits for Blake that "mythic" area of ambiguity and doubleness where contraries can coexist.

Notes

1. See *The Poetry and Prose of William Blake*, ed. David V. Erdman (Garden City, N.Y.: Doubleday, 1965), pp. 50-51, and Erdman, *The Illuminated Blake* (Garden City, N.Y.: Doubleday, 1974), pp. 139-40.

2. See Paulson, "Burke's Sublime and the Representation of Revolution," in *Culture and Politics from Puritanism to the Enlightenment*, ed. Perez Zagorin (Berkeley and Los Angeles: Univ. of California Press, 1980), pp. 254-56.

3. Thucydides, *History of the Peloponnesian War*, trans. Rex Warner (Harmondsworth: Penguin, 1954), 3.6.

4. Blake's inspiration for the plot of *America* and its sequel *The Song of Los*—with its chapters on "Africa," "Asia," and "Europe"—is the opening of Paine's second part of *Rights of Man*, which hails the American Revolution as the model for revolutions to come:

> So deeply rooted were all the governments of the old world, and so effectually had the tyranny and the antiquity of habit established itself over the mind, that no beginning could be made in Asia, Africa, or Europe, to reform the political condition of man. Freedom had been hunted round the globe; reason was considered as rebellion; and the slavery of fear had made men afraid to think.
>
> But such is the irresistable nature of truth, that all it asks, and all it wants, is the liberty of appearing. The sun needs no inscription to distinguish him from darkness; and no sooner did the American governments display themselves to the world, than despotism felt a shock, and man began to contemplate redress.

And this echoes the language of *Common Sense*: "Every spot of the old world is overrun with oppression. Freedom hath been hunted round the globe. Asia and Africa have long

expelled her. Europe regards her like a stranger, and England hath given her warning to depart. O! receive the fugitive, and prepare in time an asylum for mankind," he says, addressing America. See *Rights of Man* (Harmondsworth: Penguin, 1971), p. 181; *Common Sense*, ed. Thomas Wendel (Woodbury, N.Y.: Barron's Educational Series, 1975), p. 101.

5. See, e.g., Hazard Adams, "Reading Blake's Lyrics: 'The Tyger,'" and John E. Grant, "The Art and Argument of 'The Tyger,'" in *Discussions of William Blake*, ed. Grant (Boston: Houghton Mifflin, 1961), pp. 50-63, 64-83.

6. Romilly, letter to M. Dumont, 10 September 1792, from *Memoirs of the life of Sir Samuel Romilly, Written by Himself; with a Selection from his Correspondence*, edited by His Sons, 3 vols. (London, 1840), 2nd ed., II, 5; Wollstonecraft, *An Historical and Moral View of the French Revolution* (1794); Burke, *Letter to a Noble Lord* (1795, Worlds Classics ed.), p. 294; Wordworth, *Prelude* (1804), X, 80-82.

7. See Paulson, "Burke's Sublime," pp. 241-70.

8. *Times*, 20 July 1789.

9. Job 41:1-3. Proposed by Morton Paley, *Energy and Imagination: A Study of the Development of Blake's Thought* (London: Clarendon Press, 1970), pp. 45-46. Paley quotes from Edward Young and William Smith on the sublimity of such questions, especially in Job 37 "where we behold the Almighty Creator expostulating with his Creature. . . . There we see how vastly useful the Figure of Interrogation is, in giving us a lofty Idea of the deity, whilst every Question awes us into Silence, and inspires a Sense of our own Insufficiency" (trans. *Peri Hupsous*, p. 154, cited by Paley, p. 49). Paley sees the dichotomy as between the angels who call the Revolution evil and the poet who calls it sublime. Cf. also Harold Bloom's "strong" reading, which suggests that Cowper, as *the* sublime poet of the later eighteenth century, may be the imagined speaker (*Poetry and Repression: Revisionism from Blake to Stevens* [New Haven and London: Yale Univ. Press, 1976], p. 47; also p. 46: "The forerunners of Blake's Tyger are the Leviathan and Behemoth of Job, two horrible beasts who represent the God-ordained tyranny of nature over man, two beasts whose final name is human death, for to Blake nature *is* death").

10. Burke, *Philosophical Enquiry*, ed. J. T. Boulton (London: Oxford Univ. Press, 1958), p. 66; Job 39:5.

11. See Paulson, "Turner's Graffiti: The Sun and its Glosses," in *Images of Romanticism: Verbal and Visual Affinities*, ed. Karl Kroeber and William Walling (New Haven: Yale Univ. Press, 1978), pp. 167-88.

12. *Philosophical Enquiry*, pt. II, sec. iii-iv, pp. 58-61. I need hardly mention that my discussion in these final pages is indebted to the basic books on the subject: Jean Hagstrum's *The Sister Arts: The Tradition of Literary Pictorialism and English Poetry from Dryden to Gray* (Chicago: Univ. of Chicago Press, 1958) and *William Blake: Poet and Painter* (Chicago: Univ. of Chicago Press, 1964), and W. J. T. Mitchell's *Blake's Composite Art* (Princeton: Princeton Univ. Press, 1978). One other article, which has come to my attention after writing this essay, anticipates some of my points about the word "revolution" and the meaning of "The Tyger": Aileen Ward, "The Forging of Orc: Blake and the Idea of Revolution," *Tri-Quarterly* 22-24 (1972): 204-27.

THE FOURTH FACE OF MAN
Blake and Architecture

Morton D. Paley

I

In *Milton* Blake classifies the arts as fourfold: "But in Eternity the Four Arts: Poetry, Painting, Music / And Architecture which is Science: are the Four Faces of Man."[1] The same four arts are named in the vehement *Laocoon* aphorism "A Poet a Painter a Musician an Architect: The Man / Or Woman who is not one of these is not a Christian" (E. 272). The reason for his choice of the first two arts is clear: Blake knew himself to be both painter and poet. The third requires little explanation, for we know from Blake's contemporary John Thomas Smith that Blake made music for his songs, and that "his tunes were sometimes most singularly beautiful, and were noted down by musical professors."[2] Architecture, however, is not an art that Blake practiced in any literal sense, and he has not generally been regarded as showing any unusual interest in that subject. We can always learn more about Blake's work, however, by applying his statements seriously; and if Blake assigned such importance to architecture, we can expect to find evidence of this in his poetry and art. In fact, a remarkable sense of architecture appears in Blake's painting and printmaking, from his earliest works to his latest, and architectural motifs are important in his poetry as well. Starting with a good working knowledge of architectural draftsmanship and engraving, Blake went on to use architectural imagery as a vehicle for literal and symbolic meaning

in both the sister arts and in that unique fusion of the two that Jean Hagstrum was the first to term "composite art."[3]

Blake's artistic concern with architecture begins with his apprenticeship to James Basire. Much of value has been said about the stylistic results of the training Blake received from Basire[4]; it is also noteworthy that Blake was apprenticed to a master largely known for his architectural engravings. These two matters of style and subject are, as ever, closely related: as we can see in the superb plates for volume I of *The Antiquities of Athens*[5] signed by Basire, his style lent itself to producing architectural elevations of great firmness and clarity, possessing an almost abstract beauty. Basire was even better known for his engravings of medieval and Renaissance subjects for the Society of Antiquaries and other sponsors. His "Monument of Edward Crouchback, Earl of Lancaster" in Richard Gough's *Sepulchral Monuments of Great Britain*[6] shows a fine sense of the construction of this medieval tomb. Its architectural complexity is conveyed in Gough's description:

> The canopy of stone over this tomb consists of three trefoil pointed arches, one in the centre, and one lesser on each side of it. Each of these arches is surmounted by a double pediment, separated from the arches by a pilaster, which slopes back in three several stories, and is painted white, chequered with double red lines, in every other square of which is a red cinquefoil (the two uppermost slopes serving as a base to a pointed flowered niche) and terminates in a rich purfled finial.[7]

Such tombs are virtually models of buildings, and as Basire's apprentice, Blake executed both preliminary drawings and copper plates of subjects like this for *Sepulchral Monuments*,[8] gaining a close knowledge of medieval architectural forms.

Another Basire project that Blake almost certainly had a hand in during his apprenticeship is the plates for Jacob Bryant's *A New System, or an Analysis of Ancient Mythology* (London, 1774-76).[9] Blake's continued interest in this book is indicated by his reference to it in *A Descriptive Catalogue* (1809).[10] Among the thirty-one plates of *A New System* are three particularly appropriate to our subject, showing a temple of Mithras built into the side of a mountain in Persia.[11] (One is identified as "from Le Bruin," evidently referring to *Travels into Muscovy, Persia, and Part of the East Indies* by Cornelius de Bruin [London, 1737], a voluminously illustrated book originally published in Dutch and then in French). The slab-like, rectilinear rocks used as structural units in the Temple of

Mithras appear to have been carried over by Blake, as we shall see, to his own depictions of "Eastern" subjects. The basically cubic altar on a pediment in the first plate of volume II may also have provided the prototype for a form Blake made use of later.

In the year or so he spent as a student at the Royal Academy, Blake had ample opportunity to extend his knowledge of architecture. Students were expected to become familiar with the Academy's collection of reproductions, and Blake's own anecdote of his dispute with the Keeper, G. M. Moser, shows that Blake availed himself of the opportunity—their argument as to the comparative merits of different schools of art took place as Blake was looking over prints "in the Library of the Royal Academy."[12] There Blake would have found engravings of the great buildings of the world as well, along with architectural treatises and theoretical discussions. As Anthony Blunt suggests, Blake was familiar with the representations of Solomon's Temple, "much studied throughout the seventeenth and eighteenth centuries," of Pradus and Villalpandus,[13] and with John Wood's illustrated treatise *The Origin of Building, or the Plagiarism of the Heathen Detected.*[14] We are probably justified in assuming that Blake also saw editions of the works of Vitruvius[15] and of Palladio[16], as well as such eighteenth century works as Colin Campbell's *Vitruvius Britannicus*[17] and Sir William Chambers's *A Treatise on the Decorative Part of Civil Architecture.*[18] One such book seems especially to have stamped Blake's visual memory, to judge by what appear to be several borrowings he later made from it: *A Plan of Civil and Historical Architecture* by J. B. Fischer von Erlach.

Fischer von Erlach's book first appeared in German in 1725 and was published in an English translation by Thomas Lediard in 1730. It comprises eighty-six large plates of both ancient and modern buildings, with an explanatory text. A number of the subjects illustrated would have been of interest to Blake. Following Villalpandus, Fischer von Erlach published a ground plan and a view of the Temple of Solomon. A panorama of Babylon shows its river, geometrical gardens, and an eight-storied ziggurat. Egypt is represented by pyramids and sphinxes, and the structure (later) reproduced by Bryant as a Temple of Mithras is here entitled "The Tombs of Persepolis."[19] Fischer von Erlach's illustrations and some of Blake's designs show several striking parallels. In the water color *The Angel of the Revelation* (Metropolitan Museum of Art), Blake seems to recall Fischer's illustration of the Colossus of Rhodes[20]

(see plates 8-1 and 8-2), and in *Jerusalem* 62 we see what appears to be a deliberately grotesque version of that same figure. Fischer's depiction of "Mount Athos, cut into a *Gigantick* or *Colossal* Statue" is remarkably similar to Blake's fourth watercolor for Milton's *L'Allegro*, "The Sunshine Holiday." As can be seen in plates 8-3 and 8-4, both designs share the conception of a giant figure with a city in its lap, though Blake adds a second, female giant. Considering the unusual nature of the idea, the similarity is unlikely to be mere coincidence. The note to this design in Fischer's *Architecture*, giving examples of "the *Invention of cutting Rocks into Humane Forms*,"[21] is a mechanical counterpart of Blake's visionary inscription: "Mountains Clouds Rivers Trees appear Humanized on the Sunshine Holiday" (E. 664). Again, Fischer's presentation of Stonehenge (Book II, plate xiv), showing at its center a huge dolmen with a diminuitive rider in the foreground, may have influenced the *Milton* 4 design, which further exaggerates the disparity in size (see plates 8-5 and 8-6). These instances support the possibility that Blake was familiar with Fischer von Erlach's *Architecture* and that some of its designs passed into Blake's own repertoire of visual forms.

As a result of his apprentice work with Basire, Blake seems to have acquired a reputation for architectural competence, since one of his earliest commissions as an articled engraver was for *A Proposition for a New Order in Architecture* by Henry Emlyn (1781).[22] In addition to a signed plate showing a pedestal with a heraldic trophy, Blake may have executed a second, unsigned engraving of the lower part of a column bearing a shield.[23] In 1791, Blake was invited "to engrave any of Mr Pars's drawings for the Antiquities of Athens,"[24] linking him with a former Basire project, though in the event the subjects he chose were sculptural. For John Flaxman's *Letter to the Committee for Raising the Naval Pillar, or Monument* (1799), Blake made three plates that combine architectural and sculptural subject matter. Plate 3 demonstrates six structural forms: "Obelisk," "Column," "Meta," "Arch," "Pharos," and "Temple." The Pharos, consisting of four sections on a pediment, is especially interesting because Blake would later construct it in Dante's Hell. Plate 2 includes a competent rendering of Sir Christopher Wren's Greenwich Hospital, with its twin baroque domes and its Doric colonnades. The work Blake had previously done on medieval subjects served him well in executing the frontispiece to volume 3 of William

Hayley's *Life and Posthumous Writings of William Cowper, Esq.*
(1804). This view of John Flaxman's monument to Cowper in its
architectural setting (see plate 8-7) displays a fine sense of form,
particularly in its depictions of the Perpendicular window (replaced
in 1857)[25] and of the pointed arches in St. Edmund's Chapel. Al-
though Blake did not see the Church of St. Nicholas in Norfolk
(he worked from a drawing by Francis Stone), the print has a feeling
of authenticity. In these and other commercial engravings, we see
that Blake successfully engraved various types of architecture. He
did not, of course, set up as a specialist in this type of work, but
did incorporate architectural forms into the idiom of his art and
the imagery of his poems. There is much to indicate that he found
the use of such forms especially congenial. He was an architect of
the imagination, who used period styles and various types of struc-
tures as one way of establishing meanings.

II

Blake's use of period styles in architecture may be classified under
seven stylistic headings. These are partly a matter of convenience of
discussion and do not account for all possible manifestations of the
subject matter. My purpose here is not to catalog Blake's uses of
architecture, which would be at best a tedious business, but to show
through selected examples the importance of architecture in his
imaginative world. For this purpose, most buildings in Blake's de-
signs can be identified as Egyptian, "Eastern," Classical, "Druidic,"
Gothic, Baroque, and Contemporary. In Blake's poetry it is of course
harder to define such styles, but there too architectural periodiza-
tion occurs. There are, in addition, other important elements in
Blake's use of architecture, but those are best discussed after his
period vocabulary has been established.

 Blake's use of Egyptian architecture is almost always theoretically
determined, beginning with the early (*c.* 1789) *Tiriel Supporting
the Swooning Myratana* (Mr. and Mrs. Paul Mellon).[26] The austere
colonnade in the immediate background, consisting of dowel-like
pillars mounted on waferlike squares, corresponds to no known order
and may represent Blake's idea of Egyptian pillars. (Slightly later,
Sir William Chambers argued that the Egyptians and not the Greeks
had originated the classical orders).[27] Certainly the pyramid further
in the background is a thematic underscoring of Tiriel's pharaonic

tyranny. Blake is consistent in using the image with that meaning. The regenerate man in plate 21 of *The Marriage of Heaven and Hell*[28] is in copy D given a background of two pyramids that represent the now eclipsed negation of the divine human form. Similar contrasts occur later. Although Blake as well as other artists may have been affected by the interest in things Egyptian precipitated by Napoleon's Egyptian campaign of 1798 and by ensuing archeological discoveries,[29] the meaning of Egyptian images remained the same in Blake's works. In *The Hiding of Moses* (Henry E. Huntington Library),[30] two pyramids loom ominously over the human figures; significantly, the child is almost invisible. When he leaps triumphantly from his wicker cradle in *The Finding of Moses* (Victoria and Albert Museum),[31] the whole foreground collaborates to offset the angular background pyramids with the cursive lines of women, palm trees, birds, and bulrushes. Pyramids emblematize the not-human in Blake's texts, too. In *Jerusalem*, Los sees how "souls are bak'd / In bricks to build the pyramids of Heber and Terah."[32] And after the Spectre rebels for the last time, building "stupendous works," Los strikes with his hammer, "In unpitying ruins driving down his pyramids of pride" (91: 32, 43, E. 249). Blake even drew the visionary head of *The Man Who Built the Pyramids*,[33] a portrait of an architect, complete with hieroglyphically inscribed portfolio. This depiction, as Anne K. Mellor observes, is based on the physiognomic theories of Johann Caspar Lavater and characterizes the subject as "skilled at calculation and engineering, but . . . a cruel taskmaster and a crude, self-indulgent sensualist"[34] — appropriate qualities for the creator of an icon of dehumanization.

Closely related to Egyptian subjects, and indeed sometimes included among them, is the style that may be called "Eastern," a descriptive term for buildings in various parts of the ancient Near East by various artists, including Poussin, Turner, and in our century Rouault. In Blake's pictures the hallmark of this style is a combination of massive walls, domes, and high towers, all of which avoid the use of classical Greek components. Such is the left background of *The Virgin and Child in Egypt* (Victoria and Albert Museum)[35] and the background of *By the Waters of Babylon* (Fogg Art Museum).[36] Certain components of this style are used with the full aura of "Eastern" associations. In the illustration to Dante that has been entitled *The Complaint of the Giant Nimrod* (Fogg

Art Museum),[37] we see a wall adjoining the remains of the Tower of Babel. The wall is made of huge rectilinear blocks, the tower of bricks—no doubt the sort in which the souls of men are baked — with an entrance formed of rectangular slabs. This is the style of the Persian subjects in the illustrations to Bryant; even the mouth of the rocky cave projecting over the top foreground is reminiscent of the mountain in which the supposed Temple of Mithras is set. In such an imaginative work as this, Blake gives the "Eastern" style symbolic extension. The style is appropriate to the theme of dehumanizing tyranny also represented by Nimrod, by the crowned figure inside the tower, and by the idea of Babel itself.

Nimrod is a figure in Dante's Hell, and in general Blake employs the "Eastern" style for the architecture of Hell. Behind Farinate degli Uberti in Dante illustration no. 21 (British Museum), the buildings of the City of Dis appear as a conglomeration of domes, triangular roofs, and a domed portico with rectilinear columns, all behind a crenellated wall. The same wall is seen in no. 20, *The Gorgon-Head, and the Angel opening the Gate of Dis* (National Gallery of Victoria, Melbourne), with a huge portcullis at its center. The Pharos that Blake engraved for Flaxman's booklet reappears transformed in no. 17, *Dante and Virgil Crossing Toward the City of Dis* (Fogg Art Museum). It consists of two buttresses supporting a rectangular solid surmounted by a cube, which in turn supports a smaller cube crowned by a cupola, all the elements except the last being composed of straight lines. Similarly conceived structures appear in Blake's *Paradise Lost* design *Satan, Sin, and Death* (Henry E. Huntington Library),[38] where oblong slabs and a portcullis with a square grid form a background for the three figures. This scene was one often illustrated by British artists, among them Hogarth, Barry, Gillray, Romney, Fuseli, and Stothard; but of these only Barry in addition to Blake supplies an architectural background (made up of a round arch and a tower).[39]

The chief practitioner of the "Eastern" style of architecture in Blake's poetry is Urizen, who in Night IX of *The Four Zoas* repents "building arches high & cities turrets & towers & domes / Whose smoke destroyd the pleasant gardens" (121: 6-8, E. 375). Urizen's most ambitious feat of building is described in Night II of *The Four Zoas*, where he and his sons erect a city modeled on the Pandemonium of *Paradise Lost*. Milton's text in turn supplies "Eastern" comparisons:

Not Babylon
Nor great Alcairo in such magnificence
Equalled in all their glories . . . [40]

Urizen's city is presented with profound ambivalence. At first it seems a creation of divinely inspired order:

Then rose the Builders: First the Architect divine his plan
Unfolds. The wondrous scaffold reard all round the infinite
Quadrangular the building rose the heavens squared by a line.

(30: 8-10, E. 313)

But such limited, geometric forms cannot retain positive value for Blake, and as the passage continues, it undercuts what appeared to be an idealized description:

Trigon & cubes divide the elements in finite bonds
Multitudes without number work incessant: the hewn stone
Is placd in beds of mortar mingled with the ashes of Vala
Severe the labour, female slaves the mortar trod oppressed. (11-14)

Carefully eschewing the "Doric pillars" of Milton's Pandemonium, Blake constructs this enormous configuration with only "Eastern" materials as a cityscape of twelve bright halls and three Central Domes is produced. "Each Dome opend toward four halls & the Three Domes Encompassed / The Golden Hall of Urizen" (20-21). It is a scene worthy of John Martin,[41] and it would be interesting to trace the further evolution of the "Eastern" fantasy through Victorian dioramas and panoramas,[42] D. W. Griffith, and Cecil B. DeMille. That, perhaps fortunately, is beyond my subject. What is important here is that Blake uses "Eastern" architecture to render scenes of purely material power. The magnitude of such achievements and even their beauty may be recognized, but their massive, geometrically regular style betrays their brutal disregard for human concerns.

Blake was educated as an artist early in the Neo-Classical age, and it is therefore not surprising that he often makes use of classical Greek architecture in his works. His view of classical art changed radically shortly after 1800,[43] but this conversion from a positive to a negative attitude does not determine the implications of classical structures in particular works. In *Age Teaching Youth* (Tate Gallery),[44] a watercolor executed c. 1789, a screen of possibly Ionic columns divides the trees in the remote background from the human figures in the foreground. Here the classical allusion is ironic; the colonnade is identified with the traditional wisdom of the gowned and bearded teacher who unsuccessfully tries to get

the girl at his left to look into his extended book, while she instead points upward. In contrast, *The River of Life* (Tate Gallery),[45] painted *c.* 1805,[46] shows the houses of the New Jerusalem as fronted with graceful pilasters culminating in what appear to be Corinthian capitals. Thus the meaning of the classical motifs in these two pictures is determined not by whether they were produced before or after 1800 but by their place in a context established by the pictures themselves. In plate 15 of *Europe*, the broken column above the family of fleeing refugees obviously suggests the end of a civilization; what kind of values it represented is left for us to surmise. The Doric colonnade in *The Overthrow of Apollo and the Pagan Gods* (Henry E. Huntington Library)[47] is just as obviously meant as something that *should* be overthrown, as is fitting in an illustration to Milton's "Ode on the Morn of Christ's Nativity." Unlike the Egyptian and "Eastern" styles, which tend to have fixed meanings in Blake's work, classical architecture is capable of multiple meanings and must therefore be interpreted according to the overall sense of the work in which it appears.

For the works built by the ancient inhabitants of Britain, Blake uses a style that may be called "Druidic," as it is chiefly used to depict structures associated with the Druids. Like many of his contemporaries, Blake believed that the Druids had practiced human sacrifice at Stonehenge, and his typical use of "Druid" architecture is meant to suggest the tyranny of misdirected intellect.

> Yet immense in strength & power,
> In awful pomp & gold, in all the precious unhewn stones of Eden
> They build a stupendous Building on the Plain of Salisbury; with chains
> Of rocks round London Stone: of Reasonings: of unhewn Demonstrations
> In labyrinthine arches. (Mighty Urizen the architect.) thro which
> The Heavens might revolve & Eternity be bound in their chain.
>
> (*Jerusalem* 65: 79 - 66 : 5, E. 215-16)

Blake probably never saw Stonehenge or similar remains but learned about them through the works of William Stukeley, particularly from Stukeley's *Stonehenge: A Temple Restor'd to the British Druids* (London, 1740).[48] Against the view attributed to Inigo Jones by John Webb—that Stonehenge was a Roman temple[49]— Stukeley argued that it had been built by a colony of Phoenicians who had brought the religion of the Old Testament patriarchs to England. Blake's notion that the Druids misapplied the story of Abraham and Isaac is evidently derived from Stukeley:

Indeed, the Druids are accused of human sacrifices. They crucified a man and burnt him on the altar; which seems to be a most extravagant act of superstition, deriv'd from some extraordinary notices they had of mankind's redemption: and perhaps from *Abraham's* example misunderstood.[50]

Stukeley also hypothesized that the Egyptians contributed to the architecture of Stonehenge, speculating that they may have "fled as far westward, into the island of Britain, and introduced some of their learning, arts, and religion, among the Druids, and perhaps had a hand in this very work of *Stonehenge,* the only one I know of, where the stones are chisel'd." Stukeley dates this contribution as occurring before the building of the Second Temple, and he also compares architectural features of Stonehenge with details of the Temple of Solomon as supposedly described by Ezekiel. Thus Stukeley provides a view of Stonehenge consistent with Blake's: that it was the product of a Druid civilization that had links to the patriarchs of the Bible, and that in it human sacrifice was carried out because of the corporeal misinterpretation of allegorical command. Imagery associated with "Druid" architecture in Blake's works consequently bears, for the most part, a meaning similar to yet distinct from those of the Egyptian and "Eastern" styles.

Most of Blake's "Druid" structures fall into one of two categories. There are individual components, sometimes in scattered groups, and there are fully developed serpent temples. The first may occur as "Druid" rocks, as in the human sacrifice scene in the lower design of *Jerusalem* 69, or they may take the form of cromlechs and trilithons imbued with symbolic significance. In *Jerusalem* 70, the impossibly huge trilithon dwarfs the human figures underneath, but in 92 the trilithons are reduced in size and relegated to the background, and only one of these is left in the first light of dawn on plate 94. Blake probably derived his idea of the appearance of the trilithons from Stukeley's numerous illustrations. It is worth remarking that like Fischer von Erlach, Stukeley shows a view of a horse and rider before a great dolmen, and so may have influenced the design on plate 4 of *Milton.*

Blake took the idea of the Druids' serpent temples from Stukeley's sequel to *Stonehenge—Abury: A Temple of the British Druids* (London, 1743). Avebury, thought Stukeley, was just such a temple, built of unhewn stones in the time of Abraham, because "at that time of day, the aboriginal patriarchal method from the foundation

of the world was observ'd, not to admit a tool upon them."[51]
Blake, in the passage of *Jerusalem* 65 quoted above, sees the "un-hewn" quality of the stones as apposite to the misplaced literalism of both the Druids and of eighteenth-century science. "The precious unhewn stones of Eden" are misused by Urizen's builders to create "Reasonings of unhewn Demonstrations." Blake's inversion of the values attached by Stukeley to "Druid" architecture extends to the supposed shape of the temple itself. After investigating the positions of the megaliths at Avebury, Stukeley concluded that "the whole figure represented a snake transmitted thro' a circle; this is a hieroglyphic or symbol of highest note and antiquity."[52] The plan was supposedly communicated to the Druids by Hercules, who had come to Britain from Phoenicia in the time of Abraham; and the serpent shape was regarded as a symbol of the divine. Blake, in contrast, regards the serpent temple as part of a culture of cruelty, one having analogies with his own time. In *Europe* the defeated King "sought his ancient temple serpent-form'd," one like Avebury "form'd of massy stones, uncut / With tool" (10: 2, 7-8, E. 62). And in *Jerusalem,*

> The Serpent Temples thro the Earth, from the wide Plain of Salisbury
> Resound with cries of Victims, shouts & songs & dying groans.
>
> (81: 48-49, E. 235)

In so making the serpent temple a negatively charged image, Blake knew that he was reversing Stukeley's intention. Stukeley regards the serpent temple as an emblem of eternity, whereas for Blake it represents recurrence:

> Then was the serpent temple form'd, image of infinite
> Shut up in finite revolutions, and man became an Angel;
> Heaven a mighty circle turning; God a tyrant crown'd.[53]

Here the very fact that the serpent is an *image* of the infinite marks it as part of a process of limitation: along with other deteriorations in the human condition, man's idea of eternity is replaced by the idea of eternal recurrence. In his late works, however, Blake tends to recover the "unfallen" or regenerated aspects of "fallen" forms. Thus in plate 100 of *Jerusalem* there appears a memorable image of Avebury based on Stukeley's reconstruction (see plate 8-8).[54] Los, standing with hammer and dividers, is the builder of this structure. It is not that "Druid" architecture has absolutely changed in meaning for Blake, but rather that with "All Human Forms identi-

fied even Tree Metal Earth & Stone" (99: 1, E. 256) Blake wants to present the Serpent Temple in its original meaning as described by Stukeley.

One further detail of "Druid" architecture should be mentioned — the "cove." In canceled plate c of *America*, Albion's Angel gets ancient weapons in "the cove of armoury." Within "the stupendous building on the plain of Salisbury" are "the Cove & Stone of Torture" (66: 13), and later in the same plate "They look forth from Stone-henge! from the Cove round London Stone" (66: 57). Such coves are features of Druid temples according to Stukeley, and they are pictured in two of the plates of *Abury*.[55] He refers to this feature as "that immense work in the center, which the old *Britons* call a cove: consisting of three stones plac'd with an obtuse angle toward each other, as it were, upon an ark of the circle, like the great half-round at the east end of some old cathedrals."[56] Blake read this passage carefully enough to construct his cove accordingly in *Jerusalem* 66: 12-13:

> Her [Vala's] Two Covering Cherubs afterwards named Voltaire & Rousseau:
> Two frowning Rocks: on each side of the Cove & Stone of Torture:

By a characteristically Blakean equation, the Druid temple becomes Vala's temple of Natural Religion, containing in its cove a demonic parody of the twin Cherubim stretched over the Mercy Seat.

The Gothic is the style of architecture about which Blake's interest has been best documented. (Because Blake was not aware of the subperiodization of medieval architecture that began late in his lifetime,[57] I use the word "Gothic" for the entire period and "late medieval" for the Decorated and the Perpendicular styles.) As we have seen, Blake learned the elements of representing medieval architecture during his apprenticeship. His experience of the Gothic was probably extended by visits to Chichester cathedral in the course of his three years at Felpham. From Blake's earliest works to his latest, Gothic architecture has an important role. In the title page of *There is No Natural Religion* (both series) there is a pointed arch with Gothic tracery, and on the frontispiece to series b, Gothic panels form a background to the raising of Lazarus. These positive Gothic images should not, however, make us assume that in Blake's early works the Gothic has the theoretical meaning it acquired later. Blake's use of Gothic details is often atmospheric or "historical," and it can even be negative, as Hagstrum observes.[58]

For example, in the third treatment of *Pestilence* (Bateson Collection),[59] executed *c.* 1790-95, a Gothic archway replaces the shed-like structure at the right in the two previous versions; this "historical" detail is then retained in the two following versions. Urizen's throne in plate 11 of *Europe* is backed by Gothic arches and pinnacles, but here they have the conventional eighteenth-century meaning of ignorance and priestcraft. The Gothic tower in one of the illustrations for Thomas Gray's "Ode for Music" (Yale Center for British Art)[60] is ambiguous: it may represent the inspiration of the poet, but it could equally suggest the "dead" past as do the two barren trees beneath which the melancholy Gray has chosen to walk. In considering the implications of medieval architectural motifs in such pictures as these, we must be guided by our sense of context.

During the first few years of the nineteenth century, Blake experienced a series of inner crises and illuminations that had radical consequences for his art. As a result, he rejected classicism — though not, as we have seen, the representation of classical structures. Now the Gothic took on for him the doctrinal meaning of "Living Form,"[61] and from this time on, Gothic shapes in Blake's work are almost always infused with spiritual meaning. Thus in the second state of the engraving *Joseph of Arimathea among The Rocks of Albion*, the subject is identified as "one of the Gothic Artists who Built the Cathedrals in what we call the Dark Ages" — a powerful visionary, contrary to the subject of *The Man Who Built the Pyramids. Christ Baptizing* (Philadelphia Museum of Art)[62] has the dove of the Spirit descend between two pilasters with beautiful fan vaulting. When Satan tempts Christ in *Paradise Regained* illustration 10 (Fitzwilliam Museum),[63] it is above the roof of a Temple with late medieval pinnacles. In the Thornton's *Virgil* illustration, "Colinet Resting at Cambridge by Night," King's College Chapel gleams in the distance.[64] A wonderful architectural device is introduced in Blake's *Canterbury Pilgrims* tempera (Pollok House, Glasgow)[65] and engraving: a Gothic portico through which the pilgrims pass from an equally Gothic interior. This is completely unlike the real Tabard Inn, which Blake must have seen[66] — unlike any inn, for that matter. The entire architectural composition, with its tracery, figures in niches, and pointed arches, gives symbolic extension to the pilgrimage; Chaucer himself emerges from a poetically charged space. Even a seemingly modest detail of this type can be significant,

as we see in the miniature portrait of the Rev. John Johnson (Coll. Miss Barham Johnson),[67] where the introduction of a Gothic church tower expresses Blake's esteem for "Johnny of Norfolk."[68]

The baroque, typified for Blake by St. Paul's Cathedral, is associated in his works with the pomp of worldly power and state religion. In plate 57 of *Jerusalem*, St. Paul's with its dome and two towers is shown at the top of a disk near the word "London"; its antipodes is the tiny delineation of a Gothic cathedral near the word "Jerusalem." The same opposition is magnified in plate 46, where Vala and Jerusalem confront each other. Behind Vala is a dome surmounted by a cross, behind Jerusalem two Gothic towers and a nave. Thus the opposition between the Vala-principle and the Jerusalem-principle is reflected in the opposition of two architectural styles. These two images appear once more in *The Chaining of Orc*, more visibly in the pencil drawing (British Museum) than in the relief engraving (Henry E. Huntington Library). In the pencil drawing "Theotormon Woven" (Victoria and Albert Museum),[69] the dome surmounted by a cross occupies the center and is thematically related to the weaving of Theotormon into the material world. This baroque form becomes for Blake almost a hieroglyph, and it is sometimes impossible to distinguish it from the "Eastern" dome, as for example in *The Spiritual Form of Pitt* (Tate Gallery).[70] In some early copies of *The Book of Urizen*, plate 11, a large dome appears at the right. This shape could be baroque, but it could equally be Roman (as in the Pantheon) or "Eastern." Here the ambiguity may be a form of equation, since for Blake the type of society represented by St. Paul's is to be identified with imperial Rome and with Babylon. "I behold Babylon in the opening streets of London,"[71] writes Blake—and the architecture of Babylon too. Even the dome, however, cannot be regarded as a merely negative image, for its unfallen form will be recovered in Golgonooza.

Contemporary buildings also have a role in Blake's *oeuvre*. As he had done with classical structures, Blake continued to portray and describe Neo-Classical buildings with sympathy long after he had rejected the sources of their inspiration. He seems, for example, to have taken a special pleasure in the shape of William Hayley's Turret at Felpham.[72] The Turret, occupied by Hayley in 1798, was designed by a young architect named Samuel Bunce, whom Hayley persisted in referring to as "this pleasing little Palladio."[73] This "marine villa" was essentially a cottage with a long covered

arcade of thirty-two rustic pillars, a "Grecian" portico, and a high tower terminating in a cupola. Blake drew it in his *Landscape near Felpham* (Tate Gallery),[74] and he later recalled the "Glorious & far beaming Turret" and "the delights of the Turret of Lovely Felpham."[75] Even if we allow for a desire to please Hayley with these references, Blake's pleasure in the house and in its distinctive architectural features seems evident. Another type of building appears in two of the wood engravings for Thornton's *Virgil*. In "A Rolling Stone is Ever Bare of Moss" and in "Menalcas' Yearly Wake" Blake shows respectively the rear and front views of a beautiful Palladian mansion, suggestive of Stourhead and of a number of other buildings that Blake could have known about through Colin Campbell's *Vitruvius Brittanicus*. A more intense response to contemporary architecture may be found in *Jerusalem* 27, if Stanley Gardner is correct, as I believe he is, in arguing that the "golden builders" there are engaged in John Nash's London projects of the early nineteenth century.[76] In this lyric celebration, Blake is probably thinking of the greening of London that was effected when Regent's Park was established in 1811, linking Marylebone with Primrose Hill to the northeast and to St. John's Wood to the northwest. These builders are probably occupied with Park Crescent, opening off the New Road just south of Regent's Park, begun in 1812. More terraces were to be built on the east and west sides of the park over the next decade. Seen from the vantage of Primrose Hill (where Blake once conversed with the Spiritual Sun), these splendid, Bath-stone-colored, stucco facades would appear virtually golden, the Ionic colonnade of Park Crescent like "pillars of gold."

III

Blake's use of period styles blends into another aspect of architecture in his works, where certain structural types have a special importance, both in themselves and in relation to others.

1. *Altar*

Blake's altars are often places of human sacrifice, and as such they have "Druidic" as well as "Eastern" associations, as can be seen in *Jerusalem*:

> From willing sacrifice of Self, to sacrifice of (miscall'd) Enemies
> For Atonement: Albion began to erect twelve Altars,

Of rough unhewn rocks, before the Potters Furnace
He nam'd them Justice, and Truth. (28: 20-23, E. 173)

This passage derives from Exodus 24:4, which in turn was interpreted by Stukeley to refer to the ancestor of the Druid temple: "These temples which they call'd altars, were circles of stones, inclosing *that* stone more properly named the altar. . . . *Moses* his temple was a circle of twelve stones: and such we have in England." [77] In his visual art Blake usually represents the altar as a rectangular solid, often a cube. Sometimes it is a single mass surmounted by a slab, as in the frontispiece of *The Song of Los* and in a preliminary drawing for *Jerusalem* 25 (Fogg Art Museum). [78] It may alternatively be made of bricks or stones, as in the early *Abraham and Isaac* (Boston Museum of Fine Arts). [79] The latter construction relates it to another architectural type, the wall. This is made explicit in the design for *Milton* 15, where the murdered Abel lies by a stone altar that at some indeterminate point becomes a wall composed of similar stones. The oppressive mass and rectilinearity of the altar are its salient elements, as is emphasized by the contrasting curves of the female body in *The Sacrifice of Jephthah's Daughter* (British Museum). [80] The altar may, however, be a positive image on occasion. The context enforces a positive meaning in *The Covenant* (Mrs. Alexander M. White Coll.), [81] presumably because in Noah's time the idea of sacrifice had not yet been perverted into corporeal command. A transformation of the altar occurs in the depiction of Los's forge in *Jerusalem* (plates 6 and 32): composed of a cube placed on a larger rectangular solid, the forge is as it were an altar adapted for the purpose of creative labor.

2. Wall

The wall made up of large hewn stones is typically associated with imprisonment. Literal prison walls occur in the early *Lear and Cordelia in Prison* (Tate Gallery), [82] in plate 13 of *Europe*, and in the *Pilgrim's Progress* design *Christian and Hopeful Escape from Doubting Castle* (Frick Collection). [83] Such walls may go back to Piranesi's *Imaginary Prisons* as mediated by Hogarth's painting of the prison scene in *The Beggar's Opera*, which Blake himself engraved in 1788. Figurative prison walls are important to the meanings of "London" in *Songs of Experience* and of the "Plague" design in *Europe* (plate 10). In "London" a boy is shown leading

an old man along a massive wall made up of huge bricks or slabs—perhaps one of the "palace walls" mentioned in the text. The *Europe* design features a brick wall with a closed door in its center, claustrophobically sealing off the background. One longs to breach such walls, and the broken wall is indeed the theme of other works, but the result is seen as catastrophic. The gigantic, manacled body of Albion's Angel fills the breach in the wall of the *America* frontispiece; in *War* (Fogg Art Museum)[84] the gap is stopped with the bodies of the dead and dying. Such walls, it seems, have the power to imprison but lack the power to protect.

3. *Stairway*

Blake's stairs are of two types. One is the airy spiral staircase of *Jacob's Dream* (British Museum).[85] Blunt refers to this beautiful construction as "a complete novelty in the iconography of this subject," and compares it with a staircase in Salviati's fresco of David and Nathan.[86] But Salviati's fresco cycle in the Palazzo Sachetti had not, as Blunt points out, been reproduced in Blake's time; perhaps a more likely source is the winding staircase pictured in Palladio's *Architecture*.[87] Blake also may have known engravings of the marvelous staircase designed by Inigo Jones for the Queen's House at Greenwich. In the first flush of anticipation of his new life in Felpham, Blake imagined just such a structure:

> The Ladder of Angels descends thro' the air;
> On the Turret its spiral does softly descend,
> Thro' the village then winds, at my Cot it does end.[88]

Such a staircase is also the organizing element of Blake's pictorial epitome of James Hervey's *Meditations Among the Tombs* (Tate Gallery),[89] and it appears once more in a lightly sketched pencil drawing for Dante's *Paradiso* (British Museum), no. 91 in the series. These are spiritual staircases upon which human beings and angels move without difficulty.

Far different is the staircase built of slabs, which usually suggests great effort or pain. In Dante illustration no. 78, *Dante and Virgil Approaching the Angel Who Guards the Entrance of Purgatory* (Tate Gallery), there are three such steps, following the text of canto ix. Here and in the following design, *The Angel Marking Dante with the Sevenfold P* (Royal Institute of Cornwall, Truro), the huge, slablike steps show Blake's antipathy to the idea that sin must be marked on Dante's brow so that it may be purged.

The slabs are rearranged into curving steps ascending Mount Purgatory in nos. 81, 84, and 86, but they retain the suggestion of impediments of a slow progress. The struggle implied by such stairs may nevertheless have a positive goal, which is unmistakable in the visual contexts of *Milton* 29 and 33. The first, inscribed "WILLIAM," depicts Blake in a visionary ecstasy, falling backward toward three steps. The second, "ROBERT," shows Blake's dead brother as a virtual mirror image; but because Robert is in Eternity, his is a complete fourfold staircase. These stairways also involve pain and difficulty, but they lead to the achievement of vision, in contrast to the bondage to Law suggested in the Dante illustrations.

4. *Doorway*

Some of Blake's greatest designs center on doorways—*Death's Door* and plate 1 of *Jerusalem*, for example. A comparison of these two is instructive. The doorway of *Death's Door* (as well as those of *The Gates of Paradise* 15 and *America* 14) is of post-and-lintel construction. The effect is that of a "Druid" trilithon, and "Eastern" associations are also present, for the ancestor of this composition is once more the Temple of Mithras in Bryant's *New System*. The structure has suggestions of prison walls appropriate to the tyranny of Death, made even more explicit in *The Gates of Paradise*, where similar slabs form the walls of Ugolino's prison (plate 12). In contrast to these, the doorway that Los is about to enter in *Jerusalem* is formed by a Gothic arch, identifying Los as one who by an act of imagination "dies" to save Albion. Thus the architecture of the doorway, with other visual elements, determines our interpretation of the design. A third type of doorway is used consistently in Blake's renderings of Christ's tomb. Characterized by a round arch, this structure conveys a sense of "Eastern" antiquity and suggests as well the Babylonian captivity of Christ's body. This is especially marked in *The Entombment* (Tate Gallery),[90] where the round arch virtually dominates the picture. The wings of the angels in *Christ in the Sepulchre, Guarded by Angels* (Victoria and Albert Museum)[91] form a Gothic ogee arch that almost obliterates the dimly seen round arch in the background—the promise of the resurrection superseding the limits of the natural man; and the risen Christ himself stands under the round arch in *The Magdalen at the Sepulchre* (Yale Center for British Art).[92] The arch in these pic-

tures of the Sepulchre is both a historical or atmospheric detail and a symbol.

5. Superstructure

Despite its rarity in Blake's works, the superstructure is such a conscious reference to architecture that it should be mentioned here. Superstructures form the backgrounds of two scenes from the life of Christ: the tempera *The Christ Child Asleep on the Cross* (Victoria and Albert Museum)[93] and the watercolor *The Humility of the Saviour* (Walshall Museum and Art Gallery).[94] The first of these features a series of timber modules running across the entire midground of the picture space; two complete ones in the shapes of sections of a house or barn occupy the center, but others disappear at each side so that one does not know how many of them to imagine. These sturdy structures provide powerfully reiterated vertical, horizontal, and diagonal thrusts; and these are in turn reflected by the lines of the large cross, turned at an angle from the viewer, on which the Christ child lies. The superstructure suggests the rational order of the world that Christ has entered and in which he will be crucified. A pair of compasses, leaning against the wooden frame at the right, emphasizes this meaning. Compasses (or perhaps dividers) are actually held by Christ in the second picture, as is a right-angled carpenter's rule. This time the background, once more running from one end of the picture space to the other, is made up of a single structure of timber. Consisting of alternating horizontal beams, with the uppermost ones turned at an angle to suggest a roof, the framework implies that the architectonics of the world can be invested with the imaginative power of Christ. In this context the compasses and the rule, usually negative symbols in Blake's works, become positively valorized.

6. Cottage

Pastoral-primitive buildings evocative of the values of Innocence, Blake's cottages have the characteristics of the "Hut" discussed by Gaston Bachelard in *La poétique de l'espace*.[95] The mind delights in imagining the radically simplified lives of the inhabitants of such structures as the tiny "Peasant's Nest" engraved for Hayley's *Cowper*.[96] As with other positive images in Blake, this one has its antitype. The little houses in the design for "The Chimney Sweeper" in *Songs of Experience* squat drearily, transformed by context into

miniature prisons. "The Goblin" (Pierpont Morgan Library)[97] for *L'Allegro* has pastoral-looking cottages, but, in keeping with the subject, these look frightening rather than inviting. Yet the cottages of the Thornton's *Virgil* woodcuts, though swathed in darkness, have enormous appeal. Once more it is not the single shape but its place in a whole configuration that determines our response. Of all these cots, perhaps the most warmly presented is Blake's own. Rousseau could not have described the pleasures of the hut more vividly: "Our Cottage is more beautiful than I thought it, & also more convenient, for tho' small it is well proportion'd, & if I should ever build a Palace it would only be My Cottage Enlarged."[98] Blake builds this cottage for us in plate 36 of *Milton* (see plate 8-9). It is a deliberately childish design, completely two-dimensional, like a comic strip drawing. To reinforce the effect of a child's idea of the basic form, the design is charmingly inscribed "Blakes Cottage at Felpham."

At various points in Blake's work we come upon single architectural forms like the ones discussed, just as at times a subject is characterized by a single period style. In numerous instances, however, more complex images—pictorial or verbal—are composed of interrelated structures, extending the meaning through juxtaposition. I have already discussed the conjoining of halls and domes in Night II of *The Four Zoas*. That passage on MS page 30 develops further into an architectural fantasy involving other elements. Urizen's Golden Hall contains "A Golden Altar. . . . Foursquare sculpturd & sweetly Engravd" as well as an altar of brass. One of these stands at the entrance to the hall, reached by a stairway of twelve steps. There is also "a recess in the wall for fires to glow upon the pale / Females limbs. . . ." This description participates in the "Eastern" tradition of Beckford's *Vathek* and is particularly reminiscent of the Halls of Eblis, emphasizing, like Beckford, the powerlessness of human beings in the shadow of such massive structures ("One thousand Men of Wondrous power spent their lives in its formation"), to the point of bordering on the sadistic. A very different kind of architectural composite occurs in the design for *Jerusalem* 84. A boy is shown leading an old man ("London") away from a wall, past a dome surmounted by a cross, toward a Gothic church. Here is a clear thematic statement that does not require paraphrase but that does depend on our construing the

relationships among three architectural components. Such relationships also can contribute to extended meanings within a single work, as is the case in the engraved *Illustrations to the Book of Job.*

Job is remarkable, among other reasons, for its presentation of historically disparate architectural styles as contemporary with one another. It is true, as Bo Lindberg asserts, that "This conglomeration . . . has the effect of universalizing the story,"[99] but this does not prevent the architecture from having a thematic function as well. For example, a Gothic church appears in the background of plate 1, against the setting sun, telling us that true spiritual worship did exist in Job's age. In plate 4, after Job's trials have begun, the Gothic church is still there; but it is absent afterward, being replaced by a "Druid" trilithon in plate 5. This progression makes a simple statement that reinforces the message in the margin of plate 1: "The Letter Killeth the Spirit giveth Life."

The characteristic architecture of Job's country makes use of the slab as a module, employing it as the basis of massive works. Heavy-looking columns are also employed, as is the round but not the pointed arch. In plate 4 Job and his wife sit on a slablike bench in front of a house fronted with thick "Eastern" pilasters. When Job's children are destroyed in plate 3, Satan perches among collapsing pillars on a lintel that resembles the top of a trilithon. Gateways built of heavy slabs are pictured in plates 8 and 13, the first having a round arch, the second a rectilinear opening. This style extends to heaven too, in the plinthlike steps that lead to God's throne in plates 5 and 16. The literalness of vision that is a theme of these designs finds a correlative style in the indigenous architecture of Job's country.

Evidently the disaster that overcame Job's children in plate 3 was part of a cataclysm that affected the entire land, for ruins a-bound afterward. Plate 6 shows a ruined house behind Job, presumably his own; further back, a broken trilithon; still further, four groups of broken columns. Extensive ruins are to be found in plate 7, broken columns at the right in plate 9, ruined buildings in the background of plate 12, and another ruined house behind Job and his wife in plate 19. Needless to say, no such general catastrophe occurs in the Biblical story. Blake invents it and reiterates it to create a sense of epochal development, making the story of Job not that of a single man but of an entire society — our own.

The Gothic church is not the only positive architectural image in *Job*. In plate 7 Job looks at a cross that Blake has caused to be formed as if by accident at the right. This introduction of "cross-like architectural fragments" Lindberg finds to be a traditional one, introduced "whenever a representation of Job as *prefiguratio Christi* is intended."[100] A massive stone cross stands among the ruins in plate 9. After Job has experienced his change of heart, he sacrifices before a cubic altar made of large stones, from which a flame ascends (plate 18), clueing us to interpret the scene positively. The regenerate Job of plate 20 sits with his daughters in an art gallery adorned with pictures of his own story. Thus throughout the *Job* series, architecture reinforces the thematic meaning of the events portrayed.

Blake's most ambitious architectural construction is the great City of Golgonooza in *Jerusalem*, described extensively in plates 12 and 13 (E. 154-55) and alluded to throughout the work. The scope of this essay does not allow a comprehensive discussion of this city of the Imagination, which I hope to present in my forthcoming book on *Jerusalem*. Here I shall take up only the strictly architectural aspects of the conception in which are conflated the city and temple described in Ezekiel 40-47 and in Revelation 21. Golgonooza is of course much more than a combination of material from these sources, for Blake uses these as raw material for his own distinctive artistic creation. In doing so, he participates in a tradition according to which the structure of the Temple is regarded as a divinely transmitted prototype for subsequent architecture. This is the gist of Renaissance theories of Divine Proportion such as those of Francesco Giorgi,[101] Philibert de l'Orme,[102] and G. B. Villalpando.[103] Closer to home, it is the view of a number of writers whose works, published in English during the seventeenth and eighteenth centuries, may be seen as a bridge from the architectural theories of Renaissance humanism to the visionary architectonics of Blake's *Jerusalem*.

Joseph Mede, in his widely known *The Key of the Revelation*,[104] comments on "the Analogy of new Jerusalem" with respect to its twelvefold structure, "in the frame whereof, and the dimension of the Gates, Foundations, Court, compass of the walls, longitude, latitude, altitude, the same number of twelve, or multiplication of twelve, is used."[105] Mede also publishes a plan of the Temple's two courts: a large outer one that all the people could enter, and

an inner court that included the Tabernacle and the altar, and that only the high priests could enter. Mede does not, however, go into a further reconstruction of the Temple because this had already been done in an extraordinary book that Mede recommends to his reader: *The Temple: Especially As it stood in the days of our Saviour*, by John Lightfoot.[106] Lightfoot, relying largely on Jewish sources, gives an extensively detailed account of the structure, which he characterizes as "of a heavenly resemblance, use, and concernment, as figuring Christ's body." According to Lightfoot, the Temple was in many ways similar to a Gothic cathedral: "*Solomon's* Temple did very truely resemble one of our Churches, but onely that it differed in this, that the Steeple of it (which was the porch) stood at the East end."[107] The roof and pinnacles of the Temple in Herod's time are described by Lightfoot as much resembling the Perpendicular Gothic: "The roof was not a perfect flat, as was the roof of other houses, but rising in the middle . . . *till the very crest of the middle came up as high as the height of the battlement;* as *Kings Colledge Chappell* may be herein a parallel also; And the like battlements and pinnacles are likewise to be allotted to the lower leads."[108] That Blake thought of the Temple in a similar way can be seen in the background of the tempera *The Body of Christ borne to the Tomb* (Tate Gallery)[109] where the high steeples suggest a Gothic building. Equating the architecture of the Temple with that of the Gothic cathedrals would for Blake merely have meant extending to architecture his ideas about painting and sculpture, which he believed to be Hebraic in origin.[110]

Perhaps no other scholarly reconstruction of the Temple so combined particular detail with intense imagining as did Lightfoot's. There were nevertheless other literary restorations that could have interested Blake. The fifth chapter of Isaac Newton's *A Chronology of Ancient Kingdoms Amended*, a book that was owned by William Hayley,[111] presents a detailed description of the Temple supplemented by three floor plans showing its walls, gates, courts, and other architectural features. Like Lightfoot, Newton emphasizes the Temple's quadrilateral structure. In Plate I, *A Description of the Temple of Solomon* (see plate 8-10), a square altar is shown at the center of a square court that in turn is surrounded by a square pavement; outside is the Court of the People, also square, and a square wall surrounds the whole. It would be facile to dismiss the possible relevance of such plans to Blake's conceptions on the

grounds of Blake's well-known dislike of geometry and of Newton, for both squareness and multiples of the number four have an essential role in the structure of Golgonooza. Blake's city of the imagination has four Gates, each facing one of the cardinal points, and each gate is in turn fourfold: "And every part of the City is fourfold. . . . And every house, fourfold" (13: 20, 22). The enormous importance of the quaternary in *Jerusalem*[112] is reinforced by the spatial conception of four-squareness, as in 72: 5-8:

> For Albion in Eternity has Sixteen Gates among his Pillars
> But the Four towards the West were Walled up & the Twelve
> That front the Four other Points were turned Four Square
> By Los for Jerusalems sake & called the Gates of Jerusalem.

In the architectural plans published with Newton's *Chronology* as well as in the descriptions of Lightfoot, Blake could have found conceptions germane to his mental model of Golgonooza.

The ideas of G. B. Villalpando reappeared in the eighteenth century in published works by two master architects: J. B. Fischer von Erlach and John Wood of Bath. Fischer von Erlach, who designed the Karlskirche in Vienna according to the prevailing image of the Temple of Solomon, begins his *Civil Architecture* with a consideration of the Temple derived from the description of the Jesuits as well as from other authorities, including Lightfoot. Plate I shows "A Ground-Plan of the Temple of Solomon, With all it's Courts, according to Villalpandi, who has given the best *Designs* of this *Building* out of the *Holy Scripture*"; and Plate II is "A View of the Temple, As it appears from the side of Mount Morea, taken out of the Prophet *Ezekiel*, and after him from Villalpandi." The author argues: "It would be a Subject of a vast Extent, but might be prov'd, that the *Roman Architecture*, and the *Corinthian Order* owe their Perfection to the excellent Structure of this *Temple*. The Phoenicians having first discover'd the Beauty of it to the *Greeks*, & these to the *Romans*."[113] This view of the priority of Hebrew architecture found a fuller expression in a book by John Wood of Bath—*The Origin of Building: or, the Plagiarism of the Heathen Detected.*[114] Substantiating his view by references to the Bible and to Josephus, Wood asserts that the Tabernacle was the first of four sacred structures in which the same relationships of dimensions were observed, the others being the three successive Temples. The floor plan of the Tabernacle is the subject of plates

2 and 3, while plates 12 and 13 show the disposition of the tribes of Israel around the tabernacle in the camp, and the following plates indicate the placement of the individual tribes. Three pages of text are devoted to a list and enumeration of the twelve tribes, making Blake's long enumeration in plates 16 and 32 of *Jerusalem* appear in perspective less singular. Of course Wood places the tribes entirely according to Num. 2:3, in four camps consisting of three tribes each, one for each direction; whereas for Blake the equivalent of the four camps is England, Scotland, Wales, and Ireland, with "Gates looking every way / To the Four Points" (16:32-33). The Tabernacle's basic plan, Wood goes on to argue, was elaborated in the Temple. Plates 24 and 25 show the Temple as a rectangular structure in the form of a double square, rather than as the single square of Newton's *Chronology*. The city of Jerusalem itself is represented in plates 24 and 25, with its surrounding wall, its twelve gates, and its streets dividing the City into twelve great squares and a grand piazza at the center.

Wood's description of the Temple interior has much in common with Blake's famous passage about "the bright Sculptures of Los's Halls" (*Jerusalem* 16: 61-69), in which are represented "every pathetic story possible to happen from Hate or / Wayward Love & every sorrow & distress." According to Wood, the structure of the Tabernacle was "intended as an Hieroglyphical Representation of the past *History of the World*," and that this representation was carried out further in the Temple with consummate art:

> In this *Temple*, GOD Himself was the Historiographer of the most beautiful and explicit Kind of History the World ever produced; all the Ornaments of the Tabernacle were there collected together, and improved to the utmost Degree, beyond Imagination itself. . . . The Cherubims above [the inside entablature], and the Pillars below, represented the Inhabitants of Heaven, and those of the Earth; the first in their real Shapes, and the last Hieroglyphically.[115]

This divinely inspired plan of Tabernacle and Temple was later, according to Wood, copied by the pagans and also by the Druids: "And if we were to scrutinize all the works of the Druids, we should find them to have been copied from the work of the *Jews*."[116] Stonehenge is mentioned as an example. Wood and Blake also share the idea, held by Stukeley as well, that the original meaning of the Hebrews' symbolism was lost by the pagans. "Those People, by

neglecting the *Real Part of the Law*, having also forgot the *Symbolical*, nor could they tell us to what divine Matters the various Parts of their Sacred Edifices referr'd!"[117] Blake believes that the "wonderful originals" of the Hebrews were expressive of lost meanings, meanings that could be recovered by returning in vision to the original sources. Wood states that the proportions and figures of the sacred buildings of the Jews could be found in British buildings, "disguised under *Gothick Dress*"; in the oldest church in Britain, supposedly the Cathedral of Llandaff, these Hebrew origins could be seen distinctly in the east part, which "was built to imitate *Solomon's Temple*."[118] Thus the belief that there was a lost language of Hebrew art that could be recovered in Britain was shared by Wood, Blake, and others.

In Blake's own time, the tradition of creating mental models of Jerusalem was carried on by the prophet Richard Brothers, self-styled "Prince of the Hebrews." Because I have discussed this subject in detail elsewhere,[119] I need only summarize some pertinent points here. In 1805, when Blake was at work at his own *Jerusalem*, Brothers published *A Letter to the Subscribers for Engraving the Plans of Jerusalem, The King's Palace, The Private Palaces, College-Halls, Cathedrals, and Parliament-Houses*. Brothers's purpose is "to give to the world the model of that city, which is to be built by it, the capital of a peculiar people."[120] The basic module of the city plan is the square, as appears graphically in Brothers's engraved *Plan of the Holy City the New Jerusalem*, published some three years earlier.[121] In *A Letter to the Subscribers*, Brothers gives extensive verbal descriptions of the architecture. The king's palace would be on one side of an immense central square—the Garden of Eden, to be a park for public use.

> The square is formed by a range of twelve private palaces on each side, including the king's, which makes forty-eight in all. Each palace is 444 feet long, with a space of 144 feet between each; to every one is a lawn in front, and behind is a spacious garden. What a noble square to excite admiration! Each side of it near a mile and a half in length! Such is to be the centre of the future Jerusalem, and round it the city is to be built.[122]

Blake for his part conceives the center of the city to be occupied by Luban, the female genitalia:

> And Luban stands in the middle of the City. a moat of fire,
> Surrounds Luban, Los's Palace & the golden Looms of Cathedron.[123]

Cathedron is the womb in which golden looms weave new human bodies; it is surmounted by a "golden dome,"[124] this usually negative feature being given a positive valence in the context of a description of creative activity in Golgonooza; and it is further described in architectural terms in *Jerusalem* 59: 24-25:

> A wondrous golden Building immense with ornaments sublime
> Is bright Cathedrons golden Hall, its Courts Towers & Pinnacles

Whereas for Brothers the architecture of the new Jerusalem is literal, to be given according to quantitative measurements, for Blake that architecture is part of an enabling myth.

Walls, gates, streets, arches, pillars, houses—such structural details of the great City of Golgonooza also appear as images throughout the breadth of Blake's poetry and art. As we have seen, Blake, beginning with a knowledge derived from his early studies as an artist and engraver, employed architecture for many purposes in his mature work. Its function ranges from literal verisimilitude to symbolic statement. The extent to which he used such imagery suggests that he found it especially congenial, and nowhere more so than in the conception of Golgonooza. Here Blake realized his most ambitious plan as a mental architect. He transferred to Los the building activity once associated with Urizen, leaving only its negative aspects to the latter; and in so doing, he had the figure who represents his own imaginative presence raise a continuing city[125] as a realization of human desire. Thus for Blake, architecture is one of the eternal arts embodied by the visionary Cherubim— one of the Four Faces of Man.

Notes

1. 27: 54-55, in *The Poetry and Prose of William Blake*, ed. David V. Erdman (Garden City, N.Y.: Doubleday, 4th printing, 1970). This edition will hereafter be cited as E. For references to *designs* in illuminated books, I follow the foliations of G. E. Bentley, Jr., in *Blake Books* (Oxford: Clarendon Press, 1977). For the *Gates of Paradise* and *Job* engravings I use the plate numbers given by Blake himself.

2. From *Nollekens and His Times*, reprinted in *Blake Records*, ed. G. E. Bentley, Jr. (Oxford: Clarendon Press, 1969), p. 457.

3. *William Blake: Poet and Painter* (Chicago and London: Univ. of Chicago Press, 1964), pp. 10-20.

4. See Robert N. Essick, *William Blake Printmaker* (Princeton: Princeton Univ. Press, 1980), pp. 5-7, 12-19, 28-38. I am indebted to Professor Essick for valuable suggestions regarding the subject matter of this paper.

5. James Stuart and Nicholas Revett, *The Antiquities of Athens*, vol. I (London, 1762).

6. Vol. 1 (London, 1786), pl. xxv, p. 68. The period of Blake's apprenticeship was 1772-79, but the actual engraving for *Sepulchral Monuments* was done long before its publication.

7. P. 69.

8. See Geoffrey Keynes, "The Engraver's Apprentice," *Blake Studies*, 2nd ed. (Oxford: Clarendon Press, 1971), pp. 14-30.

9. See Ruthven Todd, *Tracks in the Snow* (London: Gray Walls Press, 1946), p. 37; Keynes, *Blake Studies*, pp. 25-27.

10. "The antiquities of every Nation under Heaven is no less sacred than that of the Jews. They are the same thing as Jacob Bryant, and all antiquaries have proved." E. 534.

11. For bibliographic details, see Bentley, *Blake Books*, pp. 537-38.

12. See Blake's annotations to Reynolds' *Discourses*, E. 628. David Bindman points out that Moser became deputy librarian as well as keeper in 1781, "a possible clue to the date of the dialogue." — *Blake As an Artist* (Oxford: Phaidon, 1977), p. 229.

13. *The Art of William Blake* (New York: Columbia Univ. Press, 1959), p. 18.

14. Ibid.

15. The first illustrated edition of Vitruvius, with Latin text, was published at Venice in 1511. An Italian text with completely new illustrations was published at Como in 1521. "These two editions," writes Sir John Summerson, ". . . with their highly imaginative 'restorations' of buildings described in Vitruvius, supplied the material for many others in several languages." — *Architecture in Britain, 1530-1830*, 6th ed. (Harmondsworth: Penguin, 1977), p. 556. During his three years at Felpham, Blake would have been able to see one of the editions of Vitruvius' *Architettura* in William Hayley's library; there were five in all at the time of Hayley's death. See *Sale Catalogues of the Libraries of Eminent Persons*, ed. A. N. L. Munby (London: Mansell, 1971), vol. 2.

16. The edition Blake is most likely to have seen is *The Architecture of A. Palladio in Four Books. . . . Revis'd, design'd and publish'd by G. Leoni. . . .* Trans. N. Du Bois, 3rd ed., (London, 1742). Inigo Jones's notes are included.

17. 3 vols., London, 1715-25.

18. London, 1759.

19. Book 1, Plate xvi, engraved by Delsenbach.

20. As the Colossus served as a lighthouse and had an interior staircase leading to the torch in its right hand, it may be considered a building.

21. *A Plan of Civil and Historical Architecture*, trans. T. Lediard, 2nd ed. (London, 1737), p. 13.

22. See William A. Gibson and Thomas L. Minnick, "William Blake and Henry Emlyn's *Proposition for a New Order in Architecture*: A New Plate," *Blake Newsletter* 26 (1972): 12-17.

23. Ibid., p. 14.

24. Letter from Willey Reveley to William Blake dated October 18 (1791), *Blake Records*, p. 44.

25. On the interior of the Church of St. Nicholas, see Nikolaus Pevsner, *The Buildings of England: North-West and South Norfolk* (Harmondsworth: Penguin, 1962), pp. 141-43.

26. *Repr. Tiriel*, ed. G. E. Bentley, Jr. (Oxford: Clarendon Press, 1967), p. 31.

27. Ruthven Todd, *Tracks in the Snow*, pp. 33 and 57, points out that Chambers did not print this view until the third edition of *Civil Architecture*, published in 1791.

28. Repr. *Complete Graphic Works of William Blake*, ed. David Bindman (London: Thames and Hudson, 1978), no. 102b. This edition includes all illuminated books and

69. Repr. Paley, *William Blake*, pl. 86.

70. Ibid., pl. 48.

71. *Jerusalem* 74: 16, E. 227.

72. A drawing of the Turret by George Engelheart is reproduced in Morchard Bischop, *Blake's Hayley* (London: Victor Gollancz, 1951).

73. Bischop, p. 200. Details of the Turret given here are from Bischop's account, pp. 204, 209, 214, 232.

74. Repr. *Tate Gallery*, no. 79.

75. To William Hayley, 27 January 1804 and 28 September 1804, *Letters*, pp. 87, 105.

76. See Gardner, *Blake* (London: Evans Brothers, 1968), pp. 141-45. On the Nash Terraces, see John Summerson, *John Nash* (London: George Allen & Unwin, 1935); Park Crescent is illustrated in Plate VIII.

77. *Abury*, p. 4.

78. Repr. Paley, *William Blake*, pl. 105. In the finished design, the figures were repositioned and the altar eliminated.

79. Repr. Keynes, *Bible*, no. 24.

80. Ibid., no. 50.

81. Ibid., no. 20. The rainbow in this picture should not be mistaken as ironical — cf. Blake's description of his *Last Judgment*, where Noah, "canopied in a Rainbow," is one of the "Persons who ascend to Meet the Lord coming in Clouds with power & great glory" (*A Vision of the Last Judgment*, E. 548).

82. Repr. *Tate Gallery*, no. 1.

83. Repr. Keynes, *Blake Studies*, pl. 46.

84. Repr. Paley, *William Blake*, pl. 2.

85. Repr. Butlin, *William Blake*, fig. 160.

86. *The Art of William Blake*, pp. 38-39.

87. Vol. 1, pl. xl, engraved by the studio of B. Picart.

88. To Mrs. Anna Flaxman, 14 September 1800, *Letters*, p. 40.

89. Repr. *Tate Gallery*, no. 45.

90. Repr. Butlin, *William Blake*, fig. 179.

91. Repr. Paley, *William Blake*, pl. 84.

92. Ibid., pl. 83.

93. Repr. Butlin, *William Blake*, fig. 137. The scene is of course extra-Biblical, as is that of *The Humility of the Saviour*.

94. Repr. Butlin, *William Blake*, fig. 171. This picture is perhaps better known as *Christ in the Carpenter's Shop*, but the mount bears the title given here. In my interpretation I follow Blunt, *The Art of William Blake*, p. 72.

95. 4th ed. (Paris: Presses Universitaites de la France, 1964), pp. 46-47.

96. Vol. II, 417. The accompanying "Weather House" is a delightful variation, also to be found in "Thenot and Colinet sup together" for Thornton's *Virgil*.

97. Repr. Butlin, *William Blake*, fig. 243.

98. Letter to Thomas Butts postmarked 23 September 1800, *Letters*, p. 42.

99. *William Blake's Illustrations to the Book of Job*, Acta Academiae Aboensis, ser. A, Åbo Akademi (Finland) 46 (1973), p. 68.

100. Ibid., p. 230.

101. Francesco Giorgi wrote in 1535: "When God wished to instruct Moses concerning the form and proportion of the tabernacle which he had to build, He gave him as a model the fabric of the world and said (as is written in Exodus 25) 'And look that thou make them after their pattern, which was shewed thee in the mount.' . . . Pondering on this mystery, Solomon the Wise gave the same proportions as those of the Mosaic taber-

nacle to the famous Temple which he erected." Rudolf Wittkower, *Architectural Principles in the Age of Humanism* (New York: Random House, 1965), p. 155.

102. Philibert de l'Orme advanced his theory in *Le premier tôme de l'architecture* (Paris, 1567), on which see Anthony Blunt, *Philibert de l'Orme* (London: A. Zwemmer, 1958), p. 124.

103. Although Blake could not have read the Latin commentary, he would no doubt have appreciated the magnificent engravings, and he could have known at least the notes to two of these in Lediard's translation of Fischer von Erlach (see above, pp. 186-87).

104. London, 2nd ed. in English, 1650. Trans. Richard More of Linley.

105. P. 74.

106. London, 1650.

107. P. 169.

108. P. 51. The words which I have elided are a quotation in Hebrew.

109. Repr. *Tate Gallery*, no. 28.

110. I discuss this subject in "'Wonderful Originals'— Blake and Ancient Sculpture," in *Blake in His Time*, pp. 170-97.

111. See *Sale Catalogues*, no. 2184.

112. On which see George Mills Harper, "The Divine Tetrad in Blake's *Jerusalem*," in *William Blake: Essays for S. Foster Damon*, pp. 235-55.

113. *A Plan of Civil and Historical Architecture*, p. 1.

114. Bath, 1741. Wood writes "From the *Tabernacle* and *Temple*. . . . the *Dorick, Ionick* and *Corinthian Orders* of Columns were taken" (p. 222).

115. *The Origin of Building*, pp. 123-24.

116. Ibid., pp. 220-21.

117. Ibid., p. 235.

118. Ibid., pp. 222, 221.

119. "William Blake, the Prince of the Hebrews and the Woman Clothed with the Sun," in *William Blake: Essays in Honour of Sir Geoffrey Keynes*, pp. 260-293.

120. P. 9.

121. In *A Description of Jerusalem* (London, 1801 [1802]). In this booklet Brothers says that the orders of classical architecture "were copied from the buildings of Solomon" (p. 69). The *Plan* is reproduced in "The Prince of the Hebrews," pl. 68.

122. P. 19. The Cathedrals are described in detail on pp. 28-30. They are to have colonnades running along their sides, on the tops of which will be flagged terraces. Each cathedral will have four square towers and one round tower, supported by interior domes. "The five towers to each cathedral, gradually decrease by divisions to the top; each division is supported by half-pillars and pilasters in the wall. . . . The pillars and pilasters are in the Corinthian form, but in diameter similar to those of Balbec and Palmyra, from whence the Greek merchants first took the model and carried it to Corinth; another diameter was then added for the height . . . and the name of Corinthian given to the pillar; but more properly its name should have been *Hebrew*, as Solomon was the first designer."

123. *Jerusalem* 13: 24-25, E. 155.

124. *Milton* 26: 36, E. 122.

125. "For here we have no continuing city, but we seek one to come." Hebrews 13:14.

9

CONSTABLE:MILLAIS/
WORDSWORTH:TENNYSON

Karl Kroeber

T hose of us who have followed Jean Hagstrum in studying rela-
tions between poetry and painting, hoping to enhance our
understanding of both arts, have seldom attempted to utilize com-
parisons to sharpen definitions of parallel historical developments in
the two arts. As a rule, we have confined our attention to a single
period or style, with good reason. But sooner or later we shall have
to venture into the realm of stylistic change. This essay, part of a
larger study of the transformation of Romanticism into Modernism,
explores the possibility of using comparisons between the arts to
illuminate the difference between British Romanticism and Vic-
torianism.[1]

As in *Romantic Landscape Vision: Constable and Wordsworth,*[2]
I work here from specific poems and pictures, for everything I've
learned since publication of the book has reinforced my conviction
that in comparing the arts the best method is to begin with particu-
lars. Especially debilitating are covert generalizations, unadmitted,
perhaps even unconscious assumptions about periods or styles.
Covert generalizations usually prevail when the object of description
is change from one manner or one era to another. The describer
begins by proving the "representativeness" of the works discussed,
thereby predetermining the results of his analysis. My technique
is to compare works without claiming representative value for
them. The four works I'll comment on—Wordsworth's "Michael,"
Tennyson's "Enoch Arden," Constable's *Salisbury Cathedral, From*

the Meadows (see plate 9-1), and Millais's *The Blind Girl* (plate 9-2)—have, in fact, representative importance. But I've chosen the works because they share enough features to make useful contrasts between poem and poem, painting and painting. My hope is that a comparison of the two contrasts will be inter-illuminating, and on the basis of a variety of such juxtapositions valid generalizations could be founded. But here I wish only to show how provocative such paired contrasts may be.

I begin with the paintings, which share the rainbow feature and considerable emphasis upon English landscape. But even saying this calls attention to a decisive difference: landscape is far more dominant in Constable's picture. Millais's painting is *The Blind Girl*; for her, landscape is background. It is more difficult to define the difference between foreground and background in Constable's painting, in which all parts of the picture flow into one another, yet not just as surfaces—the "flow" is in depth as well.

This contrast can be elucidated by noticing that Millais stresses distinction and separation. In his picture, edges are sharply defined: each detail could, as one of my students observed, be cut out with scissors. There is little visual interaction between parts of *The Blind Girl*. And when placed next to Constable's picture, Millais's shows reliance on relatively clear, bright, nearly primary colors.[3] This predilection perhaps explains the effect of flatness in Millais's work, in which we aren't confronted (as we are in Constable's painting) by dense texturing of sky, building stone, growth. Millais's emphasis on the formal elements of distinctness, clarity, and simplicity are central qualities of Pre-Raphaelite realism, which is in large measure a realism of visual surface in and for itself. In such realism human figures stand out theatrically from natural backgrounds. The rents and stains on the girl's blue skirt, for example, or the patch on the blind girl's dress, do not visually connect with other portions of the painting: they exist intensely in themselves as nothing more than part of the clothing. The "intensity" of this realism, indeed, springs from the self-sufficiency of details. Possibly the best exemplifications of this visual autonomy in *The Blind Girl* are the black birds in the middle distance. In themselves they are depicted carefully, but their size is disproportionate both to the cattle behind them and the people in front. The disproportion is so striking that we are compelled to wonder about its cause: we are provoked to interpret. We "read" the picture not in terms of visual coherence

but in terms of the meaning of self-sufficient details, finding the painting's unity in a coherence of *signification*.

Everything in the painting encourages a viewer to read "symbolically." Each element by its clear distinctness encourages us to find a "meaning" for it other than a purely visual function. This, I suspect, leads to the common, but not helpful, designation of *The Blind Girl* as a narrative picture. It does, like many Victorian paintings, "tell a story," but not in the same fashion as other "narrative" pictures, including masterworks by Giotto and Bruegel. We need to define Millais's special mode of "narrating." The nature of the mode is revealed by the butterfly, literalistic to the point of being photographic. Visually, the detail seems gratuitous. But it clinches the simplest affective purport of the picture: the poor girl cannot see, as we do, either the fragile beauty of the butterfly or the grandeur of the rainbows. The "microscopic" accuracy with which the butterfly is portrayed, furthermore, compels us to attend to it, though visually it has no discernible relation to the cloak on which it rests, the black birds, the rainbows. It is in its intensely exact rendering that we feel a lack of proportion analogous to the physical disproportion of the black birds. Why, we are driven to ask, is this trivial creature presented with such hypervivid literalness? What, in short, does it symbolize? Less troubling at first but still puzzling are the bright rainbows as backdrops to a scene no longer very wet. Whatever storm there was has definitely cleared. Then there is the sign pinned to the girl's blouse, literally "telling" us of her condition. This last is impressive because so unnecessary.[4] Surely the painting's title, the girl's dress, expression, accordion, one hand fingering the grass, her other clutching her comrade's hand, "tell" her condition adequately. Why the verbalized overkill of such literalism? One reason is that the picture signifies so definitely that no detail of its realism *can be* too distinct. To put the issue crudely, the butterfly must be so unmistakably a butterfly because we will be so impressed by the butterfly as butterfly we see (though the girl, pathetically, cannot) that we will remember (at least if we are learned enough) that the butterfly once symbolized the soul. Analogously, the black birds of mortality must be exaggerated so that, as our eyes move back from the foreground plane, we will recognize a symbolic movement to the hope of heaven embodied in the rainbows. The desire for distinctness, with consequent minimal visual interrelating, explains why Millais also is so redundant. The

unusualness of the double rainbow, to cite the obvious feature, impels us to think about the sight as something more than a natural phenomenon, just as we are "told" of the girl's blindness in more than one way.

All the characteristics I've mentioned drive the viewer back from the picture, that is, urge him to regard the picture as a finished painting quite separate from him, to be studied, "read," interpreted from a "distance." Pre-Raphaelite painters "place" their viewers in much the same position as the audience of a Victorian stage performance. The "distance" the paintings enforce is clearest in interior scenes. These tend to be filled with reflections and see-through devices, and all the mirrors, windows, reflective surfaces, and reiterated shapes emphasize the spectator's role as spectator. *The Blind Girl* functions in the same fashion, allowing us a single, sharply defined view, a simple emotional attitude of pity. What we see in the picture are not people in action but as "spectators," the blind girl overtly not seeing while her companion looks at the rainbows. As with interior scenes, say Hunt's *Awakened Conscience*, what is demanded of us as viewers is less a complex visual response, or an intricacy of emotional reaction, than an interpretation. We consider the meaning of what is seen and what is not seen. There is no question in this kind of painting of what is going on; our task as viewer, as Ruskin never tired of insisting, is to decide on the *significance* of what is portrayed clearly and is direct in its emotional appeal.

How we interpret *The Blind Girl*, however, is closely controlled — we are not permitted much range of interpretation (Ruskinian interpretations, one notices, are of *one* meaning). The distinct linear clarity of details precludes subtle ambiguity, as does the uncomplicated compositional scheme. Redundancies assure that we will understand *the* point. The whole painting is like the butterfly within it: elaborated meticulousness in surface rendering enforces a single, undivided response. By its nature, exactness of the Pre-Raphaelite "microscopic" kind works against ambiguity. If the viewer is firmly positioned by the painting in the role of detached spectator, this implied physical situation is symptomatic of the moral/intellectual/emotional view enforced on him. Visually *The Blind Girl* is built on principles of clarification and detachment, and "narratively" it conveys an equivalent singleness of meaning.

So it might be fair to call Millais's painting conceptual rather than narrative. Little action occurs *in* the picture, and the stillness of the human subjects is reinforced by the lack of interplay between visual elements—the scene strikes one not merely as static but almost as empty. In part this effect is produced by the clarity of minutiae, a clarity that prevents complexity. The butterfly, for instance, is motionless, not the smallest part of it blurred by the palpitations of life. The stains, tears, and broken stitching of the girls' skirts likewise prevent us from sensing any of the intricate foldings and fallings of cloth over living limbs. The intense exactness of literal detail may not betray Millais's lack of emotional involvement in his deliberately pathetic subject, but it indubitably compels the viewer to respond in an uncomplicated fashion—one reason many twentieth-century viewers have found paintings such as *The Blind Girl* unpleasant.

Response to Constable's art, however, from the first has been confused and uncertain. To turn from *The Blind Girl* to *Salisbury Cathedral, From the Meadows*[5] (plate 9-2) is to feel oneself plunged into a bewilderingly interactive world of continuously interpenetrating sensations. In this painting lines are lost in blots and blurs. Unlike Millais's bright, pure colors, Constable's colors are muted, dominated by *mixtures* of brown and olive green and bluish gray in which nothing is fully distinct in itself. Although several human figures inhabit Constable's scene, all are small, almost lost in the landscape. Constable's painting is a furious chiaroscuro in which details are not articulated separately but created by relations between dashes of paint contrasting light and dark. At a distance from Constable's picture, therefore, one imagines one sees objects which, on closer inspection, turn out to be flecks of pigment. The closer one comes to Millais's painting, the more distinctly the butterfly appears as a butterfly. Constable's brushstrokes work in an opposite fashion, assuring that as one comes closer to his painting ambiguities increase. What at a distance is perceived as light flashing on the stream, up close is seen as squiggles of white paint. And these visual ambiguities lead to others. As one comes closer to the picture, for instance, one sees that the man in the cart is accompanied by a woman, whose arm seems tucked under his. What is their relation?

The viewer's "position" before Constable's work is difficult to define because what one sees in the picture changes as one draws near to or away from the canvas, but what one has seen from an

earlier position remains in one's mind. When one backs away after a close inspection, one can no longer actually perceive the woman mostly hidden by the man in the cart. But one therefore *imagines* her all the more vividly. Herein lies the excitement of Constable's landscape: it arouses the viewer's imaginative perceptions. One apprehends more in the painting the longer and the more often one views it from different places, because one's imagination is constantly encouraged to "remake" it. More subtle than the woman in the cart, perhaps, is the light on the stream. After one has come close and observed that what had seemed at a distance the flash of reflected sunlight is "actually" dashes of paint, when one backs off once again, the image of reflected light is recreated more strongly than before. The reason, I believe, is that one is no longer merely "taken in" by an optical illusion; one understands how and why the illusion has been performed and, therefore, one consciously participates in recreating the illusion. The viewer is thus enabled to reenact (to a degree at least) the painter's creative artifice.

Although I've spoken of moving away from and toward the painting, its appeal to our imagination is also, and more importantly, a process of time. Not only do differences in distance require differences in time, but also a single view is not enough for one to appreciate the range of imaginative participation made possible by the painting. When one returns at a later time to re-view the picture, subliminal memories of transformations in one's earlier perceptions enhance and complicate the new "immediate" response. So there can be no single, definitive "meaning" to Constable's *Salisbury Cathedral*. Conceptually as well as visually it is "indefinite." It does not tell a simple, unitary story. Both perceptually and symbolically it renders the tensions of contradictory forces and significances. It is filled with uncertainties, that is to say, with possibilities and obscurities. The flora of nature appear in an interpenetrating variety of growth and decomposition: the dead trunk at the right puts forth new shoots, the river bank where the observer "stands" almost squelches in the luxuriant decay of its muddy fecundity. The clouds above surge in such a turbulence of light and dark that one may at first be unsure as to whether they are dispersing or reassembling, whether the rainbow signals a clearing or whether it will give way to renewed storm.

This chiaroscuro of meaning is reinforced by the fitful light on the stream and meadow, indeed, by all the "events" in the painting.

The horses, seeming to feel for footing on a mucky bottom, draw a cart (why?) against the movement of the wind sweeping the leaves and branches to the left. And the counteractive tonal "movement" from dark left to bright right is intersected by the shadowed vertical upthrust of the cathedral under the arc of the rainbow, whose apogee lies beyond the frame of the painting. Just as the frame thus arbitrarily cuts off the painting so that we are compelled to imagine what lies beyond, so the meaning of the cathedral and the rainbow is not definitively delineated. The man with his cart "moves" from the dark graveyard toward the plunge of the heavenly bow to earth on the luminous right, and the viewer's eyes rise, following the cathedral spire up from the decaying earth to what Constable called the "tender and elegant" rainbow. But the naturalistic interfusion of life and death on the earth, the turbulence of the clouds, and flickering changes of light, even in the bow itself (which is no Newtonian illustration but a real water-dimmed arc that scarcely gleams beyond the blue portion of the spectrum)—all these features render the message of hope and salvation difficult and uncertain. The cathedral lifts magnificently with the rational lines of geometric planning toward the arch of heaven. But the angle of view makes the dark trees to the left seem to tower ominously above the edifice. And against its magnificence stands the contrast of anonymous people in the foreground, unattending to either the greatness of the church or the grandeur of the sky, between land and water, bound to their absorbing but trivial purposes. We glimpse for a moment a dark-light movement in a world ever-changing and self-opposing, of which the people are among the smaller and less imposing elements. The dog stops, turning his head toward—a stranger? his master? To what end shifts this vision of never-ceasing transformations?

Any interpretation must to a degree be uncertain. Interpreting this painting is not, as with *The Blind Girl*, finding a single meaning, but engaging imaginatively in diverse, even opposed possibilities, to participate in the dubieties of creating a vision of enduring hope out of a world of evanescence, where life out of death is an order of things. We see the sublime soar of the cathedral across the rotted remnants of human structures already proved transient. In the very muck of the river banks, the shimmer of the soaked field, the dirty flow of the clogged stream, and the bending branches in the wet wind appear a reality and a beauty against which the aspiration

embodied in the cathedral may seem futile. Indeed, the central image, the cathedral spire lifting to the fading heavenly arch, is powerful because it condenses all the ambiguities of the conjunction appearing everywhere in the painting. We turn from the picture, finally, not possessed by an idea, a concept, but with a confused sense of an experience whose significance cannot be formulated, can only be lived with, and which, since life is change, will be preserved by being transformed in time and by future experience.

Does this contrast of a Romantic and a Victorian painting help to illuminate the importance of differences between the blank-verse narratives of "Enoch Arden" and "Michael"? I believe it does, particularly in centering our attention on issues of time, audience "position," and visual/moral indefiniteness.

Walter Bagehot was the first to use "Enoch Arden" as a contrast to Wordsworth's poetry, in the famous review in which he defined Tennyson's art as ornate and Wordsworth's as pure or simple. Bagehot is sometimes perceptive, as when he objects to Tennyson having his hero feel "nothing else but these great splendors" on the tropical island upon which he is marooned, or when he praises the poet's skill at depicting the "half-belief" Bagehot sees as characteristic of the Victorian era. But most revealing of the ambience in which Tennyson wrote the most popular of his longer poems is Bagehot's attitude toward Enoch, who "could not have been charming," for

> people who sell fish about the country (and this is what he did, though Mr. Tennyson won't speak out, and wraps it up) never are beautiful.

Bagehot makes his point more explicit later:

> many of the characters of real life, if brought distinctly, prominently, and plainly before the mind as they really are . . . are doubtless very unpleasant. They would be horrid to meet and horrid to think of. We fear it must be owned that Enoch Arden is this kind of person. A dirty sailor who did *not* go home to his wife is not an agreeable being. . . . Nothing is more unpleasant than a virtuous person with a mean mind. A highly developed moral nature joined to an undeveloped intellectual nature, an undeveloped artistic nature, and a very limited religious nature, is of necessity repulsive.[6]

I don't know how Tennyson felt about Bagehot's view; so far as I know he never publicly refuted it. We do know, however, that Wordsworth's "Michael" was written with the conscious hope of enlightening snobs like Bagehot. Wordsworth sent a copy of the

second edition of *Lyrical Ballads* (in which "Michael" first appeared as the final poem, having been written as a substitute for Coleridge's "Christabel") to Charles James Fox with a letter explaining he did so because of two poems, "The Brothers" and "Michael." These illustrate "a rapid decay of the domestic affections among the lower orders of society," which Wordsworth maintains "the present Rulers of this country are not conscious of, or they disregard. . . . " Wordsworth goes on to observe that "spreading of manufactures" and new social measures, such as work houses, are much to blame, and that

> The evil would be the less to be regretted, if these institutions were regarded only as palliatives to a disease; but the vanity and pride of their promoters are so subtly interwoven with them, that they are deemed great discoveries and blessings to humanity. . . . parents are separated from their children, and children from their parents; the wife no longer prepares with her own hands a meal for her husband, the produce of his labor; there is little doing in his house in which his affections can be interested, and but little left in it which he can love.[7]

These domestic affections Wordsworth says he has tried to portray in Michael, who belongs to "a class of men who are now almost confined to the North of England." These are

> small independent *proprietors* of land here called statesmen, men of respectable education who daily labour on their own little properties. The domestic affections will always be strong amongst men who live in a country not crowded. . . . But if they are proprietors of small estates, which have descended to them from their ancestors, the power which these affections will acquire amongst such men is inconceivable by those who have only had an opportunity of observing hired labourers, farmers, and the manufacturing Poor. Their little tract of land serves as a kind of permanent rallying point for their domestic feelings . . . a fountain fitted to the nature of social man from which supplies of affection, as pure as his heart was intended for, are daily drawn. (pp. 314-15)

Asserting that Fox has long publicly supported policies that would preserve these virtues, the poet observes:

> You have felt that the most sacred of all property is the property of the Poor. The two poems I have mentioned were written with a view to shew that men who do not wear fine cloaths can feel deeply. . . . I hope, whatever effect they may have upon you, you will at least be able to perceive that they may excite profitable sympathies in many

kind and good hearts, and may in some small degree enlarge our feelings of reverence for our species, and our knowledge of human nature, by shewing that our best qualities are possessed by men whom we are too apt to consider, not with reference to the points in which they resemble us, but to those in which they manifestly differ from us. (p. 315)

Lengthy quotation seems justified because Wordsworth's poem is so overtly directed to changing people's minds, and hearts, on a specific social issue.[8] "Michael" is actively related to its readers: the poem aims to challenge and improve them. The polemic in "Michael" I'll show later is not quite so simple as Wordsworth's letter may suggest, but there can be no doubt that the poem is composed to engage readers in a fashion that will force them to imagine aspects of the shepherd's situation not distinctly delineated by the poet. In this respect, Wordsworth brings to mind Constable compelling his viewer imaginatively to participate in *Salisbury Cathedral*.

The contrastive passivity imposed on Tennyson's reader is apparent from his poem's first line.

> Long lines of cliff breaking have left a chasm;
> And in the chasm are foam and yellow sands;
> Beyond, red roofs about a narrow wharf
> In cluster; then a moulder'd church; and higher
> A long street climbs to one tall-towered mill;
> And high in heaven behind it a gray-down
> With Danish barrows; and a hazel-wood,
> By autumn nutters haunted, flourishes
> Green in a cuplike hollow of the down.[9]

This ostentatiously pictorial image makes sense from one position only, from the sea, with the eye gradually traveling upward (after descending from the distantly seen skyline of cliffs). But the restriction of the viewer's spatial position is disturbed by the temporal uncertainty of "breaking," which at first can be read as "now breaking" rather than "having before broken off." Trivial as this detail is, it dramatizes an important contrast between "Enoch Arden" and "Michael." Wordsworth's poem begins with a less restrictive positioning of the reader than "Enoch Arden" while being more ingenious about temporal ordering.

> If from the public way you turn your steps
> Up the tumultuous brook of Green-head Ghyll,
> You will suppose that with an upright path
> Your feet must struggle; in such bold ascent

> The pastoral mountains front you, face to face.
> But, courage! for around that boisterous brook
> The mountains have all opened out themselves,
> And made a hidden valley of their own.
> No habitation can be seen; but they
> Who journey thither find themselves alone
> With a few sheep, with rocks and stones, and kites
> That overhead are sailing in the sky.

Leaving aside the contrast between the specificity of "Green-head Ghyll" and the namelessness of Tennyson's village, as well as Wordsworth's anthropomorphizing of topography, I call attention to the difference between Tennyson's time-confusing "breaking" followed by the "timeless" present of a spatial description and Wordsworth's bold use of a "perpetual" present, the present moment of anyone who begins to read the poem at whatever chronological date. Wordsworth's "you" is any reader, but always the particular person reading the poem "now." The events *in* the poem, therefore, are oriented toward the immediate moment of *reading*. This is one reason Wordsworth begins with the conditional "If" and "you will suppose." Like Constable, Wordsworth desires, and structures his art to accommodate, some freedom on the part of his audience. Just as diverse possibilities are portrayed in their art, so diverse possibilities of response to it are encouraged by Constable and Wordsworth. The close of the introduction to "Michael," in which the poet looks ahead to his "followers" after his death, likewise provides a continuing link to him for all future readers. Through that link even we today may imaginatively connect with the poet in 1800. Temporal processes *in* the "Michael" story are connected to both the poet's and the reader's necessarily special temporal perspectives. History is thus made intrinsic to the *experience of reading the poem*: the history of Michael is linked to the history of the poet linked to the history of the reader. This is why one ends at the same place one begins, the boisterous brook of Green-head Ghyll. Time has passed while we read, and our consciousness of time has undergone transformation, as we become aware when we find ourselves once again where we turned off "the public way."

Tennyson seeks no equivalent to Wordsworth's addressee because his poem is not itself involved in temporal processes. Both Tennyson and his reader are fixed outside the processes of time described in the story. The tenth line tells us "Here on this beach a hundred

years ago"—from when? Although Tennyson's tale is, like Words-
worth's, about effects of time, it is presented as purely past, definite-
ly separated from the current experience of poet or reader. The
reader's detachment is illustrated by the tenth line, which now,
a hundred years after its composition, falsifies the date of the poem's
events. Wordsworth's "perpetual present" and his comment on his
followers allow us a self-validating perspective (though different
from that of a reader of 1800 or 1880) on the events of his poem
even 180 years after it was composed. As a result, any reader of
Wordsworth's poem can feel a connection to Michael's history
that he is unlikely to feel for Tennyson's vaguely ancient anecdote
of a nameless place.

Tennyson, however, doesn't so much want us free to imagine
from our own angle as he wants us to appreciate his tale's single,
definite meaning, its pure pathos. He consistently precludes dubieties
that the situation of "Enoch Arden" would permit, might even seem
to encourage. Like Millais, he uses "microscopically" precise details
to separate and distinguish and thereby to enforce a unitary meaning.
This is why the brilliance of many of Tennyson's descriptions to
some readers seems to work against an emotional effectiveness poten-
tial in but not realized by the story. Even granting Bagehot's ob-
jections to the account of Enoch on the island, that description
develops at least some power because, *un*like so much of the poem,
it builds around a paradox: the sailors

> Set in this Eden of all plenteousness,
> Dwelt with eternal summer, ill-content. (557-58)

Yet even here the contradiction is kept as clear and simple as pos-
sible. Tennyson's presentation regularly denies his reader any com-
plexity of response, even when the poet deals with complexities,
perhaps most strikingly in regard to economic issues. The stylizing
of economic motives is impressive because so much of the fiction of
the mid-nineteenth century was devoted to exploration of conflicts
between emotional and financial necessities—endless examples could
be cited from Dickens, Thackeray, or Eliot, not to mention the
French. And although the last lines of "Enoch Arden" have been
condemned as vulgar, the "costlier funeral" they celebrate is in
accord with the primary motivations throughout the tale. Enoch
labors diligently and saves carefully to be able to marry and then
to give his children "a better bringing-up than his had been." He

sails off to earn money, setting up Annie with a store. It is Philip's wealth that saves her, and it is the affluent comfort of his family, seen through the window, that impels Enoch to repress his urge to reveal himself on his return. At no point, however, does Tennyson permit us anything but approval of these motives, and pity for their unfortunate results. We are meant to sympathize with, if not admire, Annie's incapacity as businesswoman as a sign of her moral worth. But, aside from the blatant sexism, this appeal is not compatible with approving Enoch's drive for economic betterment. But we are not intended to make the connection. A single aspect of each situation is made to dominate, often at the price of inconsistencies equivalent to the disproportion of Millais's black birds. Just as Tennyson strives to make us visualize sharply features of place or building, figure or scene, so we are regularly directed by him to admire without qualification the sorrowful nobility of Enoch's situation and behavior—and if we resist, as Bagehot's critique shows, we ruin the poem.

Tennyson's simplifications and clarifications seem literary equivalents to Millais's pictorial stylizations because the audience of both painting and poem is made to concentrate on what that audience must perceive and to what it must respond emotionally as alien, distant. The exactness of so-called "microscopic realism" emphasizes separation—the microscope is an instrument for seeing modes of existence different from that of the observer. The analogy between painting and poem is illustrated forcibly by the crucial, and most celebrated, passage in "Enoch Arden," that describing Enoch looking through the window—another example of Victorian protagonist as spectator.

> For cups and silver on the burnish'd board
> Sparkled and shone; so genial was the hearth;
> And on the right hand of the hearth he saw
> Philip, the slighted suitor of old times,
> Stout, rosy, with his babe across his knees;
> And o'er her second father stoopt a girl,
> A later but loftier Annie Lee,
> Fair-hair'd and tall, and from her lifted hand
> Dangled a length of ribbon and a ring
> To tempt the babe, who rear'd his creasy arms,
> Caught at and ever miss'd it, and they laugh'd;
> And on the left hand of the hearth he saw

> The mother glancing often toward her babe,
> But turning now and then to speak with him,
> Her son, who stood beside her tall and strong,
> And saying that which pleased him, for he smiled. (738-54)

This description is reminiscent of many Victorian paintings (Martineau's *Last Day in the Old Home* may ironically come to mind, for example), but it is absolutely unlike "Michael." The contrast is vivid because the plots of both poems turn on journeys away from home for economic reward to establish "home," and the climax of each poem is a negative one. Enoch does not cry out; Michael does not finish the sheepfold. Both are poems of failure, treating loss and absence. Tennyson's source, however, is literary; he elaborates on previous poems.[10] Wordsworth writes of things that really happened, but that had never before been treated in literature. The "facts" Wordsworth utilizes are important because he is determined to confront his reader with actual experience valued as actual experience, by engaging him in the uncertainties of its transformations. The reader is driven, in the language of "Simon Lee," to "make something" of material not before transformed into literature.

A comparison with Constable's practice may clarify the significance of Wordsworth's originality. To a viewer of *Salisbury Cathedral*, the painter's many careful studies of actual cloud formations are irrelevant, except that through what he learned in making those studies Constable can succeed in his painting in confronting the viewer with clouds the viewer tends to study as if they were real. I, at least, don't find it possible to look at the sky of *Salisbury Cathedral* without trying to decide whether the storm has permanently passed or is about to swing around again. Analogously, Wordsworth lures his reader into engaging himself with the problem of the historical actuality of Michael's life. Addressing the reader directly in the first line of his poem, Wordsworth calls his attention to a specific locale, the brook of Green-head, wherever that might be, but presumably a particular locale *un*familiar to the reader, and then, anticlimactically, to a more sequestered spot in the mountains with

> a few sheep, with rocks and stones, and kites
> That overhead are sailing in the sky.
> It is in truth an utter solitude; . . . (11-13)

But this introduction to emptiness is functional, for it begins the poem negatively, to prepare us for the final experience of its anticlimactic climax. The issue for the reader throughout "Michael" is not simply what happened but what he is to make of what happened. The unique specificity of unfamiliar Green-head Ghyll and the sequestered spot foreshadows the specificity of Michael's actual experiences of places and persons, experiences unknown, and in any direct sense unknowable, to the reader. The poem's function is to enable the reader to *recreate* and thus "know" the unknown Michael. The problem is the opposite of defamiliarizing, stripping away a veil of familiarity from commonplace phenomena; it is closer to the problem of "Tintern Abbey," in which the reader must be made to share the poet's unique familiarity with a particular scene.

How we can be led to know the unknown is revealed when Wordsworth calls attention to the "heap of unhewn stones" that, not surprisingly, "you might pass by, / Might see and notice not," telling us that it led to "the first / Of those domestic tales" that when he was but a boy enabled him "to feel for passions that were not my own," that is, to *have* experienced what the reader of "Michael" *will* experience. The poet then says that he will retell the story

> for the sake
> Of youthful Poets, who among these hills
> Will be my second self when I am gone. (37-39)

"Name one" is my challenge to the critics who have too casually remarked on this passage. My challenge stems from the fact that nowhere else does Wordsworth so speak of poetic followers among his hills. And, having read "Michael," I'm persuaded that we are meant at the conclusion of the poem to realize retrospectively the concealed truth of what Wordsworth foresaw: there will be no followers for the poet, no second self, as for Michael there was no son, no inheritor. The negativity of the shepherd's life, reflected in the negativity of poetic "tradition," is thus made tangible for a later reader. The singularity of "Michael" is its appropriate form.

Wordsworth is not playing a clever game. He enables his reader to achieve the difficult feat of imaginatively feeling for something that happened long ago to an unimportant human being—that is to say, to experience a unique, unrepeatable confluence of contingencies. Wordsworth's art gives life to the significance of unique

experience. So the poem, which could not exist were there not some literary tradition, must nonetheless not be traditional, must be, as Michael himself was, singular. The poem is, as its subtitle indicates, a "pastoral." But it is not a conventional pastoral, for it treats of a genuine shepherd. But the shepherd has vanished. Only human tradition, "tellings," can redeem what has physically been lost from the natural world. Individual human experience can be preserved only through "tellings" of it, as the opening lines of "Michael" make clear. Here, as throughout the poem, the poet keeps us aware that the reality of which he tells us was never part of his own experience, was only something he had been told about. Wordsworth renders things heard, not seen, and deals in verbal fabrications rather than sensory actualities because only in this way can Michael live on in others' imaginations.

Yet one must observe that *traditional* tales and myths fare badly in Wordsworth's poem. The career of Richard Bateman, the local Dick Whittington, is inverted by Luke, as is the overarching pattern of Abraham's sacrifice of Isaac and the parable of the Prodigal Son from Luke's Gospel. "Michael" remains particular, peculiar, unique; its story is ectypal, not archetypal. This is one reason why the details by which Wordsworth tells his tale are not sharp, clear, distinct. Like Constable's brushstrokes, Wordsworth's narrative elements blur, blend, and interact, for they, too, make the audience imagine, and imagine events whose meaning is "indefinite." Since "Michael" is a poem, its strokes of art are temporal rather than spatial. Something of the shifting and layering of times we have noted in the introduction. In the story itself, moreover, we do not find cleanly drawn temporal units, such as "Enoch Arden" is composed of—its most dramatic instant being the "frozen" visualization of the family seen through the window. "Michael's" anticlimactic climax is the reverse of that momentary view. The tragic culmination of Michael's story is, like the place to which we are first conducted in the introductory lines, an "utter solitude" in which nothing especially impressive can be seen.

There is in "Michael" no *moment* of culmination. The experience of the shepherd (like that of those who sympathetically watch him or those who later hear of him) is not instantaneous, and is not represented through what can be rendered as timeless image, spatialized form. In the famous conclusion Wordsworth refuses to allow us any single or simple perspective on Michael's situation, reminding

us that we are only hearing about what the poet himself only heard diffusely and diversely: "I have conversed with more than one who well / Remember the Old Man and what he was / Years after he had heard the heavy news." This presentation of a span of time *as* a span of time is characteristic of the entire poem, in which no event is separated from the flow of time. Each instant is represented as composed of and to be apprehended by the reader as part of a temporal continuity in which "now" is undetachable from "before" and "after."

The life of the shepherd is conceived as meaningful only in its continuity. In Wordsworth's view, the individuality of Michael is the nature of his whole life. Uniqueness of experience is not a feature of one or more specific episodes, of any dramatic moment (which could be spatially localized), but of the continuity of an entire life. This is why mythic patterns don't function (except negatively) in "Michael," for they would reduce the entirety of an extended temporal continuity to a timeless structure of meaning. But no such structure can define Michael's life experience.

Even the episode of Luke laying the cornerstone of the sheepfold avoids pictorial effects, foregrounding instead temporal relations by presenting the event almost entirely through Michael's words to Luke.[11] At first the shepherd speaks principally of "our two histories," and throughout he speaks of the present as a continuity between past and future.

> To-morrow thou *wilt* leave me; with full heart
> I *look* upon thee, for thou *art* the same
> That *wert* a promise to me ere thy birth,
> And all thy life *hast been* my daily joy. (332-35; my italics)

Michael says that in him and Luke "the old and young / Have played together" as a kind of repayment for the gift of love bestowed on him by his parents,

> for, though now old
> Beyond the common life of man, I still
> Remember them who loved me in my youth, (364-66)

and he "wished that thou should'st live the life they lived."

The poignant overtones in Michael's words spring from his half-awareness of a derangement in temporal order precipitated by his decision to send Luke away. His "we both may live / To see a better day" thus appropriately introduces the powerful ambivalences of

his final exhortation. "I will begin again," he says, promising to take up once more tasks he had resigned to his son, but he observes that Luke's "heart these two weeks has been beating fast / With many hopes" for his new kind of life. The contradictions inherent in his emotional honesty are rendered by inconsistency in his words that follow:

> it should be so—yes—yes—
> I know that thou could never have a wish
> To leave me, Luke; thou hast been bound to me
> Only by links of love; when thou art gone,
> What will be left to us! But I forget
> My purposes. (398-403)

The somewhat incoherent lines express the confusion of father and son's interlocked, uncompleted "histories" through verbal means that urge the reader to imagine the shepherd's perplexed ambivalence of the moment in terms of the long relation of deep affection. Luke "should" have hopes away from his father, who "knew" the boy could never wish to leave him. Subtler is the omission from the following phrase of an expectable introductory "for," so that we understand Luke has been "bound" firmly to his father because their only "links" were "of love." Yet, simultaneously, we appreciate the shepherd's hidden fear that links of love alone may not be enough, as, indeed, they prove not to be. Beyond that ambiguity lies the sure emptiness in the life of Michael and Isabel when Luke pursues his hopes, aroused by the shepherd himself. Given this context, Michael's plural "purposes" seems all too correct, though we might be hard put to define all of them.

The foregoing prepares us for the curiously uncertain admonition to Luke as he lays the cornerstone of the covenant. In a presentiment of evil, Michael urges his son to think, not of this scene, but of "this moment," and to remember "the life thy Fathers led." Again the language forces the reader beyond the immediate circumstances to imagine "things thou canst not know of" from the past along with future possibilities. So Luke's going is evoked in terms of his possible return, then to perceive what now does not exist.

> Now, fare thee well—
> When thou return'st, thou in this place wilt see
> A work which is not here. (412-14)

The ironic potential of these lines, refracting the earlier irony of the assertion that God will strengthen Luke in his need, is deepened by Michael's fears:

> whatever fate
> Befall thee, I shall love thee to the last,
> And bear thy memory with me to the grave. (415-17)

The full import of the last line will register on us when at the end of the poem we imagine the shepherd's desolate last years.

Even the immediate instant of the covenant-making, then, is presented less as a definite scene, as visual image, than as the *sound* of Michael's words to Luke, words evoking passionate ambivalences, fears and desires bound in with experiences of times past and possibilities of a doubtful future. The reader, rather than seeing, hears, almost as if he himself were Luke, perhaps even to the point of only partly comprehending the old man's conflicting feelings. Michael's speech is not muddled, but its coherence derives from so many years' experience, so much silent thought and unarticulated affection that his expression must resonate confusingly.

If I am correct, Constable painted *Salisbury Cathedral* so that no single view of the picture in either time or space would be definitive. Analogously, to Wordsworth, "experience" is falsified if rendered through the isolation of one or more "dramatic moments"— one reason Luke's ultimate defection is so swiftly reported in a few, simple words. Even the poet's representation of the shepherd's crushing sorrow, therefore, must consistently draw us from temptations to reduce that experience to a singular, neatly visualized image. Wordsworth gives us a blurred impression of diverse acts, in which we are conscious not of one definite picture of the shepherd but of our own sympathetic construction of an indefinitely outlined fantasy of his years of sorrow. Our construction, moreover, is built out of—not sights—but tales of remembered glimpses, and imaginings of what he may have done or how he may have appeared. It is worth rereading the celebrated final "description" to observe how indefinite and undescriptive it is.

> I have conversed with more than one who well
> Remember the Old Man, and what he was
> Years after he had heard this heavy news. . . .
> > as before
> Performed all kinds of labour for his sheep, . . .

And to that hollow dwell from time to time
Did he repair, to build the Fold of which
His flock had need. 'Tis not forgotten yet
The pity which was then in every heart
For the old Man— and 'tis believed by all
That many and many a day he thither went,
And never lifted up a single stone.

 There, by the Sheep-fold, sometimes was he seen
Sitting alone, or with his faithful Dog,
Then old, beside him, lying at his feet.
The length of full seven years, from time to time,
He at the building of this Sheep-fold wrought, . . . (451-71)

The contrast with Tennyson's visualization of the dramatic instant when Enoch looks in the window could not be stronger, for Wordsworth seems to be doing something like what Constable does in his painting. Constable arouses the viewer's imaginatively creative response by diffusing and refracting visual clarity. Wordsworth seeks a parallel dissipation of definiteness: "all kinds of labour," "from time to time," "sitting alone, or with." These details are in keeping with the manner of the entire poem, which always encourages us to respond "creatively" according to our specific perspective to people, places, and actions as inseparable elements in unified temporal processes. All of life Wordsworth represents as "in motion," ongoing, so experience never cleanly separates now from then (for protagonists in the poem or readers of it), each moment being an interactive mixing of half-felt memories, present sensations, uncertain prospects.

I argued that Constable's painting embodies complexity of vision into man's relations with the natural world and to his god, a complexity not found in Millais's work. When we apply this contrast to Wordsworth and Tennyson its significance increases. For the negativity of "Enoch Arden" is founded on sheer repression: Enoch's supreme act is to suppress his desire to cry out. Deliberately, though with anguish, he keeps silent. And we are asked to admire him for so acting, or, rather, not acting. I think most of us can do so, but we are likely to feel Tennyson does not do justice to the dubieties, uncertainties, and ambiguities of repressive behavior. Bagehot's objection, not to the "long convulvuses" and "scarlet shafts of sunrise" in themselves but as unmitigated by the small pains and dull incertitudes of actual experience, points us toward Tennyson's

failure to confront the moral intricacy that must be a part of Enoch's stoic heroism. But the failure is inseparable from Tennyson's style of presentation, which does not admit qualifications but, instead, enforces purity of feeling and singularity of significance.

Wordsworth by contrast does not morally oversimplify, even though, as we have noted, "Michael" is polemical. Wordsworth's poem, unlike his letter to Fox, recognizes a contradiction in Michael's love for his land. He tells Isabel:

> the land
> Shall not go from us, and it shall be free?
> He [Luke] shall possess it, free as is the wind
> That passes over it. (244-47)

"Free" here has two, incompatible, meanings, as is emphasized by a second use of the word when Michael speaks to Luke:

> And till these three weeks past the land was free.
> —It looks as if it never could endure
> Another Master. (378-80)

The land was free because enslaved to Michael. The freedom of possessing property is not the freedom of the wind, blowing where it listeth. Wordsworth is no proto-Marxist, and he admires his shepherd protagonist. But because his art works against separations of every kind and against singleness of meaning, he does not, indeed, cannot shrink from representing the ambiguity at the core of Michael's heroism. Unlike Tennyson, Wordsworth must explore the dubious and dangerous relation of affectional and economic desires. Michael is not evil, but his love is possessive. Subtly if sympathetically, Wordsworth shows us Michael's admirable, ennobling love for his son inevitably tinged with selfishness—for which we cannot condemn him, if only because it is *he* who makes the last seven years of his laborious life an empty hell. Like other aged tragic figures—Lear and the Oedipus of Colonnus appropriately come to mind—Michael reveals the corruption in the most human of hearts. "Michael" goes beyond its polemic purpose in demonstrating how the bonds of human affection at their purest make us vulnerable to moral confusion.

The poem reveals that human beings are exposed to frightful suffering because our affections can only adequately be articulated through cultural modes. The love of a parent for a child is not merely biological: it exists in and through purely human, that

is, cultural relations. Human love, like ownership of land, is *un-natural*. Animal territoriality, for instance, never includes inheritance. What makes us distinctively human is what makes our lives tragic, which is why Wordsworth uses the ceaseless, senseless, "boisterous brook" of Green-head Ghyll to frame, at first so brightly, at the conclusion so darkly, Michael's experience.

But our conventional terms of criticism must be used with caution. If "Michael" is "tragic," it is not "dramatic" in the usual sense. Like Constable's *Salisbury Cathedral*, the poem is deliberately "untheatrical"; it is unlike "Enoch Arden," in the climactic scene of which we see, as in a theater, Enoch looking through the window as into a brightly lit stage. Tennyson tells us that this perception affected Enoch more than his landlady's account of the situation, "because things seen are mightier than things heard" (762). Yet the poet would seem to contradict himself when he describes how Enoch immediately after the sight

> Stagger'd and shook, holding the branch, and fear'd
> To send abroad a shrill and terrible cry,
> Which in one moment, like the blast of doom,
> Would shatter all the happiness of the hearth. (763-66)

Sound possesses the power to destroy the picture. That Tennyson should fall into inconsistency is not surprising, for poetry is an aural, not a visual medium; yet the poet (perhaps reluctantly) has committed himself to the primacy of visual imagery, to instants of sight, the distinct, isolated "one moment" of physical perception, to the spatialization of time.[12]

There is no equivalent contradiction in "Michael," because for Wordsworth poetry is an art of sound that overcomes the tyranny of the eye. Words, not sights, the verbal, not the visual, are to him primary. All the artistry of "Michael" stands in contrast to Tennysonian "visualizing," from the introduction making it plain that only through story, through tellings, through things heard, can the actuality of Michael's experience be preserved, to the conclusion in which the antagonism of the human and the purely natural culminates in a darkening of what had seemed originally a casual pathetic fallacy of the "boisterous" brook. The fallacy is, of course, a verbal device, and it is open, consequently, to transformations to which more pictorial language is less amenable. Unlike Tennyson and Millais, who favor the single meaning implicit in distinct

visualization, and the spatializing isolation it entails, Wordsworth and Constable prefer an art that will liberate their audiences' imaginations through indefiniteness, interactivity, and a diversity of possibilities.

This difference is of special interest because it clarifies what ought to be a truism, namely, that Victorianism is closer than Romanticism to Modernism. For Modern literature is more oriented than is Victorian literature to the principle that "things seen are mightier than things heard."[13] In different ways Wilde and Proust, Conrad and James, Pound and Joyce all have insisted on the need for literature to make the reader "see," and one of their common sources, of course, is Flaubert, twelve years younger than Tennyson and eight older than Millais. John Updike, recently reviewing a collection of Flaubert's letters, pays homage to him as the *fons et origo* of Modernism, simply by listing as still compelling a series of dicta that point up the detachment and visual orientation we see already in Tennyson and Millais:

> The less you feel a thing, the more capable you are of expressing it as it is . . . This faculty is, simply, genius: the ability to see, to have the model posing before you. . . . there is no such thing as subject—style in itself being an absolute manner of seeing things. . . . I like clear, sharp sentences, which stand erect, . . . always streaming with color. When literature attains the precision of an exact science, that's something. . . . The artist . . . sucks up what was lying there below, dim and unnoticed, and brings it out in great jets to the sunlight.[14]

To understand Romanticism we must recognize its resistance to this tyranny of vision, this celebration of the "soulless image of the eye," this exact, sharp, scientific ideal that Modernism adopted so completely that we accept it as natural. We need to become aware, that is, of the historical process by which Romantic art transformed into Modern art, the shortest description of the process being "Victorianism." Anyone can see and describe differences between, say, Constable's *Salisbury Cathedral* and Jackson Pollock's *Blue Poles*, but we need to understand how *The Blind Girl*, say, reveals something of the fashion in which one art evolved into the other.

I use the example of painting, because this art provides a spectacular illustration of Modernism's roots in Victorianism. *Science and Charity* anyone would acknowledge as "Victorian," for it is a painting portraying with lucid verisimilitude a sick woman in bed,

her right wrist held by an elderly doctor counting her pulse, while on the opposite side of the bed reaching toward the woman's left hand is a young nun carrying on her arm a curly-headed child. The picture was painted three years before Queen Victoria's death by an artist more precocious than Millais, Pablo Picasso, age 16. The difference between *Science and Charity* and later Picassos dramatizes what chiefly obscures our recognition of the Victorian origins of Modernist art: the latter seeks to escape from the univocity of the former. Later Picassos are at first difficult to understand because of ambiguities in their forms. Yet these are not the Romantic ambiguities illustrated by Constable's art, such as those created by dashes of white paint representing reflected sunlight. Modern ambiguities are founded more upon "continuous picture surface," are less dependent on and concerned with time, are more intended for intellectual interpretation, are, as Joseph Frank has noted, a function of a spatializing art. To say even this much is to open a subject beyond the scope of this paper, but these proleptic suggestions may evoke a sense for parallel distinctions between Wordsworth and, for instance, Frost or Wallace Stevens. Such parallel distinctions are, I believe, evidence that the kind of analogies and contrasts I have explored here provide unique insight into fundamental and long-term processes of aesthetic history.

Notes

1. Martin Meisel read this essay in its original form and offered cogent suggestions for its improvement. I am as grateful to him for this specific criticism as for his willingness over the years to share with me his knowledge of nineteenth-century art and literature.

2. Madison, Wisc.: Univ. of Wisconsin Press, 1974.

3. Allen Staley in his excellent *The Pre-Raphaelite Landscape* (Oxford: Clarendon Press, 1973) emphasizes Pre-Raphaelite preference for "bright colour . . . minimum of shadow" (p. 5) and "insistence upon bright local colours at the expense of tonal modulation" (p. 185). Staley's careful and informed discussion of *The Blind Girl* (pp. 53-55) notes that the background of the painting was done at Winchelsea two years before the figures were painted in Scotland and that Millais has some trouble with the picture's spatial recession, which is established only by the smaller size of background objects (p. 53). *The Blind Girl* is one of the earliest Pre-Raphaelite paintings that attempts to make weather a significant part of the picture. To do this, interestingly, Millais gave up dependence on direct observation. As Staley puts it: "The double rainbows are a studio concoction whose colours Millais got wrong . . . and had to repaint" (p. 54). John Ruskin praises *The Blind Girl* elaborately in "The Three Colours of Pre-Raphaelitism," which first appeared in *Nineteenth Century*, 1878, though he notices the distortion in the representation of the crows: "he paints the spark of light in a crow's eye a hundred yards off, as if he were only painting a miniature of a crow close by" (cited from *The Complete Works of John*

Ruskin [New York: Thomas Crowell, n.d.], xxvii, 230). Robert Rosenblum, in a review of the Museum of Modern Art's exhibition of British painting in 1957 (*Partisan Review* 24 [1957]: 95-100), anticipates Staley in stressing the two-dimensional patterns and over-all surface activity of Pre-Raphaelite paintings, which he sees, surprisingly, as suggestive of Tobey or Pollock (p. 97) and not offensive to "the contemporary predilection for a flat, continuous picture surface undefiled by detailed modeling or sudden plunges into space" (p. 95). By now we should be less surprised to find these links between Victorian and Modern art.

4. Such a girl would have worn such a tag, but the painter could as easily have made it illegible. On windows, see-through devices, and mirrors in Victorian art one may consult Gerhard Joseph, "Victorian Frames: The Windows and Mirrors of Browning, Arnold, and Tennyson," *Victorian Poetry* 16 (Spring-Summer, 1978): 70-87, although Joseph ignores "Enoch Arden." Like his predecessors who have discussed the topic, including Hillis Miller in *The Disappearance of God* (Cambridge, Mass.: Harvard Univ. Press, 1976) and W. David Shaw in *Tennyson's Style* (Ithaca, N.Y.: Cornell Univ. Press, 1976), Joseph concentrates on representations of looking *out*. This focus neglects the situation of the audience toward the "spectators" *within* this art, and, a more important omission, the spatializing of time implicit in such Victorian representations of looking. Perhaps most fascinating in this regard is Holman Hunt's *Awakened Conscience*, an attempt to portray a moment of revelation. The woman looks "out" of the picture ("seeing" her innocent past) while the man still looks up lustfully at her face. The seeing/not seeing analogue to the Blind Girl and her companion suggests how fundamental a Victorian iconographic structure this is—one that reappears, of course, in the climactic scene of "Enoch Arden."

5. Exhibited in 1831, but worked over and over again by Constable subsequently; indeed, the picture is referred to in the last letter he wrote in 1837. An important picture, for reviews and commentary on which see item 282 in *Constable: Paintings, Watercolours and Drawings*, catalog to the great London exhibition, by Leslie Parris et al. (London: The Tate Gallery, 1976), p. 164.

6. Bagehot's essay is "Wordsworth, Tennyson, and Browning: Or Pure, Ornate, and Grotesque Art in English Poetry," in the *National Review* (Nov. 1864), pp. 27-66, and has often been reprinted; my citations are from John D. Jump, *Tennyson: The Critical Heritage* (London: Routledge and Kegan Paul, 1967), pp. 289 and 291.

7. *The Letters of William and Dorothy Wordsworth: The Early Years, 1787-1805*, ed. E. De Selincourt, 2nd ed., rev. Chester L. Shaver (Oxford: Clarendon Press, 1967), p. 313. Subsequent citations are given by page number in my text.

8. One should also notice the letter to Thomas Poole of 9 April 1801, in the same volume of letters, the key passages of which are quoted by Ernest De Selincourt in *The Poetical Works of William Wordsworth*, 2nd ed. (Oxford: Clarendon Press, 1952), II, in the valuable notes to "Michael" on pp. 478-85. All my quotations from "Michael" are from this edition, cited by line number in my text.

9. All quotations from "Enoch Arden" are from Christopher Ricks's edition, *The Poems of Tennyson* (London: Longmans, 1969), pp. 1130-52, cited by line number in the text. The ambiguity in the first line noted below has been drawn to my attention by undergraduates encountering the poem for the first time—nearly half of them read "break-ing" as continuing activity.

10. The immediate source of "Enoch Arden" was a prose sketch given to Tennyson by Thomas Woolner, who had read of the incident, though from first publication of the poem, Crabbe's "The Parting Hour" and Mrs. Gaskell's *Sylvia's Lovers* were recognized as contributing influences. Ricks, p. 1129, summarizes well the sources, though he calls Adelaide Anne Procter's "Homeward Bound" an "analogue," on the basis of Hallam Tennyson's remark that his father only encountered her poem after composing his own. In the

light of close parallelisms between the two works I find Hallam's claim unlikely. Earlier commentators on Tennyson, for instance, Morton Luce, *A Handbook to the Works of Alfred Lord Tennyson* (London: G. Bell and Sons, 1895, rev. ed. 1914), take it for granted that Tennyson reworked Procter's poem (published in 1858). Luce, for example, cites ll. 633-77 of "Enoch Arden" as showing how "Tennyon does not alter; he merely adds detail and colour" to Procter's "rough sketch" in her lines:

> It was evening in late Autumn,
> And the gusty wind blew chill;
> Autumn leaves ever falling round me,
> And the red sun lit the hill. (Luce, p. 204)

11. The conversations in "Michael" are impressive, for Wordsworth, without attempting verbal literalism, creates a remarkable imitation of the manner of "country" speech. Isabel's apparently sudden assertion to Luke, "Thou must not go" (l. 295), in fact springs from two nights of feeling Michael's uneasy sleep in the bed beside her. Appropriate, too, is her recovery of heart as soon as "she had told her fears" and her son answered with "jocund voice," for Michael's fears are not hers. Wordsworth, moreover, never loses sight of the discrepancy between what a shepherd like Michael seems able to express in answer to questioning by a casual tourist and what, to someone better attuned to his feeling and thinking, he would be capable of expressing. In lines he finally did not use in the poem, Wordsworth represents this difference powerfully:

> No doubt if you in terms direct had ask'd
> Whether he lov'd the mountains, true it is
> That with blunt repetition of your words
> He might have stared at you, and said that they
> Were frightful to behold, but had you then
> Discours'd with him in some particular sort
> Of his own business, and the goings on
> Of earth and sky, then truly had you seen
> That in his thoughts there were obscurities,
> Wonders and admirations, things that wrought
> Not less than a religion in his heart.
>
> (De Selincourt, p. 482)

12. The contradiction epitomized by line 762 perhaps expresses Tennyson's unhappy awareness of loss of an effective *voice*. Such loss is not, of course, a biographical incident but the surfacing of strain in relations between an artist and his audience. The hyperpictorial vividness of "Enoch Arden's" climactic vision (particularly when considered in the light of Tennyson's many ostentatious audial splendors, that tend, however, toward inhuman roars, murmurs, and the like) impresses me as a symptom of art in stress. The hyperbolic repression of ll. 763-66, then, may be regarded as a kind of desperate protest against the de-vocalization of Modernist art toward which the Victorian artist, however reluctantly, is carried.

13. The point is, of course, a focus of Joseph Frank's famous discussion of spatial form in modern literature in which he links literary and graphic phenomena, for example:

Just as the dimension of depth has vanished from the sphere of visual creation, so the dimension of historical depth has vanished from the content of the major works of modern literature. Past and present are apprehended spatially, locked in a timeless unity that while it may accentuate surface differences eliminates any feeling of sequence by the very act of juxtaposition.

The Widening Gyre (New Brunswick, N.J.: Rutgers Univ. Press, 1963), p. 59. Not yet adequately understood is how antithetical to Romantic practice is this aspect of Modernism, which Victorian art, especially in its visual intensity, initiates. That intensity is defined by John Ruskin in a famous passage in Chapter 16, Part IV, Volume III of *Modern Painters*: "the greatest thing a human soul ever does in this world is to *see* something, and tell what it *saw* in a plain way. Hundreds of people can talk for one who can think, but thousands can think for one who can see. To see clearly is poetry, prophecy, and religion,—all in one."

 14. *The New Yorker* 56, No. 1 (25 Feb. 1980): 127-34 (p. 127).

A Bibliography of Works
by Jean H. Hagstrum

A BIBLIOGRAPHY OF WORKS BY JEAN H. HAGSTRUM

Books

Samuel Johnson's Literary Criticism. Minneapolis: Univ. of Minnesota Press, 1952; rpt. Chicago: Univ. of Chicago Press, 1967.

The Sister Arts: The Tradition of Literary Pictorialism and English Poetry from Dryden to Gray. Chicago: Univ. of Chicago Press, 1958; rpt. 1974.

William Blake Poet and Painter: An Introduction to the Illuminated Verse. Chicago: Univ. of Chicago Press, 1964; rpt. 1978.

Samuel Johnson. *Sermons*. Ed. Jean H. Hagstrum and James Gray. *The Yale Edition of the Works of Samuel Johnson*, vol. 14. New Haven: Yale Univ. Press, 1978.

Sex and Sensibility: Ideal and Erotic Love from Milton to Mozart. Chicago: Univ. of Chicago Press, 1980.

Articles

"The Sermons of Samuel Johnson." *Modern Philology* 40 (1943): 255-66.

"*La Figlia che Piange* by T. S. Eliot." *English "A" Analyst*, No. 3 (1947): 1-7.

"On Dr. Johnson's Fear of Death." *ELH* 14 (1947): 308-19.

"Johnson's Conception of the Beautiful, the Pathetic, and the Sublime." *PMLA* 64 (1949): 134-57.

"The Nature of Dr. Johnson's Rationalism." *ELH* 17 (1950): 191-205. Rpt. in *Studies in the Literature of the Augustan Age: Essays Collected in Honor of Arthur Ellicott Case*. Ed. Richard C. Boys. Ann Arbor: George Wahr for the Augustan Reprint Society, 1952, pp. 88-103.

"Some Opportunities for Research in Eighteenth Century Literature." *Newberry Library Bulletin* 3 (1954): 177-88.

"Romantic Skylarks." *Newberry Library Bulletin* 5 (1959): 45-54.

"The Poetry of Stanley Kunitz: An Introductory Essay." *Tri-Quarterly* 1, No. 3 (1959): 20-26. Rpt. in *Poets in Progress*. Ed. Edward Hungerford. Evanston: Northwestern Univ. Press, 1962, pp. 38-58.

"William Blake Rejects the Enlightenment." *Studies on Voltaire and the Eighteenth Century* 25 (1963): 811-28. Rpt. in *Blake: A Collection of Critical Essays*. Ed. Northrop Frye. Englewood Cliffs, N.J.: Prentice-Hall, 1966, pp. 142-55.

"William Blake's 'The Clod & the Pebble.'" In *Restoration and Eighteenth-Century Literature*. Ed. Carroll Camden. Chicago: Univ. of Chicago Press, 1963, pp. 381-88.

"Blake's Blake." In *Essays in History and Literature*. Ed. Heinz Bluhm. Chicago: Newberry Library, 1965, pp. 169-78.

"'The Wrath of the Lamb': A Study of William Blake's Conversions." In *From Sensibility to Romanticism: Essays Presented to Frederick A. Pottle*. Ed. Frederick W. Hilles and Harold Bloom. New York: Oxford Univ. Press, 1965, pp. 311-30.

"The Rhetoric of Fear and the Rhetoric of Hope." *Tri-Quarterly* 11 (1968): 109-23.

"The Sister Arts: From Neo-Classic to Romantic." In *Comparatists at Work: Studies in Comparative Literature*. Ed. Stephen G. Nichols, Jr., and Richard B. Vowles. Waltham, Mass.: Blaisdell, 1968, pp. 168-94.

"The Fly." In *Blake: Essays for S. Foster Damon*. Ed. Alvin H. Rosenfeld. Providence: Brown Univ. Press, 1969, pp. 368-82.

"Kathleen Raine's Blake." *Modern Philology* 68 (1970): 76-82.

"Blake and the Sister-Arts Tradition." In *Blake's Visionary Forms Dramatic*. Ed. David V. Erdman and John E. Grant. Princeton: Princeton Univ. Press, 1970, pp. 82-91.

"Verbal and Visual Caricature in the Age of Dryden, Swift, and Pope." In *England in the Restoration and Early Eighteenth Century: Essays on Culture and Society*. Ed. H. T. Swedenberg, Jr. Berkeley and Los Angeles: Univ. of California Press, 1972, pp. 173-95.

"Dryden's Grotesque: An Aspect of the Baroque in his Art and Criticism." In *Writers and Their Background: John Dryden*. Ed. Earl Miner. London: G. Bell, 1972, pp. 90-119.

"'Such, Such Were the Joys': The Boyhood of the Man of Feeling." In *Changing Taste in Eighteenth-Century Art and Literature*. Los Angeles: William Andrews Clark Memorial Library, 1972, pp. 41-62.

"Babylon Revisited, or the Story of Luvah and Vala." In *Blake's Sublime Allegory*. Ed. Stuart Curran and Joseph Anthony Wittreich, Jr. Madison: Univ. of Wisconsin Press, 1973, pp. 101-18.

"Christ's Body." In *William Blake: Essays in Honour of Sir Geoffrey Keynes*. Ed. Morton D. Paley and Michael Phillips. Oxford: Clarendon Press, 1973, pp. 129-56.

"Gray's Sensibility." In *Fearful Joy: Papers from the Thomas Gray Bicentenary Conference at Carleton University*. Ed. James Downey and Ben Jones. Montreal: McGill-Queen's Univ. Press, 1974, pp. 6-19.

"Eros and Psyche: Some Versions of Romantic Love and Delicacy." *Critical Inquiry* 3 (1977): 521-42.

"Blake and British Art." In *Images of Romanticism: Verbal and Visual Affinities*. Ed. Karl Kroeber and William Walling. New Haven: Yale Univ. Press, 1978, pp. 61-80.

"Romney and Blake: Gifts of Grace and Terror." In *Blake in His Time*. Ed. Robert N. Essick and Donald Pearce. Bloomington: Indiana Univ. Press, 1978, pp. 201-12.

"Byron's Songs of Innocence: The Poems to 'Thyrza.'" In *Evidence in Literary Scholarship: Essays in Memory of James Marshall Osborn*. Ed. René Wellek and Alvaro Ribeiro. Oxford: Clarendon Press, 1979, pp. 379-93.

"Johnson and the *Concordia Discors* of Human Relationships." In *The Unknown Samuel Johnson*. Ed. John J. Burke, Jr., and Donald Kay. Madison, Wisc.: Univ. of Wisconsin Press, 1983, pp. 39-53.

"Pictures to the Heart: The Psychological Picturesque in Ann Radcliffe's *The Mysteries of Udolpho*." Forthcoming in *Greene Centennial Studies: Essays Presented to Donald Greene on the Occasion of the Centennial of the University of Southern California*. Ed. Robert R. Allen and Paul J. Korshin.

Reviews

The Grand Tour in Italy, by Paul Franklin Kirby. *Italica* 29 (1952): 272-73.

"The Theoretical Foundations of Johnson's Criticism," by W. R. Keast. *Philological Quarterly* 32 (1953): 276-78.

Originals Abroad, by Warren H. Smith, and *English Travellers Abroad 1604-1667*, by John Walter Stoye. *Italica* 31 (1954): 253-54.

Young Sam Johnson, by James L. Clifford. *Modern Language Notes* 71 (1956): 131-33.

The Achievement of Samuel Johnson, by Walter Jackson Bate. *Modern Philology* 54 (1956): 66-69.

The Providence of Wit in English Letter Writers, by William Henry Irving. *Modern Language Notes* 72 (1957): 130-33.

The Italian Influence in English Poetry from Chaucer to Southwell, by A. Lytton Sells. *Italica* 34 (1957): 115-16.

English Miscellany, ed. Mario Praz. *Victorian Studies* 1 (1957): 196-97.

Literary Criticism: A Short History, by William K. Wimsatt, Jr., and Cleanth Brooks. *Philological Quarterly* 37 (1958): 307-9.

Italy and the English Romantics, by C. P. Brand. *Italica* 36 (1959): 149-50.

Things Common and Preferred, by Karl A. Olsson. *Book News Letter of Augsburg Publishing House*, No. 308 (July 1959): 1.

A Philosophical Enquiry into . . . the Sublime and Beautiful, by Edmund Burke, ed. J. T. Boulton. *Philological Quarterly* 38 (1959): 306-7.

Mountain Gloom and Mountain Glory, by Marjorie Hope Nicolson. *Modern Language Notes* 76 (1961): 48-51.

A History of Literary Criticism in the Italian Renaissance, by Bernard Weinberg. *Italica* 39 (1962): 140-42.

From the Renaissance to Romanticism, by Frederick B. Artz. *Philological Quarterly* 42 (1963): 314-15.

Research in Written Composition, by Richard Braddock, Richard Lloyd-Jones, and Lowell Schoer. *College English* 26 (1964): 53-56. Rpt. in *Issues and Problems in the Elementary Language Arts*. Ed. Walter T. Petty. Boston: Allyn and Bacon, 1968, pp. 396-401.

The Two Worlds of American Art, by Barry Ulanov. *Chicago Tribune*, 19 September and 3 October 1965.

Johnson on Shakespeare, ed. Arthur S. Sherbo. *Studia Neophilologica* 41 (1969): 435-38.

The Princeton Index of Christian Art. *UCLA Librarian* 23 (1970): 58.

The Seamless Web, by Stanley Burnshaw. *Comparative Literature Studies* 8 (1971): 271-73.

The Rambler, by Samuel Johnson, ed. W. J. Bate and Albrecht B. Strauss. *Studia Neophilologica* 43 (1971): 318-20.

The Art of Ecstasy, by Robert T. Petersson. *Modern Language Review* 66 (1971): 649-50.

Mnemosyne: The Parallel Between Literature and the Visual Arts, by Mario Praz. *English Language Notes* 8 (1971): 308-10.

The Notebook of William Blake, ed. David V. Erdman with Donald K. Moore. *Philological Quarterly* 53 (1974): 643-45.

Blake and Visionary Art and *The Romantic Rebellion*, by Kenneth Clark, and *British Romantic Art*, by Raymond Lister. *Blake Newsletter* 8 (1975): 143-44.

The Figure in the Landscape, by John Dixon Hunt. *English Language Notes* 15 (1978): 307-9.

Blake as an Artist, by David Bindman. *Blake: An Illustrated Quarterly* 12 (1978): 64-67.

Alexander Pope and the Arts of Georgian England, by Morris R. Brownell. *Eighteenth-Century Studies* 12 (1979): 391-96.

George Eliot and the Visual Arts, by Hugh Witemeyer. *Nineteenth-Century Fiction* 34 (1979): 217-20.

William Blake's Designs for Edward Young's "Night Thoughts," ed. John E. Grant, Edward J. Rose, and Michael J. Tolley. *Eighteenth-Century Studies* 15 (1982): 339-44.

The Paintings and Drawings of William Blake, by Martin Butlin. *Modern Philology* 79 (1982): 445-51.

A Checklist of Modern Scholarship
on the Sister Arts

A CHECKLIST OF
MODERN SCHOLARSHIP
ON THE SISTER ARTS

The following checklist comprises articles and books that focus on the sister arts—and especially on the relations between English painting and literature—from roughly 1700 to 1850. I have also cited works that raise general questions about the comparative study of the arts, and works that center on major texts and figures outside this period. Any checklist of scholarship in a field this diverse must necessarily be selective. I have attempted, however, to choose works that are representative of the critical methodologies with which recent scholars have approached verbal and visual texts, and I have included a representative sampling of works devoted to the relations between literature and sculpture, garden and landscape design, architecture, and book illustration.

Several bibliographical guides have already appeared. *Literature and the Other Arts: A Select Bibliography 1952-1958* (New York: New York Public Library, 1959) was followed by yearly supplements published from 1959 to 1967 by the Modern Language Association Discussion Group, "General Topics IX." These materials were later published together as *A Bibliography on the Relations of Literature and the Other Arts 1952-1967* (New York: AMS Press, 1968). For more specialized lists, see John Graham, "'Ut Pictura Poesis': A Bibliography," *Bulletin of Bibliography* 29 (1972): 13-15, 18, and Jeffrey R. Smitten, "Space and Spatial Form in Narrative: A Selected Bibliography of Modern Studies," in *Spatial Form in Narrative*, ed. Smitten and Ann Daghistany (Ithaca: Cornell Univ. Press, 1981), pp. 245-63. Recent work on Blake has been cataloged in *A Blake Bibliography: Annotated Lists of Works, Studies, and Blakeana*, ed. G. E. Bentley, Jr., and Martin K. Nurmi (Minneapolis: Univ. of Minnesota Press, 1964), and in Bentley's *Blake Books* (Oxford: Clarendon Press, 1977). A bibliography also appears periodically in *Blake: An Illustrated Quarterly.*

Richard Wendorf

Abel, Elizabeth. "Redefining the Sister Arts: Baudelaire's Response to the Art of Delacroix." In *The Language of Images*. Ed. Mitchell. Pp. 37-58.

Abrams, M. H. *The Mirror and the Lamp: Romantic Theory and the Critical Tradition.* 1953; rpt. New York: Norton, 1958.

Alldritt, Keith. *The Visual Imagination of D. H. Lawrence.* Evanston, Ill.: Northwestern Univ. Press, 1971.

Allen, B. Sprague. *Tides in English Taste (1619-1800): A Background for the Study of Literature.* 2 vols. 1937; rpt. New York: Rowman and Littlefield, 1969.

Allen, Robert J. "Pope and the Sister Arts." In *Pope and his Contemporaries: Essays Presented to George Sherburn.* Ed. James L. Clifford and Louis A. Landa. New York: Oxford Univ. Press, 1949; rpt. 1968, pp. 78-88.

Allentuck, Marcia. "Scott and the Picturesque: Afforestation and History." In *Scott Bicentenary Essays: Selected Papers Read at the Sir Walter Scott Bicentenary Conference.* Ed. Alan Bell. Edinburgh and London: Scottish Academic Press, 1973, pp. 188-98.

Alpers, Svetlana and Paul. "*Ut Pictura Noesis?* Criticism in Literary Studies and Art History." *New Literary History* 3 (1972): 437-58.

Alpers, Svetlana Leontief. "*Ekphrasis* and Aesthetic Attitudes in Vasari's *Lives.*" *Journal of the Warburg and Courtauld Institutes* 23 (1960): 190-215.

Ault, Norman. "Mr. Alexander Pope: Painter." In *New Light on Pope.* London, 1949; rpt. Hamden, Ct.: Archon, 1967, pp. 68-100.

Baker, C. H. Collins. "The Sources of Blake's Pictorial Expression." *Huntington Library Quarterly* 4 (1941): 359-67.

Barrell, John. *The Dark Side of the Landscape: The Rural Poor in English Painting 1730-1840.* Cambridge: Cambridge Univ. Press, 1980.

_____. *The Idea of Landscape and the Sense of Place 1730-1840: An Approach to the Poetry of John Clare.* Cambridge: Cambridge Univ. Press, 1972.

Battestin, Martin C. *The Providence of Wit: Aspects of Form in Augustan Literature and the Arts.* Oxford: Clarendon Press, 1974.

Bauer, George Howard. *Sartre and the Artist.* Chicago: Univ. of Chicago Press, 1969.

Behrendt, Stephen C. "A Vocabulary of Lineaments: Blake and the Language of Art." *Blake Studies* 10 (1981), forthcoming.

Bell, C. F. "Thomas Gray and the Fine Arts." In *Essays and Studies by Members of the English Association*, vol. 30. Oxford: Clarendon Press, 1945, pp. 50-81.

Benamou, Michel. "Wallace Stevens: Some Relations Between Poetry and Painting." *Comparative Literature* 11 (1959): 47-60.

Bender, John B. *Spenser and Literary Pictorialism.* Princeton: Princeton Univ. Press, 1972.

Benjamin, Walter. "The Work of Art in the Age of Mechanical Reproduction." In *Illuminations.* Ed. Hannah Arendt. Trans. Harry Zorn. New York: Schocken, 1969, pp. 217-51.

Bindman, David. *Blake as an Artist.* Oxford: Phaidon; New York: Dutton, 1977.

Binyon, Laurence. "English Poetry in Its Relation to Painting and the Other Arts." *Proceedings of the British Academy* [8] (1917-18): 381-402.

_____. *Landscape in English Art and Poetry.* London: Cobden-Sanderson, 1931.

Blunden, Edmund. "Romantic Poetry and the Fine Arts." *Proceedings of the British Academy* 28 (1942): 101-18.

Blunt, Anthony. *The Art of William Blake.* New York: Columbia Univ. Press, 1959.

Bowden, Edwin T. *The Themes of Henry James: A System of Observation through the Visual Arts.* New Haven: Yale Univ. Press, 1956; rpt. 1960.

Boyce, Benjamin. "Baroque Into Satire: Pope's Frontispiece for the 'Essay on Man.'" *Criticism* 4 (1962): 14-27.

————. *The Character-Sketches in Pope's Poems*. Durham, N.C.: Duke Univ. Press, 1962.

————. "Sounding Shells and Little Prattlers in the Mid-Eighteenth-Century English Ode." *Eighteenth-Century Studies* 8 (1974-75): 245-64.

Brower, Reuben A. "Visual and Verbal Translation of Myth: Neptune in Virgil, Rubens, Dryden." *Daedalus* 101, No. 1 (Winter 1972): 155-82.

Brownell, Morris R. *Alexander Pope & the Arts of Georgian England*. Oxford: Clarendon Press, 1978.

Chapin, Chester F. *Personification in Eighteenth-Century English Poetry*. 1955; rpt. New York: Octagon, 1968, esp. pp. 116-30.

Chernowitz, Maurice E. *Proust and Painting*. New York: International Univ. Press, 1945.

Chew, Samuel C. *The Pilgrimage of Life*. New Haven: Yale Univ. Press, 1962.

Clark, David Ridgley. "Landscape Painting Effects in Pope's Homer." *Journal of Aesthetics and Art Criticism* 22 (1963): 25-28.

Cohen, Ralph. *The Art of Discrimination: Thomson's "The Seasons" and the Language of Criticism*. Berkeley and Los Angeles: Univ. of California Press, 1964.

Connolly, Thomas E. and George R. Levine. "Pictorial and Poetic Design in Two Songs of Innocence." *PMLA* 82 (1967): 257-64.

Daniells, Roy. *Milton, Mannerism and Baroque*. Toronto: Univ. of Toronto Press, 1963.

Davie, Donald. *Ezra Pound: Poet as Sculptor*. New York: Oxford Univ. Press, 1964.

Davies, Cicely. "*Ut Pictura Poesis*." *Modern Language Review* 30 (1935): 159-69.

Deane, C. V. *Aspects of Eighteenth Century Nature Poetry*. Oxford; Blackwell, 1935, pp. 63-109.

DeLaura, David J. "The Context of Browning's Painter Poems: Aesthetics, Polemics, Historics." *PMLA* 95 (1980): 367-88.

Desai, Rupin W. "William Cowper and the Visual Arts." *Bulletin of the New York Public Library* 72 (1968): 359-72.

de Voogd, Peter Jan. *Henry Fielding and William Hogarth: The Correspondences of the Arts*. Amsterdam: Rodopi, 1981.

Doebler, John. *Shakespeare's Speaking Pictures: Studies in Iconic Imagery*. Albuquerque: Univ. of New Mexico Press, 1974.

Doughty, Oswald. "Rossetti's Conception of the 'Poetic' in Poetry and Painting." In *Essays by Divers Hands*, vol. 26. Ed. Joseph Bard. London: Oxford Univ. Press, 1953, pp. 89-102.

Dunbar, Pamela. *William Blake's Illustrations to the Poetry of Milton*. Oxford: Clarendon Press, 1980.

Eaves, Morris. "Blake and the Artistic Machine: An Essay in Decorum and Technology." *PMLA* 98 (1977): 903-27.

————. *William Blake's Theory of Art*. Princeton: Princeton Univ. Press, 1982.

Eicholz, Jeffrey. "William Kent's Career as a Literary Illustrator." *Bulletin of the New York Public Library* 70 (1966): 620-46.

Eitner, Lorenz. "Cages, Prisons, and Captives in Eighteenth-Century Art." In *Images of Romanticism*. Ed. Kroeber and Walling. Pp. 13-38.

Epstein, Lynne, "Mrs. Radcliffe's Landscapes: The Influence of Three Landscape Painters on Her Nature Descriptions." *Hartford Studies in Literature* 1 (1969): 107-20.

Erdman, David V. and John E. Grant, eds. *Blake's Visionary Forms Dramatic*. Princeton: Princeton Univ. Press, 1970.

Essick, Robert N., ed. *The Visionary Hand: Essays for the Study of William Blake's Art and Aesthetics*. Los Angeles: Hennessey and Ingalls, 1973.

_____. *William Blake, Printmaker*. Princeton: Princeton Univ. Press, 1980.

Fairchild, Arthur H. R. *Shakespeare and the Arts of Design (Architecture, Sculpture, and Painting)*. Univ. of Missouri Studies, vol. 12, No. 1. Columbia, Mo.: Univ. of Missouri, 1937.

Farnham, Fern. "Achilles' Shield: Some Observations on Pope's *Iliad*." *PMLA* 84 (1969): 1571-81.

Farnham, Willard. *The Shakespearean Grotesque: Its Genesis and Transformations*. Oxford: Clarendon Press, 1971.

Fernando, Lloyd. "Thomas Hardy's Rhetoric of Painting." *Review of English Literature* 6, No. 4 (October 1965): 62-73.

Finley, Gerald. *Landscapes of Memory: Turner as Illustrator to Scott*. London: Scolar Press; Berkeley and Los Angeles: Univ. of California Press, 1980.

Fowler, Alastair. "Periodization and Interart Analogies." *New Literary History* 3 (1972): 487-509.

Frank, Ellen Eve. *Literary Architecture: Essays Toward a Tradition*. Berkeley and Los Angeles: Univ. of California Press, 1979.

Frank, Joseph. "Spatial Form in Modern Literature." *Sewanee Review* 53 (1945): 221-40, 433-56, 643-53. Rpt. in *The Widening Gyre: Crisis and Mastery in Modern Literature*. 1963; rpt. Bloomington, Ind.: Indiana Univ. Press, 1968, pp. 3-62.

Frankel, Hans H. "Poetry and Painting: Chinese and Western Views of Their Convertibility." *Comparative Literature* 9 (1957): 289-307.

Freeman, Rosemary. *English Emblem Books*. London, 1948; rpt. New York: Octagon, 1966.

Frye, Northrop. *Anatomy of Criticism: Four Essays*. Princeton: Princeton Univ. Press, 1957, esp. pp. 243-337.

_____. "Blake's Reading of the Book of Job." In *Spiritus Mundi: Essays on Literature, Myth, and Society*. Bloomington, Ind.: Indiana Univ. Press, 1976, pp. 228-44.

Frye, Roland Mushat. *Milton's Imagery and the Visual Arts: Iconographic Tradition in the Epic Poems*. Princeton: Princeton Univ. Press, 1978.

Gale, Robert L. *The Caught Image: Figurative Language in the Fiction of Henry James*. Chapel Hill, N.C.: Univ. of North Carolina Press, 1964.

Garvin, Harry R., ed. *The Arts and Their Interrelations*. Lewisburg, Pa.: Bucknell Univ. Press; London: Associated Univ. Presses, 1979. [Also published as the *Bucknell Review* 24, No. 2 (Fall 1978).]

Gilman, Ernest B. *The Curious Perspective: Literary and Pictorial Wit in the Seventeenth Century*. New Haven: Yale Univ. Press, 1978.

_____. "Word and Image in Quarles' *Emblemes*." In *The Language of Images*. Ed. Mitchell. Pp. 59-84.

Giovannini, G. "Method in the Study of Literature in Its Relation to the Other Fine Arts." *Journal of Aesthetics and Art Criticism* 8 (1950): 185-95.

Goldstein, Harvey D. "Ut Poesis Pictura: Reynolds on Imitation and Imagination." *Eighteenth-Century Studies* 1 (1967-68): 213-35.

Gombrich, E. H. *Art and Illusion: A Study in the Psychology of Pictorial Representation*. Bollingen Series 35, No. 5. 1960; rev. ed., Princeton: Princeton Univ. Press, 1961.

_____. *Symbolic Images: Studies in the Art of the Renaissance*. London: Phaidon, 1972, esp. pp. 1-22 and 123-91.

Goslee, Nancy M. "From Marble to Living Form: Sculpture as Art and Analogue from

the Renaissance to Blake." *Journal of English and Germanic Philology* 77 (1978): 188-211.

_____. "'Under a Cloud in Prospect': Keats, Milton, and Stationing." *Philological Quarterly* 53 (1974): 205-19.

Grant, John E. "The Fate of Blake's Sun-Flower: A Forecast and Some Conclusions." *Blake Studies* 5 (1974): 7-64.

_____. "Visions in *Vala*: A Consideration of Some Pictures in the Manuscript." In *Blake's Sublime Allegory: Essays on "The Four Zoas," "Milton," "Jerusalem."* Ed. Stuart Curran and Joseph Anthony Wittreich, Jr. Madison, Wisc.: Univ. of Wisconsin Press, 1973, pp. 141-202.

Greene, Theodore Meyer. *The Arts and the Art of Criticism.* 1940; rpt. New York: Gordian Press, 1973.

Grundy, Joan. *Hardy and the Sister Arts.* London: Macmillan, 1979.

Halsband, Robert. *"The Rape of the Lock" and its Illustrations 1714-1896.* Oxford: Clarendon Press, 1980.

Hammelmann, Hans. *Book Illustrators in Eighteenth-Century England.* Ed. T. S. R. Boase. New Haven: Yale Univ. Press for the Paul Mellon Centre for Studies in British Art, 1975.

Harvey, J. R. *Victorian Novelists and Their Illustrators.* London: Sidgwick and Jackson, 1970; New York: New York Univ. Press, 1971.

Hatzfeld, Helmut A. "Literary Criticism through Art and Art Criticism through Literature." *Journal of Aesthetics and Art Criticism* 6 (1947): 1-21.

_____. *Literature through Art: A New Approach to French Literature.* 1952; rpt. Chapel Hill, N.C.: Univ. of North Carolina Press, 1969.

Heckscher, William S. "Shakespeare in His Relationship to the Visual Arts: A Study in Paradox." In *Research Opportunities in Renaissance Drama: The Report of the Modern Language Association Conference,* vols. 13-14 (1970-71). Ed. S. Schoenbaum. Evanston, Ill.: Northwestern Univ. Press, 1971, pp. 5-71.

Heffernan, James A. W. "The English Romantic Perception of Color." In *Images of Romanticism.* Ed. Kroeber and Walling. Pp. 133-48.

_____. "Reflections on Reflections in English Romantic Poetry and Painting." In *The Arts and Their Interrelations.* Ed. Garvin. Pp. 15-37.

Helsinger, Elizabeth K. *Ruskin and the Art of the Beholder.* Cambridge, Mass.: Harvard Univ. Press, 1982.

Henn, T. R. *The Lonely Tower: Studies in the Poetry of W. B. Yeats.* 1950; 2nd ed., London: Methuen, 1965, esp. pp. 238-71.

_____. "Yeats and the Picture Galleries." *Southern Review,* n.s. 1 (1965): 57-75.

Hermerén, Göran. *Influence in Art and Literature.* Princeton: Princeton Univ. Press, 1975.

_____. *Representation and Meaning in the Visual Arts: A Study in the Methodology of Iconography and Iconology.* Lund Studies in Philosophy, 1. Lund, Sweden: Läromedelsförlagen, 1969.

Hill, Nancy K. *A Reformer's Art: Dickens' Picturesque and Grotesque Imagery.* Athens, Ohio: Ohio Univ. Press, 1981.

Hillis, Frederick Whiley. *The Literary Career of Sir Joshua Reynolds.* 1936; rpt. Hamden, Conn.: Archon, 1967.

Hinnant, Charles H. "Dryden and Hogarth's *Sigismunda.*" *Eighteenth-Century Studies* 6 (1972-73): 462-74.

Hipple, Walter John, Jr. *The Beautiful, The Sublime, & The Picturesque in Eighteenth-Century British Aesthetic Theory.* Carbondale: Southern Illinois Univ. Press, 1957.

Hodnett, Edward. *Image and Text: Studies in the Illustrations of English Literature.* Menston, Yorkshire: Scolar Press, 1982.

Holcomb, Adele M. "Scott and Turner." In *Scott Bicentenary Essays: Selected Papers*

Read at the Sir Walter Scott Bicentenary Conference. Ed. Alan Bell. Edinburgh and London: Scottish Academic Press, 1973, pp. 199-212.

Holtz, William V. *Image and Immortality: A Study of "Tristram Shandy."* Providence, R.I.: Brown Univ. Press, 1970.

Howarth, William L. "Some Principles of Autobiography." *New Literary History* 5 (1974): 363-81. Rpt. in *Autobiography: Essays Theoretical and Critical.* Ed. James Olney. Princeton: Princeton Univ. Press, 1980, pp. 84-114.

Hunt, John Dixon. "Dickens and the Traditions of Graphic Satire." In *Encounters.* Ed. Hunt. Pp. 124-55.

————, ed. *Encounters: Essays on Literature and the Visual Arts.* London: Studio Vista, 1971.

————. *The Figure in the Landscape: Poetry, Painting, and Gardening during the Eighteenth Century.* Baltimore: Johns Hopkins Univ. Press, 1976.

————. *The Pre-Raphaelite Imagination 1848-1900.* London: Routledge and Kegan Paul, 1968.

————. "'Story Painters and Picture Writers': Tennyson's Idylls and Victorian Painting." In *Writers and their Background: Tennyson.* Ed. D. J. Palmer. London: Bell, 1973; Athens, Ohio: Ohio Univ. Press, 1975, pp. 180-202.

Hussey, Christopher. *The Picturesque: Studies in a Point of View.* 1927; rpt. Hamden, Ct.: Archon, 1967.

Irwin, David. *English NeoClassical Art: Studies in Inspiration and Taste.* London: Faber and Faber, 1966, pp. 125-46.

Jack, Ian. *Keats and the Mirror of Art.* Oxford: Clarendon Press, 1967.

Jensen, H. James. *The Muses' Concord: Literature, Music, and the Visual Arts in the Baroque Age.* Bloomington, Ind.: Indiana Univ. Press, 1976.

Johnson, Mary Lynn. "Emblem and Symbol in Blake." *Huntington Library Quarterly* 37 (1974): 151-70.

Kamholtz, Jonathan Z. "Spenser and Perspective." *Journal of Aesthetics and Art Criticism* 39 (1980): 59-66.

Kayser, Wolfgang. *The Grotesque in Art and Literature.* [1957.] Trans. Ulrich Weisstein. 1963; rpt. New York: McGraw-Hill, 1966.

Kemp, Martin. "Scott and Delacroix, with some Assistance from Hugo and Bonnington." In *Scott Bicentenary Essays: Selected Papers Read at the Sir Walter Scott Bicentenary Conference.* Ed. Alan Bell. Edinburgh and London: Scottish Academic Press, 1973, pp. 213-27.

King, Alec. *Wordsworth and the Artist's Vision: An Essay in Interpretation.* London: Athlone Press, 1966.

Klonsky, Milton, ed. *Speaking Pictures: A Gallery of Pictorial Poetry from the Sixteenth Century to the Present.* New York: Crown, 1975.

Kolve, V. A. "Chaucer and the Visual Arts." In *Writers and their Background: Geoffrey Chaucer.* Ed. Derek Brewer. London: Bell, 1974, pp. 290-320.

Krieger, Murray. "The Ekphrastic Principle and the Still Movement of Poetry; or *Laokoön* Revisited." In *The Play and Place of Criticism.* Baltimore: Johns Hopkins Univ. Press, 1967, pp. 105-28.

Kristeller, Paul Oskar. "The Modern System of the Arts: A Study in the History of Aesthetics." *Journal of the History of Ideas* 12 (1951): 496-527, and 13 (1952): 17-46. Rpt. in *Renaissance Thought and the Arts: Collected Essays.* Princeton: Princeton Univ. Press, 1980, pp. 163-277.

Kroeber, Karl and William Walling, eds. *Images of Romanticism: Verbal and Visual Affinities*. New Haven: Yale Univ. Press, 1978.

Kroeber, Karl. "Romantic Historicism: The Temporal Sublime." In *Images of Romanticism*. Ed. Kroeber and Walling. Pp. 149-65.

————. *Romantic Landscape Vision: Constable and Wordsworth*. Madison, Wisc.: Univ. of Wisconsin Press, 1975.

Kurman, George. "Ecphrasis in Epic Poetry." *Comparative Literature* 26 (1974): 1-13.

Landow, George P. *Images of Crisis: Literary Iconology, 1750 to the Present*. London: Routledge and Kegan Paul, 1982.

————. "Ruskin's Theory of the Sister Arts." In *The Aesthetic and Critical Theories of John Ruskin*. Princeton: Princeton Univ. Press, 1971, pp. 41-86.

Langdon, Ida. *Milton's Theory of Poetry and Fine Art: An Essay with a Collection of Illustrative Passages from his Works*. Cornell Studies in English, No. 8. New Haven: Yale Univ. Press, 1924, pp. 27-58.

Langer, Susanne K. "Deceptive Analogies: Specious and Real Relationships Among the Arts." In *Problems of Art: Ten Philosophical Lectures*. New York: Scribner, 1957, pp. 75-89.

Larrabee, Stephen A. *English Bards and Grecian Marbles: The Relationship between Sculpture and Poetry Especially in the Romantic Period*. 1943; rpt. Port Washington, N.Y.: Kennikat Press, 1964.

Laude, Jean. "On the Analysis of Poems and Paintings." *New Literary History* 3 (1972): 471-86.

Leader, Zachary. *Reading Blake's "Songs."* London: Routledge and Kegan Paul, 1981.

Leavis, Q. D. "The Dickens Illustrations: Their Function." In *Dickens the Novelist*. F. R. and Q. D. Leavis. 1970; rpt. Harmondsworth: Penguin, 1972, pp. 429-79.

Lee, Rensselaer W. *Names on Trees: Ariosto into Art*. Princeton: Princeton Univ. Press, 1977.

————. "*Ut Pictura Poesis*: The Humanistic Theory of Painting." *Art Bulletin* 22 (1940): 197-269. Rpt. New York: Norton, 1967.

Lichtenberg, Georg Christoph. *The World of Hogarth: Lichtenberg's Commentaries on Hogarth's Engravings*. Trans. Innes and Gustav Herdan. Boston: Houghton Mifflin, 1966.

Lipking, Lawrence. *The Ordering of the Arts in Eighteenth-Century England*. Princeton: Princeton Univ. Press, 1970.

————. "Periods in the Arts: Sketches and Speculations." *New Literary History* 1 (1970): 181-200.

Mace, Dean Tolle. "*Ut Pictura Poesis*: Dryden, Poussin and the Parallel of Poetry and Painting in the Seventeenth Century." In *Encounters*. Ed. Hunt. Pp. 58-81.

Mack, Maynard. *The Garden and the City: Retirement and Politics in the Later Poetry of Pope 1731-1743*. Toronto and Buffalo: Univ. of Toronto Press; London: Oxford Univ. Press, 1969.

Malek, James S. *The Arts Compared: An Aspect of Eighteenth-Century British Aesthetics*. Detroit: Wayne State Univ. Press, 1974.

Malins, Edward. *English Landscaping and Literature 1600-1840*. London: Oxford Univ. Press, 1966.

Manwaring, Elizabeth Wheeler. *Italian Landscape in Eighteenth Century England: A Study Chiefly of the Influence of Claude Lorraine and Salvator Rosa on English Taste 1700-1800*. 1925; rpt. New York: Russell and Russell, 1965.

Matthiessen, F. O. "James and the Plastic Arts." *Kenyon Review* 5 (1943): 533-50.

McLuhan, Marshall and Harley Parker. *Through the Vanishing Point: Space in Poetry and Painting.* New York: Harper and Row, 1968.

Meisel, Martin. "The Material Sublime: John Martin, Byron, Turner, and the Theater." In *Images of Romanticism.* Ed. Kroeber and Walling. Pp. 211-32.

_____. *Realizations: Narrative, Pictorial, and Theatrical Arts in Nineteenth-Century England.* Princeton: Princeton Univ. Press, 1983.

Mellor, Anne Kostelanetz. *Blake's Human Form Divine.* Berkeley and Los Angeles: Univ. of California Press, 1974.

_____. "Coleridge's 'This Lime-Tree Bower My Prison' and the Categories of English Landscape." *Studies in Romanticism* 18 (1979): 253-70.

Merchant, W. Moelwyn. *Shakespeare and the Artist.* London: Oxford Univ. Press, 1959.

Merriman, James D. "The Parallel of the Arts: Some Misgivings and a Faint Affirmation." *Journal of Aesthetics and Art Criticism* 31 (1972): 153-64, 309-21.

Meyers, Jeffrey. *Painting and the Novel.* Manchester: Manchester Univ. Press; New York: Barnes and Noble, 1975.

Miller, J. Hillis. "The Function of Realism: *Sketches by Boz, Oliver Twist,* and Cruikshank's Illustrations." In *Charles Dickens and George Cruikshank.* Los Angeles: William Andrews Clark Memorial Library, 1971, pp. 1-69.

Millgate, Jane. "Narrative Distance in 'Jane Eyre': The Relevance of the Pictures." *Modern Language Review* 63 (1968): 315-19.

Mitchell, W. J. T. *Blake's Composite Art: A Study of the Illuminated Poetry.* Princeton: Princeton Univ. Press, 1978.

_____, ed. *The Language of Images.* Chicago: Univ. of Chicago Press, 1980. [Comprises essays first published in *Critical Inquiry.*]

_____. "Spatial Form in Literature: Toward a General Theory." In *The Language of Images.* Ed. Mitchell. Pp. 271-99.

Monk, Samuel Holt. *The Sublime: A Study of Critical Theories in XVIII-Century England.* 1935; rpt. Ann Arbor: Univ. of Michigan Press, 1960.

Moore, Robert Etheridge. *Hogarth's Literary Relationships.* 1948; rpt. New York: Octagon, 1969.

_____. "Reynolds and the Art of Characterization." In *Studies in Criticism and Aesthetics, 1660-1800.* Ed. Howard Anderson and John S. Shea. Minneapolis: Univ. of Minnesota Press, 1967, pp. 332-57.

Munro, Thomas. *The Arts and Their Interrelations.* 1949; rev. ed., Cleveland: Press of Western Reserve Univ., 1967.

Murdoch, J. D. W. "Scott, Pictures, and Painters." *Modern Language Review* 67 (1972): 31-43.

Nemerov, Howard. "On Poetry and Painting, With a Thought of Music." In *Figures of Thought.* Boston: David Godine, 1978, pp. 95-99. Rpt. in *The Language of Images.* Ed. Mitchell. Pp. 9-13.

New Literary History 3, No. 3 (Spring 1972). [An issue devoted to "Literary and Art History."]

Noyes, Russell. *Wordsworth and the Art of Landscape.* Indiana Univ. Humanities Series, No. 65. Bloomington, Ind.: Indiana Univ. Press, 1968.

O'Hara, J. D. "Ambiguity and Assertion in Wordsworth's 'Elegiac Stanzas.'" *Philological Quarterly* 47 (1968): 69-82.

Paley, Morton D. *William Blake.* Oxford: Phaidon, 1978.

Panofsky, Erwin. "Iconography and Iconology: An Introduction to the Study of Renais-

sance Art." In *Meaning in the Visual Arts: Papers in and on Art History*. Garden City, N.Y.: Doubleday, 1955, pp. 26-54.

Park, Roy. *Hazlitt and the Spirit of the Age: Abstraction and Critical Theory*. Oxford: Clarendon Press, 1971, pp. 95-158.

Passler, David L. *Time, Form, and Style in Boswell's Life of Johnson*. New Haven: Yale Univ. Press, 1971, pp. 31-63.

Patten, Robert L., ed. *George Cruikshank: A Revaluation*. Princeton: Princeton Univ. Library, 1974. [Also published as *Princeton University Library Chronicle* 35, Nos. 1-2 (Autumn, Winter 1973-74).]

Paulson, Ronald. "The Artist, the Beautiful Girl, and the Crowd: The Case of Thomas Rowlandson." *Georgia Review* 31 (1977), 121-39.

_____. *Book and Painting: Shakespeare, Milton, and the Bible*. Knoxville, Tenn.: Univ. of Tennessee Press, 1982.

_____. "Burke's Sublime and the Representation of Revolution." In *Culture and Politics from Puritanism to the Enlightenment*. Ed. Perez Zagorin. Berkeley and Los Angeles: Univ. of California Press, 1980, pp. 241-69.

_____. *Emblem and Expression: Meaning in English Art of the Eighteenth Century*. London: Thames and Hudson; Cambridge, Mass.: Harvard Univ. Press, 1975.

_____. *Hogarth: His Life, Art, and Times*. 2 vols. New Haven: Yale Univ. Press, 1971. [An abridged version, in one volume, was published in 1974.]

_____. *Literary Landscape: Turner and Constable*. New Haven: Yale Univ. Press, 1982.

_____. *Popular and Polite Art in the Age of Hogarth and Fielding*. Notre Dame, Ind.: Notre Dame Univ. Press, 1979.

_____. *Rowlandson: A New Interpretation*. London: Studio Vista; New York: Oxford Univ. Press, 1972.

_____. "The Tradition of Comic Illustration from Hogarth to Cruikshank." In *George Cruikshank: A Revaluation*. Ed. Patten. Pp. 35-60.

Peckham, Morse. "Blake, Milton, and Edward Burney." *Princeton University Library Chronicle* 11 (1950): 107-26.

_____. *Man's Rage for Chaos: Biology, Behavior, and the Arts*. 1965; rpt. New York: Schocken, 1967.

Petersson, Robert T. *The Art of Ecstasy: Teresa, Bernini, and Crashaw*. New York: Atheneum, 1970.

Pickering, F. P. *Literature & Art in the Middle Ages*. Coral Gables, Fla.: Univ. of Miami Press, 1970.

Pointon, Marcia R. *Milton & English Art*. Manchester: Manchester Univ. Press, 1970.

Praz, Mario. *The Hero in Eclipse in Victorian Fiction*. Trans. Angus Davidson. London: Oxford Univ. Press, 1956.

_____. *Mnemosyne: The Parallel between Literature and the Visual Arts*. Bollingen Series 35, No. 16. Princeton: Princeton Univ. Press, 1970.

_____. *On Neoclassicism*. Trans. Angus Davidson. Evanston, Ill.: Northwestern Univ. Press, 1969.

_____. *The Romantic Agony*. Trans. Angus Davidson. London, 1933; 2nd ed., 1951; rpt. Cleveland: World, 1965.

_____. *Studies in Seventeenth-Century Imagery*. London, 1939; 2nd ed., Rome: Storia e Letteratura, 1964.

Price, Martin. "The Picturesque Moment." In *From Sensibility to Romanticism: Essays Presented to Frederick A. Pottle*. Ed. Frederick W. Hilles and Harold Bloom. New York: Oxford Univ. Press, 1965, pp. 259-92.

Read, Herbert. "Parallels in Painting and Poetry." In *In Defence of Shelley & Other Essays*. London: Heinemann, 1936, pp. 223-48.

Reverand, Cedric D., II. "*Ut pictura poesis*, and Pope's 'Satire II,i.'" *Eighteenth-Century Studies* 9 (1975-76): 553-68.

Rice-Sayre, Laura and Henry M. Sayre. "Autonomy and Affinity: Toward a Theory for Comparing the Arts." In *The Arts and Their Interrelations*. Ed. Garvin. Pp. 86-103.

Ringe, Donald A. *The Pictorial Mode: Space & Time in the Art of Bryant, Irving & Cooper*. Lexington, Ky.: Univ. Press of Kentucky, 1971.

Roe, Albert S. *Blake's Illustrations to the Divine Comedy*. Princeton: Princeton Univ. Press, 1953.

Rogerson, Brewster. "The Art of Painting the Passions." *Journal of the History of Ideas* 14 (1953): 68-94.

Rose, Edward J. "'A Most Outrageous Demon': Blake's Case Against Rubens." *Bucknell Review* 17, No. 1 (March 1969): 35-54.

————. "Visionary Forms Dramatic: Grammatical and Iconographical Movement in Blake's Verse and Designs." *Criticism* 8 (1966): 111-25.

Saisselin, Rémy G. "*Ut Pictura Poesis*: Dubos to Diderot." *Journal of Aesthetics and Art Criticism* 20 (1961): 145-56.

Sambrook, James. "Pope and the Visual Arts." In *Writers and their Background: Alexander Pope*. Ed. Peter Dixon. London: Bell, 1972, pp. 143-71.

Schapiro, Meyer. *Words and Pictures: On the Literal and the Symbolic in the Illustration of a Text*. Approaches to Semiotics: Paperback Series, No. 11. The Hague and Paris: Mouton, 1973.

Seznec, Jean. "Art and Literature: A Plea for Humility." *New Literary History* 3 (1972): 569-74.

————. "Flaubert and the Graphic Arts." *Journal of the Warburg and Courtauld Institutes* 8 (1945): 175-90.

————. *The Survival of the Pagan Gods: The Mythological Tradition and Its Place in Renaissance Humanism and Art*. [1940.] Trans. Barbara F. Sessions. Bollingen Series 38. Princeton: Princeton Univ. Press, 1953.

Shesgreen, Sean. *Literary Portraits in the Novels of Henry Fielding*. DeKalb, Ill.: Northern Illinois Univ. Press, 1972.

Smart, Alastair. "Pictorial Imagery in the Novels of Thomas Hardy." *Review of English Studies*, n.s. 12 (1961): 262-80.

Souriau, Etienne. "Time in the Plastic Arts." *Journal of Aesthetics and Art Criticism* 7 (1949): 294-307.

Spencer, Jeffry B. *Heroic Nature: Ideal Landscape in English Poetry from Marvell to Thomson*. Evanston, Ill.: Northwestern Univ. Press, 1973.

Spencer, John R. "Ut Rhetorica Pictura: A Study in Quattrocento Theory of Painting." *Journal of the Warburg and Courtauld Institutes* 20 (1957): 26-44.

Spencer, T. J. B. "The Imperfect Parallel Betwixt Painting and Poetry." *Greece and Rome*, 2nd ser. 7 (1960): 173-86.

Steadman, John M. "Iconography and Renaissance Drama: Ethical and Mythological Themes." In *Research Opportunities in Renaissance Drama: The Report of the Modern Language Association Conference*, vols. 13-14 (1970-71). Ed. S. Schoenbaum. Evanston, Ill.: Northwestern Univ. Press, 1972, pp. 73-122.

Steig, Michael. "The Critic and the Illustrated Novel: Mr. Turveydrop from Gillray to *Bleak House*." *Huntington Library Quarterly* 36 (1972): 55-67.

————. "George Cruikshank and the Grotesque: A Psychodynamic Approach." In *George Cruikshank: A Revaluation*. Ed. Patten. Pp. 189-211.

Stein, Leo. "On Reading Poetry and Seeing Pictures." In *Appreciation: Painting, Poetry, Prose*. New York: Crown, 1947, pp. 91-138.

Steinberg, Theodore L. "Poetry and the Perpendicular Style." *Journal of Aesthetics and*

Art Criticism 40 (1981): 71-79.

Steiner, Wendy. *The Colors of Rhetoric: Problems in the Relation between Modern Literature and Painting.* Chicago: Univ. of Chicago Press, 1982.

_____. *Exact Resemblance to Exact Resemblance: The Literary Portraiture of Gertrude Stein.* New Haven: Yale Univ. Press, 1978.

Stevens, Wallace. "The Relations between Poetry and Painting." In *The Necessary Angel: Essays on Reality and the Imagination.* New York: Knopf, 1951, pp. 157-76.

Stone, Harry. "Dickens, Cruikshank, and Fairy Tales." In *George Cruikshank: A Revaluation.* Ed. Patten. Pp. 213-47.

Storch, R. F. "Abstract Idealism in English Romantic Poetry and Painting." In *Images of Romanticism.* Ed. Kroeber and Walling. Pp. 189-209.

_____. "Wordsworth and Constable." *Studies in Romanticism* 5 (1966): 121-38.

Swingle, L. J. "Wordsworth's 'Picture of the Mind.'" In *Images of Romanticism.* Ed. Kroeber and Walling. Pp. 81-90.

Sypher, Wylie. *Four Stages of Renaissance Style: Transformations in Art and Literature 1400-1700.* Garden City, N.Y.: Doubleday, 1955.

_____. *Loss of the Self in Modern Literature and Art.* New York: Random House, 1962.

_____. *Rococo to Cubism in Art and Literature.* New York: Random House, 1960.

Tayler, Irene. *Blake's Illustrations to the Poems of Gray.* Princeton: Princeton Univ. Press, 1971.

Tinker, Chauncey B. *Painter and Poet: Studies in the Literary Relations of English Painting.* 1938; rpt. Freeport, N.Y.: Books for Libraries Press, 1969.

Trimpi, Wesley. "Horace's 'Ut Pictura Poesis': The Argument for Stylistic Decorum." *Traditio* 34 (1978): 29-73.

_____. "The Meaning of Horace's *Ut Pictura Poesis.*" *Journal of the Warburg and Courtauld Institutes* 36 (1973): 1-34.

Tyson, Gerald P. "The Rococo Style of *Tristram Shandy.*" In *The Arts and Their Interrelations.* Ed. Garvin. Pp. 38-55.

Vogler, Richard A. "Cruikshank and Dickens: A Reassessment of the Role of the Artist and the Author." In *George Cruikshank: A Revaluation.* Ed. Patten. Pp. 61-91.

Walling, William. "More Than Sufficient Room: Sir David Wilkie and the Scottish Literary Tradition." In *Images of Romanticism.* Ed. Kroeber and Walling. Pp. 107-31.

Watson, J. R. *Picturesque Landscape and English Romantic Poetry.* London: Hutchinson, 1970.

_____. "Turner and the Romantic Poets." In *Encounters.* Ed. Hunt. Pp. 96-123.

_____. "Wordsworth and Constable." *Review of English Studies*, n.s. 13 (1962): 361-67.

Watts, Emily Stipes. *Ernest Hemingway and the Arts.* Urbana, Ill.: Univ. of Illinois Press, 1971.

Webster, T. B. L. *Hellenistic Poetry and Art.* London: Methuen, 1964.

Wechsler, Judith. *A Human Comedy: Physiognomy and Caricature in 19th Century Paris.* Chicago: Univ. of Chicago Press, 1982.

Wecter, Dixon. "Burke's Theory Concerning Words, Images, and Emotion." *PMLA* 55 (1940): 167-81.

Weisinger, Herbert. "Icon and Image: What the Literary Historian Can Learn from the Warburg School." *Bulletin of the New York Public Library* 67 (1963): 455-64.

Weisstein, Ulrich. "The Mutual Illumination of the Arts." In *Comparative Literature and Literary Theory: Survey and Introduction.* Trans. William Riggan. Bloomington, Ind.: Indiana Univ. Press, 1973, pp. 150-66.

Wellek, René. "The Parallelism between Literature and the Arts." In *English Institute Annual*, 1941. 1942; rpt. New York: AMS Press, 1965, pp. 29-63.

Wellek, René, and Austin Warren. *Theory of Literature*. 1949; 3rd ed., New York: Harcourt, Brace and World, 1956, pp. 125-35. [A shorter version of the previous entry.]

Wendorf, Richard. "Jonathan Richardson: The Painter as Biographer." Forthcoming in *New Literary History*.

Wisenfarth, Joseph. "*Middlemarch*: The Language of Art." *PMLA* 97 (1982): 363-77.

Williams, Ralph M. *Poet, Painter, and Parson: The Life of John Dyer*. New York: Bookman Associates, 1956.

Wimsatt, William K., Jr. "Laokoön: An Oracle Reconsulted." In *Day of the Leopards: Essays in Defense of Poems*. New Haven: Yale Univ. Press, 1976, pp. 40-56. [See also his supplement, pp. 57-73.]

Wimsatt, William K., Jr., and Cleanth Brooks. *Literary Criticism: A Short History*. 1957; rpt. New York: Knopf, 1966, pp. 252-76.

Wind, Edgar. *Pagan Mysteries in the Renaissance*. 1958; rev. ed., 1968; rpt. New York: Norton, 1969.

Winner, Viola Hopkins. *Henry James and the Visual Arts*. Charlottesville: Univ. Press of Virginia, 1970.

Witemeyer, Hugh. *George Eliot and the Visual Arts*. New Haven: Yale Univ. Press, 1979.

Woodring, Carl. "What Coleridge Thought of Pictures." In *Images of Romanticism*. Ed. Kroeber and Walling. Pp. 91-106.

Ziff, Jerrold. "J. M. W. Turner on Poetry and Painting." *Studies in Romanticism* 3 (1964): 193-215.

A NOTE ON CONTRIBUTORS

Karl Kroeber, Professor of English at Columbia University, has written *Romantic Narrative Art* (1960), *The Artifice of Reality: Poetic Style in Wordsworth, Foscolo, Keats, and Leopardi* (1964), and *Romantic Landscape Vision: Constable and Wordsworth* (1975). He is co-editor of *Images of Romanticism* (1978), and is currently writing a study of the development of modern art.

Lawrence Lipking is Chester Tripp Professor of the Humanities at Northwestern University. He is author of *The Ordering of the Arts in Eighteenth-Century England* (1970) and *The Life of the Poet* (1981), which received the Christian Gauss Award; he has coedited *Modern Literary Criticism 1900-1970* (1972) and edited the recent collection of essays in honor of M. H. Abrams, *High Romantic Argument* (1981). He is now at work on a literary study of abandoned women.

Earl Miner is Townsend Martin, Class of 1917, Professor of English and Comparative Literature at Princeton University. Among his many books are *Dryden's Poetry* (1967) and a three-volume study of English poetry in the seventeenth century (1969-74). He has been working more recently on literary theory and Japanese literature, and, with Hiroko Odagiri and Robert Morrell, *The Princeton Companion to Classical Japanese Literature.*

W. J. T. Mitchell edits *Critical Inquiry* and is the author of *Blake's Composite Art* (1978). His most recent publications are two collections of essays by several hands, *The Language of Images* (1980) and *On Narrative* (1981). He is working on a book entitled

Iconology: The Image in Literature and the Visual Arts. He is Professor of English and Art and Design at the University of Chicago.

Morton D. Paley, Professor of English at the University of California, Berkeley, is the author of *Energy and the Imagination* (1970), *William Blake* (1978), and (with Robert N. Essick) *The Grave by Robert Blair, Illustrated by William Blake* (1982). He is co-editor of *William Blake: Essays in Honour of Sir Geoffrey Keynes* (1973), and co-editor of the journal *Blake: An Illustrated Quarterly*. He has recently completed a book on Blake's *Jerusalem*.

Ronald Paulson is Thomas E. Donnelley Professor of English at Yale University. He is the author of *Theme and Structure in Swift's "Tale of a Tub"* (1960), *The Fictions of Satire* and *Satire and the Novel* (1965), and several studies of Hogarth, Rowlandson, and English painting. His most recent books are *Popular and Polite Art in the Age of Hogarth and Fielding* (1979), *Literary Landscape: Turner and Constable* (1982), *Book and Painting: Shakespeare, Milton, and the Bible* (1982), and *Representations of Revolution* (1983).

Larry Silver is the author of numerous articles on Flemish, Dutch, and German art of the sixteenth century, as well as the recent book *Prayer and Laughter: The Paintings of Quinten Massys* (1983). He is currently completing work on a catalog of old master paintings at the Art Institute of Chicago and on a study of the ideology and patronage of Emperor Maximilian I. He is Chairman of the Department of Art History at Northwestern University.

Robert R. Wark is Curator of Art Collections at the Henry E. Huntington Library and Art Gallery. Among his many publications on British art are his edition of Reynolds's *Discourses* (1959), *Ten British Pictures, 1740-1840* (1971), *Drawings from the Turner Shakespeare* (1973), and *Drawings by Thomas Rowlandson in the Huntington Collection* (1975). His present work continues to be in the general field of British drawings and watercolors.

Richard Wendorf is Associate Chairman of the English Department at Northwestern University. He is co-editor of *The Works of William Collins* (1979) and author of *William Collins and Eighteenth-Century English Poetry* (1981). He is currently writing a comparative study of biography and portrait painting in the seventeenth and eighteenth centuries, entitled *The Elements of Life*.

Index

INDEX